LARGE 738.
Clark, Gar
American c So-AEK-416
present

A M E R I C A N C E R A M I C S

1876 to the Present

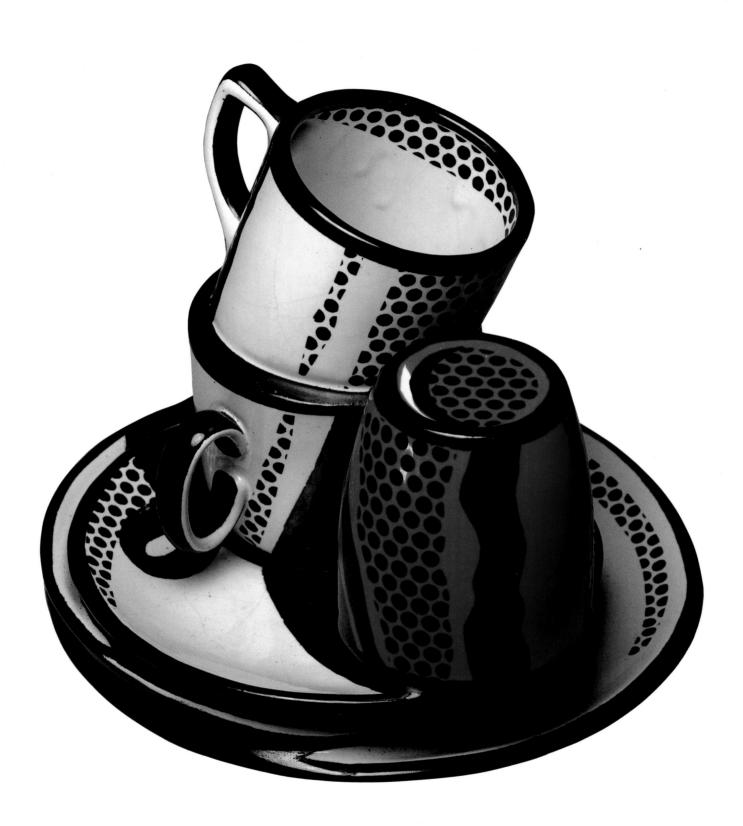

AMERICAN CERAMICS

_____ 1876 to the Present _____

GARTH CLARK

ABBEVILLE PRESS•PUBLISHERS•NEW YORK

NK 4007 .C56 1987 Editor: Libby W. Seaberg

Copy Editor: Bitite Vinklers

Designer: Joel Avirom

Production Manager: Dana Cole

Library of Congress Cataloging-in-Publication Data Clark, Garth, 1947– American ceramics, 1876 to the present.

Rev. ed. of: A century of ceramics in the United States, 1878–1978. c1979.

Bibliography: p. Includes index.

- 1. Pottery, American. 2. Pottery—19th century—United States.
- 3. Pottery—20th century—United States. 4. Porcelain, American.
- 5. Porcelain—19th century—United States. 6. Porcelain—20th century—United States. 7. Potters—United States—Biography.
- I. Clark, G. Garth, 1947– Century of ceramics in the United States, 1878–1978. II. Title.

NK4007.C56 1987 738'.0973 87-1177 ISBN 0-89659-743-1

Copyright © 1987 Cross River Press, Ltd.

All rights reserved under International and Pan-American Copyright Conventions. No part of this book may be reproduced or utilized in any form or by any means, electronic or mechanical, including photocopying, recording, or by any information storage and retrieval system, without permission in writing from publisher.

Inquiries should be addressed to Abbeville Press, Inc., 488 Madison Avenue, New York, N.Y. Printed and bound in Japan. Revised edition.

FRONTISPIECE: Roy Lichtenstein Ceramic Sculpture #11, 1965. See page 130.

PHOTOGRAPH ON PAGE 8: Toshiko Takaezu Closed Form, 1980.

Porcelain, height 6". Collection Daniel Jacobs.

ACKNOWLEDGMENTS

This book is the result of shared knowledge and passion on the part of many friends and colleagues. I have attempted to thank those individuals who provided special assistance, but if I have omitted any names it is just my inefficiency and does not reflect a lack of gratitude. First, I wish to thank Margie Hughto and Ronald Kuchta, director of the Everson Museum of Art, for encouraging me to write A Century of Ceramics in the United States ten years ago, the book on which this volume is based. In many ways that book and the exhibition it accompanied changed my professional life, and I am grateful for Hughto's initiative and Kuchta's support and trust over the years. As far as the present project is concerned, I wish to thank my editor, Amy Walsh, for enduring my confusing bicoastal communications, computer glitches, missing discs, and electronic "anomalies." She worked energetically under great pressure. Abbeville Press has been a flexible and understanding partner. In particular the professionalism and cheerful encouragement of Abbeville's Sharon Gallagher and Libby Seaberg's attention to detail and matters of scholarship have made this project a pleasure to work on.

Many museum curators and directors have assisted in gathering the photographic material, and in particular I wish to thank Marjorie Beebe (Galleries of the Claremont Colleges), Ulysses Dietz (The Newark Museum), Suzann Dunaway (Mills College Art Gallery), Susan Harkavy (American Craft Museum), Philip Johnston (Museum of Art, Carnegie Institute), Martha Lynne (Los Angeles County Museum of Art), David McFadden (Cooper-Hewitt Museum), the indefatigable Barbara Perry (Everson Museum of Art), Kevin Stayton (The Brooklyn Museum), Davira Taragin (The Detroit Institute of Arts), John L. Vanco (Erie Art Museum), and Oliver Watson (Victoria and Albert Museum). The cooperation of all the artists and their galleries is enormously appreciated, and although I am loath to single out any individuals, the friendly assistance of Asher/Faure, Allan Frumkin and his gallery staff, Fuller/Goldeen, Barbara Gladstone,

and the Jordan-Volpe Gallery was considerable.

I am grateful to all the collectors for helping to arrange photography and for access to their collections. Betty Asher, Martin Davidson and Dawn Bennett, Gwen Laurie Smits, the Jedermann Collection, and Hope and Jay Yampol were most generous with their time. A special thanks must go to Daniel Jacobs for making his impressive and scholarly archives available to me and for allowing so many examples from his collection to be reproduced—the time and energy he expended on this project were considerable and have enhanced the quality of this book. The talents of many photographers (past and present) have been assembled in this book, but in particular I wish to thank Courtney Frisse, Tony Cunha, and the magical John White for their efficient and creative support. In addition my thanks to Joel Avirom for his sensitive design of the book.

In order to write this book I have had to take off five months from my gallery duties. It was my staff and partners, Alice Hohenberg, Wayne Kuwada, and Mark Del Vecchio, who filled in for me. I wish to thank both Wayne and Alice for assisting in organizing the photography. My greatest debt is to Mark for the freedom he provided me during this frenetic time by taking on so much work and for the thankless task of keeping my spirits high. Without him the book could not have been completed in so short a period of time. Lynne Wagner also provided valuable assistance, being a seasoned veteran from the *Century* book.

My sons Kelly and Mark exercised a restraint and maturity beyond their years over the past five months and were charmingly supportive and inquisitive as the project progressed. Last, my thanks to my parents, Reg and Babs Clark, whose visit to this country coincided *again* with my work on the book, and when required they uncomplainingly took a back seat to the bank of clattering Kaypro word processors.

This book is dedicated to Mark Del Vecchio and the creative individuals whose spirit and achievement ennoble these pages.

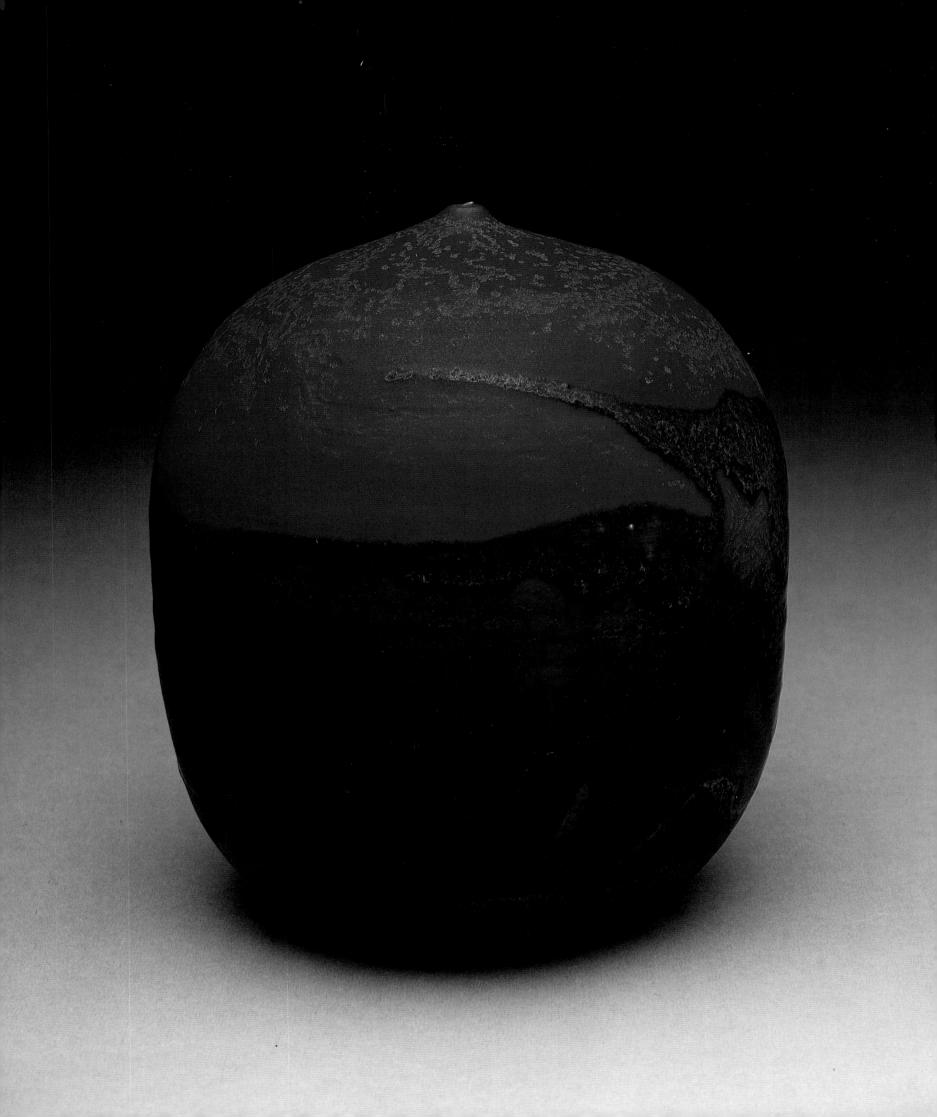

A decade has passed since I began to work on the book A Century of Ceramics in the United States 1878–1978. Much has changed in that relatively brief period of time. Contemporary American ceramics has progressed from the anonymity of the craft shop to the critical spotlight of the museum and the art gallery. Its aesthetic concerns have become the focus of serious scholarly attention. The politics of patronage have dramatically altered from an academic system dominated by educational institutions to free-market support from corporate and private collectors. American art pottery has come out of the attics and into the feverish arena of the auction houses and specialty dealers. It seemed that by 1980 ceramics had, almost overnight, acquired a large and influential audience—a development in which the Century book played a role.

The book became the catalogue for an exhibition of the same title, which I co-curated with Margie Hughto and which was organized by the Everson Museum of Art. The timing of the exhibition was perfect—igniting a massive interest in the media. It traveled through the United States from 1979 to 1981, drawing unusually large audiences and enthusiastic support from the art critics. Part of the fascination with the exhibition was in the excitement of discovery. This was the first time that the modern history of American ceramic art had been assembled and presented in an art context.

Most viewers did not realize that ceramics had enjoyed such a cohesive, complex, and provocative tradition. It also became apparent from this exhibition that while the medium was responsive to other visual arts, it also revealed a tough independence, dealing with issues, visual languages, and metaphors that were unique to the medium. In addition, it was also evident that from the 1950s onward American ceramics had taken on a radical leadership role in the ceramics world—a position that it still retains today despite energetic competition from Europe and Japan.

The importance of ceramics in the broader art fabric of the United States has been acknowledged

since 1979 by many museums. In the past few years major surveys confirming the originality and importance of American ceramics have taken place at the Victoria and Albert Museum, London; Stedelijk Museum, Amsterdam; Museum of Fine Arts, Boston; Whitney Museum of American Art, New York; Los Angeles County Museum of Art; Nelson-Atkins Museum of Art, Kansas City, Missouri; San Francisco Museum of Modern Art; and many other institutions.

All of these developments have altered the structure of the medium, and with the emergence of a new generation of actively exhibiting ceramists, it was necessary to update and enlarge the Century book. The project began as such projects often do-with modest ambitions. In fact, the text has grown by forty percent, and many of the chapters were rewritten, as were most of the biographical essays. In addition, new photography was commissioned. Surprisingly, few of my opinions have altered over the decade. Indeed, I believe that many of the viewpoints, particularly some of the more controversial issues, have been vindicated with time. However, upon rereading the text I found many statements to be too generalized and I have tried to refine definitions and judgments and make them much more specific.

The other difference between this book and its predecessor is that this revision has essentially grown into two books. The first part is a historical narrative organized by decade. The second part constitutes a very substantial body of "back matter." All of the artists in the book are described and discussed in the biography section. Some entries give only a brief introduction to the artist, while most of the entries on the more seminal figures have evolved into detailed and major essays. I would suggest that the narrative be read in tandem with the biographies.

The second part of the book includes a selected listing of ceramics exhibitions since 1876 and a 1,200-entry bibliography, together with a subject and artist index to the bibliography. This provides a substantial resource for scholars and for those

who wish to research American ceramics beyond the limits of this overview.

Last, I wish to apologize to the many talented artists whose work I have not been able to include in this study. American ceramics has grown into a massive activity and it will take many books in the future to give this medium all the exposure

and credit that is its due. I trust, however, that those artists who have been included will be effective ambassadors for the field at large and represent the complementary mix of tradition and innovation that has characterized the ceramics movement in the United States and maintained its vanguardist role internationally.

A M E R I C A N C E R A M I C S

_____ 1876 to the Present _____

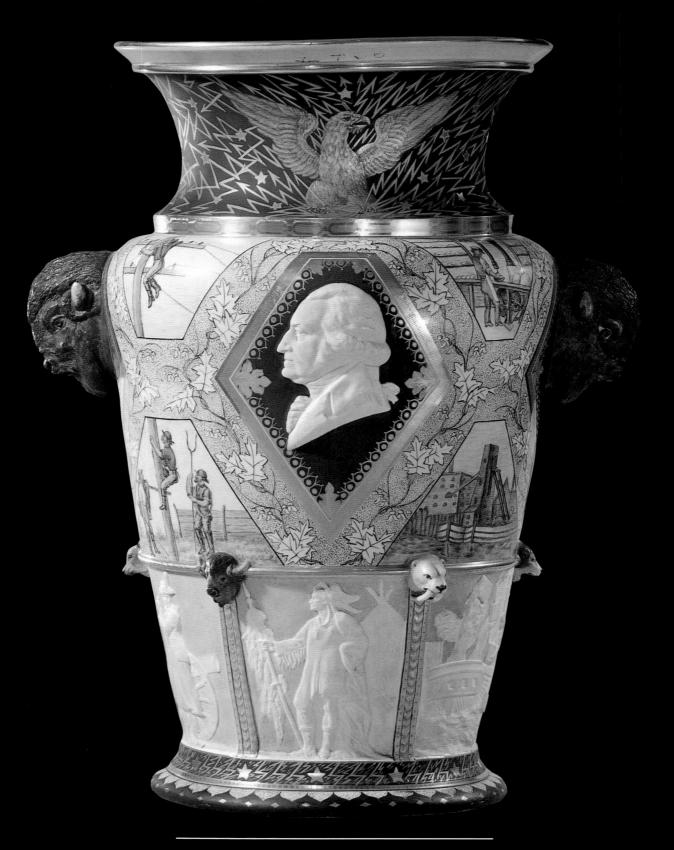

Karl Müller Union Porcelain Works, Greenpoint, New York. Century Vase, 1876. Porcelain, height 22½". The Brooklyn Museum. Gift of Carll and Franklin Chace in Memory of Pastora Forest Smith Chace.

The Centennial Exposition of 1876 in Philadelphia provided little indication of the brewing revolution in ceramic art. Indeed, the opposite seemed to be true. Isaac Clarke criticized American ceramics, stat-

ing that "American attempts at artistic decoration were such as to make the judicious grieve . . . [there was] nothing to approach even the lower grades of European ware." Yet underlying the poor design at the Centennial were the seeds of an American aesthetic that could be seen in Karl Müller's Century Vase and Isaac Broome's Baseball Vase. The latter was of particular interest because it drew from indigenous experience, resulting in an original, if slightly incongruous, form.

Also at the Centennial was a little-noticed display of painted china by a group of women artists from Cincinnati. Their work was not remarkable in itself, but it represented the first sign of a spirit of invention and achievement that was beginning to surface in this affluent Ohio city, and that was to lead in the next four years to the founding of the art pottery movement in the United States. More importantly, their work set the ceramist on a course that was to lead, eighty years later, to the preeminence of the United States in the world of ceramic art and to the redefinition of the medium's role in the fine and decorative arts.

The first phase of the art pottery movement in the United States lasted from 1878 to 1889. This seminal period covers three important developments: the development of what was later to become known as Cincinnati faience; the founding of the Rookwood Pottery in 1880; and, in 1889, the first international recognition of American art pottery. These achievements were largely the result of the efforts of two socially prominent women, Mary Louise McLaughlin and Maria Longworth Nichols. Both women were central figures in the women's art movement in Cincinnati, "a group of unusually talented and energetic ladies [in] an expanding Midwestern community yearning for culture, refinement and recognition equal to that of the older

CHAPTER ONE

1876

cities along the Eastern Seaboard."2

Both McLaughlin and Nichols became involved in pottery decoration through their interest in china painting. Karl Langenbeck, a glaze chemist who had received a set of

German china paints as a gift, introduced Nichols to the "Devil's art" in 1873. In the following year, McLaughlin took instruction in china painting from Marie Eggers as part of Benn Pitman's course in wood carving at the Cincinnati School of Design.³ The course was a popular success, although Ms. Eggers knew little more of the technique than did her students. Excited by the overglaze techniques, the students formed a committee to select chinapainted wares for the Centennial in 1876. They raised funds for the city's participation in the Centennial by holding a Martha Washington tea party and auctioning china cups that had been painted at the School of Design. The cups fetched as much as \$25 each, and the sale raised \$385.

The painted china selected for the Centennial was exhibited alongside carved wood, needlework, and watercolors in the Cincinnati Room of the Woman's Pavilion. Although these china objects lacked formal accomplishment—and at times showed unfortunate lapses of taste—they represented one of the earliest attempts in the United States to employ ceramics as an independent art medium. The sensation of the Centennial, however, was the Japanese ceramics display and the slippainted procès barbotine⁴ wares of Haviland Auteuil, which were also exhibited in the French court. First introduced by the French artist-potter Ernest Chaplet, barbotine wares are characterized by their rich, Rembrandtesque underglaze surfaces in tones of brown, ocher, and blue. Writing about what he called the Limoges faience, R. H. Soden Smith of the South Kensington Museum (later known as the Victoria and Albert Museum) hailed the artistic excellence of the work and suggested that "it is not impossible that it will have an art influence on our time."5 The words were indeed prophetic. For a time, barbotine was the rage of Europe and was extensively imitated. The interest in Europe was short-lived, however, while in the United States the variants of this technique were the basis for the early pioneering work of McLaughlin, Charles Volkmar, Hugh Robertson, and the Rookwood Pottery. Barbotine became the dominant technique in American art pottery, a position it maintained until the early twentieth century.

Soon after the Centennial McLaughlin began to experiment at the Patrick L. Coultry Pottery,

Mary Louise McLaughlin Patrick L. Coultry Pottery, Cincinnati. Pilgrim Jar, 1876. Slip-painted, glazed earthenware, height 103/8". Cincinnati Art Museum.

attempting to reproduce the barbotine wares. At first she made the common error of painting underglaze with pure oxides. Then, in 1877, she realized that the depth and richness of the barbotine palette came from mixing the oxides with slip to form an engobe. She applied the engobes to the pots while unfired and leather-hard. In her first firing, in October 1877, she applied the slips too thinly, and the yellow color of the body showed through, marring the effect. But, by January 1878, she had drawn the first technically successful piece from the kiln—a pilgrim bottle. The first exhibition of these wares took place in May, under the auspices of the Women's Art Museum Association. The

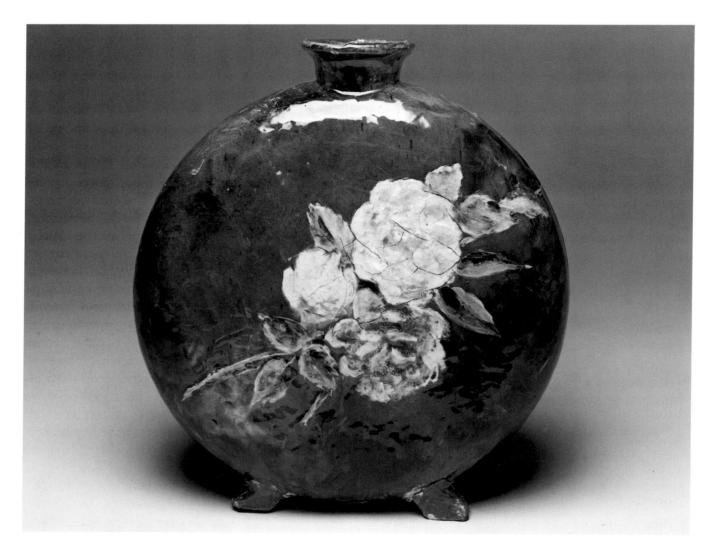

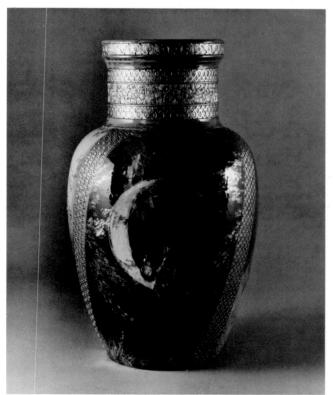

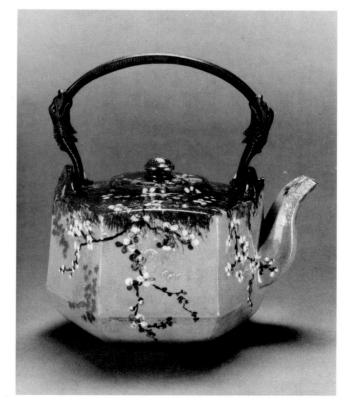

Charles Volkmar Greenpoint, New York. Handled Vases, 1879–81. Earthenware, slip painting under clear glaze, height 12½". The Brooklyn Museum. Gift of Leon Volkmar.

LEFT: *Mary Louise McLaughlin* Frederick Dallas Pottery, Cincinnati. Ali Baba Vase, 1880. Earthenware, slip-painted under a clear glaze, height 36½". Cincinnati Art Museum. Gift of Rookwood Pottery.

Matthew A. Daly Rookwood Pottery, Cincinnati. Vase, 1886. Earthenware, slip painting under clear glaze, height 201/4". Private collection.

The Arts and Crafts Movement had little effect on the aesthetics of Rookwood, but it had an impact in other ways. Rookwood was to adopt many of the progressive attitudes of the movement, including the employment of women decorators and the liberal treatment of its "artists." The attention and publicity that the Arts and Crafts Movement was receiving in England provided both a validation and a spur for similar activities in the United States. The art pottery movement in the United States did not, however, have the hard, anti-industry ideological stance of its counterpart in England. Whereas the English movement was socialistic in character, its American version was capitalistic. The art potteries, and in particular Rookwood, were very much at ease with the marriage of industry, art, and craft. Profit was held to be as sacred as aesthetics.

Nichols began to employ decorators at Rookwood. Gradually the pottery developed purpose, becoming an art pottery in the true sense, concentrating on unique pieces while still producing some transfer wares. An important figure in Rookwood's success story was Benn Pitman, the founder of the Cincinnati School of Design. Most of the earliest, and ultimately some of the most influential, of Rookwood's decorators graduated from Pitman's school. Albert R. Valentien (né Valentine) was Rookwood's first decorator, joining the pottery in September 1881 after graduating from the School of Design. In 1881 and 1882 the pottery engaged new decorators: Alfred L. Brennan, Laura A. Fry, Clara Chipman Newton, Harriet ("Nettie") Wenderoth, Matthew A. Daly, Joseph N. Hirschfield, and William P. MacDonald. All but Brennan were students of Pitman.

Pitman had originally come to the United States from England to promote his brother's invention shorthand—but he remained to head the School of Design. He was a "progressive" educator and a disciple of John Ruskin and William Morris. In particular, he was passionate in his advocacy of nature as the source of ornament. This was not a unique position. It had been advocated in the influential writings of Owen Jones (Grammar of Ornament, 1856) and of Christopher Dresser (Studies in Design, 1876). However, the style Pitman advocated relied less on the stylized forms preferred by the Arts and Crafts Movement and more on the clear, balanced, restrained forms of the Beaux-Arts Movement. Pitman's interest in flowers and plants was not just a matter of theoretical or intellectual pursuit; the late nineteenth century was characterized by a populist fascination with nature:

Perhaps no other century was so taken with flowers and plants as was the nineteenth. Indeed the century's cultural preoccupation with nature is deserving of thorough study. Flowers and plants surrounded the daily lives of people in the past century: through interior designs in wallpaper, carpets and textiles, in cut arrangements, in gardens and parks, in illustrations in popular magazines. Long associated with rituals of courtship and courtesy and invested with profound iconographical religious meaning, flowers became the element of a complicated

"language" developed to permit the wordless expression of sentiment. Through Kate Greenaway and other nineteenth century writers and illustrators the "language of flowers" entered popular culture. 13

In 1883 Nichols appointed William Watts Taylor as manager and from then on took an ever-diminishing role in the pottery's affairs. Taylor proved to be a shrewd manager, and although Newton never approved of Taylor personally, she rightly credited him with being responsible for the financial and artistic success of the pottery, saying that he was "due the honor of carrying the pottery up from the mud banks of the river to the heights of Mt. Adams."

Taylor's first changes were to cease all transferware production and to evict the Pottery Club (with Nichols's consent), as he did not enjoy nurturing what he saw as a future competitor on the premises. Although businesslike in his handling of affairs, Taylor recognized that the independence of the artists and the encouragement of experiment were important. Thus, he organized lectures on art for his staff and assisted them in their studies and researches. He was careful, however, to allow the production only of wares that were of a conservative nature and astutely avoided the bizarre and exotic. This meant eradicating the remaining grotesque qualities of Nichols's japonisme, on which the early style of the pottery had been based,15 and modifying the Japanese style with that of the more formal Beaux-Arts. Rookwood had been trying since 1881 to enlist a Japanese decorator and finally succeeded, in 1887, in hiring a talented young artist, Kataro Shirayamadani, who introduced a new elegance and purpose to the Rookwood style. The marriage of Japanese art to Pitman's naturalism remained the most vital force acting upon the Rookwood style.

The introduction of significant technical innovations altered the mawkishness of the wares produced during the first three years at Rookwood, giving way to a more accomplished and safe style of slip painting. In 1883 Laura Anne Fry had adapted a throat atomizer to apply the slips on greenware, a technique she later patented at the suggestion of Taylor. ¹⁶ Aware of the need to have greater control of the ceramic processes, Taylor employed Karl Langenbeck in 1884 as the first glaze chemist in the nation. About the time of Langenbeck's arrival, the distinctive tiger's-eye, a crystalline aventurine glaze, was accidentally discovered at Rookwood. European factories, including Sèvres and Meissen, were intrigued by these early innovations in Cincinnati and produced their own imitations.

The Cincinnati art pottery movement came of age in 1889, when Rookwood received a coveted gold medal in competition with Europe's finest potteries at the Exposition Universelle in Paris. The exposition was a double triumph for Cincinnati, since a silver medal was awarded to McLaughlin for her overglaze decoration with metallic effects. This brought to an end what might be termed the movement's period of innocence. Through sheer

Laura Anne Fry Cincinnati Pottery Club. Plaque, 1881. Slippainted earthenware under clear glaze, diameter 14¾". The Saint Louis Art Museum. Gift of the artist.

naiveté and empiric experiment, the movement's leaders had stumbled on a number of significant decorative techniques and glazes. A period of difficult sophistication, in both intent and aesthetics, lay ahead.

The East Coast played only a minor role in art pottery until the late 1890s. Two of the early pioneers, Hugh Cornwall Robertson and Charles Volkmar, were involved, however, in the production of barbotine wares before this date. Soon after the Centennial, Robertson produced Bourg-la-Reine

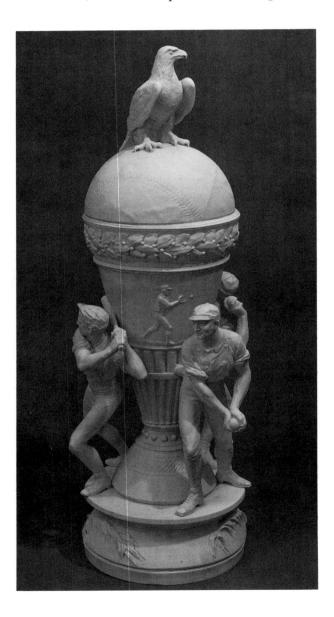

wares at the Chelsea Keramik Art Works, his family pottery, founded in 1872 in Boston. He named the wares in honor of the town where Chaplet had revived the barbotine process. Volkmar had learned of the process while working with the *maître faïencier* Theodore Deck in Paris. ¹⁷ The wares that Volkmar produced on his return to the United States in 1879 were termed "Volkmar faience" and were the closest in style and technique to the original barbotine wares. Working on Long Island, Volkmar became known for the bucolic landscapes in the style of the Barbizon school that he painted onto forms derived from Classical Greek models.

Both Robertson and Volkmar eventually turned from the slip-painted wares to Oriental techniques and glazes. Robertson's obsession was with the flambé rouge and sang de boeuf glazes; unfortunately, he became so preoccupied with these glazes that he neglected the management of the pottery, which closed in 1888. In 1891, with a group of wealthy Bostonians as backers, Robertson established the Chelsea Pottery and continued his experiments. Volkmar meanwhile moved his kilns first to Corona, Long Island, and then to Metuchen, New Jersey. Despite their importance historically—Robertson for his glaze science and Volkmar as a teacher neither was an artist of consequence, and their achievements fade in comparison to those of their contemporaries in Cincinnati.

Isaac Broome Ott and Brewer Co., Trenton, New Jersey. Baseball Vase, 1876. Parian ware, height 35". New Jersey State Museum, Trenton.

RIGHT: Maria Longworth Nichols Vase, 1879. Press-molded earthenware, blue underglaze painting and gilt overglaze, height 6". Cincinnati Art Museum.

Susan Frackelton Milwaukee, Wisconsin. Olive Jar, 1893. Salt-glazed stoneware, height 30". Philadelphia Museum of Art. Gift of John T. Morris.

During the 1890s the interest in the Arts and Crafts Movement became more sophisticated and better organized. Between 1896 and 1915, when the movement's membership

peaked in the United States, thou-

sands of groups were organized to bring together amateur and professional craft workers; Boston and Chicago formed exhibiting societies for the arts and crafts in 1897. Collectively these new craft groups sought to change both public taste and the role of the craftsman in an industrial world. They were influenced by the writings and works of William Morris, founder of the English crafts movement. Several leaders of the English movement visited the United States: Oscar Wilde in 1882, Walter Crane in 1891–92, and Charles R. Ashbee in 1896. A further measure of the new sophistication in the field is the number of new periodicals that began to be published during these years, including House Beautiful (1896); Common Clay and Ornamental Iron (1893); International Studio (1897); Brush and Pencil (1898); and Keramik Studio and Fine Arts Journal (1899).

The decorative arts were becoming part of mainstream American culture. As public awareness grew, a profitable market opened up for what the Victorians had euphemistically termed "art manufacture." Ceramics seemed to be one of the most promising activities. During the 1890s a number of new potteries opened, and several existing functional potteries began to turn their attention to decorative wares. For the first part of the decade, Rookwood continued to dominate. But the competition of new potteries, such as the Lonhuda Pottery in Steubenville, Ohio (founded 1892), and the introduction of imitations of so-called Standard Rookwood (with its basic brown palette of slip painting) by Samuel A. Weller and J. B. Owens in Zanesville, Ohio, led to a proliferation of slippainted wares. The importance of these Beaux-Arts pots began to recede in favor of the simple forms and monochrome glazes that would find favor during the latter part of the decade.

CHAPTER TWO

The major event for American decorative art during the formative years of the 1890s was the 1893 World's Columbian Exposition in Chicago. It was there that William Grueby saw the flambé rouge and

mat-glazed pots of Auguste Delaherche and Ernest Chaplet, two of France's leading artist-potters, which would later lead to a revolution in pottery tastes. The exposition also exhibited the proto-Art Nouveau ceramics of the brilliant Dutch ceramist Theodoor A. C. Colenbrander.² The women's movement still dominated much of the activity in American ceramics. The Cincinnati Pottery Club was re-formed for the exposition, and it exhibited wares in the Cincinnati Room of the Woman's Building. The exhibition of this work marked the end of an era in ceramics, as male, entrepreneurial ceramists began to dominate. Newton called the exposition "a fitting port in which to anchor the good ship, 'Cincinnati Pottery Club' . . . the ripples that vessel made broadened into a great and farreaching circle which had more influence than we realized possible over the ceramic art of the country."3

Susan Goodrich Frackelton, another major figure in the early china-painting movement, received a gold award at the Columbian Exposition for her salt-glazed stonewares.4 The following year her Frackelton Dry Colors (gold and bronzes) were awarded medals by Leopold II, King of the Belgians, at a competition in Antwerp. She also gained prominence in the field through other activities. In 1892 she had sought to improve communications within the burgeoning china-painting movement and formed the National League of Mineral Painters. In 1895 her book Tried by Fire, the bible of the china painters, was published in its third and enlarged edition.

The last major venture into painted decoration came in 1895, with the opening of the Newcomb Pottery in New Orleans. The pottery was a part of Sophie Newcomb Memorial College for Women (today a division of Tulane University) and was

conceived as a practical training ground for women pottery decorators. Mary G. Sheerer, a graduate of the Cincinnati Art Academy, joined the pottery at its inception to teach underglaze slip and china painting. At first there was an attempt to emulate Standard Rookwood, but the technique proved difficult to control. About 1897 a new style emerged. Designs were incised into wet clay and painted with oxides after the first firing. The wares were then glazed with a transparent high-gloss glaze. Newcomb was to be associated with this technique until 1910, when it changed to mat glazes under Paul E. Cox.

Newcomb wares, with their distinctive palette of blue, green, yellow, and black, are the most original and freshly inventive of the later painted wares. The choice of color and subject reflected the idyllic setting of the pottery, the Garden District of New Orleans above Canal Street, surrounded by magnolias and huge, spreading oaks. In order to give the pottery a unique character, all motifs and landscapes used in decoration were drawn from the flora and fauna of New Orleans and the surrounding bayou country. The forms were either chosen from the "damp room" or designed by the decorators and thrown by Joseph Fortune Meyer, a gifted and intuitive potter. None of the designs was ever repeated (unless requested by the purchaser), so they retained their lively character, winning numerous honors between 1900 and 1915.6 The first decorators were undergraduate students, but the later, permanent employees represented a changing nucleus of four to five women who had graduated from the college. In addition to the accomplished decorator Mary G. Sheerer, another important early decorator was Mazie T. Ryan. Her decorations are self-contained within the threedimensional frame they occupy and have a particular spontaneity and invention. Later stalwarts of the decorating team at the Newcomb Pottery were Sadie Irvine, Anna Frances ("Fannie") Simpson, and Henrietta Bailey.

Decorative tastes began to change in the late 1890s, and a demand for simpler form and limited

decoration began to replace the cluttered eclecticism of late Victorianism. This was a victory for the Arts and Crafts Movement purists such as Elbert Hubbard, Gustav Stickley, and Frank Lloyd Wright. In responding to new fashions, American ceramics drew from the simplicity of Chinese and Japanese ceramics as interpreted by the French artist-potters, such as Chaplet and Delaherche. Inspiration also came directly from the growing interest in collecting Oriental ceramics among American museums and private collectors.7 A number of ceramists, notably Robertson and Volkmar, began to work in imitation of the Chinese potters, but their achievements were uneven and their production limited. Robertson was best known for his Dedham Pottery crackle wares, with their blue framing of rabbit, whale, butterfly, and floral motifs.8

The work of William Grueby in Boston⁹ was the most significant breakthrough in the modern aesthetic. Grueby concentrated on the relationship between form and the unpainted texture and color of the surface. After seeing the works of Delaherche at the World's Columbian Exposition in Chicago in 1893, Grueby began experimenting to produce a natural mat glaze that did not require bathing the glazed surface with acid, an artificial means of achieving mat surfaces at the time. He accomplished this feat in 1897-98, producing a superb range of intense mat glazes in greens, yellows, ochers, and browns. The most successful glaze was the distinctive "Grueby green," which responded well to the relief-decorated form. The glaze broke to a lighter tone on the raised surfaces, and an overall veined effect, resembling a watermelon rind, enlivened the surface. The character of the glazes was unlike any other in use at the time. Grueby's glazes represented a major breakthrough for the empiric art pottery movement in the United States. The surface of these wares was extremely seductive and, as Jervis wrote in his Encyclopedia of Ceramics (1902), it was a glaze "so soft, beautiful, so perfectly glossless, that at one bound it leapt into public favor."10

Unlike the glazes, which were an original de-

velopment, Grueby's early forms relied heavily upon a paraphrasing of the pottery of Delaherche.¹¹ The early Grueby forms (1898–1901) were designed by George Prentiss Kendrick and show the same climactic use of the shoulder and the massive, monumental neck as are found in the works of Delaherche. Some of the translations, however, were original and inspired, notably Kendrick's adaptation of a multihandled vase, in which the use of clay was lively and less imitative of Delaherche.

In part, the aesthetic character of the ware was conditioned by technical issues. The center of the kilns became too hot for tiles and so Grueby decided to fill this space with vessels. The semiporcelain clay body that was created out of the tile clay to withstand the higher temperatures, in turn, played its role in the "look" of Grueby:

Some of the heft of a Grueby pot's massiveness is due to natural causes, as the grainy clay was basically the same as that used for Grueby tiles and it necessitated *heavy* potting. However we may see the heavy potting and thick glaze as emblematic of the handcraft revival and the revolt from slickness. The slight irregularities in the relief lend the vibrant quality that art lovers under Ruskin's guidance had come to value. The glaze was temperamentally congenial to the pots and moved with deliberation down their sturdy walls, and in some cases developed a surface as uneven as sculpture slowly patted up over an armature.¹²

The final product had a crispness because no molds were used, even though the designs were reproduced in quantity. Each form was thrown by an elderly potter, and then the relief decoration was applied by young girls culled from the local art

TOP: Mary Given Sheerer, decorator, and Joseph F. Meyer, potter Newcomb Pottery, New Orleans. Vase and Stand, 1898. Earthenware with incised and underglaze decoration, height 12". Cincinnati Art Museum. Gift of Miss Mary Sheerer.

Grueby Pottery Grueby Faience Company, Boston. Vase, *c.* 1898–1902. Earthenware, mat green glaze, height 12½". Courtesy Jordan-Volpe Gallery, New York.

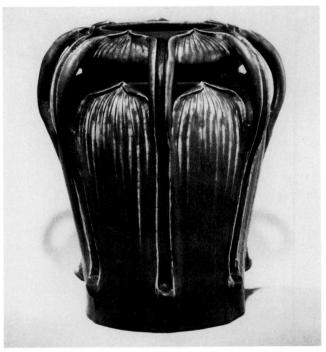

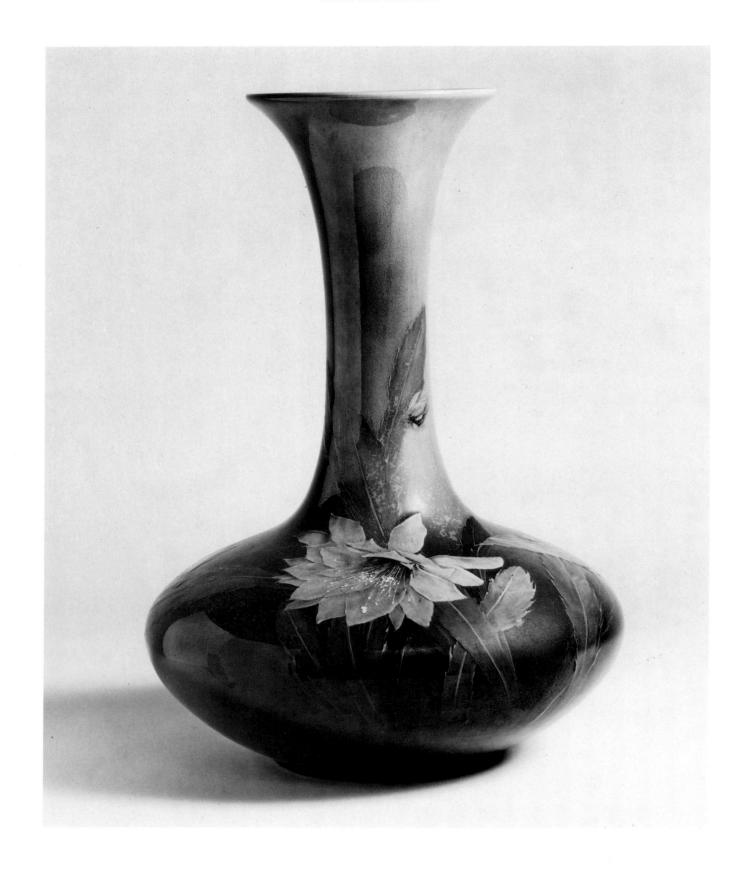

OPPOSITE: *Albert R. Valentien* Rookwood Pottery, Cincinnati. Vase, 1893. Slip painting under clear glaze, earthenware, height 12½". Private collection.

Matthew A. Daly Rookwood Pottery, Cincinnati. Vase, 1899. Standard glaze on earthenware with slip painting, height 14". Courtesy Jordan-Volpe Gallery, New York.

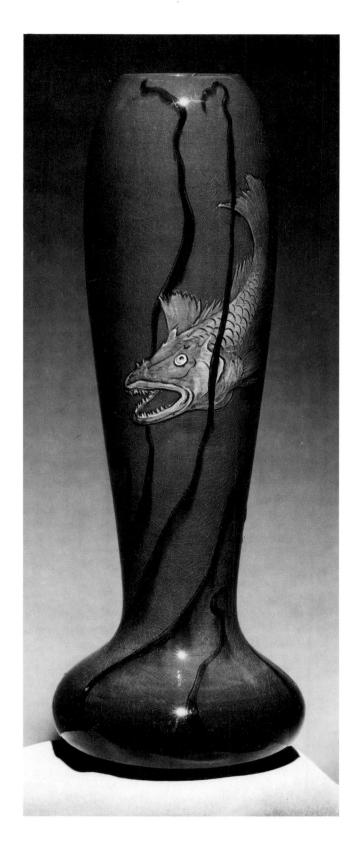

schools.¹³ The wares were an immediate success and were given the all-important endorsement of Gustav Stickley, who had emerged as the leader of the Arts and Crafts Movement in the United States, incorporating Grueby wares into his interiors.

Grueby won numerous awards both at home and abroad and was given the signal honor of being represented in Paris by Maison Bing l'Art Nouveau. It is possibly this association that led to Grueby's being linked to the French Art Nouveau style that had emerged in the mid-1890s and had become so popular in Paris. Although Grueby's designs do use stylized, organic shapes, the wares lack other characteristics of French Art Nouveau: the whiplash line in decoration, the symbolic use of the female form, and what the historian Tschudi Madsen calls the "linear thrall" of the forms. There is a slight affinity between Grueby's wares and Jugendstil, the German variant of Art Nouveau, which is more structural and abstract than its French antecedent. In essence, the wares produced by Grueby were a Mission-style adaptation of Delaherche's classic forms. The semantics of Grueby's aesthetic lineage were of little concern to the art pottery movement, which now became involved in a scramble to copy the "eternal matt green with which every potter is trying to outdistance Grueby and win fame and fortune."14

Two other noteworthy pioneers were active at the same time as Grueby: Mary Louise McLaughlin and a Biloxian, George E. Ohr. McLaughlin returned to ceramics in 1895 after a long hiatus, remarking, "One who has experienced the fascination of working in wet clay is never safe from its lure, and after a while I was again dreaming of the possibility of carrying out another venture, this time of a much larger scope." At the Brockman Pottery she worked in earthenware and developed a technique for inlaid decoration, which she patented, having learned her lesson from the Wheatley debacle. She was dissatisfied with these wares, however, since they had to be produced with the assistance of a potter. She was eager to have a

more intimate contact with her material and began to experiment with porcelain in 1898. After an arduous period of trial and error, involving eighteen clay bodies and forty-six glazes, she perfected her first new works in 1899.

These "Losantiwares," as she termed them, were small ovoid forms with a delicate carved decoration that was alive with the curvilinear energy and rhythm of Art Nouveau. Ironically, McLaughlin was one of the most outspoken critics of this style, warning that it could not be "followed without reason or moderation except to the detriment and

Mary Louise McLaughlin Losanti Vase, c. 1899. Glazed, once-fired porcelain, height 4½". National Museum of American History, Smithsonian Institution, Washington, D.C.

degradation of the beautiful."16 A group of twentyseven Losantiwares was shown in 1901 at the Pan-American Exposition in Buffalo, where they received a bronze medal. At about the same time Adelaide Alsop Robineau wrote that it would take a generation before a new aesthetic in porcelain would arrive. 17 McLaughlin countered with a note pointing out her own achievements. Robineau printed the note in the July 1901 issue of Keramic Studio, and invited McLaughlin to contribute an article on her work for the December issue. Once again McLaughlin had emerged in the vanguard of the art pottery movement, this time as one of the first artists to work in the self-sufficient manner of the studio potter. After 1906 her interest waned, although she continued intermittent production of her porcelains until 1914.

The work of George E. Ohr is difficult to categorize. Working in Biloxi, Mississippi, where he ran the Biloxi Art Pottery, he was the maverick of American ceramists and produced the most original work of his day. He was an extremely conspicuous member of the art pottery movement. He often accompanied his work to the major fairs and expositions, where, with his resplendent twentyinch-long mustache tucked into his shirt or combed into a bizarre shape, he gave demonstrations on potting. Ohr developed extraordinary skill on the potter's wheel, to which he responded "like a wild duck in water,"18 and threw vulnerable earthenware forms to the point of collapse. He would then fold, ruffle, twist, and pummel the thin vessels and add sinuous, intricate handles. Of Ohr's throwing skills, Paul E. Cox wrote: "It is said that Ohr could work on the wheel whichever way it turned. Certainly he could throw wares of considerable size with walls much thinner than any potter ever has accomplished. It is quite probable that George Ohr, rated simply as a mechanic, was the most expert thrower the craft has ever known."19

The manner in which Ohr worked with clay was not entirely without precedent. The ruffling of forms was popular in Victorian glass; both Emile Gallé and the Danish craftsman-designer Theobald

Bindesboll had produced pummeled and ruffled pots in the 1880s. These were effetely decorative, however, whereas the work of Ohr was furiously gestural. It is most likely that Ohr developed this style from the Southern folk pottery wares, of which he must have been well aware and in which this kind of vocabulary, employed more crudely than by Ohr, was common.

Ohr's glazes ranged from livid, mottled pinks and startling polychromes to somber browns and metallic finishes. Few of his contemporaries could appreciate his sense of form, most were impressed and even intimidated by his skill in creating glazes. The opinion of the ceramics historian Edwin Atlee Barber that "the principal beauty of his ware lies in the richness of the glazes" infuriated Ohr. Ohr often made pieces that were deliberately left in the bisque state as completed wares. Once, to underscore this point, he scribbled a legend around a photograph of a group of unglazed pots: "Color and quality counts [sic] nothing in my creations. . . . God put no color or quality in souls."

Ohr, who began working about 1879, was chronologically the first of the American studio potters and also the first to achieve stylistic inde-

George E. Ohr Biloxi Art Pottery, Biloxi, Mississippi. Bank, c. 1898. Earthenware, length 3½". Collection Martin and Estelle Shack.

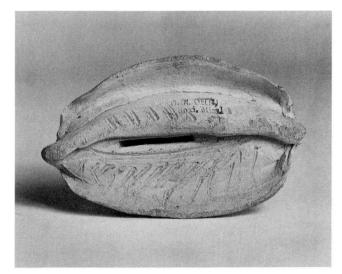

pendence from Europe. He led the assault on the boundaries of applied and fine art, blurring the definition of what the critic John Coplans so succinctly terms "the hierarchy of media." This is implicit in his turning away from the controlled surface concerns of Victorian decorative art and plunging into the aesthetics of risk. Early in his career, Ohr insisted on seeking out the unique and became obsessed with the slogan "no two alike." He pushed to the limit the expressionist qualities of the material, dealt with form on a level of poetic anthropomorphism, and played a capricious game with function. Ohr was able to sidestep the limitations of European formalism with which others, such as Adelaide Robineau and Charles Fergus Binns, became embroiled. Ohr's work expresses the vision of his time. He was the true prophet of American ceramics, anticipating the expressionism, the verbal-visual art, and the surrealism that were to become mainstream concerns in the 1950s and 1960s.20

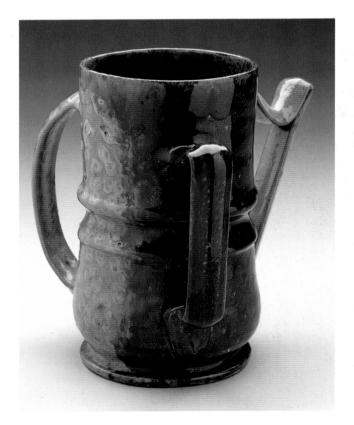

George E. Ohr Vase, c. 1898. Glazed earthenware, height 61/8" Collection Irving Blum.

LEFT: George E. Ohr Three-Handled Mug, c. 1898. Glazed earthenware, height 8". Collection Jasper Johns.

RIGHT: George E. Ohr Teapot, 1899–1904. Glazed earthenware, height 8". Jedermann N. A. Collection.

Current-day judgment views Ohr as a great American artist,²¹ but only a few appreciated Ohr in his own time. Their distinction, however, makes up for their paucity in numbers: Cox, Barber, and William King. In an address in Buffalo, King made one of the most telling contemporary judgments of Ohr's work: "Ohr is an American potter who stands in a class by himself, both in personality and in his pottery. Sometimes he is referred to as the 'mad potter of Biloxi.' He calls himself the 'second Palissy'; issues a challenge to all potters

of the world to compete with him in making shapes and producing colors. . . . While much of Mr. Ohr's work will not meet the requirements of accepted standards . . . there is art, real art—in this Biloxian's pottery."²²

The majority of Ohr's contemporaries took a harsher view of his achievement. Most could appreciate his skills but not his aesthetic, so provocative and passionate that it was at odds with the genteel, static style of the Arts and Crafts Movement. Frederick Rhead, a potter and self-elected spokesperson for the field, wrote of Ohr: "Ohr, really a most skillful thrower... who was concerned only with regard to his personal reputation. Entirely without art training and altogether lacking in taste, he deliberately distorted every pot he made in order to be violently different from any other potter."²³

The two important words in the critique are "training" and "taste," the cornerstones of the Arts and Crafts Movement and its prime defenses later against the forces of change and the avantgarde. Ohr, the son of a blacksmith, was not educated in the arts in the formal sense of the term, nor was he concerned with pandering to notions of taste. Indeed, much of his work was a deliberate assault on accepted taste. But, in terms of a ceramic literacy, Ohr was the most sophisticated practitioner of his day. His sources were apparently quite eclectic, ranging from Southern folk wares to the pottery of Bernard Palissy. After a period of apprenticeship to the potter Joseph Fortune Meyer in New Orleans, Ohr left on a sixteen-state, twoyear trip, during which he "sized up every potter and pottery . . . and never missed a window, illustration or literary dab on ceramics since that time, 1881."24

About the turn of the century, Ohr began to withdraw his major work from sale, selling only fair trinkets and "gimcracks." The reason was that Ohr believed himself to be a genius and that he wished his works to be "purchased entire" by the nation. In fact, the hoard of over six thousand pots that he set aside—the major part of Ohr's art

production—remained in the Ohr family warehouse until 1972, when a New York antiques dealer purchased them for resale.

Ohr's impact on his own time was limited, partly the result of his decision not to sell his art pieces after 1900, partly the result of his incompatibility with the arts and crafts elite. About 1906 he ceased potting and, despite successes at the Pan-American and Saint Louis fairs, disappeared from the American ceramics arena. Aware that he could not compete in the drawing-room atmosphere in which most of his contemporaries operated, Ohr set up his own world of pranks and outrageous behavior, which only led to his being dismissed as a Southern eccentric. There is good reason to believe, however, that he used his bizarre behavior as a defense against the rejection he received as an artist. A clue can be found in an extremely poignant interview described in a letter from Paul Cox to Robert Blasberg: "He sat on the edge of the bed blinking his black eyes at me. Finally he said, 'You think I am crazy don't you?' I replied that Mever had told me about him and that I did not think he was crazy (I still don't). With that George stopped his act and remarked, 'I found out a long time ago that it paid me to act this way.' ''25

The letter offers an intimate glimpse of the artist and the mask he wore. This country buffoon was the same man who had the artistic integrity to refuse to sell his work in his lifetime, knowing that his vision would be better appreciated in another time, one more sophisticated in the issues of art. He was a sensitive and committed artist, who played the role of jester to counter the feelings of hurt and frustration at being rejected and misunderstood. He left us a wonderful legacy. Compared to the perfect but sterile works of some of his contemporaries, Ohr showed us that a tour de force of craftsmanship has no value by itself: it must be matched by an equal tour de force of spirit.

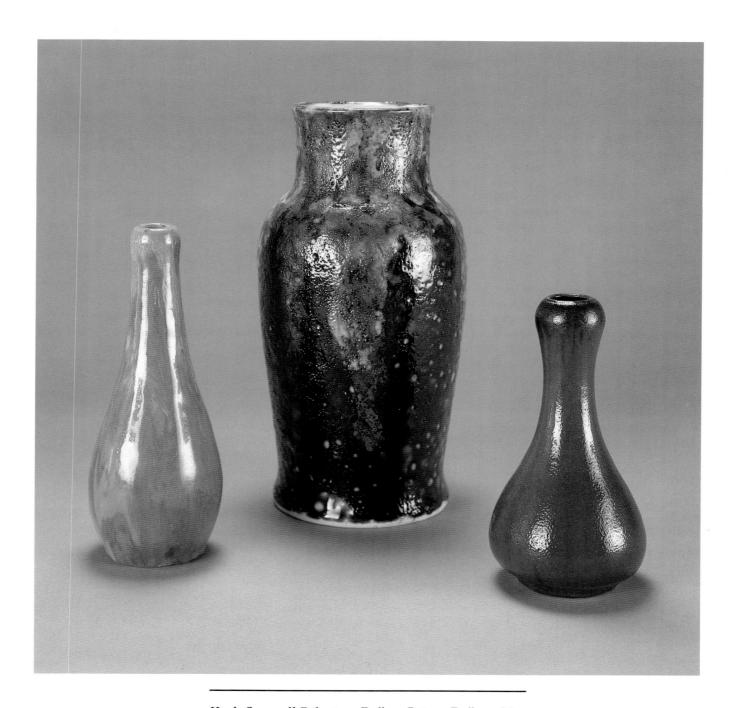

Hugh Cornwall Robertson Dedham Pottery. Dedham, Massachusetts. Three vases, c. 1893. Glazed stoneware, height 5", 8%", 6". Cooper-Hewitt Museum, Smithsonian Institution/Art Resources, New York.

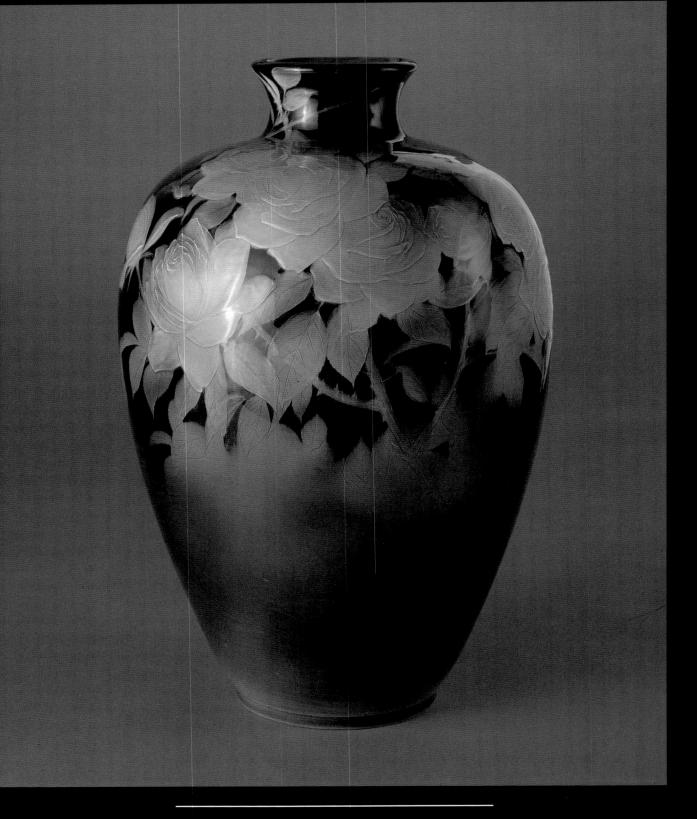

Kataro Shirayamadani Rookwood Pottery, Cincinnati. Vase, 1900. Earthenware, slip painting in light relief under clear glaze, height 173/8". Philadelphia Museum of Art. Gift of John T. Morris.

The first decade of the twentieth century was a period of significant growth and expansion for the ceramics movement. During these years the art potteries produced some of their most mature work, a

1900

CHAPTER THREE

compete with each other rather than European potteries.

nascent studio pottery movement took hold, and the "art tile" industry expanded. Sculptural issues now entered into the creation of the vessel, while the university emerged as the dominant patron of the ceramic arts.

The 1900 Exposition Universelle proved to be a major victory for American ceramics, confirming the promise that America's art pottery had made on the same platform eleven years earlier. Rookwood showed exceptional wares by Kataro Shirayamadani, Artus Van Briggle, William P. McDonald, Sara Sax, Carl Schmidt, John Wareham, and Harriet Wilcox, and won a Grand Prix. Grueby received one silver and two gold medals and, with Auguste Delaherche, justly won another Grand Prix. Medals also went to the Newcomb Pottery. Nichols (by then Mrs. Bellamy Storer), McLaughlin, and Frackelton were also represented in the exposition. Grueby was particularly popular, and its booth was sold three or four times over. The success of the American ceramists was confirmed when many of Europe's leading museums purchased American wares for their collections of decorative art.1 Rookwood and Grueby went on to receive major awards at the Exposition Internationale de Céramique et Verrière in Saint Petersburg, Russia (1901), and at the International Exposition of Modern Decorative Art in Turin, Italy (1902).

The excellent reception of American ceramics at these pivotal world's fairs brought new confidence. From 1900 onward a spirited independence began to enter American ceramics. Artists no longer worked with one eye toward recognition in Europe. This was largely due to a series of important expositions that were held in the United States and redirected the interest of the American decorative arts. At the expositions in Buffalo in 1901 and in Saint Louis in 1904, American ceramists began to

The already weakened importance of Rookwood declined further during the first years of the twentieth century, although various at-

tempts were made to sustain its leadership. Following poor sales at the Saint Louis fair, Rookwood tried to develop mail-order sales, but the relatively high prices (from \$20 to \$250) proved to be unsuitable for merchandising in that manner. New techniques and glazes, notably the mat, vellum glaze, were introduced by a new glaze chemist. The slip-painting technique was improved to include cooler colors, under a brilliant, clear glaze. The Philadelphia Museum of Art owns a masterwork of this style, a vase by Shirayamadani, by far the most talented and skilled of Rookwood's decorators. The shoulder of the pot is wrapped in a swath of roses and painted in a trompe l'oeil manner with a delicate green slip. The brilliant, clear glaze responded to the light relief of the painting, crackling slightly to enhance the illusionary depth of the work. In the end, however, Rookwood suffered because the public had tired of painted pottery, regardless of the skills presented. Artists who worked in a more sculptural manner now began to dominate.

Yet, despite Rookwood's gradual fall from commercial favor, the Arts and Crafts Movement continued to regard it as an ideal. Oscar Lovell Triggs, founder of Chicago's Industrial Arts League, hailed the pottery as the perfect modern workshop:

The pottery is not merely a workshop; it is in a sense a school of handicraft, an industrial art museum and a social center. The craftsmen, creating and initiating on their own ground, constantly improve in skill and character. . . . A portion of the building is now devoted to exhibition. By means of lectures and other entertainments at the pottery, the public participates in some degree in the enterprise, and by reaction shapes the project. Here are all the elements needed for an ideal workshop—a self-directing workshop, an incidental school of craft, and an associative public.²

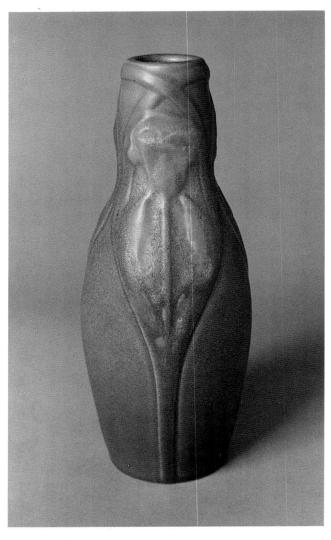

Artus Van Briggle Vase, 1903. Glazed earthenware, height 9". National Museum of History and Technology, Smithsonian Institution, Washington, D.C.

Rookwood was very much a business enterprise. The creation of vases from 1883 onward was based upon the industrial division of labor—a Rookwood vase went through twenty-one hands before completion. Working conditions at Rookwood were difficult. Rookwood's decorators were presented as artists, yet they received salaries as low or lower than other craftsmen in the ceramic industry: Rookwood's male decorators were paid marginally more than their counterparts in other

potteries, while the women were paid the same wages as women who performed unskilled chores in the ceramic industry. Decorators were fined for misnumbering vases or for other infringements of the management code. Furthermore, every piece made at Rookwood belonged to the factory. One of the devices the decorators employed to get pieces of their own work that they wanted to retain was to designate the works as seconds, which would allow them to be acquired at a substantial reduction. William Watts Taylor, the manager, was nevertheless also careful to nourish the egos of his creative staff by providing them with perks, such as trips to major expositions and time to make holiday presents to balance their low wages.

Rookwood responded cautiously to the international fascination with Art Nouveau. American interest in this style was unenthusiastic and short-lived—the nation's avant-garde preferred the more austere structuralism of the English Arts and Crafts Movement. William McDonald and Anna Valentien, however, produced figurative wares in a mild Art Nouveau style. Valentien's works showed the influence of her studies in France with, among others, the French sculptor Auguste Rodin. Mary Chase Perry also worked on carved, sculpted forms that were somewhat irregular in shape. Basically, however, she kept to floral relief decoration, and her work was closer in essence to that of Delaherche and Grueby.

The two artists who dominated the sculptural approach to the vessel were Artus Van Briggle and Louis Comfort Tiffany. Van Briggle's work of this style dates from 1900, when he moved for health reasons from Rookwood to Colorado Springs. There, with the assistance of William H. Strieby, a chemist at Colorado College, he adapted the local materials to his needs and established the Van Briggle Pottery. At the Paris Salon in 1903, Van Briggle held the first exhibition of his major works, including *Lorelei* and *Despondency*. The critical and commercial success of this showing was followed in 1904 by the response to his wares at the Louisiana Purchase International Exposition in

Saint Louis, where the wares received two gold, one silver, and two bronze medals. Van Briggle was denied the Grand Prix only because of a rule prohibiting its award to first-time entrants.³ Van Briggle died while the exposition was in progress, and his exhibition cases were draped in black. He had modeled a large number of works between 1900 and 1904, and in a short period had managed to achieve his objective of "getting ceramics away from glass coating and let the pot itself carry its own beauty."⁴ After his death, the Van Briggle Pottery was continued by his wife, Anne Gregory Van Briggle.

Tiffany Studios (Corona, Long Island) introduced Favrile pottery in 1904 at the exposition in Saint Louis and offered it for sale for the first time the following year. It is not known to what extent Louis Comfort Tiffany was directly involved in the

RIGHT: Artus Van Briggle Toast Cup, 1901. Glazed earthenware, height 11". Courtesy Jordan-Volpe Gallery, New York.

Anna Marie Valentien Rookwood Pottery, Cincinnati. Bowl, 1901. Glazed earthenware, diameter 10½". Private collection.

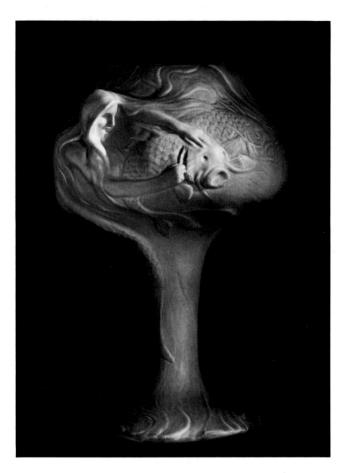

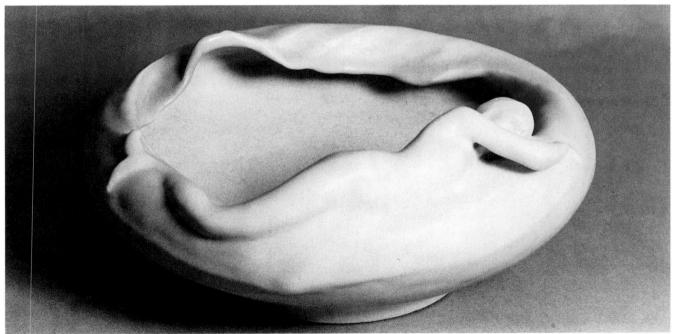

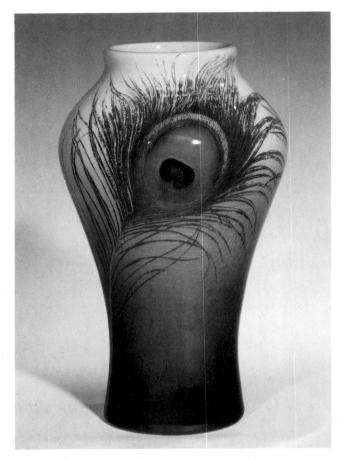

Carl Schmidt Rookwood Pottery, Cincinnati. Vase with Peacock Feather, 1905. Slip painting under glaze, height 10". The Metropolitan Museum of Art, New York. Purchase 1969, Edward C. Moore Fund.

BELOW: *Marie de Hoa Le Blanc* Newcomb Pottery, New Orleans. Three-Handled Vase, c. 1901. Glazed earthenware, height 163/8". Cooper-Hewitt Museum, Smithsonian Institution/Art Resources, New York. Gift of Marcia and William Goodman.

RIGHT: Sarah Elizabeth Coyne Rookwood Pottery, Cincinnati. Iris Vase, 1907. Slip painting under clear glaze, height 9". Collection Mark Del Vecchio.

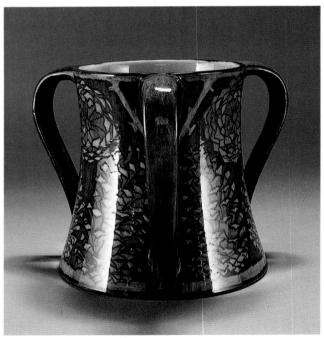

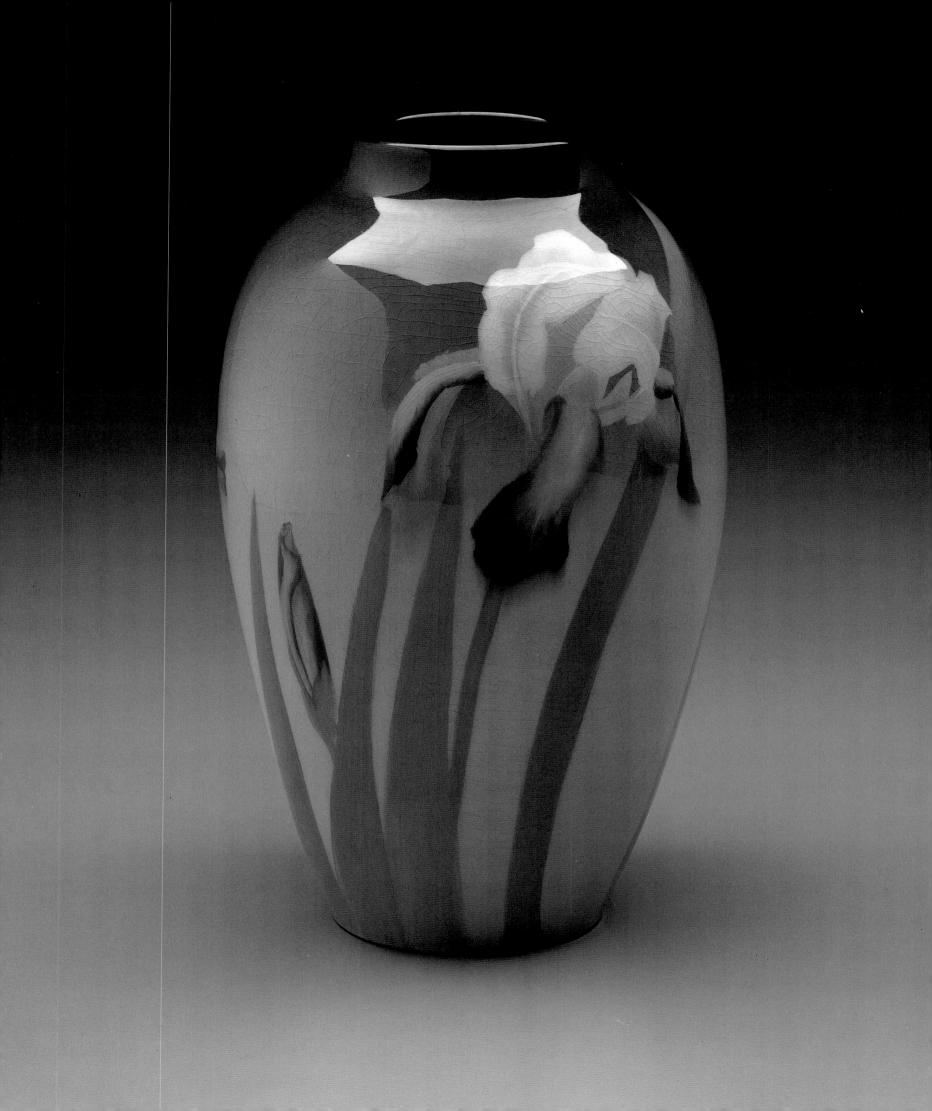

creation of Favrile pottery. 5 Although the works of Tiffany Studios were produced by anonymous craftsmen from Louis Tiffany's designs, the pottery reflects his intuitive sensitivity to the materials and his clear compositional style. In placing this work stylistically, we have traditionally referred to the pieces as Art Nouveau. However, as pointed out by Martin Eidelberg, the work only occasionally shows the use of the Art Nouveau grammar. The relief modeling is elegant but static. It resembles most closely the Parian wares that were produced by the Bennington Pottery about 1850; it has the same tautness of line, the rhythmic growth of the stalks from the base of the pots, and the formal integration of the floral motifs and form.6 This work by Tiffany, in common with many other "Art Nouveau" wares, by Fulper, Grueby, and Weller, belongs most properly to a category that Kirsten Keen identifies in her catalogue American Art Pottery as "structural naturalism."

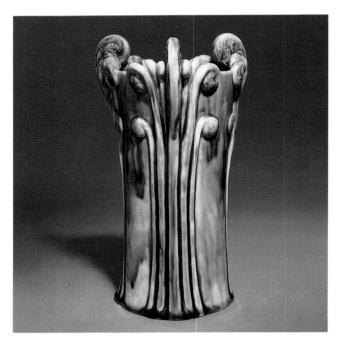

Louis Comfort Tiffany Tiffany Pottery, Corona, New York. Vase, c. 1905–14. Glazed earthenware, height 9". The Newark Museum, Newark, New Jersey. Purchase 1975, Wallace M. Scudder Bequest Fund.

The studio pottery movement, beginning some thirty years after art pottery, was little involved in the notion of the painted pot. This comment from a 1905 article by William Burton summarizes the central concern and direction of the studio potters:

In the presence of wonderful examples of the Chinese single color flambé glazes, so perfect in their beauty, so decorative in their appearance, and so entirely free from any effect except those proper to clay and glaze, the Western potter could not but ask himself questions as to the artistic value of his own productions. . . . At the commencement of the twentieth century, therefore, we find that reaction against the elaborately painted pottery of the previous century and a half has reached the position of an international movement, which seems designed to bring pottery once again in harmony with its qualities.⁸

Charles Fergus Binns was a key figure in the development of a support structure for studio pottery in America. Just prior to his move to America in 1897, Binns was the superintendent of the Royal Worcester Porcelain Works and was being groomed to replace his father as director. His wealth of knowledge in ceramic science found an excellent outlet in 1899 through the American Ceramic Society, which he was instrumental in founding. His influence was most important, however, at the New York School of Clayworking and Ceramics in Alfred, New York. Binns directed the school from its inception in 1900 until his retirement in 1931.9 The school was the second of its kind in the country, and under Binns's astute direction, it rapidly established itself as the premier ceramics school in the nation. 10 Binns advocated a perfectionist aesthetic of restraint based upon Oriental classicism, which was actively propagated and continued by his students and his students' students. The aesthetic grew out of Binns's fondness for the quieter periods of Chinese and Korean pottery.

The "classic Alfred vessel," as it is colloquially known in ceramic circles, is distinguished by a sophisticated use of materials, clean and simple form, little or no ornament, and a strongly classical inspiration. This style brought about a welcome

sophistication in craftsmanship and other formal values. But these were won at the expense of expressionist qualities in clay. In many ways, the Binns legacy was inhibiting artistically, and it was not until the 1950s that Alfred began to demonstrate its freedom from this "less is more" regime.

By contrast, Mary Chase Perry was an adventurous artist with a love of color, experiment, and the chance generosity of the kiln. Together with her close friend Adelaide Robineau, Perry was a leading member of the National League of Mineral Painters until 1903, when both artists gave up overglaze decoration. Robineau turned to porcelains, and Perry, in partnership with her intimate friend and business associate Horace J. Caulkins, established the Pewabic Pottery as an art pottery in Detroit. Together, Perry and Caulkins developed the Revelation kiln, a portable, kerosene-burning, muffle kiln that became the standard for the chinapainting movement and was used by many of the leading art potteries. In her workshop, Perry adopted an open, modern approach to processes. She installed an electric kiln within a few months of opening the pottery and continued to involve herself with innovative kiln design and clay-handling techniques. Her craft ethic was, however, staunchly anti-industry. She stated that it was not the aim of a pottery to become an "enlarged, systematized, commercial manufactory" but "to solve progressively the various ceramic problems that arise and [to work] out the results and artistic effects that may remain as memorials, or at least to stamp a generation as one that brought about a revival of ceramic art."11

In her work, Perry chose not to deal with what she saw as purely mechanistic concerns and never learned to throw. Rather, she had the potter Joseph Herrick produce forms from her drawings while she busied herself with her first love, glaze chemistry. Because she adopted this nineteenth-century "white-collar" approach to pottery, the forms lacked the evolution and continuity of the works of Binns and Robineau. Nonetheless, she produced a few masterpieces, whose beauty derives largely from

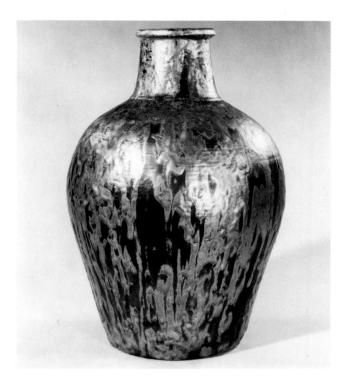

Mary Chase Perry Pewabic Pottery, Detroit. Vase, 1909–11. Earthenware with iridescent glaze, height 18". The Detroit Institute of Arts. Gift of Charles L. Freer.

her range of extraordinary glazes—from elusive, iridescent glazes to cloudy, rich in-glaze lusters. Her real contribution as an artist can be found in her architectural commissions, which will be discussed later in this chapter.

Although each of these figures has an important position in the history of this decade, it is Adelaide Alsop Robineau who was the most formidable figure. She was the influential editor of the leading ceramics journal, *Keramik Studio*; a dedicated teacher; and the one American studio potter whose work was ranked, without qualification, alongside that of Europe's greatest masters. She was an inspirational example as an artist both for ceramics in general and for the women's art movement in particular. Moreover, through the pages of *Keramik Studio*, she was responsible for introducing ceramists around the nation to the finest work of artists at home and abroad. She encouraged an intelligent use of ceramic processes and materials and herself

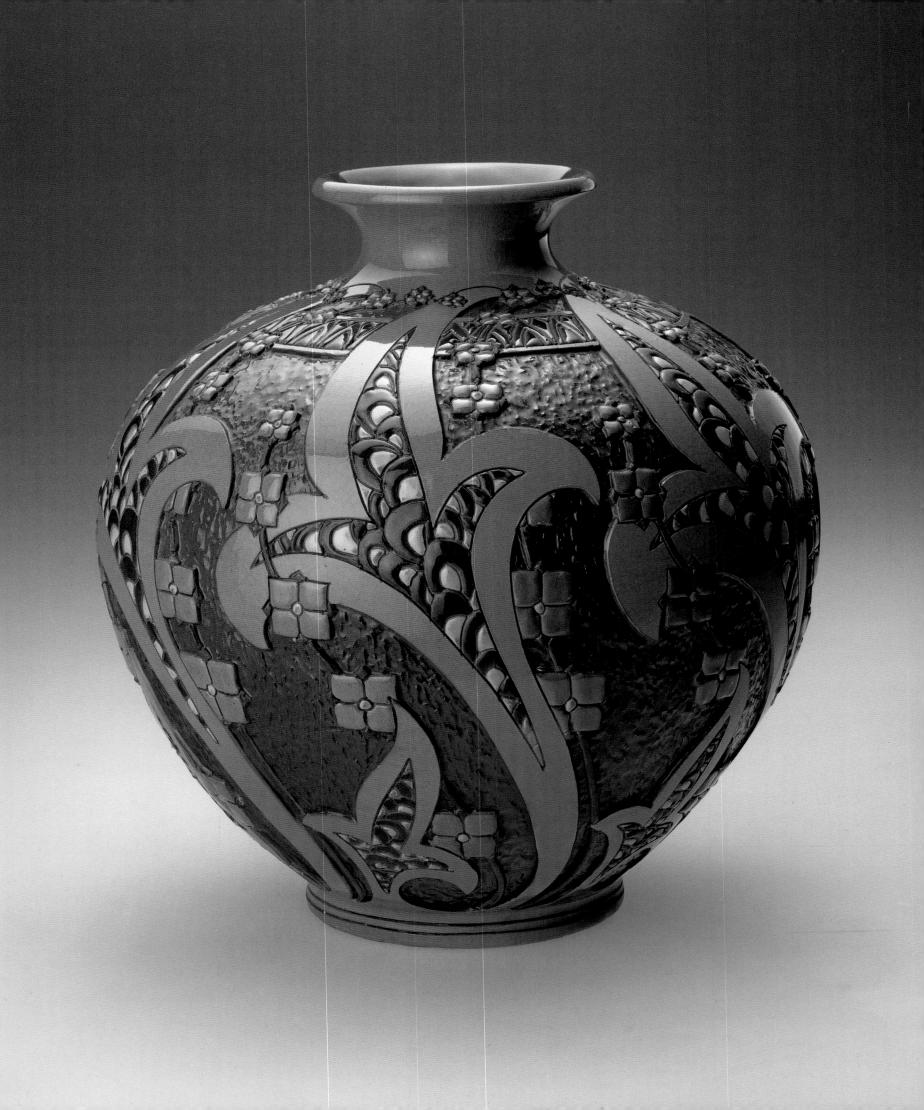

provided a standard of artistry and skill.

In 1899, the date of the first publication of Keramik Studio by her husband, Samuel Robineau, and an associate, Adelaide Robineau was still involved with the Beaux-Arts style of the china painter's movement, in which she was one of the most prominent decorators. Her work at this point was concerned with the painting of overglaze on commercially produced blanks, which her contemporary Frederick Rhead described as a "veritable riot of gold and color."12 The seeds of her conversion to a more intimate use of the materials were just discernible in her editorial for the first issue of Keramik Studio, in which she called for higher ideals and remarked that the ceramic arts had grown beyond the china-painted "stereotyped spray of flowers and the inevitable butterfly."13

Until recently it has been accepted that the French ceramist Taxile Doat was the crucial force in Robineau's conversion from china painter to studio potter. But Martin Eidelberg's probing examination of Robineau's early work in Adelaide Alsop Robineau: Glory in Porcelain has revealed a much more complex process of change.14 Instead of beginning "cold," in 1903, we find that Robineau had actually been quietly planning her move for two years. Robineau made her first pot in 1901, at the studio of Charles Volkmar in New York. It was a crude, lumpish object but decorated somewhat prophetically with a scarab or beetle clutching a disk in its feelers, the motif she would use for her Scarab Vase in 1910–11.15 It seems likely that she later also took lessons in throwing from Volkmar. Eidelberg's research also indicates that Robineau attended Charles F. Binns's Alfred summer school in 1902, rather than 1903, as is generally cited.¹⁶

Eidelberg argues convincingly that the die was cast in 1901 and not 1903, as Robineau's husband was later to claim. Her earlier involvement is supported by the mood of the time. Robineau herself

Frederick Hurten Rhead Roseville Pottery, Roseville, Ohio. Della Robbia Vase, c. 1904. Glazed earthenware, height 10½". Erie Art Museum, Erie, Pennsylvania.

wrote in 1901 that there was a "spreading tendency to go into Keramic work from clay to finish." ¹⁷ Speaking at the National League of Mineral Painters, Susan Frackelton reminded her audience that women were civilization's first potters and that this tradition should be revived. ¹⁸ Frackelton, a doyenne of the china painters, had already been making salt-fired wares for some time.

In 1902 Keramic Studio published an article by William P. Jervis on Doat and illustrated his fecund gourd forms with their luminous mat glazes. Intrigued by his work, the Robineaus obtained a treatise by Doat on high-fired porcelains that they published as a series in the magazine during 1903 and 1904, and in 1905 as a handbook, the first on its subject in the English language. Even though Robineau obviously admired Doat's work, she was only slightly interested in his technique of pâtesur-pâte. Instead, she turned to incising and carving, an interest that can be traced back to July 1901 and a review by Robineau of the porcelains of Bing and Grondahl. In this article, which reads more like a personal manifesto for her future work than a review, Robineau warns against naturalism and does a volte-face on the works of the Danish pottery Royal Copenhagen Porcelain:

The artists of the Royal Manufactory are painters. Bing and Grondahl are modellers and sculptors. Here the paste is everywhere incised, broken by open work decoration, thrown in powerful and striking shapes, and the color is only used to complete the decoration, while in the Royal Manufactory works the color is the whole decoration. The latter's wares give the impression of charm and refinement, the Bing & Grondahl wares that of strength.¹⁹

Equipped with what she learned from her studies with Volkmar, from Doat's thesis, and from three weeks of study with Charles Fergus Binns at Alfred, Robineau built her first kiln on a hillside overlooking Syracuse, New York, in 1903. Her ceramic study had been sporadic, and she was still very much an amateur with minimal skills. At first she employed assistants, but the attempt to commercialize her talent was "a dismal fail-

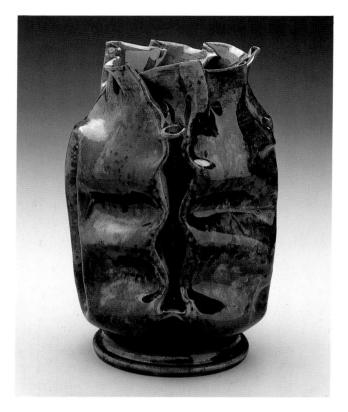

George E. Ohr Vase, c. 1900–1904. Earthenware, height 8". Jedermann N. A. Collection.

BELOW: George E. Ohr Three double-handled vases, c. 1900. Glazed earthenware, height $11^{1}/2^{"}$, $9^{1}/2^{"}$, $12^{"}$. Collection Martin and Estelle Shack.

RIGHT: **Ruth Erickson** Grueby Pottery, Grueby Faience Company, Boston. Vase, c. 1900. Earthenware with green mat glaze, height 163/8". Cooper-Hewitt Museum, Smithsonian Institution/Art Resources, New York.

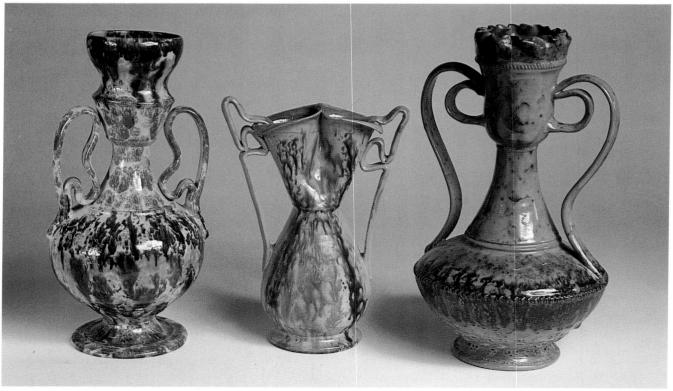

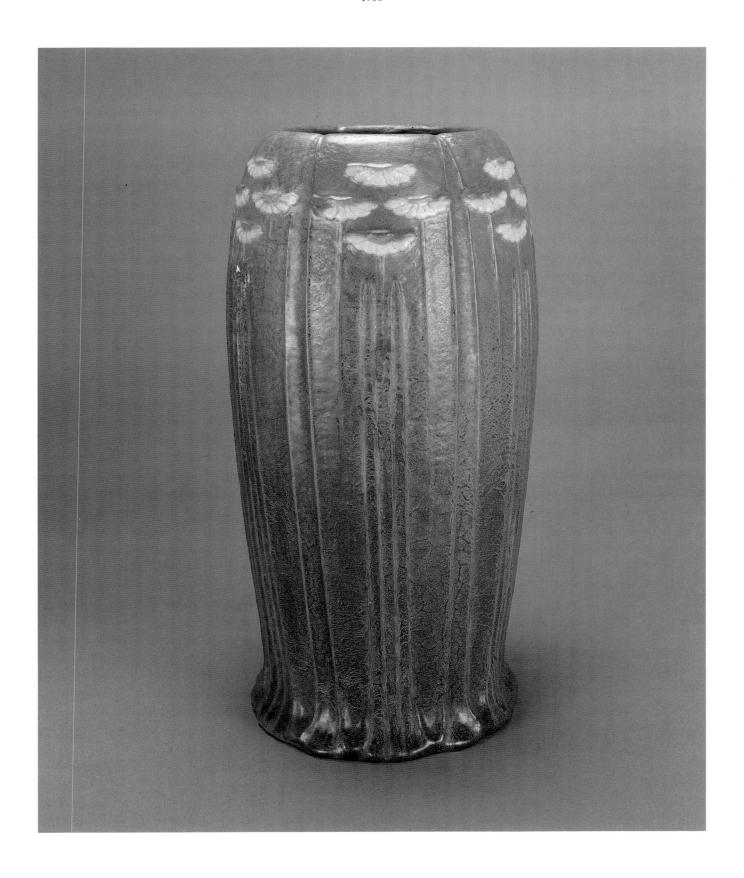

ure . . . she did not like the casting process and even shapes thrown on the wheel by professional throwers from designs, however accurate they were, lacked that finishing touch that she alone could give them."²⁰ The early porcelains were undecorated, molded, crystalline-glazed bottles and vases, "many of which have disappeared, for the museums were not interested and sales were difficult . . . most people, not understanding high fire porcelain work, objected to the price, which was around \$30.00 or \$35.00"²¹

In 1905 Robineau began to perfect the technique with which she was to become most closely associated, the carving and excising of dry but unfired porcelain. During the next five years she produced some of her most economical and finely resolved pieces, including the Viking (1905), Monogram (1905), and Crab (1908) vases now in the collection of the Everson Museum of Art, Syracuse, New York. Although bearing a relationship to carved Chinese porcelains, Robineau's interpretation was personal and progressive. Certain pieces were vaguely reminiscent of Doat's early work, of Art Nouveau, proto-Art Deco, and other styles in vogue at the time. The works are expressions of Robineau's eclecticism, given their character and uniqueness through the artist's individual and personal response to a material, its process, and its traditions.

This unique quality was won at high cost, for the techniques employed by Robineau were remorseless, and any error of judgment or skill could result in failure. Once Samuel Robineau, seething with frustration and rage, wrote: "I have never felt so disgusted and discouraged in my life... every one of the new pieces is warped and blistered... anybody who is foolish enough to do cone 9 porcelains ought to be shut up in an insane asylum."²² But the Robineaus persevered despite the vagaries of the kiln and the indifference of the public. Their triumph finally came in 1911.

As the first decade of the twentieth century drew to a close, the studio potters began to reject direct mainstream influences such as Art Nouveau and turned their backs on painting and sculpture.

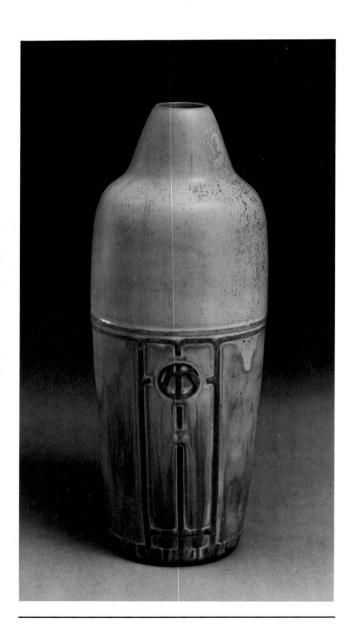

Adelaide Alsop Robineau Monogram Vase, 1905. Thrown form, glazed porcelain, height 12³/₈". Everson Museum of Art, Syracuse, New York.

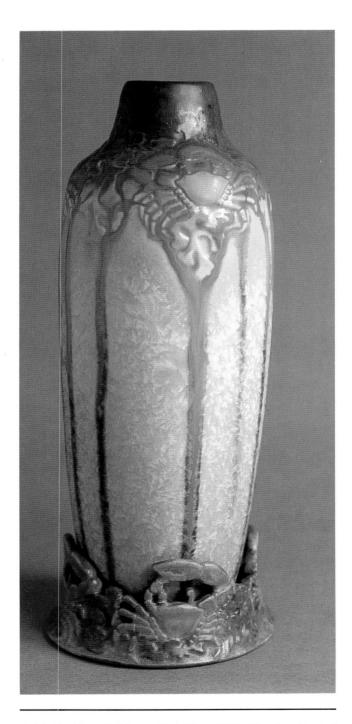

Adelaide Alsop Robineau Crab Vase, 1908. Glazed and incised porcelain, height 73/8". Everson Museum of Art, Syracuse, New York.

The independent spirits, such as Charles Fergus Binns, Mary Chase Perry, Henry Chapman Mercer, and last, but most significant, Adelaide Alsop Robineau, developed strong, personal aesthetics based on the interpretation and imitation of the monuments of ceramic history. This development was a mixed blessing. On the one hand, it resulted in an identity for ceramics based on its own roots and not a second-hand interpretation in clay of painting or sculpture. But this hermeticism meant that the revolutionary changes in concepts of surface and form that were beginning to emerge in the modern art movement had no influence on the potter. Anyone looking for influence from the Cubists, Fauves, or Constructivists in studio pottery in the first quarter of the century would come away emptyhanded. As a result, for several decades the vessel tradition remained an anachronistic pursuit, related to the objet d'art aesthetic, with all its overtones of preciousness, bourgeois materialism, and pedantic craftsmanship. Nonetheless this period, with its unabashed sybaritism, has a lasting charm, despite, or possibly because of, its distance from the stylistic changes that were beginning to sweep American art.

During this decade another development in American ceramics began to peak. Known in the nineteenth century as "art" tiles, they were produced between 1870 and 1930, the "only period when tiles played a significant role in the decorative arts of the [United States]."²³ The achievements of American tilemakers during this time were among the finest of the Arts and Crafts Movement. Until the early 1870s most tiles had been imported from England. After the Centennial Exposition in Philadelphia awakened American ceramists to the "full realization of their insignificance in this field,"²⁴ several large industrial potteries were established: American Encaustic Tile (1875), United States Encaustic Tile (1877), Low Art Tile (1878), and others.

Most potteries maintained some level of tile production, as interest among the more progressive architects in architectural detailing of fireplaces, custom-designed tiled floors, and doorway frames grew under the influence of the Arts and Crafts Movement. Some potteries produced only architectural ceramics. Among these were the Moravian Pottery and Tile Works and Ernest Batchelder, whose first tile plant opened in Pasadena, California, in 1909. Some tile producers, such as Grueby and Fulper, however, later moved into art pottery. For the purposes of this study, only the tiles produced by the art potteries are of interest. The work of Mary Chase Perry and of one of the Arts and Crafts Movement's most enigmatic and complex figures, Henry Chapman Mercer, will be examined more closely.

The involvement of Perry and her Pewabic Pottery in tile production began when Charles Lang Freer, a leading art connoisseur and patron of the pottery, introduced Perry to the architect Ralph Adams Cram. Cram was in the process of designing Saint Paul's Cathedral in Detroit, and incorporated Perry's tiles as a feature of the building. The commission was completed in 1908 and executed in a glowing palette of blues and deep, lustrous gold. The success of the installation drew the attention of many of the nation's leading architects and commissions from Cass Gilbert, Greene and Greene, Bryant Fleming, and others.²⁵ Until the 1930s the creative concerns of the pottery were dominated by massive projects that took up to eight years to complete, as in the case of the National Shrine of the Immaculate Conception in Washington, D.C. Perry later directed her energies toward teaching and continued to be involved in the management of Pewabic until her death in 1961, at the age of ninety-four.

Henry Chapman Mercer was a lawyer-turned-archaeologist-turned-potter, and the Moravian Pottery and Tile Works, which he established in Doylestown, Pennsylvania, in 1901, represents one man's mission to preserve and eulogize the craft achievements that he believed constituted the genius of civilization. He undertook this task with the contradictory qualities of visionary and retrogressive romantic, which so often characterized the makeup of the Victorian Arts and Crafts leaders.

On the one hand, he decried the progress of mechanization, and on the other he designed and erected three of the first reinforced-concrete buildings in the country and devised ingenious equipment to reproduce his tiles.

Mercer had at first intended to make pottery to reestablish the tradition of the Pennsylvania German potter, which to his dismay had died out. The clay, however, proved intractable and suitable only for tiles. The first designs came from the castiron Moravian stove plates that he collected. From these relief-modeled surfaces, Mercer, a rapacious eclectic, derived ideas and images from which to develop his narrative tile panels. He employed bright primary colors in his glazes, as well as clay stains, and often left his designs unglazed to highlight the free and unbounded values of his local red clay. Mercer's work was in great demand. Like Perry, he was associated with many architects of the Arts and Crafts Movement. He died in 1930, leaving behind a vast legacy that is only now being fully explored.²⁶

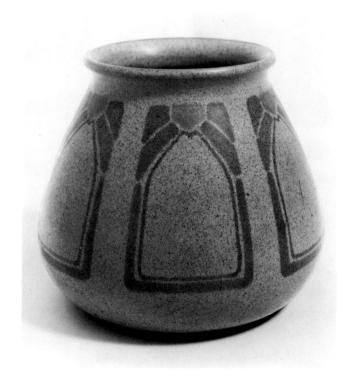

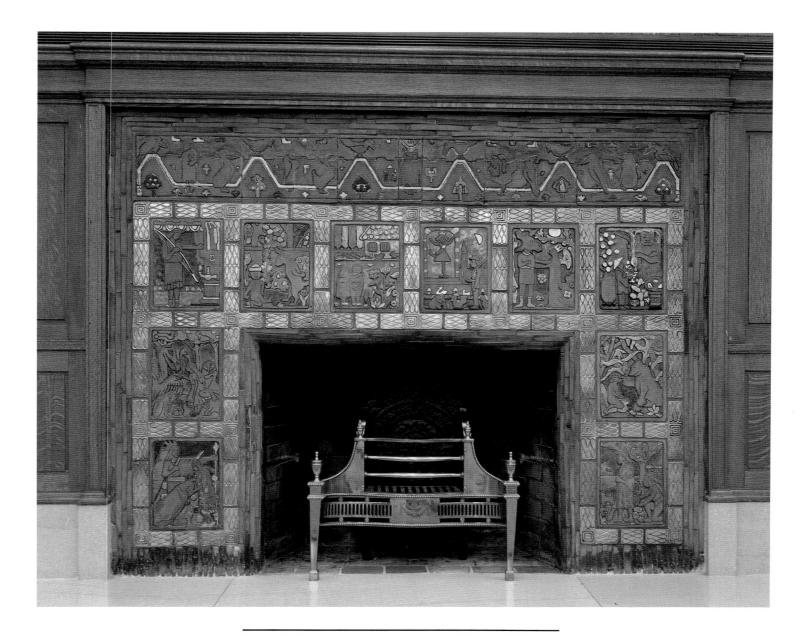

Henry Chapman Mercer Moravian Tile Works, Doylestown, Pennsylvania. Installation, c. 1909.

LEFT: **Arthur Eugene Baggs** Marblehead Pottery, Marblehead, Massachusetts. Vase, c. 1908. Mat-glazed earthenware, height 5½". Private collection.

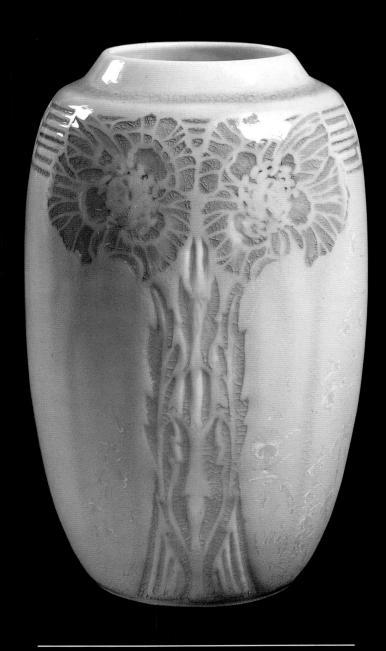

Adelaide Alsop Robineau Poppy Vase, 1910. Porcelain with incised decoration of poppies, inlaid slip and crystalline glaze. Height 61/4". Everson Museum of Art, Syracuse, New York.

By 1910 the foundations for the modern movement in ceramics had been laid. Ceramic art now had its own schools, active exhibiting societies, publications, and some artists of consequence. The preceding

decade had greatly enlarged the technical vocabulary of ceramics, the secrets of high fire had become known, and more new glazes were introduced during that time than during any other decade before or since. This technical knowledge was rapidly expanding as ceramics became a more international pursuit. The decade is distinguished by Robineau's successes in Europe and America, the founding of the University City Pottery, and a decline in the importance of the art pottery industry in favor of the studio potter. Aesthetically the potter moved slightly to the right, drawing upon an Oriental historicism as the major inspiration. What the decade lacked, however, was aesthetic direction. Craftsmanship and decorating skills were advanced to a high level of proficiency, but no new vision emerged to give the medium direction.

Unquestionably, the establishment of the University City Pottery was the event of the decade. As the potter Frederick Hurten Rhead later wrote:

This venture is unique in the history of American ceramics because it is the only one of which I have any knowledge where hundreds of thousands of dollars were lavishly expended for no other purpose than to create and produce beautiful pots. Kings, princes and potentates in other countries have done this sort of thing and some governments are still doing it, but I know of no other instance where a group of potters were assembled together and permitted to run amock regardless of cost and monetary returns.¹

In 1910 the School of Ceramic Art was opened as part of the Fine Art Academy at the People's University in University City, a suburb of Saint Louis. The school was part of a project by Edward Gardner Lewis, publisher of the Saint Louis Star, to create a center for culture in the Midwest. Lewis built his empire on the American Women's League,

CHAPTER FOUR

1910

which he had established in 1907, and on the magazine subscription marketing system on which its fortunes depended—league members (mainly living in remote rural areas) sold magazine subscriptions from

which Lewis received a 50-percent commission. Soon these women, whose desire for education Lewis so profitably exploited, were bringing him a staggering income of \$40,000 a day. In return, the women were offered free education by correspondence through the People's University. Their response was immediate and overwhelming: over fifty thousand women registered for courses. The best of these were invited as honors students to study at the Fine Art Academy.

The academy was built as part of an ornate square-mile development on the outskirts of Saint Louis that incorporated commercial and residential areas as well as the university. The academy was designed in the Italian style, providing excellent facilities for ceramics, sculpture, and painting. Lewis had assembled a strong faculty, with the sculptor George Julian Zolnay at its head. He hired Taxile Doat to be director of the ceramics school. Doat was then one of the preeminent ceramists in Europe, and his appointment was a coup for Lewis. Doat was paid a magnificent salary, \$10,000 a year, and was allowed to bring with him (at the league's cost) the former foreman of a Paris pottery, Eugène Labarrière, and Emile Diffloth, the art director from the Boch Frères Pottery in Belgium. Robineau was appointed instructor of pottery; Frederick Rhead and Kathryn E. Cherry, a Saint Louis china painter, completed the faculty.

Although the venture was short-lived—the Lewis empire foundered and collapsed in 1911—during the year and a half of its existence, the pottery had unlimited resources and aesthetic freedom. The academy sought to foster an atmosphere of creativity and experimentation; there were funds available to encourage investigation into every facet of ceramics. In the chemistry department, thousands of samples of American clayware were

tested, and many were evaluated as being superior to European clays.² The working conditions at the academy proved, however, to be less than ideal. In particular, the atmosphere was poisoned by Diffloth, a bitter obstructionist who caused numerous problems and isolated Doat from the American potters. Diffloth denied the faculty access to most of Doat's technical information, and their contact with him was disappointingly sporadic.

The ceramists worked in a circuslike atmosphere, for Lewis constantly guided visiting dignitaries through the studios to meet the world-famous Doat. Every opening of the kiln was an opportunity for the publicity-conscious Lewis (himself a dabbler in clay) to call a press conference. The firing of Doat's *University City Vase* was one such occasion:

About everyone except the chief of police and the president of the United States was invited to peep through the spy-holes while [the kiln] was under fire. Photographers were dragged in and everyone and everything was photographed every ten minutes in all manner of

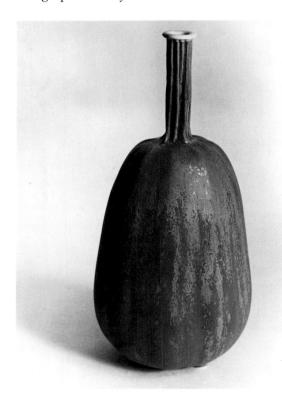

positions. The opening of the kiln was a breathtaking affair. So many people were in the kiln room that it was hardly possible to open the kiln door. Doat in a cutaway coat was there in all his glory; Diffloth, his first assistant, on one side; Labarrière, chief porter, on the other, with photographers snapping hither and yon. It was most impressive.

Lewis would even bring complete conventions to tour the studios; on one occasion Rhead recalls that the entire ceramics faculty had to stand in line for two hours and shake hands with a "visiting aggregation of over seven thousand people."

This atmosphere of a continuing media event had an impact on the production of art at the pottery. The artists felt a pressure to make a showy pièce de résistance. Doat set out to make his *Uni*versity City Vase and Robineau accepted a commission from the league to make the Scarab Vase, one of the most famous pieces of American ceramic art. The vase was titled *Apotheosis of the Toiler* (1910) and reputedly took one thousand hours to incise. For Robineau it was literally and figuratively a monument to the Protestant work ethic. She, however, incorrectly described it as depicting a beetle or scarab pushing a ball of food and noted that this symbolized the toiler and his work. She apparently misunderstood the scarab's use of the ball of dung to enclose its eggs. The scarab hardens the dung in the sun and then buries it in the ground; from it the larva later emerges. But the issue is less one of the accuracy of natural history than of the artist's personal symbolism of the imagery she was using.

It is difficult to understand the commitment that this vase represented without some knowledge of the technique employed by Robineau. Rhead was present during its making and recorded the detailed process involved:

It is a definite fact that carving or excising is the most risky process of all. The carving cannot

Taxile Doat University City Pottery, University City, Missouri. Gourd Vase, 1912. Glazed earthenware, height 9". Private collection.

be well done until the piece is dry, and it is impossible to cut with the freedom possible in wood and ivory. The material is so short and brittle that any undue pressure will chip the surface. A line or excised surface of any depth must be extremely carefully scraped away bit by bit, gradually going deeper. A slight difference in the pressure of the tool, and considerable work, if not an entire piece can be ruined. I have seen the Scarab vase in all its stages of construction. Many times Mrs. Robineau would work all day, and on an otherwise clean floor there would be enough dry porcelain dust to cover a dollar piece and half an inch more carving on the vase.³

While Rhead might have dutifully recorded its creation, he did not approve of the final work. He felt that it had several of the failings of Doat's *University City Vase*. In later writings he referred to the *Scarab Vase* as a "monstrosity... the sort of thing that a criminal condemned for life would whittle to pass the time."

Modern judgment tends to support Rhead's view. Eidelberg writes of the *Scarab Vase* that it represents a significant "turn away from 'modern' design" and a return to historicism. The form was that of the so-called Chinese ginger jar, the glaze a traditional celadon, and the motif of a scarab holding the sun disk was drawn from Racinet's *Polychromatic Ornament*, the textbook for her earlier forays into historicism. The theme of the scarab was also a return to the subject of her first handmade pot in 1901. Certainly works such as the masterful *Poppy Vase* (1910), *Wind* (1913), and the *Cloudland Vase* (1914) are more substantial works.

Most of the faculty of the Fine Art Academy departed in 1911, when the Lewis empire began to crumble. The pottery, however, was carried on under the indomitable Doat, and in 1912 was reorganized on more spartan lines. It continued to produce exceptional porcelains until 1915, when

Adelaide Alsop Robineau Apotheosis of the Toiler (also known as the Scarab Vase or the Thousand Hour Vase), 1911. Excised and carved, glazed porcelain, height 165/8". Everson Museum of Art, Syracuse, New York.

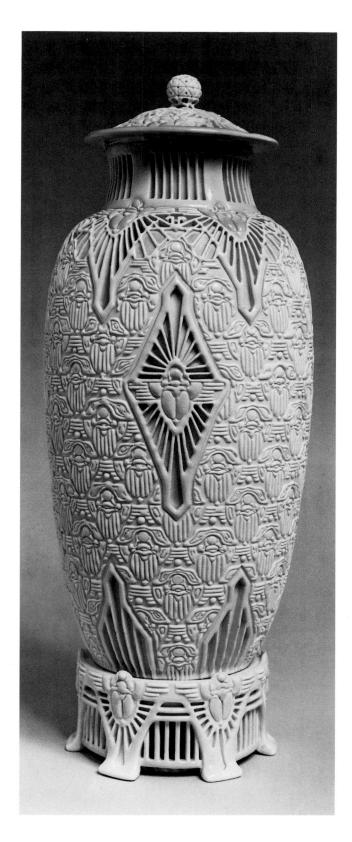

Doat returned permanently to France. Whatever its failings, the University City Pottery proved to be a significant venture. It was through the American Women's League that Robineau assembled a group of fifty-five of her own porcelains and submitted them to the Turin Exposition in 1911.5 The group, including the Scarab Vase, was awarded the grand prize, the highest award at the exposition. Because of a rule preventing the presentation of the grand prize to an individual, the award was formally given to the league while Robineau herself was given the Diploma della Benemerenza, adjudging her porcelains the finest in the world. The award was a signal honor, achieved in the face of competition from Sèvres, Meissen, and other major porcelain factories in Europe. What they achieved through skilled teams of artisans and artists, Robineau, with the support of dutiful Samuel, had matched and surpassed. She was invited to exhibit in the following year at both the Paris Salon and the Musée des Arts Décoratifs. While in Paris, she demonstrated her throwing skills at the Sèvres manufactory to prove that the forms were not cast and that porcelain could be used to throw with precision.6

Frederick Rhead probably gained the most from the University City experiment. It enabled him to work closely with Robineau, who was generous in sharing her knowledge. He seemed to enjoy the steamy political atmosphere of the ceramics school, as well as the considerable personal publicity he received during his short stay. Rhead was now emerging as an important presence in American ceramics. Like Binns, he had come from a long line of British potters. He had arrived in the United States in 1902 to manage Vance/Avon, a small, sixkiln pottery in Tiltonville, Ohio. Rhead became a competent designer (if lacking in originality), an educator, and a critic. Above all, Rhead was one of the most enthusiastic promoters of American ceramic art and design.

In mid-1911 Rhead left University City and set up the Arequipa Pottery for Dr. Philip King Brown's tuberculosis sanatorium in Marin County, north of San Francisco. Dr. Brown only wanted to have the pottery for therapeutic purposes, but the ambitious Rhead saw it as an opportunity to set up a major commercial pottery. His wares proved popular, and within a year the pottery was selfsupporting. But Rhead became overambitious and soon had a falling-out with Dr. Brown. In 1914 he set up the Rhead Pottery in Santa Barbara, California, where he also founded a magazine, the Potter, in 1916. The magazine and the pottery were both short-lived; the magazine lasted for only three issues, and the pottery closed in 1917. During this short period, however, Rhead produced some strong pottery and perfected his famous "mirror black" glaze. The Potter was adventurous for its day and presented a sophisticated and critical view of the ceramic arts. After 1917, when Rhead went to work for the American Encaustic Tiling Company, his importance as a potter declined in favor of a highly successful career as a designer. He remained, however, an impassioned voice for the ceramic arts and wrote extensively on the potter's art.7

As we look back on this decade, the Scarab Vase, with all its failings, characterizes the aesthetic direction of the decade. Robineau's lapses into historicism and her search for perfection and control were repeated in the work of the Binns school. For instance, Binns would throw his forms, even small vases, in three sections. He would then turn them on a lathe to the desired thinness and the exact shape he required; finally he would reassemble them. An indication of his artistic credo can be gleaned from the following excerpt from an article titled "In Defense of Fire": "Glazes must acknowledge the artistic restraint by which the whole work is controlled. Not an ear drop of molten glaze must pass the limit. At the bottom of every piece is a tiny rim of dead ground, a bisque line of demarcation. This far the fluid glaze can come but not further."8 This formalism, which both Robineau and Binns represented in different ways, continued to be an influence for many decades. The American potter, having obtained a tangible success in technical and design terms, was reluctant

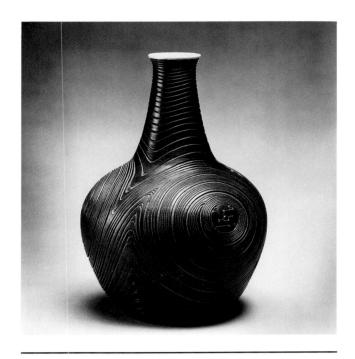

Adelaide Alsop Robineau Indian Vase, 1913. Porcelain, black bronze glaze, height 14½". The Detroit Institute of Arts. Gift of George G. Booth.

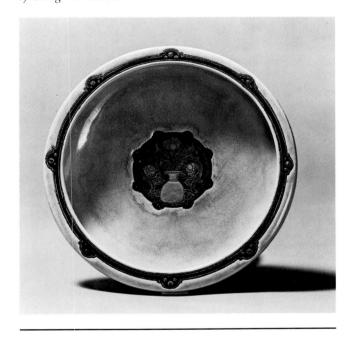

Frederick Hurten Rhead Rhead Pottery, Santa Barbara, California. Bowl, c. 1915. Glazed earthenware, diameter 7½". Collection Bob Schmid. Courtesy Erie Art Museum, Erie, Pennsylvania.

to leave the safety of these disciplines and take on the aesthetic of risk and invention.

The decade ended prematurely, in art terms, at the 1915 Panama-Pacific International Exposition in San Francisco. From then on, the harsh reality of World War I dominated life in America. The first phase of the American Arts and Crafts Movement had come to an end:

After 1915, when Elbert Hubbard was lost with the Lusitania and Gustav Stickley went bankrupt, the arts and crafts movement came to a symbolic end. The original crusading impulse had been incorporated into the middle-class outlook and style; as a motif for home or office or leisure activity—rather than a new way of life or a more humane form of work—arts and crafts easily succumbed to the latest decorating fad or popular pastime. Arts and crafts still promised to relieve the body politic by providing an alternative to industrialization and its discontents, but the initial partnership of art and labor was nearly lost, buried under handicraft stands in national parks and a proliferation of do it vourself kits.

In assessing the achievement of American art pottery over the previous four decades, Martin Eidelberg wrote, "Although the movement originated in response to the growing threat of nineteenth century industrialization, it did not successfully resolve the relation of the individual ceramist to an industrialized society."10 Ironically, many pots that today are classed as "art pottery" were actually industrially produced, ersatz renderings of the craft idiom. These sold well, while those of the studio potter did not. When World War I ended, the ceramists and potters found that the energies that had given impetus to the Arts and Crafts Movement had been spent. Much of the popular public support had been lost; industry began to turn its back as art pottery became less profitable. In their search for patronage, the potters drew closer to the educational establishment and more remote from the art marketplace and art criticism. This created a dilemma, "whose repercussions were felt throughout the present century."11

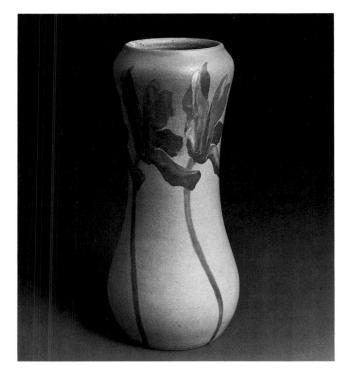

Albert R. Valentien Valentien Pottery, San Diego, California. Vase, c. 1915. Glazed earthenware, height 11¾". Collection Michiko and Alfred Nobel.

BELOW: **Charles Fergus Binns** Three vases, c. 1919. Glazed stoneware, height, 9"–117/s". The Detroit Institute of Arts. Gift of George G. Booth.

RIGHT: **Fulper Pottery** Flemington, New Jersey. Vase, 1914. Glazed stoneware, height 12½". The Newark Museum, Newark, New Jersey. Gift of the Fulper Pottery, 1915.

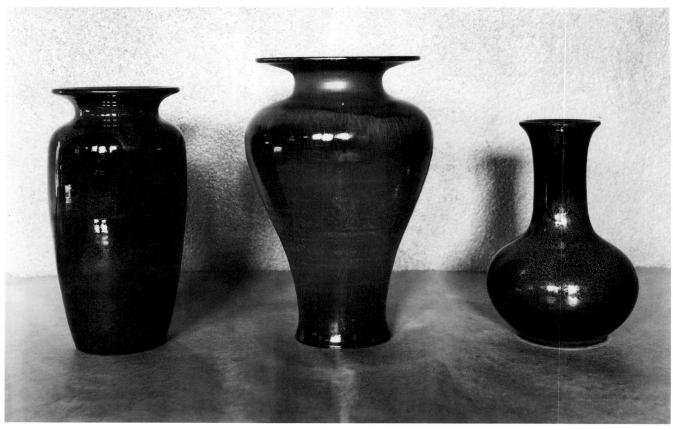

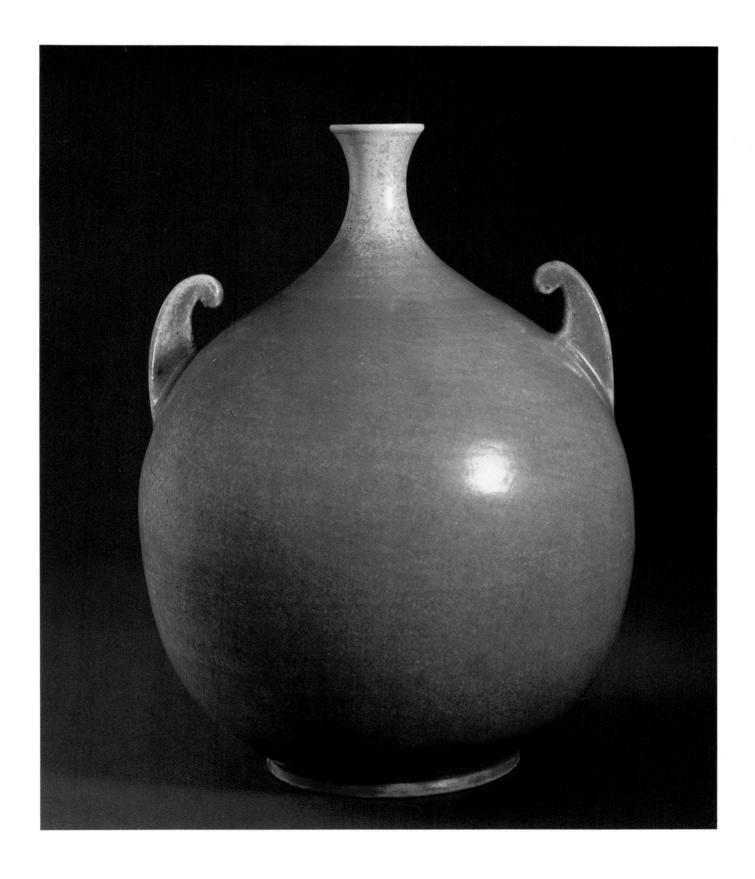

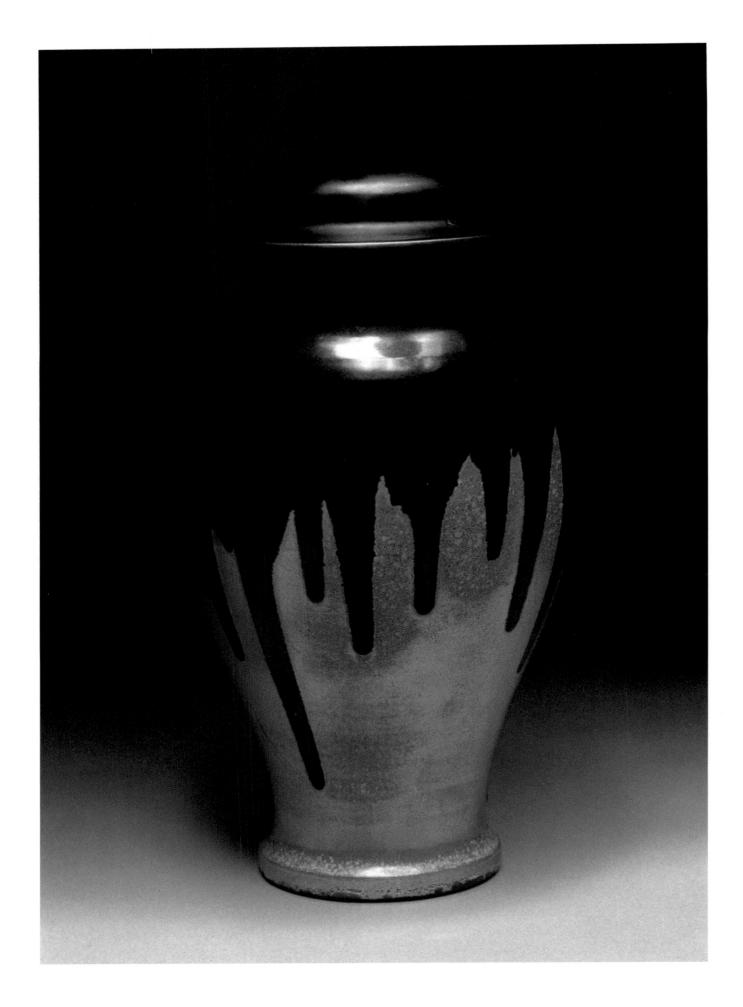

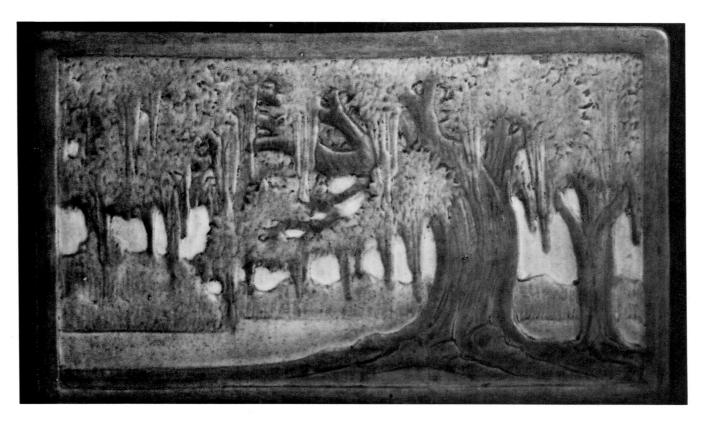

LEFT: *R. Guy Cowan* Cowan Pottery Studio, Cleveland. Ginger Jar, 1917. Earthenware, luster with black running glaze, height 14". Cowan Pottery Museum, Rocky River Public Library, Rocky River, Ohio.

ABOVE: **Anna Frances Simpson** Plaque, c. 1915. Glazed earthenware, height 5". Private collection. Courtesy Jordan-Volpe Gallery, New York.

RIGHT: Fulper Pottery Flemington, New Jersey. Vase, 1915. Glazed stoneware, height 12½". Cooper-Hewitt Museum, Smithsonian Institution/Art Resources, New York. Gift of Marcia and William Goodman.

Waylande Gregory Cowan Pottery Studio, Cleveland. Burlesque Dancer, c. 1929–30. Porcelain, height 18". Cowan Pottery Museum, Rocky River Public Library, Rocky River, Ohio. Produced in limited edition of 50.

After the First World War the art establishment turned against the romantic craftsmanship of the previous decade, and "modernism" became de rigueur in art and design. In 1920 the Arts and Crafts

style was considered passé, even embarrassing, and objects of this period were consigned to the attic and basement. Before modernism began to affect taste and style in the United States, there was a return to the classic simplicity of early American furniture and artifacts. It was the decade that began the uneasy marriage between art and industry (never to be fully consummated) and that found its expression in the machine-art exhibitions held annually at the Museum of Modern Art, New York. Through this involvement the museum conceived its curious policy that functional ceramics made by industry could be art, whereas vessels made by a potter with a wealth of intuition were craft and, by implication, of lesser importance.1 American studio ceramics produced very little that conformed to the cultist machine-age ethic. The small cadre of potters in America were in the process of discovering their past and were little concerned with the present, much less the future, represented by the vanguard art movements. The vessels produced during the 1920s were contemporary interpretations of the Tang and Song dynasties, as well as of the ancient works of Egypt and Persia. The strongest contemporary influence came from the Art Deco potters of France, largely as a result of the publicity given to these artists at the 1925 Paris Exposition Internationale. The French potters were themselves involved in a somewhat decadent rephrasing of past styles.

The ceramists, in search of an aesthetic identity but uninterested in the modern fine-art movements, turned, with uneven results, to contemporary European decorative arts. The 1920s was one of the weakest decades for American ceramics, so it is not surprising that Frank Lloyd Wright wrote pessimistically of ceramics in the United States: "We have little or nothing to say in the clay figure or

CHAPTER FIVE

pottery as a concrete expression of the ideal of beauty that is our own. No sense of form has developed among us that can be called creative-adapted to that material. And it may never come. The life that

flowed into this channel in ancient times apparently now goes somewhere else."2 What Wright and others did not recognize were the foundations that the 1920s were building for later achievement.

The decade has a few important highlights. In 1928 the American Federation of Arts organized the International Exhibition of Ceramic Art. It opened in New York at the Metropolitan Museum of Art and subsequently traveled to seven other museums in the United States, attracting considerable attention from the daily press and from art magazines. The best American pottery of the time—painted earthenware by Henry Varnum Poor, Hunt Diederich, and Carl Walters, and the spartan later works of Robineau—was arrayed alongside the work of Europe's best ceramists and potters: Bernard Leach, Michael Cardew, William Staite Murray, Emile Decoeur, Emile Lenoble, Susi Singer, Vally Wieselthier, Hertha Bucher, and others. The comparison was instructive and showed that although the American potters could equal the technical achievements of their European counterparts, the genre as a whole lacked direction. The naiveté of the American potter at that time can be gleaned from Arthur Baggs's delight in discovering the plastic qualities "of the potter's thumbprint" in 1929, after twenty-four years as a practicing potter.³

The American potter learned the lessons slowly, as he tried to outgrow the bias of the Alfred school, which tended to treat vessel making as a means of solving design problems rather than as an art of expression. The studio potter wavered between sterile design and vacuous decoration. Of course, there were a few exceptions, notably Henry Varnum Poor.

The lack of vitality in pottery was compensated for by evident signs of growth in ceramic sculpture. Until the 1920s the sculptural treatment of clay in

America had been either confined to the pompous nineteenth-century art porcelains of Ott and Brewer in Trenton, New Jersey, or incorporated into the vessel format, as in the work of Anna Valentien, Artus Van Briggle, and others. The development and acceptance of ceramics as an independent, decorative sculptural genre owed much to the formative role of two artists, Carl Walters and R. Guy Cowan. Walters was the first artist of consequence to use the material sculpturally, and Cowan set about orchestrating the institutions and instruments of power needed to establish the medium as a separate and valid art genre.

Walters was a successful painter when he decided to move to ceramics. His first efforts, in 1921, resulted in painted pottery, but from 1922 on, with the setting up of his kilns in Woodstock, New York, Walters began to produce a body of figurative

work. His first showing was in 1924 at the Whitney Studio Club; from this exhibition the Whitney Museum of American Art, New York, later acquired Walters's piece *The Stallion*. Walters dealt almost exclusively with animal subjects, although he did do a few human figures. One of the best of these is the circus fat lady *Ella* (1927, The Museum of Modern Art, New York), a voluptuous figure that threatens to overwhelm the spidery, wrought-iron boudoir stool on which she sits.

Stylistically, Walters's work is difficult to place. It has affinities with what has been termed *folk realism* in paintings of the period. One also finds some of the whimsy in his pieces that later became a stamp of American ceramic sculpture. In Walters's work, however, it is presented without the sentimentality of the Ohio schools. Walters was clearly American in his boldness, verve, and ingenuity of

technique, yet, as William Homer commented in his memorial tribute:

It is difficult to associate him with a native style in ceramics. Because the United States depended heavily on European examples until the present century and because of our insistence on pottery as a utilitarian art, no unified American style had emerged when Walters appeared on the scene. He shared the general spirit of American work in this medium but his main sources were ancient Egypt, Persia and China. By turning to the masters of this art in the distant past, he recaptured the dignity of the medium—and in so doing restored glazed pottery as a sculptural material.⁴

R. Guy Cowan began to campaign actively for the cause of modern ceramic art in 1925. His interest stemmed from his production of limited-edition figurines at the Cowan Pottery Studio in Rocky River, a suburb of Cleveland. The aesthetic level of the early figures was uneven, and the term ceramic sculpture, so often used in descriptions of his work, can be applied only loosely. From 1927 on, however, his standards improved markedly. Several talented designers worked with Cowan, including Alexander Blazys and Waylande DeSantis Gregory. The group of Russian peasant figures by

LEFT: *Carl Walters* The Stallion, 1921. *Glazed earthenware, height* 10". Whitney Museum of American Art, New York.

TOP: Alexander Blazys Cowan Pottery Studio, Cleveland. Dancer from Russian Peasants, 1927. Glazed porcelain, height 10". Cowan Pottery Museum, Rocky River Public Library, Rocky River, Ohio.

Hunt Diederich Cowboy Mounting Horse, c. 1926. Glazed earthenware, diameter 15". The Metropolitan Museum of Art, New York. Gift of Mrs. Hunt Slater.

LEFT: Adelaide Alsop Robineau Foxes and Grapes, 1922. Glazed porcelain with incised decoration, height 7¹/₄". Courtesy Jordan-Volpe Gallery, New York.

UPPER RIGHT: **Adelaide Alsop Robineau** Vase, 1924. Crackle glaze on porcelain, height 123/4". The Newark Museum, Newark, New Jersey. Purchase, 1926.

Mary Chase Perry Pewabic Pottery, Detroit. Vase, c. 1920. Glazed stoneware, height 12". Courtesy Thomas Brunk.

Blazys was given the first prize to be awarded for ceramic sculpture as a separate category at the 1927 Annual Exhibition of Work by Cleveland Artists and Craftsmen—also known as the May Show.

This success was a double victory for Cowan, for not only was the prize-winning piece from his studio, but also the creation of the award was the direct result of his shrewd lobbying in Cleveland art circles. The director of the museum, William M. Milliken, became an enthusiastic patron of ceramics, and "all the prestige of the Cleveland Museum was thrown behind the ceramic artists so as to encourage the creative."5 Milliken joined with the Cleveland School of Art and Cowan Pottery to encourage ceramic sculpture. Cowan taught at the school and employed the students at his pottery, while Milliken provided a platform for their work at the May Shows. Yet, while Milliken was no doubt a valuable friend to the Cleveland ceramist, his friendship was not without its drawbacks, as is pointed out in the Everson Museum's exhibition catalogue Diversions of Keramos: American Clay Sculpture 1925–1950:

Unlike most museum directors in large cities who embraced an elitist "art for art's sake" attitude in their administrative policies, Milliken felt the museum should address itself to broader social interests in the community. Firmly convinced of the commercial applicability of the visual arts, he felt that the competitive display of commercial products in a Museum setting could raise the standards of design in local industries. To make the field of art more accessible to a broader public, he actively refuted the idea that artists were "different" . . . but normal members of society who contributed to the public welfare, and who like everyone else, needed a job. Such an attitude was not without its humanitarian nobility and practicality in terms of financial support [but] it also cast an undeserved populist pallor over the objects themselves, as if they owed their existence to the efforts of good hearted bureaucrats and their desire to please a broad unknowledgeable public.6

The tendency toward commercialization was encouraged by Cowan. From 1928 on, an "exper-

imental" laboratory in ceramic sculpture was run at the school by Cowan, Baggs (for a short period), and Mrs. A. R. Dyer. It was experimental in the least dynamic sense of the word, for Cowan was seeking marketable figurines and not avant-garde works of art. This initial class produced most of the future luminaries of the movement: Viktor Schreckengost, Thelma Frazier, Edward Winter, Paul Bogatay, Russell Aitken, and Edris Eckhardt.

In 1930 the Cowan Pottery Studio went into receivership, a victim of the Depression, and Cowan moved to Syracuse, New York. He had been a successful catalyst, and the momentum that he had built up accelerated in the 1930s. Cowan continued to play a central role in the growth of ceramic sculpture and in the Ceramic Nationals that would be initiated during the 1930s. But the commercializing influence of Milliken and Cowan took its toll in a tendency toward the most sentimental and vacuous of works, totally unresponsive to the mainstream of sculpture.

Finally, a major influence on the direction that sculptural-figurative ceramics was to take in the coming years in the United States came from Austrian ceramics. The 1925 Exposition Internationale des Arts Décoratifs et Industriels Modernes in Paris reawakened interest in European ceramics. A series of ten articles written by Adelaide Robineau and published in Design-Keramik Studio gave saturation coverage to the works in this exhibition. The American potters were at first attracted by the example of the French Art Deco pottery. Gradually, however, their interests turned to the Austrian ceramists working with the Wiener Werkstätte.7 The exhibition of works by the Wiener Werkstätte excited much controversy at the highly publicized 1928 International Exhibition of Ceramic Art at the Metropolitan Museum of Art. The critic Helen Appleton Read denounced their "careless technique and frivolity"8 as being tired and vulgar. What most critics failed to perceive was that the "modern style of sobriety and dignity" that they demanded had already been explored by the Viennese ceramists at the beginning of the century, in the seminal

Sezessionstil aesthetic. The artists of the twenties were, in fact, rebelling against the colder, architectonic use of clay by their elders, replacing it with a witty, expressionist approach, liberating the material's potential as a medium for making polychrome figurative imagery.

The "Wiener Werkstätte style," as it was termed, had an immediate impact on the American ceramic arts despite its mixed critical reception. Several artists, including Russell Aitken, Viktor Schreckengost, and Ruth Randall, went to study in Vienna under Michael Powolny at the Kunstgewerbeschule. The influence of the Wiener Werkstätte lessened the sugary aspect of American ceramic sculpture and gave it a tougher, more satiric sense of the decorative. In addition, two of Vienna's most celebrated ceramists, Vally Wieselthier and Susi Singer, moved to the United States. Although neither produced work in the United States to rival the quality of the Viennese period, both were influential in a broader sense. Wieselthier arrived in New York in 1929, joined the decorative-arts group Contempora, and exhibited at the Art Center with Rockwell Kent and Lucien Bernhard. Wieselthier proved to be a strong influence and an articulate spokesperson for a particular school of decorative sculpture. Writing soon after her arrival in the United States, she explained the raison d'être behind her work:

There are arts which have no deep message to give the world save that of their own beauty and the artist's joy in making intimate arts that make life gayer, and yet have all the seriousness of a thing that is felt intensely and worked out with the utmost care. Of these, pottery is the chief. . . . Good pottery has the feeling of its purpose always in it; it expresses attitudes and moments of life which to the great poet or prophet may seem almost superficial but are, for the ordinary people, of the very stuff of life itself, the delight of the true "Lebenskünstler."

Henry Varnum Poor's entry into pottery was the result of both aesthetic attraction and economic pragmatism. Poor was a painter, but at the beginning of the 1920s he found himself drawn to the

applied arts because he genuinely believed "that the natural development of modern art lies in a closer application to things more related to everyday usage."10 He also felt, however, that potentially he could make a greater income from the applied arts than he was receiving for his paintings. In her excellent essay for the catalogue of a Poor retrospective, Linda Steigleder described his move toward pottery: "Sometime in 1920 Poor surveyed New York galleries and shops to familiarize himself with the state of the ceramic arts. He disliked contemporary products, particularly those with overglaze painted decoration. Poor deduced that no innovative potters were working in America, and he was convinced that the field desperately needed rejuvenation."11

Poor received a Revelation kiln as a gift. Undaunted by his lack of skills and knowledge, he set up a makeshift pottery studio at his home, Crow House, in Rockland County, New York. His first works were sold at the Bel Maison Gallery of Wanamaker's department store in New York. Originally, he intended to continue the tradition of making anonymous, utilitarian pottery in the style of the eighteenth- and nineteenth-century Hudson River kilns, but the demand became overwhelming, and rather than develop a production workshop, he decided to limit his production, make unique pieces, and increase his prices. He was taken on in mid-1922 by the dealer Newman Emmerson Montross, an eminent figure in the New York art world and one of the few champions of modern art. Poor's first one-person show at Montross took place in December of that year and was entitled Decorated Pottery, Paintings and Drawings by H. Varnum Poor. The exhibition was a considerable success, and the Metropolitan Museum of Art acquired a handsome plate, Portrait of a Woman.

Montross and Poor enjoyed an affectionate relationship. Poor recalled his frequent visits to the city, with his Model T Ford stacked with wicker baskets full of pottery: "[Montross] would stand and watch while I unwrapped everything and would teeter back and forth on his heels and say,

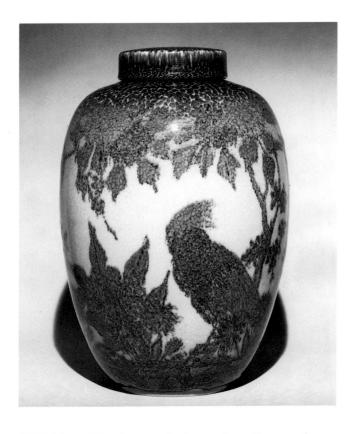

'Well Henry! Let's see what merchandise you have now.' . . . It was sort of a joke between us that this pottery was merchandise and he sold it like merchandise too. . . . My prices . . . were very low, and I sold everything I could [make]."¹²

For the next ten years Poor worked almost exclusively on ceramics and design projects. He received several large commissions, including the domed ceiling of the Union Dime Savings Bank in New York in 1927 (demolished in 1956), and in 1928 a mural, Sports, for the Hotel Shelton in New York. In the fall of 1928, encouraged by the apparent interest in the decorative arts, Poor and a group of fourteen other artists founded the American Designers' Gallery, Incorporated, drawing upon the model of French design studios such as Maison Bing l'Art Nouveau, Maison Moderne, Primavera, and others.¹³ The first exhibition of the American Designers' Gallery took place in October on Fiftyseventh Street in New York. The show included, among other works, a large, ambitious bathroom with painted tile that featured a life-size tile panel of a nude in the "modern manner." The life of the gallery was brief, and the showroom was closed just before the stock market crashed in October 1929.

Poor continued to make pots and to show them at the Montross Gallery. He became more proficient at his craft, although this had only a small impact upon his work, the most noticeable being a slight increase in scale. Poor was never a perfectionist in terms of pottery technique. Later in his life he was asked by Senator William Benton about a warped plate and he replied: "My work has never been notable for technical perfection. In my first show of pottery at Montross Gallery . . . I enraged the potters by showing warped and even kiln cracked plates because I considered them as works of art. Luckily the critics agreed; the show sold out and played some part in bringing American ceramics to life."¹⁴

Poor did indeed bring life to American ceramics of his time and was one of the most significant ceramists of the period between the two world wars. Poor attracted a large audience for his work, including Helen Hayes (for whom he created a ceramic fountain that is now in the collection of the Museum of Art, Pennsylvania State University, University Park), Burgess Meredith, Theodore Dreiser, and numerous museums. He also played a significant role as a critic and theorist for his field. He carried American ceramics into the thirties with his mixture of simple, direct craftsmanship and an evolved and sophisticated sense of the decorative.

TOP LEFT: *Edward T. Hurley* Rookwood Pottery, Cincinnati. Covered Jar, 1928. Earthenware with mottled glaze, height 19". Courtesy Jordan-Volpe Gallery, New York.

RIGHT: **Henry Varnum Poor** Portrait of a Woman, plate, 1926. Glazed earthenware, diameter 6½". Courtesy Poor Estate and Garth Clark.

The 1930s produced a number of developments: the beginning of a challenging vessel aesthetic, the growth of a decorative ceramic-sculpture movement, and, most significantly, the founding of the

CHAPTER SIX

any experimental or avant-garde inclinations, but it also promoted a sense of whimsy and humor as a visual antidote to the harsh realities of day-to-day life. This ideally suited polychrome figurative sculpture.

Ceramic Nationals in Syracuse—the annuals were to become the major platform for the ceramic arts for the next forty years. All this activity took place under the cloud of the Great Depression. The austerity of the decade had an indelible influence on the decorative arts, introducing humor to ceramic sculpture, encouraging the use of inexpensive materials and processes, and causing many of the ceramists and potters to acquire a sense of ideological mission.

What proved to be salable were classical vessels and jocular, amusing sculpture. The austerity of the period gave attention to and encouraged the use of cheaper materials, which introduced several "visitors" to the medium, such as Alexander Archipenko, Reuben Nakian, Isamu Noguchi, and Elie Nadelman.² Even Jackson Pollock was attracted to ceramics; encouraged by Thomas Hart Benton, Pollock worked with china paints while he lived in Kansas City.

Recalling the reaction to the 1930s, Mary Chase Perry remembered how the flow of cheaply produced industrial bric-a-brac offended the craftsmen of the day: "We had been given a flood of the commonplace, the crude and the unlovely. That is why it was important for the individual craftsman to keep working and to keep his place in the community, to train our eyes to recognize the fine things. That is one reason why hand-made pottery will always be needed and why the craftsman's studio will always have a place in the scheme of things."

Until 1930 Nadelman had worked mainly on large, monumental figures, but with the decline of his fortunes and the loss of his home and studio, he turned to experimenting with plaster, papiermâché, and ceramics in the hope that "room-size statuary, mass produced in inexpensive materials could channel a residual interest in free standing figures."3 His respect for the more common materials was an outgrowth of his consuming interest in folk art. The figures he formed from clay and glazed simply in white, grays, yellows, and blacks have the directness of the objects he respected and collected, the toys of the Central European folk artists, and the baked clay figures of Tanagra and Taranto. The commanding elegance in these ceramics in 1934-35 gave way to a fragmented and cursory modeling. After Nadelman's death in 1946, hundreds of small plaster and ceramic figures were found in his studio; they represent his last body of work. The figures are bloated and disfigured, yet they are strangely compelling and erotic. Nadelman was happy with his works in clay and believed that he had "achieved what he wanted" in these works.4 They remain some of the most enigmatic pieces of American sculpture and, to a great extent, they defy categorization: "These strange creatures, the last objects from Nadelman's hands, are reminiscent of nearly everything from

Perry's view was somewhat simplistic but did provide a necessary purpose and idealism. In retrospect, only a few craftsmen provided the bulwark against ugliness; many created as much unlovely bric-a-brac as industry. Some of the most superb examples of clay vessels during this period actually came from industry. The most notable examples are the powerful, sleek forms of the so-called refrigerator ware produced by Hall and Company in East Liverpool, Ohio, as giveaways and premium offers for the refrigerator manufacturers; the bright "California monochromes" from the Bauer Pottery; and Rhead's imitative "Fiesta" wares for Homer Laughlin.

The Depression proved to be a double-edged sword for ceramics. On the one hand, it did staunch

ancient cult figures, Kewpie dolls and Mae West to circus performers, burlesque queens and chorus girls. Despite numerous interpretations the figurines remain totally mystifying, the baffling culmination of a lifetime in sculpture."⁵

The Depression also gave birth to the Welfare Art Program of the Works Progress Administration, which was the solution offered by Roosevelt's New Deal brain trust to maintain the professional artist and, thus, the cultural momentum of the nation. The WAP/WPA invited artists to work on projects for a subsistence wage of about \$97 a month. Because the program was biased toward populist forms of expression, ceramics fared well. Ceramic sculpture was produced in various parts of the country-some of the better works coming from Tony Rosenthal and Emmanuel Viviano in Chicago and Sargent Johnston in San Francisco. In addition, a Ceramic Sculpture Division was set up under the aegis of the WAP in Cleveland-reinforcing the importance of Ohio as a ceramic-arts center during the 1930s. The division was directed by Edris Eckhardt, and under her pragmatic guidance it undertook a number of projects: figures from children's literature were created for display in the libraries throughout the nation, murals and garden ornaments were produced for estates around Cleveland, and murals were painted for public buildings.6

The preference for public rather than for private artworks through WAP/WPA patronage resulted in an ambitious approach to scale, as ceramists sought to rival the monumental outdoor works produced in bronze. One of the most successful artists in this regard was Waylande DeSantis Gregory. In 1938 he completed his largest work, *The Fountain of Atoms*, arguably the largest single work in modern ceramic sculpture. Created for the World's Fair in New York in 1939–40, it comprised twelve colossal earthenware figures, each weighing over a ton: *Fire*, *Earth*, *Air*, *Water*, and the eight *Electrons*. They were an extraordinary technical achievement. Gregory developed a honeycomb method of building up the pieces in the same

Waylande Gregory Water, from the Fountain of Atoms, 1938. Stoneware, height 72". Courtesy the Estate of Yolande Gregory and Everson Museum of Art, Syracuse, New York.

manner as the wasp builds up its nest of mud: what he termed "inner modeling." The work was returned to Gregory's New Jersey studio in 1941 and not publicly exhibited again until 1983, when it was shown at the Everson Museum's exhibition Diversions of Keramos. As E. W. Watson wrote, it was an ambitious, sybaritic work: "In the 'water' a sculptured male swimmer of warm terra cotta descends through swirling, watery forms of greenblue glass, accompanied by maroon fish and lemon bubbles. The fire figure is covered in tongues of reddish glaze and reflected areas of faint blue and

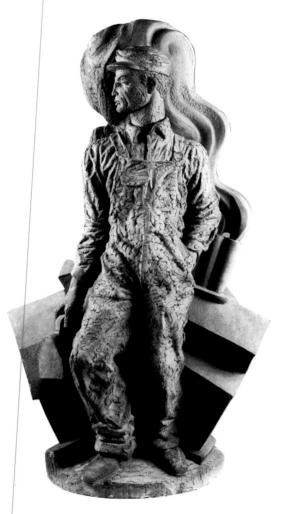

Waylande Gregory Factory/Farm Worker, 1938. Stoneware, height 70". Private collection. Courtesy Everson Museum of Art, Syracuse, New York.

green. The color tone [is] being handled so as to give the sense of being viewed through fumes. $^{\prime\prime}{}^{8}$

Gregory also received a commission from General Motors at the World's Fair—a sculptural group entitled *American Imports and Exports*:

In contrast to the exuberant and somewhat flashy style he favored for the fountain, this work reflects the artist in a more sober mood. Eschewing the bright glazes and animated poses of his fountain figures, Gregory here applied the clay so that its texture remained somewhat rough, and he maintained its natural color. The centerpiece for the display was a Janus-like fig-

ure, Factory/Farm Worker, a suitable paean to American labor. Almost life-size, the figure conveyed a sense of quiet responsibility and dignity, very much in keeping with the images of idealized workers found in paintings of this period.⁹

Gregory's success at the World's Fair resulted in another large commission, an eighty-foot mural for the Municipal Center in Washington, D.C., that depicted the services of the police and firemen.

The success enjoyed by Gregory and other ceramists in the 1930s was also the result of the attention drawn to the medium by the annual Ceramic National, 10 which was inaugurated in 1932 as a memorial to Adelaide Robineau by Anna Olmsted, the director of the Syracuse [New York] Museum of Art (later known as the Everson Museum of Art). In the first year, entries were restricted to artists from New York State and no funds were available for either a catalogue or proper installation. The objects were set out on sateen-covered folding banquet tables borrowed from the YMCA. In 1933 the annual was declared "open to potters of the United States." Writing to Carlton Atherton, professor of art at Ohio State University, who had assisted in the first annual, Olmsted remarked that the city had again cut the museum budget and that the exhibition's allocation for the full year was now \$419. "Perhaps it is rather mad to consider a national exhibition just now," she concluded, "but with no other national exhibition devoted exclusively to ceramics in the country this might truly be the chance of a lifetime, and the museum ought to be put on the art map thereby."11 These were prophetic words.

The second annual, which included 199 pieces representing seventy-two ceramists from eleven states, was accompanied by a simple catalogue. A period of hand-to-mouth improvisation followed, and the annual survived only as a result of Olmsted's indefatigable energy and optimism and, later, through R. Guy Cowan's efforts in obtaining corporate support. Among the many credits for assistance in the early years was a regular and curious entry, the Marcellus Casket Company. Olmsted

had discovered that the casket manufacturer had a large stock of boxes, in which the caskets were shipped. These, covered in sateen, lined the walls of the annual for several years, with smaller crates, used for infants' caskets, serving as pedestals. The installation for each annual began with the arrival of the Marcellus truck with its macabre cargo. This seemingly irrelevant "exposé" of the poverty of the museum rather amused the Rockefeller Foundation. It was also instrumental in obtaining financial assistance from the foundation for one of the annual's major achievements of the decade, the first exhibition of American ceramics to tour abroad.¹²

In 1937 an exhibition of 133 pieces of American ceramics from the Ceramic National went to Helsinki; Göteborg, Sweden; and Copenhagen. On its return, it was engaged for an unscheduled showing at the Hanley Museum in Stoke-on-Trent, England, before coming back in triumph to the Whitney Museum of American Art in New York. The tour and the exhibition at the Whitney received enthusiastic notices in the American press and art magazines. One of the most instructive was an article in Fortune magazine entitled "The Art with the Inferiority Complex." In this special portfolio, with eight pages of color illustrations, the anonymous writer remarked that America had yet to produce its Wedgwoods, Böttgers, or a Wiener Keramik and that, by comparison with Europe and the East, "has lacked even a high point from which to decline." For this reason, the writer concluded, the interest and growth in ceramics in the 1930s was more portentous than simply a passing fashionable fad, and that the boisterous, mocking heroic figures of Russell Aitken, the speckled bulls of Carl Walters, and the terra-cotta horses of Waylande Gregory represented a breakthrough:

The stodgier collectors of pottery, with one eye cocked on ancient China and the other on price, may damn such pieces as miniature giraffes and small shiny ruminating hippopotamuses as expensive bric-a-brac. But ceramic enthusiasts see them as signs of the vitality of a growing American art, and if they are true collectors,

treasure them in the way that the homeowners of Rome probably treasured their collections of unterrifying, homely, familiar little household gods. American ceramic art is beginning to show signs of life.¹³

The signs of life were not as evident in the vessel aesthetic—dressed in its less theatrical forms and glazes—but they were nonetheless there. The 1930s showed signs of strong maturity in the work of Charles Harder, Arthur Baggs, Glen Lukens, and others who exhibited regularly in the Ceramic Nationals. European artists also began to play an influential role: the Swiss potter Paul Bonifas, Maija Grotell from Finland, Gertrud and Otto Natzler

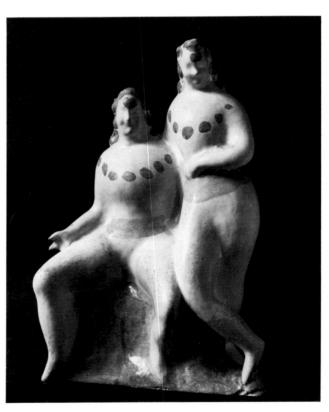

Elie Nadelman Two Women, c. 1935–36. Glazed earthenware, height 163/4". Courtesy Zabriskie Gallery, New York.

RIGHT: Russell Barnett Aitken Futility of a Well-Ordered Life, 1935. Glazed earthenware, height 18½". The Museum of Modern Art, New York. Anonymous gift.

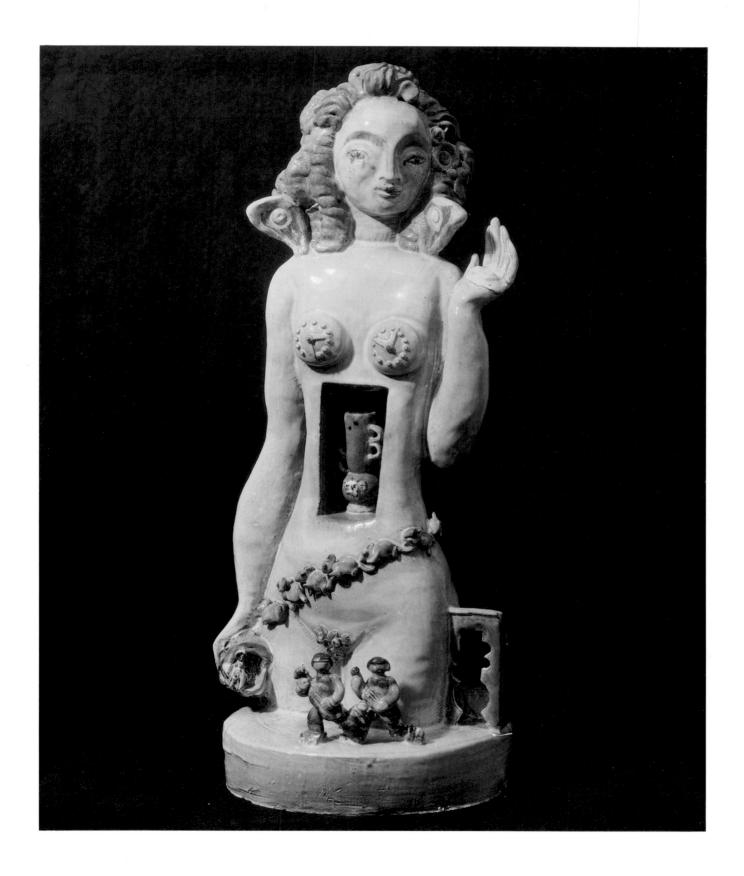

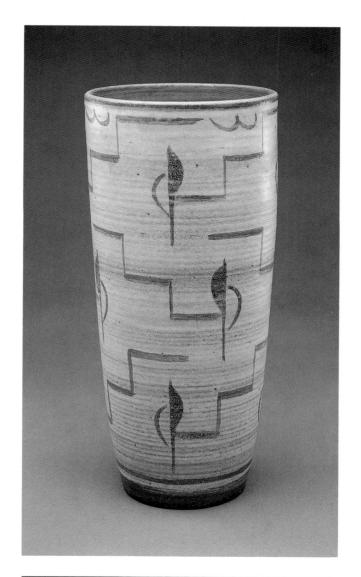

FAR LEFT: Arthur Eugene Baggs Cookie Jar, 1938. Salt-glazed stoneware, height 11³/4". Everson Museum of Art, Syracuse, New York. Exhibited at the seventh Ceramic National. Awarded first prize for pottery.

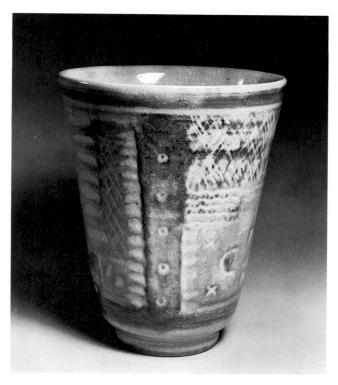

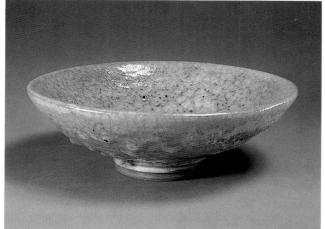

TOP LEFT: Maija Grotell Vase, c. 1938. Glazed stoneware, height 13". Collection Robert Cugno.

BOTTOM LEFT: **Glen Lukens** Bowl, c. 1936. Glazed earthenware, diameter 11⁵/s". Everson Museum of Art, Syracuse, New York. Gift of the artist.

ABOVE: **Charles M. Harder** Vase, 1935. Stoneware, sgraffito and slip decoration, height $9\frac{1}{2}$ ". Private collection.

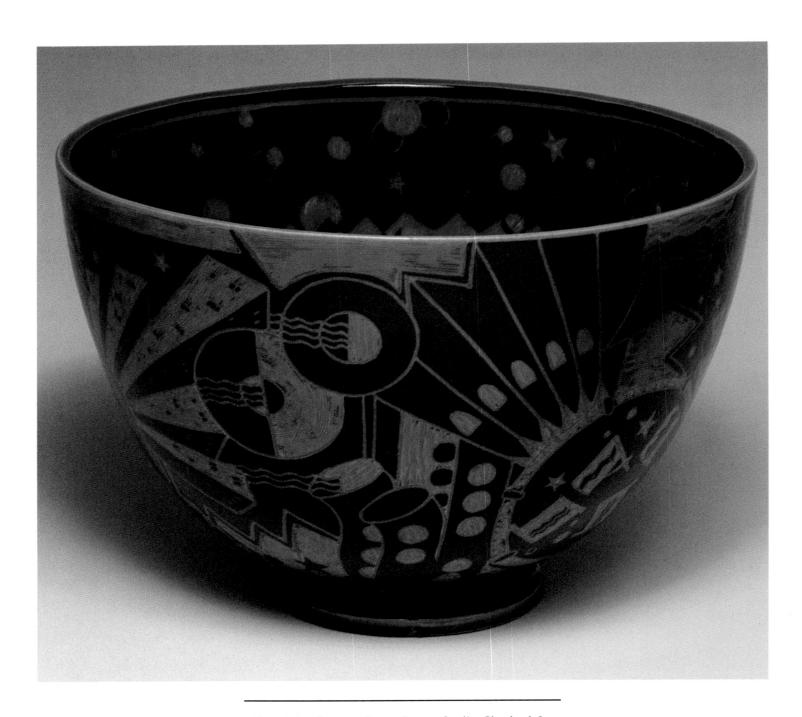

Viktor Schreckengost Cowan Pottery Studio, Cleveland. Jazz Bowl, 1931. Porcelain with sgraffito decoration, height 11". Cowan Pottery Museum, Rocky River Public Library, Rocky River, Ohio.

Maija Grotell Vase, 1939. Glazed stoneware, height 15½". The Metropolitan Museum of Art, New York. Purchase, Edward C. Moore, Jr., Gift.

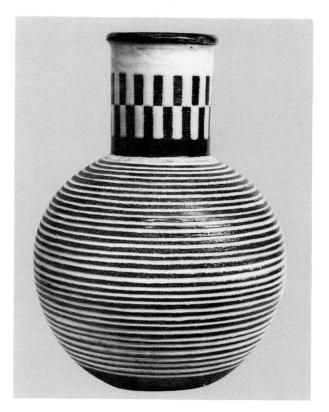

Carl Walters Cat in Tall Grass, c. 1939. Glazed earthenware, height 15½". The Metropolitan Museum of Art, New York. Rogers Fund, 1942.

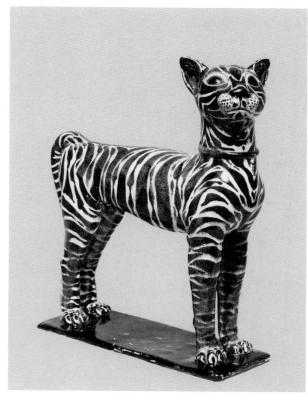

education.

The same situation was evident in the ceramic education of the time. Ceramics was not taught as a discipline in itself but as a convenient tool of art education. Clay was a simple, plastic, and above all, cheap, material with which teacher trainees could learn about surface, texture, color, and form. The interest in ceramic education grew and the medium became more popular, but it was at high cost. The "art education" approach did not acknowledge that the material had its own specific and long-standing tradition as an art form. Literature proliferated, but it was of the simplistic "twenty ways to make a clay horse" variety—an amateur-art bandwagon that later attracted even the usually discerning Museum of Modern Art in New York. The entire emphasis was now placed on the "how-to" aspect of the art. There were, however, a few exceptions: Baggs, Harder, and Lukens. But in terms of creating a sense of professionalism and self-esteem as potters and artists, it was the Natzlers who set a particularly impressive example.

The Natzlers gave lessons for three years after their arrival in the United States in 1939 and played an important, informal role in the education of Beatrice Wood and Laura Andreson. Their major contribution was not, however, as teachers. They were cautious, even secretive, in sharing their information. Their importance to the history of American ceramics was in providing a model for professionalism and for high, formal, aesthetic standards. Their sensibility was new to the United States, where chunky, thick-walled vessels (sometimes due to a lack of skill in forming the vessels) were the order of the day. Gertrud Natzler threw elegant, paper-thin forms. She was arguably the most refined thrower to work in the United States. Otto Natzler created the glazes.

The Natzlers perceived themselves as artists and spoke with pride and authority of pottery as an art form. They defined themselves as purists and held clear and strong views on the character of good pottery form, views that were not unlike those espoused by Binns in "In Defense of Fire" or by the French artist-potter Auguste Delaherche:

The form of a pot is the main part of its spiritual substance. Its outline, its proportions, the fingermarks impressed on its wall, are the simple statement of its creator, spontaneous and personal as his handwriting. The same pot does not happen twice. . . . A pot is four-dimensional: One can think of it as sculpture in three dimensions with the important inside added as a fourth. The inside, while not identical with the outline of the pot, must relate to it. Only when the pot breaks will it reveal itself, like a tree that reveals much of the marvellous structure of its growth only in death and decay. ¹⁵

The refinement that gave the work its distinction was, however, out of step with the growing movement toward a more expressionist vocabulary. The European ideal of achieving the sublime was being replaced by a search for raw energy. Skilled at marketing, Otto Natzler organized many exhibitions and published several excellent, but highly romantic, catalogues of their work. Although the achievement of the Natzler partnership was extraordinary, it remains strangely out of step with American ceramics and needs to be evaluated on its own terms, isolated like a small, exotic island from the growing storm that was developing on the "mainland" of contemporary pottery.

It was Lukens who spoke most prophetically for the coming changes, changes that would deemphasize craftsmanship as the standard of quality. The course that Lukens taught at the University of California at Los Angeles from 1934 onward was established initially with structured, art-educational purposes. Lukens succeeded in introducing a sensitivity to the materials and a respect for the potter's traditions. He achieved this by advocating a gentle, monistic view of creativity that anticipated the attitude Bernard Leach was to propose in 1940 in his classic A Potter's Book. Lukens had at first been taught to believe, as had most of his contemporaries, that cleverness was the aim in art. Through a close friend, he discovered that this approach simply externalized the creative process, and that to escape this self-consciousness, the potter must sublimate his ego to the material and explore a more inward experience: "There in New Mexico among the priceless remains of a magnificent pre-Civilization, I was taught to study the self-expression of a race of people who for more than a thousand years trained the mechanism of the consciousness so that what they now do takes place independently of the conscious intelligence. The only approach to a sound philosophy of life. The one sure approach to creativity in art." ¹⁶

Lukens was influential because his works matched his rhetoric. He succeeded in the difficult task of making an almost primitive statement without seeming to be what the French term faux naïf. His forms went beyond simplicity and can best be termed "primal shapes," with their thick, viscous glazes developed from local raw materials. These glazes in strong yellows, turquoises, and greens were, in the words of R. Guy Cowan, "as luscious as ripe fruit." Lukens was an inspiration to his fellow artists on the West Coast. He was also instrumental in getting the ceramics movement there under way in 1938, when the first all-California ceramic-art exposition was held. "This exhibition," he announced, "means that the Pacific Coast ceramic child is able to walk alone."17 Lukens lived into the 1960s and was able to see the fruits of that first step, as California began to play the central role in the growth of the ceramic arts.¹⁸

Isamu Noguchi The Queen, 1931. Terra-cotta, height 45½". Whitney Museum of American Art, New York. Gift of the artist.

Louise Nevelson Moving—Static—Moving Figures, 1945. Earthenware, height 60". Whitney Museum of American Art, New York. Gift of the artist.

The 1940s saw new concerns emerge in the sculpture of David Smith, Alexander Calder, Joseph Cornell, and others. These artists pointed the direction that sculpture was to follow for the next three decades:

found objects, assemblage, and the fabrication of metal began to replace the traditional craft of the sculptor and his skills of modeling and carving. Sculptors now sought a different "sculptural unity," which allowed the use of totally disparate and discordant elements. This freedom had grown out of early modern art movements—primarily collage, Constructivism, and Suprematism, which had developed in Russia and Europe in the late teens and early twenties. This "constructivist" tendency had a strong impact on the way in which sculptors, and fine artists in general, began to view materials and processes: "To create sculpture by assembling parts that had been fabricated originally for quite a different context did not necessarily involve new technology. But it did mean a change in sculptural practice, for it raised the possibility that making sculpture might involve a conceptual rather than a physical transformation of the material from which it is composed."1

This thinking was the death knell of the first ceramic-sculpture movement in the United States. The sculptors working in the medium had, with a few exceptions, based their aesthetic on the ideals of middle-class connoisseurship and on an intimate artist-material relationship in which the subtle nuances of the firing and glazes were all-important. The ceramic sculptors also found that public interest in figurative sculpture was on the wane and that a nation facing the specter of world conflict for the second time in less than twenty-five years was not in a mood for supercilious ceramic humor.

Except for the work of Viktor Schreckengost, the Ohio school declined rapidly, unable to outgrow the cloying whimsy of the early work. Schreckengost retained his playful style of clay handling and the brash comic-book palette of colors, but the content of his works changed markedly. During the 1930s

CHAPTER SEVEN

his work had reflected the influence of the Viennese school, dealing with decorative surfaces and elegant visual puns. Then, in 1939-40, he turned to political satire, which was surprisingly well-suited to his style.

In 1939 he completed The Dictator, a masterwork from the Ohio school, representing Stalin, Hitler, Mussolini, and Hirohito gamboling in the robes of a corpulent Caesar. A starker quality can be seen in Apocalypse (1942), where three of the leaders are mounted on a frenzied horse—striking a disturbing balance between humor and horror.2

Although the momentum was lost in ceramic sculpture during the forties, there was some activity of note. Louise Nevelson worked successfully in terra-cotta, creating the constructivist work Moving—Static—Moving Figures (1945), which consisted of a group of fifteen assembled clay forms with brusque drawing on the surfaces. The Kansan sculptor Bernard Frazier produced work of a different character in a series of ash-glazed horse sculptures. Two of these, Prairie Combat (1941) and *Untamed* (1948), are in the collection of the Everson Museum of Art, Syracuse, New York, having been acquired at the tenth and thirteenth Ceramic Nationals. The style was distinctive and fully employed the plasticity of the material. Frazier massed and distorted elements of the forms so as to direct the viewer's eye and create an almost brutal and explosive sense of strength.

These high points in ceramic sculpture were few, however, as the focus of the medium began to return to the vessel aesthetic. The potters prospered despite the inclement climate in the fine arts because, unlike sculptors, they had little need of the patronage of museums and major galleries. Pottery was a popular and intimate art form that could reach a wide public because of its low price. For two decades pottery had existed outside the mainstream of fine art and had built up an independent structure of patronage and exhibiting platforms. Far from attempting to match developments in painting and sculpture, the potters in many cases consciously saw themselves as providing an alternative—retaining the traditions of craftsmanship against the onslaughts of modernism.

The decade saw a strong group of potters emerge in the United States, many having come to the country in the 1920s and 1930s as already established artists. Although they shared certain characteristics and a common volumetric discipline, the potters were a diverse group, philosophically and intellectually. Some, such as Wildenhain, adhered to a stern functionalist view. This attitude, based on repetition and production ware, was anathema to Beatrice Wood, Maija Grotell, and others who worked with the same intent as painters and sculptors. Between the two poles of thought were the potters who took a vocational view of the art, based on a romantic, traditionalist conception of pottery as a cooperative workshop. This view was reflected in the number of potteries run by husband-and-wife teams, such as Gertrud and Otto Natzler, Edwin and Mary Scheier, and Vivika and Otto Heino.

Of the potters of this decade, Maija Grotell,

Mary and Edwin Scheier Bowl, c. 1949. Glazed earthenware, height 6¹/₄". University Art Museum, University of Minnesota, Minneapolis. Ione and Hudson Walker Collection.

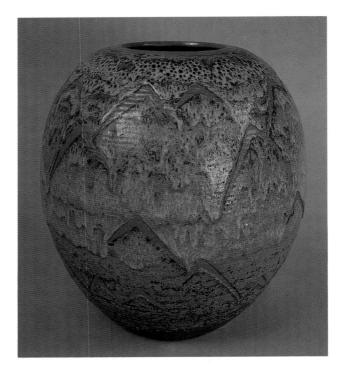

Maija Grotell Vase, 1949. *Glazed stoneware with slip, height* 24". Courtesy Fifty/50, New York.

both as a teacher and as an artist, was the most outstanding figure. Grotell arrived in New York from Helsinki in 1927 and worked first at the Inwood Pottery and then at the Henry Street Settlement House in New York City. In 1936 she joined Rutgers University, New Brunswick, New Jersey. Her early style, with painted Art Deco motifs on simple ovoid or cylindrical forms, was popular and won awards at the 1929 Barcelona and 1937 Paris world's fairs. In 1938 she was appointed the head of the ceramics department at the Cranbrook Academy of Art in Bloomfield Hills, Michigan.

The Cranbrook Academy of Art was part of a complex of small private schools established by the newspaper publisher and art connoisseur George C. Booth. The project began in 1904, when he purchased one hundred acres of rolling Michigan farmland. At first his interest in arts and crafts was restricted to purchases of objects for his home and as gifts for the Detroit Institute of Arts. During the forties, Booth was the most active patron of

the work of both Robineau and Perry. The inspiration for Cranbrook had come in the 1920s, when Booth had conceived of a plan for an ideal artists' community, where practicing artists could live, work, and teach in a stimulating, pedagogical environment. He found an active supporter of these ideas in the architect Eliel Saarinen, who designed a complex of buildings for the schools and the academy and also enlisted artists for the faculty. The setting was superb, with large sculptures in manicured gardens, custom-designed furnishings and fabrics, and the very best in Art Deco lamps and accessories. Booth's tastes in ceramics changed, and he began to collect the work of the French moderne potters, such as André Metthey, Emile Lenoble, René Buthaud, Georges Serré, and others. Waylande Gregory was the first to teach ceramics at Cranbrook, in 1932, but his stay was brief and ended in an acrimonious lawsuit. The sculptor Marshall Fredericks supposedly taught pottery thereafter, but, in fact, there was no real program of ceramics until Grotell's arrival in 1938, joining an all-European faculty: Eliel and Loja Saarinen from Finland, the Finnish weaver Marianne Stren-

Bernard ("Poco") Frazier Untamed, c. 1948. Stoneware, height 26". Everson Museum of Art, Syracuse, New York. Gift of IBM, Inc., thirteenth Ceramic National.

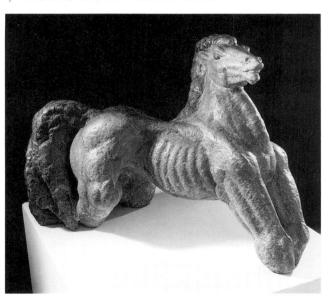

Viktor Schreckengost Spring, 1941. *Glazed earthenware, height* 15". Everson Museum of Art, Syracuse, New York. Gift of IBM, Inc., tenth Ceramic National.

gel, and the Swedish sculptor Carl Milles.

The work at Cranbrook soon began to change and to assume a monumental quality. This quality had little to do, however, with the scale of the pieces, which ranged from shallow bowls to four-foot-high thrown vases. The presence of Grotell's work derived from the strength, gravity, and simplicity of her forms. For most of her career, Grotell concentrated on only two types of forms. She had come to understand most thoroughly the dynamics of enclosing space, but she did so without any search for elegance or lightness. Her pots "sit" quite heavily on their truncated feet. At times this gives the work a brooding, stoic quality. In other pieces the feet are poorly resolved and her pots end too abruptly.

Grotell developed a palette of direct colors—deep turquoises, reds, and burnt oranges—with which she could draw on her forms emphatic motifs that show a carefully considered relationship to the thrust, lines, and proportions of the host vessel.

LEFT: **Susi Singer** Oriental Woman with Child, 1946. Glazed earthenware, height 14". Scripps College, Claremont, California.

RIGHT: *Laura Andreson* Untitled Bowl, 1941. *Glazed earthenware, height 63*/4". *Private collection*.

BELOW: **Henry Varnum Poor** Man Seated, 1947. Earthenware with slip painting and sgrafitto under glaze, diameter $12\frac{1}{2}$ ". Museum of Art, Carnegie Institute, Pittsburgh, Pennsylvania.

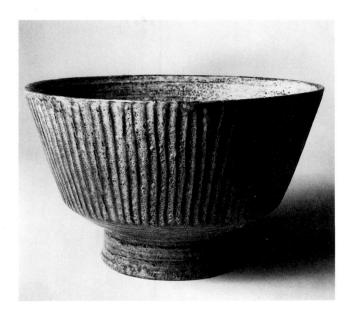

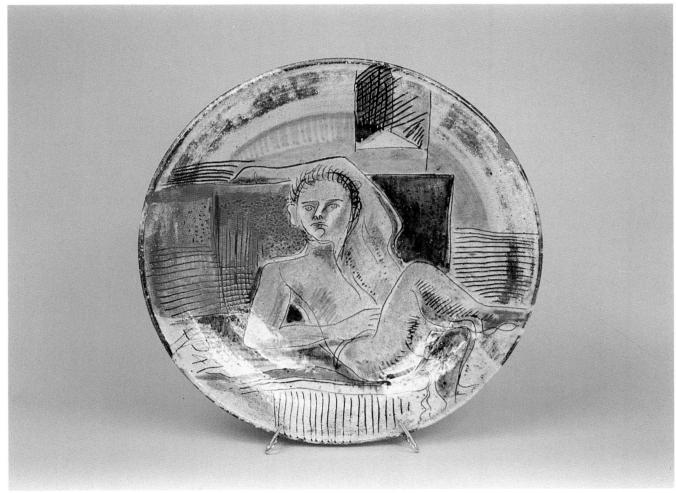

Later she became known for distinctive, craterous glazes, which she obtained by painting a clear Bristol glaze over Albany slip. The results were uneven. Grotell was never content to play safely within accessible decorative limits; she was constantly experimenting, saying, "Discovering new ways of doing interests me most. . . . Once I have mastered a form, a glaze, an idea, I lose interest and move onto something else . . . this helps as a teacher but not as an exhibitor."

Grotell was also an unorthodox teacher. She rejected the structured, doctrinaire methods employed by Myrtle French, Arthur Baggs, and others, and taught by example of spirit rather than by example of work. She disliked imitation of her pots and encouraged self-reliance among her students, assisting them in discovering their most truthful responses to the medium. As a result, by 1950 the Cranbrook Academy of Art had developed into one of the most important institutions in ceramic art education in this country, rivaling in reputation the huge school at Alfred University. Several of Grotell's post-World War II students are included in this study: Toshiko Takaezu, Richard DeVore, John Glick, and Susanne and John Stephenson. Under the leadership of DeVore and, subsequently, Graham Marks, the tradition has continued.4 The legacy that Grotell left through her students and in her vessels was an aesthetic not based on conventional object d'art virtues of beauty. Instead of pleasing in the simplistic sense, Grotell's work challenges and confronts the viewer with its bluntness, its toughness, and its honesty.

Another artist of importance working at Cranbrook in the late 1940s was Leza McVey, who taught summer school at Cranbrook in 1948 at Grotell's invitation. McVey was somewhat radical in her approach. Wheel-thrown symmetry bored her. She preferred asymmetrical forms with strong and unusual silhouettes, to which she very often gave the formal climax of a small, sculpted stopper. Her work received considerable recognition, and in 1951 a black vase with a stopper received the first prize for pottery at the Ceramic National.

The same striving to extend the vocabulary of the medium can be seen in the work of one of the major catalysts of the decade, Thomas Samuel ("Sam") Haile. Haile's indelible influence on American pottery is surprising, considering his short stay in the country. He came to the United States in 1939, shortly after having graduated from the Royal College of Art in London, where he had studied under one of Europe's finest artist-potters, William Staite Murray. Haile was first and foremost a painter; he stumbled upon ceramics only through force of circumstance. Yet, although he brought to the medium certain painterly qualities—as well

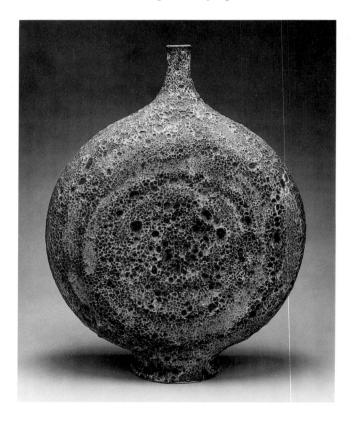

ABOVE: Gertrud and Otto Natzler Pilgrim Bottle, 1949–50. Earthenware with crater glaze, height 17". Los Angeles County Museum of Art. Gift of Howard and Gwen Laurie Smits.

RIGHT: **T. Samuel Haile** Chichén Itzá Vase, 1942. Stoneware, glazed, height 15". The Detroit Institute of Arts. Founders Society Purchase, General Membership Fund.

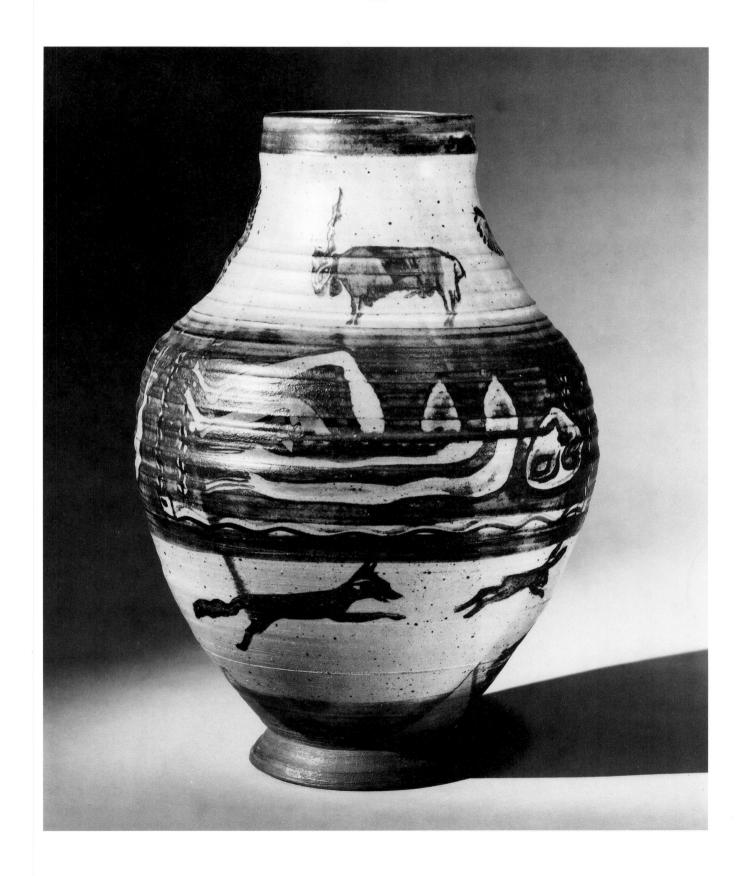

AMERICAN CERAMICS

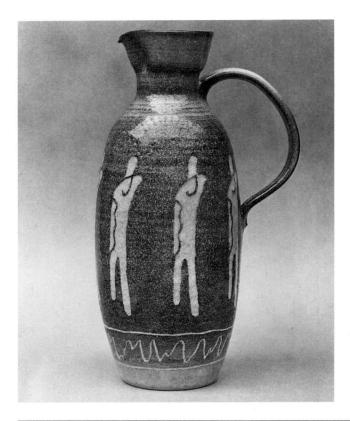

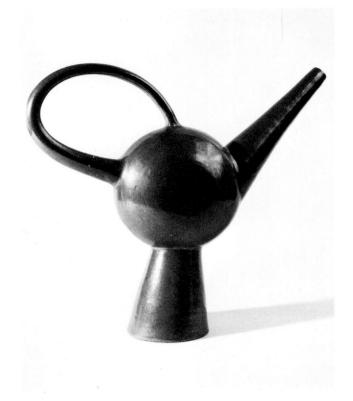

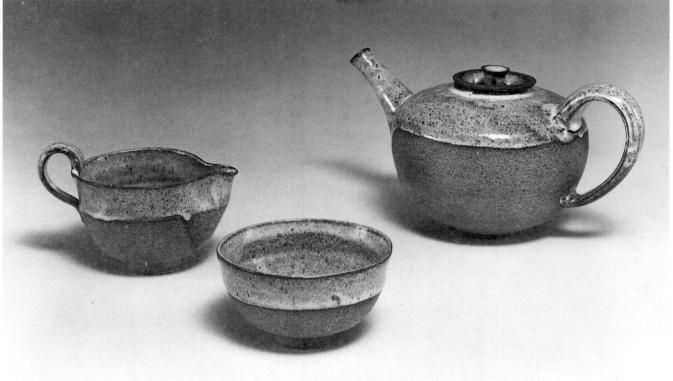

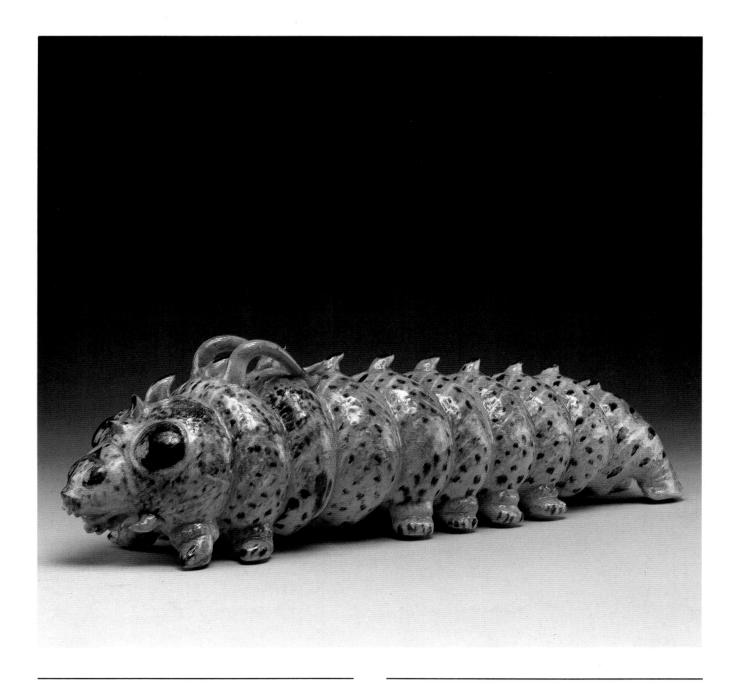

TOP FAR LEFT: **Antonio Prieto** Pitcher, c. 1948. Ceramic with salt glaze and engobe, height 12". The Metropolitan Museum of Art, New York. Purchase, Edward C. Moore, Jr., Gift.

BOTTOM LEFT: *Marguerite Wildenhain* Tea Service, c. 1946. Glazed stoneware, height of pot, 5". Everson Museum of Art, Syracuse, New York. Recipient of the Richard B. Gump Award and purchase prize, eleventh Ceramic National.

TOP LEFT: **F. Carlton Ball** Teapot Form, 1947. Glazed earthenware, height 14". (Made at Mills College Workshop, Oakland, California.) Collection Jack Lenor Larsen. Courtesy Fifty/50, New York.

ABOVE: Carl Walters Caterpillar, 1945. Glazed earthenware, length 16½". The Detroit Institute of Arts. Gift of Mrs. Lillian Henkel Haass.

as his strong Surrealist affinities—Haile always acknowledged ceramics as an independent discipline that required an approach altogether different from that of paint and canvas.

After his arrival in New York, Haile exhibited extensively but did only odd jobs until invited by Charles Harder to study and teach at Alfred University. At Alfred he found glazes being compounded in science laboratories from a highly academic viewpoint. Haile challenged this practice, insisting that "all that craft separated the artist from his instincts and visions."5 He advocated, instead, simple glazes compounded from two or three readily available materials, and a creative use of the kiln in obtaining variations of color. This refreshing view found a sympathetic ear among the young potters of the time, who had grown weary of Alfred's pedantic use of materials. Harder had plans to groom Haile as his successor, but Haile's restless spirit was not easily tamed, and he moved to Ann Arbor, Michigan. There he taught at the University of Michigan until his induction into the United States Army in 1944; he returned to England after the war.

Haile's work, although figurative, showed many of the same instincts that were to resurface in the so-called Abstract Expressionist ceramics of the mid-1950s. One of the most distinctive qualities was the manner in which Haile dealt with the vessel as format. Unlike many of the potters of the day, who decorated passively within the frame of the vessel, Haile disregarded the defining line on his vessels. His carefully conceived, but freely executed, painting gave depth and purpose to the form. Sometimes his painting quietly conformed to the shape of the vessel, as in *Orpheus* (1941). In other pieces, however, the strong movement of line around the form would break down the outer edge of his bowls, vases, or pitchers so that the interaction of form and painting became complex. One of the finest examples of the latter technique, Cern Abbas Giant (1938), has unfortunately been lost, but other masterworks, such as the Chichén Itzá Vase (1942) and Cretan Feast (1939), have found their way into American public collections.

Haile died in an automobile accident in England in 1948. As a tribute to an artist who had contributed richly to a more progressive view of the vessel as an art form in America, the Institute of Contemporary Arts (Washington, D.C.) held a well-publicized memorial exhibition of his work in the United States. Robert Richman, the director of the institute, praised Haile's work for demonstrating "belief in the principle that art is a way of thinking, meeting art and function at their foundations by making for use yet transcending it." Speaking more specifically of Haile's influence in this country, Richman added:

To Americans conditioned to ceramic trivia—fish, gazelles and earrings—the work of Haile is a fresh wind. Here is pottery that is not only perfection in form, and glazes controlled miraculously, but with decorations like those in Etruscan and Greek pots. And always a simple statement: this is a pot, this is a dish, this is a jug. Haile could throw stoneware to the absolute limit of its yield point, achieving thereby a rhythmic tension quite [of] the same essence as sculpture.⁷

The pottery of Beatrice Wood during the forties was similar in spirit to that of Haile. Wood was as unimpressed with notions of perfectionist craftsmanship as he, arguing that "knowing what one was about to take out of the kiln is as exciting as being married to a boring and predictable man." Freely admitting to being a "terrible" craftswoman, Wood looked at ceramics with a sensibility very different from that of most of her contemporaries. Her early involvement in art had come through her membership in Duchamp's Dada circle in New York, 8 so her expectations of ceramics were different from those who had entered the field via the crafts or decorative arts. Wood had dabbled with pottery figures and other ceramics since the early 1930s, but in the late forties began to concentrate on luster glazes. Working out of a small studio/home in Ojai, California, she explored a nonformalist approach to form and materials. Her remarkable success with her glazes soon earned her an international reputation, but because of her laissezfaire approach to craftsmanship, the generally conservative world of ceramics viewed her efforts with suspicion and dismay. However, the livelier spirits, such as Peter Voulkos, saw her work as valid, unique, and radical.

Wood was not interested in luster for its preciousness but for its manipulation of light and color. Indeed, her approach to luster was unique and cannot be directly compared to any lusterwares within the ceramic tradition, with the exception of Mary Chase Perry, who similarly used simple forms and rich surfaces. The surfaces and the soft, informal shapes of Wood's work have a far closer affinity, in fact, to the shimmering patina of Roman glass. Up until the time of Beatrice Wood, the use of luster glazes had always been decorative, as in the work of William De Morgan, one of the leading nineteenth-century potters in the British Arts and Crafts Movement. More commonly, luster was used as an on-glaze technique associated with the vulgar excesses of the china-painting fraternity. Wood's pots, in contrast, have the surfaces of vessels that have been buried for centuries and have acquired a pitted patina of polychromatic iridescence. The primal forms, at times verging on crudeness, provided the perfect canvas for the glowing surfaces.

Wood attracted a small coterie of admirers, including the writer Anaïs Nin, who wrote of her work in a review for Artforum: "People sometimes look wistfully at pieces of ancient ceramics in Museums as if such beauty were part of a lost and buried past. But Beatrice Wood is a modern ceramist creating objects today that would enhance your life. The colors, textures and forms are at once vivid and subtle. Her colors are molded with light. Some have tiny craters, as if formed by the evolutions, contractions and expansions of the earth itself. Some seem made of shells or pearls, others are iridescent and smokey, like trailways left by satellites."9 With her spirit of freedom and experiment, Wood provided an avant-garde bridge between the 1940s and the revolution in vessel aesthetic that was to take place in Los Angeles in the 1950s.

Beatrice Wood Plate, 1947. Glazed earthenware, diameter 18". Courtesy Garth Clark.

Glen Lukens Bowl, c. 1940. Glazed earthenware, diameter 12". Collection Howard and Gwen Laurie Smits.

Gertrud and Otto Natzler Elliptical Bowl, 1958. Earthenware with tiger's-eye glaze, height 10". Collection Richard Schroeder.

The 1950s was the decade of liberation. The American potter finally cut loose the shackles that had bound him for so long to the manners and values of European art and design. That is not to say that

Europe ceased to be an influence. On the contrary, Constructivism and the example of artists such as Miró and Picasso, who worked in ceramics during the early 1950s, were crucial to the development of American ceramics. These influences were, however, interpreted, digested, and applied to a new style, a new "machismo," and a new ambitiousness that was distinctively American. Very soon, the tables would be turned, and Europe and Japan would look to the United States for leadership in this ancient art.

The beginnings of the decade were inauspicious, with little indication of the revolution to come. Henry Varnum Poor viewed the activities of the day cynically, pronouncing that "hygienic hotelware" was the true American ceramic aesthetic. Ceramics, together with the other craft media, was experiencing a surge of interest. Popular magazines exhorted housewives to take to macramé, pottery, and weaving in search of the cultural opiate, self-expression. Others, early members of the counterculture movement and ex-GIs, came to the crafts in search of a gentle, romantic life-style.

Out of this interest grew a number of dedicated artists who set aside the romantic traditions of the material and began to establish a contemporary vocabulary. This group included those artists who gathered around Peter Voulkos at the Otis Art Institute (formerly the Los Angeles County Art Institute) during the mid-1950s. Many influences contributed to the breakthrough in the vessel aesthetic in the Otis group: the growing appreciation of jazz, the beat poets, the developments in American art, and, most broadly, the general climate of urgency and release that followed World War II. In purely visual terms, three influences dominated: the Zen pottery of Japan, the surface energies of Abstract Expressionist painting, and the Con-

CHAPTER EIGHT

1950

structivists' freedoms of form.

The dominant influence on American ceramics during the 1950s came from Japanese pottery and the Zen Buddhist theories that accompanied it. The artists on the West

Coast were particularly sympathetic to Oriental philosophy. Under the leadership of such scholars as Alan Watts in San Francisco, a popular interest in Zen was growing. In his study on Zen in Japanese culture, Daisetz Suzuki explains part of the Oriental concept of beauty:

Evidently beauty does not necessarily spell perfection of form. This has been one of the favorite tricks of Japanese artists—to embody beauty in a form of imperfection or even ugliness. When this beauty of imperfection is accompanied by antiquity or primitive uncouthness, we have a glimpse of sabi, so prized by Japanese connoisseurs. Antiquity and primitiveness may not be an actuality. If an object of art suggests even superficially the feeling of historical period there is sabi in it. Sabi consists in rustic unpretentiousness, apparent simplicity of effortlessness in execution, and, lastly, it contains inexplicable elements that raise the object in question to a rank of artistic production.1

Zen concepts of beauty appealed to the American potter for a number of reasons. Japanese pottery offered the potter aesthetic values different from those of the West.2 Above all, Zen was the key to breaking with the formalist regime of European objecthood and its demands for perfectionist craftsmanship. Through Japanese pottery the California potters glimpsed a new value, based on risk and expression. They saw new forms of expression in the subtle asymmetry, in the simplicity, and in the often random, abstract decoration of the wares of the tea ceremony. The earlier works of Japan, particularly the architectonic structure of prehistoric Jomon pottery, inspired curiously weighted proportions and tension between surface and form.

For most American potters the first contact with Oriental philosophy came through Bernard

Leach. In 1940 this English potter wrote *A Potter's Book*, one of the classics of ceramic literature. In the opening chapter, "Towards a Standard," Leach proposed a meeting of East and West that he was later to define as "Bauhaus over Sung." This interest in the bridging of cultures had been a popular crusade among artists and intellectuals during the 1930s and 1940s, when Leach had been a member of an elite group of intellectuals that had assembled at Dartington Hall, a progressive school in Devon, England. The group included Mark Tobey, Ravi Shankar, Aldous Huxley, and Pearl Buck, all of whom were interested in exposing the West to the monistic sensibilities of Eastern philosophy and culture.

In late 1949 Leach visited the United States and toured from coast to coast, drawing large and appreciative audiences. Leach, who was awarded the Binns Medal in 1950 by the American Ceramic Society, had a strong impact on American ceramics. He did, however, slightly sully his reception by pointing out that American ceramics was without a taproot and, by implication, without any sense of direction.3 It is ironic that the society that Leach had declared to be rootless was the first to achieve his ideal. Earlier Leach had emphasized that "because a potter belongs to our time and aspires to the position of creative artist he is divided in his allegiance between the contemporary movements in our own art and his challenge from the classic periods of the East."4 The answer, he felt, lay in balance and integration. These qualities were not achieved in Leach's work, nor in that of his contemporaries in England, who remained staunchly traditionalist. The fusion of East and West was to occur in the following years in the United States.

Leach returned to America in 1952. This time he brought with him two close friends, the potter Shoji Hamada and the founder of the Mingei craft movement and director of the National Folk Museum of Japan, Soetsu Yanagi. They had just come from the first International Conference of Potters and Weavers, at Dartington Hall, and were to begin a tour of the United States, speaking on the

issues and concerns raised at that conference. The tour was organized by Alix MacKenzie. The trio (Bernard Leach, Shoji Hamada, and Soetsu Yanagi) drew large audiences wherever they spoke. In Los Angeles more than a thousand people packed a hall to hear them. Hundreds of others were turned away. Leach spoke persuasively of what the Orient had to offer the West; Yanagi explained the mystical principles of Zen Buddhist aesthetics; and Hamada demonstrated throwing and painting pots. For those

Antonio Prieto Vase, 1958. Glazed stoneware, height 18". Mills College, Oakland, California.

who participated in the various seminars, lectures, and symposia, the tour proved to be a rich and challenging event. The seminars at the Archie Bray Foundation in Montana and at Black Mountain College in North Carolina proved to be particularly far-reaching.

Other visitors provided a different view of Japanese ceramics. In 1954 the perspicacious Rosanjin toured the country, exhibiting at the Museum of Modern Art and at the Grace Borgenicht Gallery, both in New York. Rosanjin was one of the most important ambassadors of the Oriental aesthetic. At one time, he had been a most respected gourmet restaurateur in Japan. When he required certain pottery for his restaurant and was unable to find it from practicing potters, he began to work himself. His approach was audacious. Sidney Cardozo affectionately termed him "the supreme amateur and dilettante,"5 for he imitated and paraphrased all the great periods, styles, and masters in Japanese ceramics. The results, nonetheless, were distinctly the works of Rosanjin, and his brushwork—so brusque and economical—spoke of his years of studying calligraphy.

To Western eyes, at least, Rosanjin was the embodiment of sabi, a mixture of sophistry and savagery. His mercurial temper was legendary, and his progress through the United States was peppered with incidents. Following a heated exchange at Mills College (Oakland, California) with Antonio Prieto, head of the ceramics department, Rosanjin closed his exhibition after only twentyfour hours. Rosanjin had told Prieto that he did not think that his fat, bulbous forms with miniature necks and spouts were the last word in elegance. Prieto responded by calling Rosanjin's pots "turds and kiln shelves." Rosanjin took his pottery from the Mills exhibition to the ceramics department at the California College of Arts and Crafts, where students—including Manuel Neri, Viola Frey, and others—had free access to the pieces for several months.

While in San Francisco, Rosanjin gave a memorable lecture. In contrast to the paternalism of

Leach, he spoke enthusiastically of American ceramics and prophesied that the nation would make a great and unique contribution to the ceramic arts in the coming years. In his address, he also dealt with the more spiritual concerns of the potter, insisting that pottery was not an art of technical expertise—machines and soulless craftsmanship, he said, were "reckless tools"—but that ceramics was an art of the mind, "dependent solely upon the beauty of the mind":

I am learning by trying to produce pottery as fine art, in accordance with art for art's sake principles. Work done by machines is after all, work by machines. A work is of no value unless it moves the human mind and the human spirit. As for pottery of daily use, which should of necessity be of moderate price, I think there is nothing wrong with manufacturing it by mechanized methods. But once a man wishes to become an artist with the determination to dedicate his mind to the creation of first class art he must disregard the advantages of the machine. In other words, the fine arts are all activities of the intuitive mind and are not affected by the development or advancement of our knowledge, intelligence, or reason alone.6

Rosanjin was followed to the United States by the Bizen master Toyo Kaneshige, who gave extraordinary demonstrations. He would swiftly pummel his thrown form and, after a moment's contemplation, declare it good or bad and so consign it to either the kiln or to the soak bin.

The first reaction in American ceramics to the heady influences from Japan was imitation. Many potters made pilgrimages to Japan to learn how to copy Japanese wares, while others, less concerned with purity, simply copied from the examples represented in books and museums. Quasi-Oriental wares proliferated, and potters working outside this tradition found difficulty in being shown at fairs and exhibitions. An archaeologist digging in the future through the shard piles of the mid-1950s could be excused if he deduced that during this time the United States was overrun by an army of fourth-rate potters from China, Korea, and Japan. As more and more Oriental pottery of

quality became available and was shown in public collections, however, a greater understanding of the nature of the objects and their beauty began to emerge, and the quality of the pieces produced in America improved.

From a fine-arts point of view two influences were significant for the fifties, Abstract Expressionism and Constructivism. The influence of Constructivism and the idea of collage that grew out of the Dada movement has already been briefly discussed. Although its overall significance has been greatly exaggerated, Abstract Expressionism was important to the American ceramist for several reasons. It was the first major art movement originating in the United States. American ceramists, trying to establish an identity separate from that of their European counterparts, felt considerable kinship with painters such as Jackson Pollock, Clyfford Still, Franz Kline, and others.

The movement began to take shape in the 1940s, but it was not until the 1950s that it began to attract wide attention and recognition. Also named the "New York school," after the city that became its headquarters, the movement involved several ideas with which the ceramist could identify. The critic Harold Rosenberg coined the term "action painting" to describe the creative process of certain painters in the movement, notably Pollock. The term implied a macho physicality and a one-to-one contact between the artist and his materials that had a certain similarity of spirit to that of the Zen potter. The notion of nonobjective art—of using color, form, and texture rather than recognizable subject matter as content—was one with which the vessel maker in particular was familiar, albeit from a more traditional vantage point.

Yet, in spite of certain affinities, ceramics, traditionally a conservative art form, was moving ahead much more slowly than painting. The revolutionary spirit that had so transformed American painting in the forties was not to reach the ceramics movement until a decade later. And when it did touch ceramic art, it was greatly modified by the ceramists' interest in their own traditions and roots.

The revolutionary force for ceramics in the fifties was to be Peter Voulkos, a young, dashingly handsome, and precociously talented painter-turnedpotter, who provided crucial leadership for a medium in the throes of redefinition. Voulkos had a unique ability to blend the influences from Eastern ceramics with Western art. He had originally studied to be a painter but changed his major to ceramics. He was obsessed with the wheel. While studying for his B.F.A. he had refused to create forms by any other technique. Only when threatened with the withholding of his degree did he consent to work briefly with hand-building techniques. Voulkos received his M.F.A. in 1952 from the California College of Arts and Crafts in Oakland. At the time, he was producing strong, fullformed, but conventional vessels. In a short time, Voulkos established himself as a nationally known potter. Before leaving graduate school, he had won

Peter Voulkos Lidded Bird Vessel, 1956. Glazed stoneware, height 20". Private collection.

Peter Voulkos Lidded Jar, 1954. Glazed stoneware, height 17". The Newark Museum, Newark, New Jersey.

several prizes from the Ceramic Nationals at Syracuse and had begun to win prizes in international shows as well.

After receiving his M.F.A., Voulkos worked with Rudy Autio at the Archie Bray Foundation as one of the foundation's first artists in residence. The Archie Bray Foundation in Helena, Montana, had been established as a creative workshop by Archie Bray (1886–1953). Bray was the owner of Helena's Western Clay Manufacturing Works, a brick and pipe factory for which Autio also produced large murals. Bray wished to leave the foundation as a memorial, "a fine place to work for all who are sincerely and seriously interested in any branch of creative ceramics." Under the leadership of various artists who succeeded Autio, including Ken Ferguson and David Shaner, the foundation has continued to fulfill Bray's vision.

In 1954 Voulkos moved to Los Angeles, where he set up the ceramics facility at the Otis Art Institute and, together with Harrison McIntosh, ran the department. For the first few months, there was little sign of a revolution brewing. Voulkos was then concentrating on functional wares. Slowly, however, the pace toward a new aesthetic began to develop: the students challenged his work; at the same time, Voulkos experienced something of a revelation through a period of studying music.8 The ceramic work of the European artists Miró, Chagall, Léger, Fontana, and Picasso also began to inspire and excite the American ceramic world. The tempo of experiment built up, and soon Otis was producing the most radical ceramics in the country. The word got around Venice, California, the art enclave for Los Angeles, that "something was happening at Otis," and artists drifted in and

Peter Voulkos Vessel with Slab Surface, 1957. Glazed stoneware, height 22". Collection Howard and Gwen Laurie Smits.

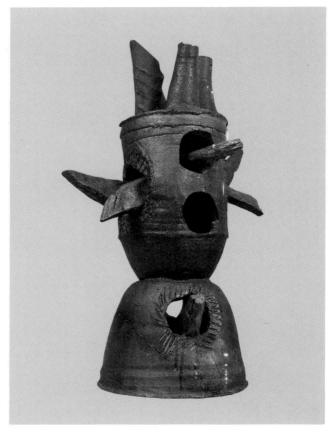

LEFT: *Peter Voulkos* Untitled, 1957. *Glazed stoneware, height* 62". *Private collection*. *Courtesy Braunstein Gallery, San Francisco*.

RIGHT: **Peter Voulkos** Rocking Pot, 1956. Glazed stoneware, cut and assembled from thrown and slab elements, height 19". Jedermann N. A. Collection.

FAR RIGHT: **Isamu Noguchi** Lonely Tower, 1951. Unglazed stoneware, height 28". Collection the artist.

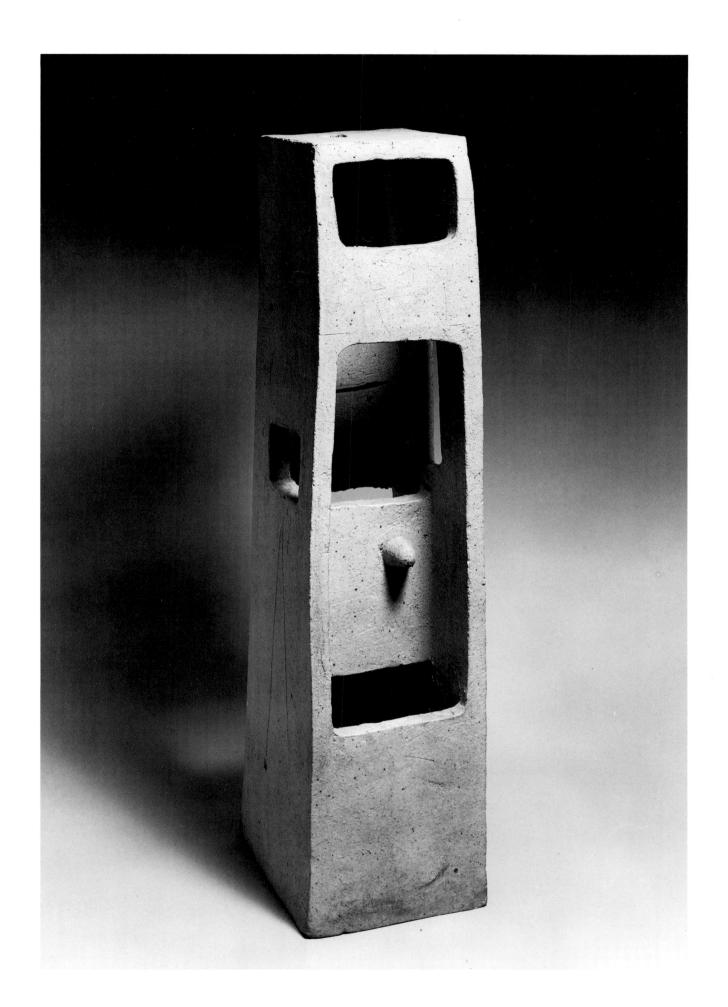

joined the department; among these were Paul Soldner, Kenneth Price, John Mason, Billy Al Bengston, Henry Takemoto, Malcolm McClain, and Jerry Rothman. Artists from other media also became interested in the energies being generated at Otis. Robert Irwin and Craig Kauffman each titled a painting *Black Raku* in recognition of the ceramists' achievements.

There was no common style or ideology at Otis—other than the tacit agreement not to have any common style or ideology. The group was freely, almost purposely, eclectic. They drew from a myriad of sources: Haniwa terra-cottas; Wotruba's sculpture; Pollock's paintings; music; poetry; and the brash, inelegant Los Angeles environment. Books were the major "museum" of the group. Voulkos, in particular, was a ravenous consumer of ceramic literature. The photographs were marvelously abstracting. Soldner recalls a case when Voulkos was inspired to imitate what he saw as the gigantic scale of a Scandinavian pot that he had seen illustrated. Later, however, he discovered that the pot was a mere six inches in height.

The environment celebrated the individual. There were, however, common qualities that linked an otherwise diverse group of artists. One of the first students, Mac McClain (McCloud) recalls the atmosphere that existed: "It became quickly evident that all of us would be 'sharing a studio' with each involved at their own independent level. Pete radiated an overwhelming individuality, a relaxed and humorous charm, radical creative initiative and an enjoyable mix of down home earthiness and aesthetic brilliance. We were all roughly the same age, part of the Post-World-War II generation of young artists searching for a place to make things."9 The manner in which they handled the clay was looser and more informal than ever before, and there was generally a unifying sense of incompleteness in the seemingly cursory finish of

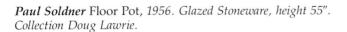

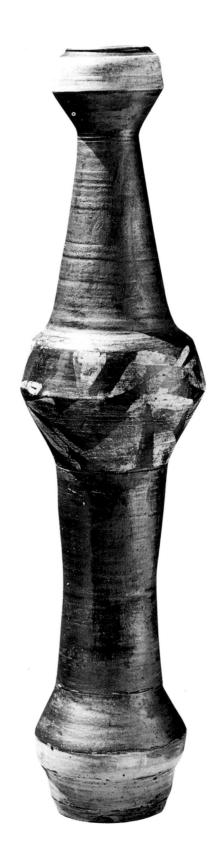

the works. What was taking place was a broadranging experiment that caused the critic Harold Rosenberg to propose that craft represented the ideal in contemporary art—an unfocused play with materials.

In explaining the motivations of the group, the critic John Coplans was later to write that the artists "were totally uninterested in exhibiting. What they needed was time to mature as artists, to seek their own path free from external pressures. The pot, they felt, was no more than an idiom." They were keenly aware of what was taking place in the art world, particularly in San Francisco and New York, but no one in the art world (apart from Rose Slivka, editor of *Craft Horizons*, and Fred Marer, who had collected their work from the outset) was aware of what was taking place, and "this suited their purposes at the time."

The central figure of the decade was undoubtedly Voulkos, but he was not, as recent critics have attempted to suggest, solely responsible for the breakthrough in American ceramics. Voulkos was involved in a dynamic relationship with his stu-

Kenneth Price Plate, 1958. Glazed stoneware, height 11½". Collection Happy Price.

RIGHT: **John Mason** Vase, 1958. Glazed stoneware, height 23³/₄". Marer Collection, Scripps College, Claremont, California.

Malcolm McClain Chamber of Spheres, 1959–60. *Stoneware, height 27*". *Jedermann N. A. Collection*.

dents; Otis's victory was really the victory of a highly competitive environment where the participants functioned as "independent contestants." Ilm Melchert, who had worked with Voulkos since 1958, wrote that working with him gave one the feeling of being onto something big and real:

At the same time it was unforgettably disturbing. To build confidence in your own authority you had to keep surpassing your preconceptions and expectations. Having Voulkos for a teacher was the most demanding situation that I had encountered. To him a person's notion of existing limitations was largely imaginary. He constantly cautioned against underestimating the artist. If the persons working with him broke with the standard conceptions of formal structure they also managed to get around technical obstacles.¹²

Voulkos set an intimidating example, producing fifteen pots to everyone else's one. Frequently he

and the students would work seven days a week, sometimes through the night, firing hundreds of pots a week. Voulkos influenced students by example; if he had any message or doctrine, it was that the artist must first trust intuition:

When you are experimenting on the wheel there are a lot of things you cannot explain. You just say to yourself, "the form will find its way"—it always does. That's what makes it exciting. The minute you begin to feel you understand what you are doing it loses that searching quality. You reach a point where you are no longer concerned with keeping this blob of clay centered on the wheel and up in the air. Your emotions take over and what happens just happens. Pottery has to be more than an exercise in facility—the human element, expression, is usually badly neglected. 13

In the work of Voulkos at Otis, three devel-

Jerry Rothman B, 1957. Ceramic and metal, height 120". Awarded National Prize, Wichita National.

opments emerged. First, by imitating the ceramics of Picasso, Voulkos came to the same realization as the master painter, that the overall painting of the pot surface destroys the sense of three-dimensionality. At the same time, it allows the artist to rebuild the form, using line and color, and so to distribute the climactic aspects of the form. Second, Voulkos began to assemble his vessels with separate elements. Instead of a fluid, compositional unity, the pots became fragmented, as one part competed for attention with the others. Later, Voulkos and Soldner were to remember the exact point at which this breakthrough was made:

Paul Soldner: Do you remember when, probably for the first time, you broke with the symmetry of the bottle? Some good looking girls came in from Chouinard Art School and asked if you would throw a big pot for them. You threw the pot, and they were impressed. I remember you kept looking at the pot. And then after they left you went over and cut the top off. Then you threw four or five spouts and started sticking them around the rim. And that didn't seem to work, because it was still the same old bottle lip. Then you pared that off. The pot was still soft. Then you recentered it on the wheel and gouged three huge definitions, the top third, the center third and the bottom third. In one afternoon you went from one kind of thinking to something completely different.

Peter Voulkos: I remember it.

Paul Soldner: Do you remember the name of the pot?

Peter Voulkos: Yeah, Love Is a Many-Splendored Thing. I showed it at my show at the Felix Landau Gallery in 1956, and it was sold. . . . Pottery at this point began to be noticed by painters and sculptors. ¹⁵

The third development in Voulkos's work at Otis was in his treatment of form. Voulkos began to deal less and less with the pot as volume—a contained space—and more with the pot as mass. The forms were made from almost solid pieces of clay. The traditional components—foot, main form, and neck—remained, but the vessel now became more *sculptural* and constructivist. The claim that Voulkos "turned ceramics into sculpture" is, how-

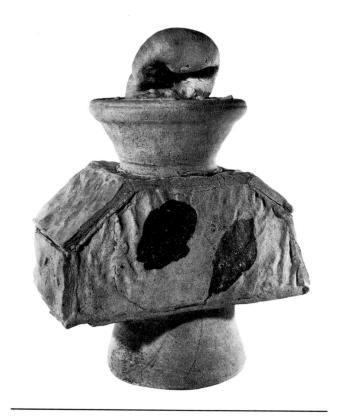

Michael Frimkess Pot, 1959. Earthenware, height 19½." Marer Collection, Scripps College, Claremont, California.

ever, a misconception. For no matter how sculptural his works became, they remained patently part of the tradition of pottery rather than of sculpture. In reviewing the exhibition *Otis Clay—The Revolutionary Years*, the critic Christopher Knight wrote: "While it cannot be denied that a good deal of ceramic work was created with a concern for sculptural values and with an awareness of contemporaneous developments in Abstract Expressionist painting, the 'revolution' which occurred in Otis in the late 1950s is not found in ceramics attempting to mimic the conventions—long held or newly held—of either sculpture or painting. Rather, it was revolution within the tradition of pottery itself." 16

Voulkos also began to produce clay sculptures toward the end of the Otis period and after his move in 1958 to the University of California, Berkeley. Some of his forms have a brooding presence.

Generally speaking, however, this was Voulkos's most uneven and unsuccessful period of work. In 1962 he turned to metal as his sculptural medium.

About 1957 the Otis students began to show a more assertive independence. In many cases their exploration of the medium took them in directions different from that of Voulkos. Kenneth Price concentrated on the play of line and color, deemphasizing mass and even volume as he satirically dealt with the counterpoints of two- and three-dimensionality. This has been a continuing theme in his work. John Mason and Malcolm McClain were more intellectually involved in the medium. Their works from this period are clearly constructivist, usually produced out of carefully placed and even modules. Mason also went through a phase of Abstract Expressionist work, when he

created huge wall pieces by trailing long slabs of clay over one another, in a random manner. But his interests became more and more geometrically formal, as he progressed toward Minimalism and Conceptualism.

Henry Takemoto dealt largely with the pot as a canvas, covering his plates and fecund pot forms with energetic calligraphic drawing that was loosely inspired by the work of Miró. Billy Al Bengston worked for a while as the technical assistant to Voulkos, signing his work "Moondog." He did not graduate much beyond the level of inspired dabbler, and his involvement was short-lived and ended when he left ceramics to become a successful painter. Paul Soldner remained a functional potter; Michael Frimkess dealt with the material in an iconographic manner; and Jerry Rothman, the

Harrison McIntosh Bottle Vase, c. 1959. Glazed stoneware, height 13½". Everson Museum of Art, Syracuse, New York. Purchase, twenty-first Ceramic National.

LEFT: **Karen Karnes** Demitasse Set, c. 1958. Glazed stoneware, coffee pot, height 8½". Everson Museum of Art, Syracuse, New York. Purchase, twentieth Ceramic National.

maverick of the group, flirted at first with Constructivism, creating twelve-foot-high clay and metal sculptures for the Ferus Gallery in 1958. Thereafter, he moved on to more expressionist works, such as his serenely sensual *Sky Pots* of the early sixties.

What took place at Otis was by any standard a major event. The students in that group have gone on to become the leading artists, teachers, and designers in ceramics today. But the momentum did not stop at Otis. In Berkeley a new group assembled around Voulkos—Ron Nagle, Jim Melchert, Stephen DeStaebler, and others—giving rise to a body of strong sculpture in the 1960s and some interesting refinements of the vessel aesthetic. The activities attracted visitors, notably Manuel Neri, who had been working sporadically in clay since 1954, when he had first come in contact with

Voulkos at Archie Bray; and Harold Paris, who worked on mammoth ceramic walls. The peak of the so-called Abstract Expressionist development came between 1957 and 1960. Later developments were to lead away from abstract concerns to figurative imagery, but the effect of the early years of the experiment, as Coplans has noted, has been "to totally revolutionize the approach to ceramics. . . . What was done in those days is now mainstream ceramics."

On the East Coast and in the Midwest, a quieter revolution was taking place. The seeds planted there in the 1950s took a longer time to grow, but the achievements of this time should not be discounted. Alfred University was for the first time producing students with an adventurous approach to their material. Most remained respectful of the functional disciplines of the art but thrived within its limitations, producing a generation of strong potters: Bob Turner, Karen Karnes, Val Cushing, Ken Ferguson. Other students were more experimental. David Weinrib began to produce structured slab pots before moving into a successful career as an internationally known sculptor. Daniel Rhodes developed techniques of combining fiberglass and clay to create sculptural forms that had previously been technically impossible. Rhodes was also to be one of the most influential educators of the post-World War II period through his series of books on clays, glazes, kilns, and recently, potter's form.

Black Mountain College, near Asheville, North Carolina, a progressive community that included at various times such diverse figures as Josef Albers, Clement Greenberg, and Robert Rauschenberg, was a magnet for the Alfred artists. Robert Turner worked there in 1952, building an immaculate and imaginative pottery. When he left, he was replaced by Karen Karnes and her husband, David Weinrib. Their reception was hostile. The dominant radical element in the school looked upon "the crafts" as being insupportably bourgeois. Weinrib was at least experimental, but the down-to-earth functional ware of Karnes was adjudged "not real or grubby

Leza McVey Ceramic Forms, 1950. Glazed stoneware, height 16" and 103/s". Everson Museum of Art, Syracuse, New York. Gift of Harshaw Chemical Company, sixteenth Ceramic National.

TOP: *Maria and Popovi Martinez* Bowl with Feather Design, 1956. Burnished earthenware, diameter 12½. American Craft Museum, New York. Gift of Johnson Wax.

BOTTOM: Maija Grotell Bowl, 1956. Glazed stoneware, height 14". Syracuse University, Syracuse, New York.

enough," and above all she committed the cardinal sin of "actually selling in commercial outlets." 18 On one occasion, the students demonstrated their dislike of the pottery by piling dinner scraps on Karnes's pots. But after the ten-day International Ceramics Symposium at Black Mountain in 1953, with Bernard Leach, Shoji Hamada, Soetsu Yanagi, and the host, Marguerite Wildenhain, the community began to reassess the pottery. At the symposium held in the following year, the embattled resident potters were given official billing with Rhodes and Warren MacKenzie, one of the most influential of Leach's American apprentices. Weinrib recalled that the community finally saw the pottery as a "measurable" achievement and that the more conservative members began to question the depth of students who became "too instantly hip" on reading Rimbaud and Proust, welcoming the potters' contrasting practicality as a counter to the overly libertine elements of the school.19

What took place at Black Mountain was a

dramatization of what was happening throughout the country. A popular interest in the medium was resulting in the introduction of ceramics programs in art schools, colleges, and universities. The medium, however, was not accepted by the influential postmodernists, who were beginning to take over the academic art institutions and devalue the importance of both craft and object. Furthermore, ceramics still carried the aura of being a tool of art education, and critics and media found it difficult to treat ceramics as a serious medium. Those in the Otis group, for instance, found that once they attempted to engage an audience with their work they were arbitrarily consigned "to what they considered to be a twilight world, that of the crafts, which caused considerable misgivings, even anguish."20 In the decade that followed, the most determined assault on the boundaries of fine arts took place, during which the American ceramist was finally to establish an artistic beachhead for the medium.

FAR LEFT: **Frans Wildenhain** Coffee Service, 1951. Stoneware, height 8". Private collection.

TOP LEFT: **Toshiko Takaezu** Bottle, 1958. Stoneware, glazed, height 13½". The Detroit Institute of Arts. Winner of the Founders Society Purchase Prize of Michigan Artist-Craftsmen Exhibition, 1958.

BOTTOM LEFT: **Rudolf Staffel** Oval Bowl, 1951. Glazed earthenware, height 8". Los Angeles County Museum of Art. Gift of Howard and Gwen Laurie Smits.

BELOW: **Beatrice Wood** Three bowls, 1958–60. Luster-glazed earthenware, height $7^{1}/8^{n}$, $3^{3}/4^{n}$, 6". Private collection.

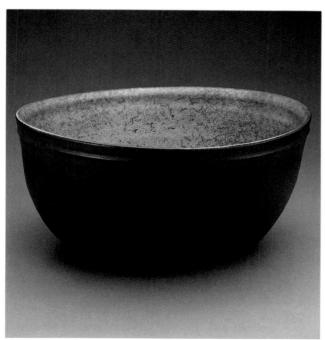

Peter Voulkos Bottle, 1961. Thrown and altered stoneware, glazed, height 18". Collection Mr. and Mrs. Monte Factor.

The sixties was the second decade of revolution for American ceramics. Whereas the previous decade had established a new vision for the vessel in contemporary art, the sixties would prove to be the most

formative period for ceramic sculpture. In this decade we see the emergence of the Funk movement, which would dominate ceramic sculpture into the seventies, and also the beginnings of a high-crafted, trompe l'oeil style of still life/object making that I have entitled the "Super-Object." Most of this activity took place in San Francisco and in the adjoining Bay Area. Seattle was the center for a similar movement in painted ceramic sculpture, while in Los Angeles a quieter and less strident change took place, within the region's socalled fetish-finish style in painting and sculpture. The East Coast continued to produce strong work during this period, but it did not contribute meaningfully to the innovative thrust of the medium. Rather, it was the West Coast (California and Washington State) that dominated this decade.

Before a discussion of these new movements, it is necessary to examine the impact of Voulkos and the Otis school during the early 1960s. Up until this point knowledge of the work being done by Voulkos and his followers in Los Angeles and later at Berkeley was limited to the immediate sphere of the participants. Some work had been seen around the country, but the full consequence of what was taking place had not yet been appreciated. It was Rose Slivka's article in the July–August 1961 issue of *Craft Horizons*, titled "The New Ceramic Presence," that brought the new aesthetic into the national forum.

Slivka had been in contact with Voulkos and his students since 1958 and had, in turn, introduced Voulkos to her friends in New York, including Willem de Kooning and others of the New York school. Her article caused a furor, despite her having taken great pains to be nonpartisan and to present as merely *one* approach to the medium the works of Voulkos, Mason, Takemoto, Rothman, and a young

CHAPTER NINE

1960

potter named Robert Arneson. The largely conservative membership of the magazine's parent, today called the American Craft Council, felt confused, angered, and threatened. A debate opened as letters poured

in, and it continued for some years. In the long run, the reaction proved to be a healthy one, as the ceramics community began to question and to reject its own entrenched criteria.

Slivka wrote the article from a painterly rather than from a ceramic viewpoint. Thus, while she acknowledged the importance of Japanese pottery for these artists, she did not explore the depth of its influence. What she did not understand was that the primary experience for the potter of the 1950s had been the recognition of the complexity of the Japanese ceramic aesthetic. The pouring of colored pigments one over another, gestural painting, a random use of color, and pure abstraction developments new to painting-had been consciously explored in a highly sophisticated manner by Japanese potters for centuries. Abstract Expressionism modified the experience of Japanese pottery and gave it a new contemporary context. For the first time in the twentieth century, ceramic tradition and the fine-arts mainstream were involved in parallel ideas and sensibilities.

One of the most insightful comments in Slivka's article had nothing to do with painting—it was Slivka's linking of the new ceramics with jazz, thereby implying the greater importance of the act of making the object than of the object itself. Until the 1950s potters had tended to observe the European approach that viewed process simply as means. In jazz, means and end become one:

Spontaneity, as the creative manifestation of this intimate knowledge of tools and their use on materials in the pursuit of art, has been dramatically an American identity in the art of jazz, the one medium that was born here. Always seeking to break through unexpected patterns, the jazzman makes it while he is playing it. With superb mastery of his instrument and intimate identification with it, the

instrumentalist creates at the same time as he performs; the entire process is there for the listener to hear—he witnesses the acts of creation at the time when they are happening and shares with the performer the elation of the creative act.¹

A second explanation of the changes wrought during the 1950s came in 1966, when John Coplans, an art critic who had been pioneering the importance of contemporary ceramics for some years, organized the exhibition *Abstract Expressionist Ceramics* at the Art Gallery of the University of California, Irvine. The exhibition was one of the most important single events in American ceramics history, bringing the ceramics "revolution" to a broader audience than before and, to some extent, legitimizing the body of work within the art world. For numerous ceramists working today it was a turning point in their careers, introducing a new and more challenging vocabulary for ceramics in general and for the vessel in particular.

The selection of works was excellent, pinpointing some of the early masterpieces by Voulkos and his group. What was assembled, however, was not Abstract Expressionist ceramics, but for the first time it was identifiably American. The exhibition catalogue was in great demand and ran to three printings. Coplans's catalogue essay is one of the more important statements in contemporary American ceramics. But, in common with Slivka's earlier article, it viewed the work as an experiment in painting—"the most ingenious regional adaptation of . . . Abstract Expressionism . . . yet" rather than as an independent achievement of a distinct and different discipline—ceramics.2 Furthermore, the links with Abstract Expressionism were hardly strong enough to justify the title, since Constructivism was patently a more central influence for many works in the exhibition. Even Coplans later admitted that the title was not an effective umbrella, but that "it seemed convenient at the time."3

The collector Fred Marer was involved with the project from the beginning, having literally stumbled into the pottery at Otis soon after Voulkos's arrival. Marer was fascinated with the group and became its earliest supporter, patron, and collector. Marer feels that the Abstract Expressionist element has consistently been overexploited and overromanticized. Apart from other considerations, there was an underlying element of figurative expression that was freely explored at Otis. Even when Voulkos began to reject the figure about 1957, it proved difficult to exclude. In a letter to the author in January 1977, Marer commented, "I watched Voulkos making his six-seven feet high sculptures, fighting desperately to subdue the figurative formations that seemed to creep out." Interestingly, although Voulkos first met with some of the major figures of the New York school in 1953, there is no mention of any influence from this group until after his 1958 visit to New York, by which time his signature style had already emerged.

Another exhibition, titled Funk Art and held at the University of California, Berkeley, in 1967, pinpointed a major new energy and direction. Organized by Peter Selz, the exhibition contained objects in every medium, but it was the clay objects that seemed closest to the aesthetic Selz suggested in his catalogue essay. In fact, the exhibition proved to be far less a definition of Funk than a survey of West Coast art that lacked stylistic labels (the cool egg forms of Kenneth Price and the clean polychrome metal sculptures of Robert Hudson clearly did not belong to the title). The exhibition was nonetheless extremely important, drawing attention to broad Funk concerns in art and providing a showcase for some of the ceramic talents in this area—David Gilhooly, Robert Arneson, and others.

Harold Paris, in an article titled "Sweet Land of Funk," had earlier pinpointed the context out of which the "style" had grown. It was less an identifiably visual expression than an attitude. Each artist interpreted it in a different manner, but when Bay Area artists spoke of Funk, each knew what the other meant. Funk was, in a sense, protest (unspecific) coming out of a feeling (equally unspecific) of being betrayed by traditional forms

and ideas in society: "Artists of the current generation have turned inward. Rejecting collective ideas and moral judgment they are hypersensitive to their own elemental feelings and processes. What is felt is real and tangible; what is thought to be is distrusted. Intuitive perception is desirable. The residue, or the by-product, is more interesting and provocative than the intellectual process that creates it. In essence, 'It's a groove to stick your finger down your throat and see what comes up,' this is funk."

Funk originated with the Rat Bastard Protective Association, a group of artists who in 1951 mounted the exhibition *Common Art Accumulations*, at the Place Bar in San Francisco. Bruce Conner, Joan Brown, and others put together ephemeral conglomerations combining all kinds of uncombinable things, "called them Funk and didn't care what happened to them." The term "Funk" was taken from the term "bagless funk," describing a free, improvised, earthy street jazz and also used in Cajun patois to describe the musk smell of a woman's groin.

On the West Coast, the early Funk art had its roots in Dada and Surrealism. The artists were drawn to the blend of insouciance, poetic juxtaposition of found or common objects, and rejection of establishment values in the fine arts. More importantly, Dada and Surrealist objects proposed a new type of sculpture, the "art object." Marcel Duchamp's readymade The Fountain (1917), a urinal signed by R. Mutt; Man Ray's Gift (1921), an iron with nails attached to the flat surface; and later, Meret Oppenheim's fur-lined teacup and Salvador Dalí's lobster telephone from the exposition *Objets* Surréalistes at the Galerie Charles Ratton, Paris, in 1936, all have one thing in common. Unlike traditional or even most modernist sculpture, which is primarily concerned with form, these objects are equally involved with context. The judgment of good or bad form becomes suspended by the provocative and contextual elements in the art object. Even the participants in the Dada-Surrealist movement agreed that their objects were "Objects of Symbolic function. . . . They depend solely upon our amorous imagination and are extra plastic."⁶ The use of found objects and their composition caused a growing involvement with concepts of collage, where "the very conditions of the activity forced the artist to make decisions of a purely pictorial order."⁷ As a result, much of ceramic Funk art has tended toward a type of three-dimensional illustration.

Funk continued in spirit through the 1960s at the ceramic department of the University of California at Davis. There, under the leadership of Robert Arneson, a group of students began to explore Funk as an alternative both to the cool,

Robert Arneson No Return, 1961. Glazed ceramic, height 10³/₄". Collection Mr. and Mrs. Paul C. Mills.

mannered Pop art and to the so-called Abstract Expressionist ceramics. The latter were then already considered passé by the younger students, who derogatorily referred to them as "the blood-andguts school." In the mid-sixties Davis produced a body of Funk work that Suzanne Foley described as "expressionist, surrealist and offensive."

The Davis faculty attracted individualists; in addition to Arneson, Wayne Thiebaud, William T. Wiley, Manuel Neri, and Roy De Forest taught there. The art department was established in the early 1960s. Therefore there was, in the words of Arneson, "no academic hierarchy... no worshipful old-timers whose word was law. There was no academic infighting. Above all, there was no one to say this is the right way, that is the wrong way, and everybody could work as they saw fit."

Arneson's radicalism had begun to surface long before he joined the Davis faculty. At the California State Fair in the summer of 1961, he had placed a ceramic cap on a "handsomely thrown" bottle and marked it "no return." Until then Arneson had been a potter, making vessels and winning prizes at decorative-art shows such as the Wichita National.

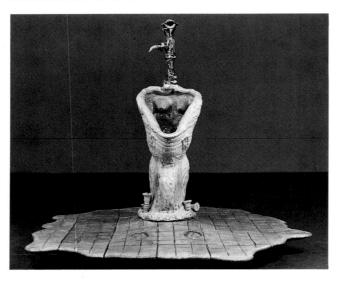

Robert Arneson Herinal, 1965. Glazed earthenware with colored epoxy, height 25½". Private collection. Courtesy Fuller Goldeen Gallery, San Francisco.

The gesture was not unlike that of Jasper Johns a year earlier, when—in response to Willem de Kooning's remark that Leo Castelli could sell anything, even beer cans—he had made a bronze out of two Ballantine ale cans, titling it *Painted Bronze* (*Ale Cans*).

In his catalogue of Arneson's 1986 retrospective, Neal Benezra describes this moment at the State Fair as the beginning of Arneson's "estrangement" from the ceramic establishment. But, on the contrary, No Return signaled one of the first salvos in a palace revolution that would place a new California elite in control of American ceramics and Arneson firmly entrenched as the doyen of ceramic sculpture. Arneson's stance vis-à-vis the ceramics world was not "revulsion," as Benezra states, but "ambivalence."

It took another two years before the gesture in *No Return* was to be matched. In 1963 Arneson was invited to participate in the exhibition *California Sculpture*, which took place on the roof of the Kaiser Center in Oakland. Curated by Walter Hopps, Paul Mills, and John Coplans, the exhibition included thirty-two sculptors, including Voulkos, Mason, Edward Kienholz, Simon Rodia, and others. This was the final break for Arneson with both traditional ceramics and with his play with organic, Prieto-esque, Miró-esque sculpture:

I could see myself, Bob Arneson, between John Mason and Peter Voulkos and would I just be the junior version of those two? I really put my mind together and reflected back on my heritage as a ceramist—somebody who dealt in reproduction. I really thought about the ultimate ceramics in Western culture . . . so I made a toilet and cut loose and let every scatological notation in my mind freely flow across the surface of that toilet.¹²

The finished piece was, in the artist's opinion, his first mature work. He had finally "made a Bob Arneson." Entitled *Funk John*, the piece remained on exhibition for one day, after which a Kaiser Center official, offended by both the subject and its "ceramic emblems" of excrement, had the work removed. In a sense, the gesture was a reenactment

of Duchamp's placement of *The Fountain* in the 1917 Indépendants Salon. While the sensibility of the two artists was totally different, their determination to declare independence and to provoke a cause célèbre was indeed similar.

An important change in *Funk John* was the move from stoneware, a clay body that was de rigueur for the Abstract Expressionist, to whiteware, a white earthernware associated with hobbyists and industry. Jim Melchert and Ron Nagle had begun to work intermittently with whiteware at the San Francisco Art Institute in 1961, experimenting with bright, low-fire glazes and later with photographic decals. This provided Arneson with a neutral white ground to paint and removed any of the rustic, "truth to materials" romance from his work.

During the next two years Arneson produced additional works in the *John* series: *John with Art* (1964) and the anthropomorphic and deliciously vulgar work *Herinal* (1965). At the same time a new style was emerging. It was nourished, like that associated with Otis, by the loose, unstructured teaching environment at Davis, which promoted student-teacher interaction. In the fall of 1966, an important exhibition took place at the San Francisco gallery of the American Craft Council. Arneson exhibited alongside seven of his undergraduates: Margaret Dodd, David Gilhooly, Stephen Kaltenbach, Richard Shaw, Peter Vandenberge, Chris Unterseher, and Gerald Walburg.

Arneson's work from the mid-1960s can be seen in two periods. In the first stage he was, in the words of Dennis Adrian, "a fringe Pop Gangster." His early objects from the mid-1960s have become classics but are not his most important works. These early objects—such as the group of eight Seven-up bottles; *Toasties* (1965); *Typewriter* (1966), with red-lacquered fingernails replacing the keys; and the visual puns in *Call Girl* (1967), a telephone with breasts—are amusing and seditious, but they are less confrontational today than they were at the time of their first exhibition. These works are important historically, however, for they

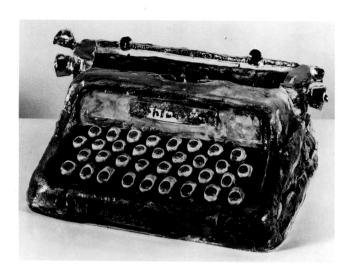

Robert Arneson Typewriter, 1966. Glazed earthenware, length 12". Courtesy Allan Stone Gallery, New York.

show the manner in which the early ceramic Funk artists were working out of a Dadaesque inversion of Pop art. The icons were common to both—typewriters, toilets, canned foods. The difference between the two is a matter of degree rather than kind. Peter Plagens succinctly defined it as the dirty and the clean. Pop reflected the clean: cool, lobotomized images, as in Claes Oldenburg's soft toilets. In Arneson's *John* series, in contrast, the toilets were made out of genitals and were left splendidly unflushed.

In 1967–68 a new phase of Arneson's work began to emerge. His pieces were now less art objects à la Dada and more sculptural. His seminal work *Alice House Wall* (1967), made up of modules, was particularly important in Arneson's growth as a sculptor. It allowed him to work on a larger scale, culminating in works such as *Fragments of Western Civilization* (1972), *Swimming Pool* (1977), and *Mountain and Lake* (1978).

The growth of the verbal-visual in Arneson's work became more considered and less of a one-liner. The wordplay with objects began early in Arneson's work. Among his students, such as Gilhooly, it has continued and spread into non-Funk art, becoming one of the identifying characteristics

of contemporary object making in American ceramics. At its best, Arneson's use of the pun evokes a complex and often emotional response from the viewer. In a penetrating study of Arneson's work, Dennis Adrian emphasizes this aspect:

The catch is of course that to an English/speaking/thinking audience, the pun is usually interpreted as simplistically humorous on a fairly low level, so statements of double meaning in art—as elsewhere—tend to elicit giggles, and not much more. Yet as any scholar of Joyce or Japanese poetry will wearily insist, the primary function of any kind of pun is the expansion of meaning, within discrete form, into at least two simultaneous modes of thought. This is the key to a large area of art which concerns itself seriously with the truly comic; but, because of the fluky nature of the pun in English, intrepretation in that language frequently thrusts aside or misconstrues such art as ignoble.¹⁵

Apart from a distinguishing use of humorous titles and images among the Funk artists, there is also a common approach to the material. When Alfred Frankenstein said that Arneson had gone one better than Dada, that he had produced the "ready-made home-made," 16 he touched the essence of the Funk aesthetic. The sloppy use of the material was carefully sustained, linking the objects with the hobby-craft aesthetic of thick, oozing, and virulently colored glazes over complacent whiteware. In this sense the Funk ceramists shared another similarity with the Pop artists: both used craft techniques that were considered outside the boundaries of high art—Pop art drew from commercial art and poster painting, and Funk from the hobbyist. Arneson's realization of this quality in the work is substantiated by his bumper sticker, "Ceramics is the world's most fascinating hobby," and by the works that play on simplistic pottery making, such as Pottery Lessons (1967) and How to Make the Big Dish Plate (1967).

The Funk artists were also shamelessly eclectic, drawing from many sources and changing directions and subject matter from one exhibition to the next. This catholicism is evident in Gilhooly's frog-world misanthropy. Gilhooly began by pro-

ducing facetious animal-related objects, such as the *Elephant Ottoman* (1966), but, influenced by Maija Peeples, turned to frogs. Gilhooly's invented culture has allowed him a platform from which to playfully satirize all society and particularly its art.

The last of the Funk artists to be discussed here is Clayton Bailey. Bailey is ceramics' most insistent raconteur. His aesthetic credo can be summed up simply from a statement he once made about his work: "Anyone can do things in poor taste—it takes an artist to be truly gross."17 Certainly the critics agree that Bailey is beyond poor taste. In his article for the March 1970 issue of Art and Artists, David Zack called his work "as gross and phallic as a draught horse's mating equipment." It is a measure of his anarchistic approach that Bailey most treasures reviews that denigrate his work. One of his favorite and most quoted reviews came from Cynthia Barlow, a reviewer for the Saint Louis Globe Democrat, who denounced his exhibition at the Craft Alliance Gallery as "a show that is tasteless, obscene and barely above the level of bathroom humor. Dismembered and disfigured fingers, lips and other portions of the human anatomy make up a large part of the objects presented. Even the titles are unpleasant—Nite Pot, Kissing Pot. The pieces are crudely done, carefully painted to the point of lewdity."18

Bailey's works, Arneson's penis teapots and genital trophies, Gilhooly's frogs fornicating with vegetables, and—outside the Bay Area school the phallic cameras of Fred Bauer constitute the second exorcism for American ceramics. More irreverent than the Otis group and its assault on the vessel, they dealt with the preciousness of the figurative ceramic objects. They broke completely with the role of the ceramist as the producer of tasteful, overly crafted bric-a-brac for middle-class sideboards and mantelpieces. Until then the ceramist had been associated with the conceited and refined court figurines from eighteenth-century Europe; the sentimental figures of Royal Copenhagen; the highly priced limited-edition porcelains of Boehm and Cybis; and, by contrast, the vulgar,

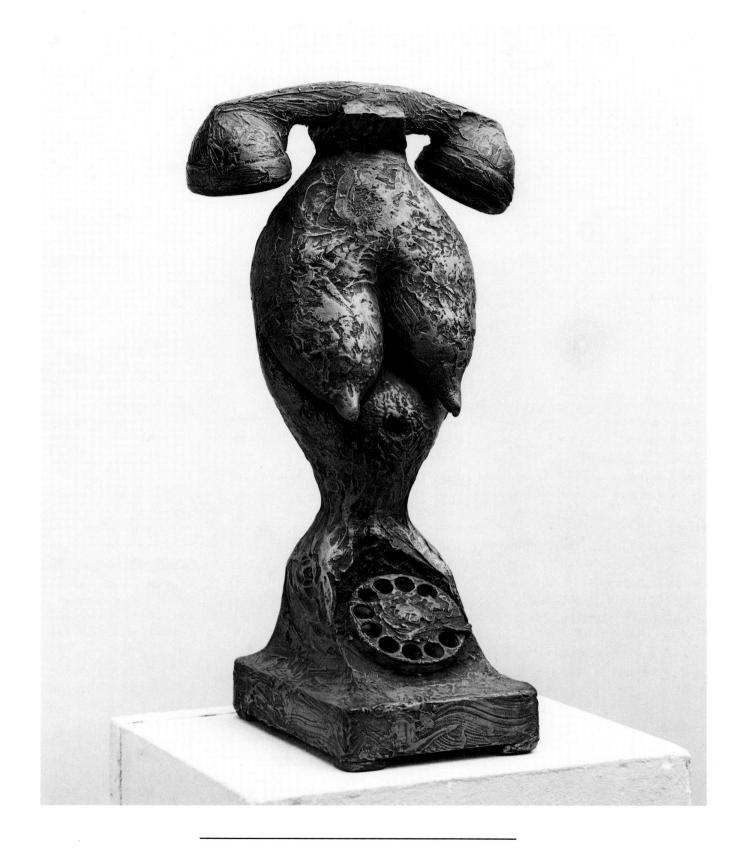

Robert Arneson Call Girl, 1967. Glazed earthenware and sculp-metal, height 18". Collection Diana Fuller. Courtesy Fuller Goldeen Gallery, San Francisco.

Kenneth Price M. Green, 1961. Lacquer and acrylic on stoneware, height 10". Collection Betty Asher.

mass-produced ornaments of the gift shops, with their gilding and lace draping.

The impact of the Funk movement was considerable, but ceramics students misunderstood the complex cultural statement that was developing. Funk was imitated mindlessly throughout the United States and even in Scandinavia and in England (particularly at the Wolverhampton Polytechnic, which became the center for the peculiarly English style of "gentlemanly Funk"). Funk became the ceramic buzzword. It seemed that overnight everything was Funk: colors, glazes, images, attitudes. But by 1975, as suddenly as it had become vogue, the Funk movement had fizzled out, leaving behind an embarrassing surfeit of objects that were vulgar, banal, and formless. In retrospect, only a small cadre of artists had produced credible work by 1975; most progressed to a more mature expression in which Funk was not the "style" but only an element. Within the space of fifteen years, it had moved from being avant-garde to a dated, "historical" style. Yet it had served its purpose as a purgative, flushing out the last vestiges of formalism in ceramics and adding the second indigenous "school" to the American mainstream of ceramic art within a decade.

The protest inherent in Funk ceramics was by no means an isolated activity, unique to the medium. It was taking place close to the Haight-Ashbury district of San Francisco, the spiritual center of the Hippie movement. Draft dodgers were burning their draft cards, feminists were burning their bras. America's youth was "dropping out" of society and rejecting its parents' values and life-styles. In this context it seems appropriate that the Bay Area ceramists should so rudely have turned their backs on the expectations of ceramics as a refined, nonrevolutionary and bourgeois art form.

The true ceramic Funk was never transplanted outside the Bay Area, where those who succeeded in applying the style all lived. Funk, therefore, grew very much out of regional energies and concerns. In describing Funk, the artist Harold Paris emphasized this regionalism: "The casual insincere, irreverent California atmosphere with its absurd elements—weather, clothes, skinny-dipping, hobby craft, sun drenched metality, Doggie Diner, perfumed toilet tissue, do-it-yourself—all this drives the artist's vision inward. This is the land of Funk." 19

In contrast to the "dirty" aspect of Funk, the art of the clean was growing apace. In the early sixties this was centered primarily in the Los Angeles area and in what was termed the "fetishfinish" style. This was not a single style so much as it was a sensibility that the Los Angeles artists seemed to share. Gradually a taste began to grow in Los Angeles for finely crafted art as a counterpoint to both the rawness of Funk and the macho casualness of the Abstract Expressionists. This can be seen in the ceramics of Kenneth Price, the elegant Minimalism of Robert Irwin, Ron Davis's linoleum-like splatter paintings, Craig Kauffman's

serene Plexiglas works, and Bengston's meticulous air-brushed paintings. Price's biomorphic egg forms from the early 1960s placed him among the leaders of this group. Unlike the work in the Bay Area, which was authentically regional, Price's sculpture showed a debt to European abstractionists—in particular the biomorphism of Jean Arp. It was immaculately crafted, with a purist use of form, line, and acidic colors. "Like the geometric redness of the Black Widow's belly or the burning rings of the Coral snake," Henry Hopkins wrote, "these objects proclaim their intent to survive." 20

John Mason moved away from his earlier involvement with pottery and turned to sculpture, working on a memorable series of monoliths that were up to six feet in height. The first and most successful of these were produced in 1962–63. They were heroic and moving. Mason then worked in a Minimalist format, building up geometric, hard-edged forms with what were intended to be flat, monochrome-glazed surfaces. Elaborate systems of drying the large forms were devised, but, despite the care, the forms warped and cracked, and colors flowed into a rich and busy surface. These and the earlier sculptures were shown in

1966 at the Los Angeles County Museum of Art, proving that the modernist ethos (with slight modification for the clay medium) could be successfully expressed in ceramics. In addition, Mason was working on a series of masterful walls that revealed the formal modularity that in the 1970s was to take him inevitably into Conceptual sculpture and installations of fire brick.

The work of Michael Frimkess from the late 1960s reflects a similar approach. Working in Venice, California, he threw incredibly thin forms that were readily identifiable as cultural "stereotypes": Chinese ginger jars, Greek amphorae, Zuñi bowls. He then covered these with tight, linear, cartoon drawings that dealt with the artist's visions of a utopian society. Although they were different from most of the art of Los Angeles because they dealt with "issues" and not abstraction, in terms of their execution they were nonetheless part of an emerging "look" in the city's art.

Jerry Rothman worked at the same time to

John Mason Wall X, 1965. Ceramic, length 14½'. Courtesy the artist.

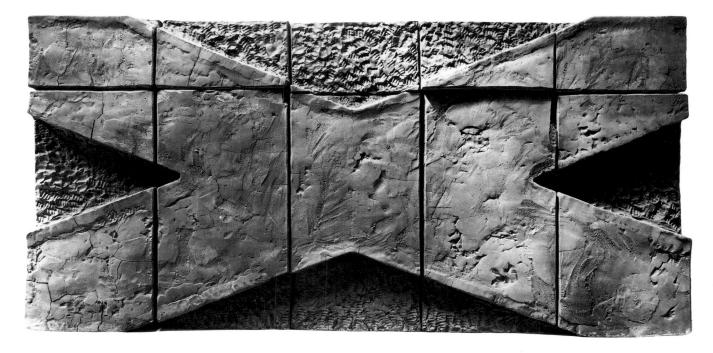

enlarge the scope of the material and overcome the limitations of ceramics that made it unsuitable for the sculptural ambitions of the time. However, Rothman, always the maverick, worked very much outside the ruling style of Los Angeles art. He began to assemble huge triptychs consisting of very erotic figures and dealing with birth and other issues that understandably caused problems in the arena of public art. On one occasion, a 1974 exhibition of his work at the Oakland Museum was removed because of a public outcry over the subject matter.

The sixties also saw the creation of another aesthetic in Los Angeles ceramics, tied to the fetishfinish school but, at the same time, more closely tied to traditional ceramics. It came out of the Chouinard Art Institute, under the chairmanship in 1963–72 of one of its graduates, Ralph Bacerra.

Howard Kottler Bunny Hop Pot, 1969–70. Earthenware with decals, glaze, and overglaze luster, height 21". Collection Daniel Jacobs.

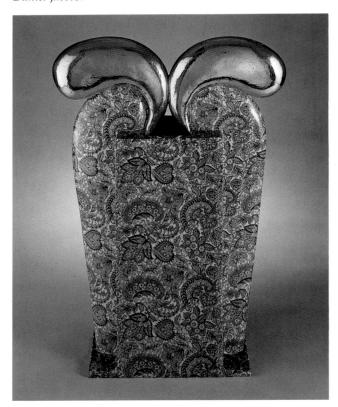

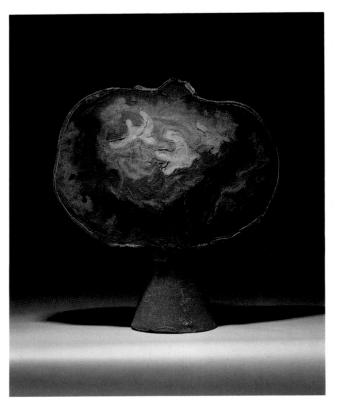

Jerry Rothman Sky Pot, 1960. Sand-glazed stoneware, thrown and slabbed forms, altered and assembled, height 29". Marer Collection, Scripps College, Claremont, California.

At Chouinard the training was more formalized and more rooted in technique than at Otis. But, given Bacerra's passion for technical virtuosity, this took on a lively quality, and technique began to emerge in this group as an "edge" to be pushed to the point that it became content in itself. The impact of the group would not be strongly felt until the late seventies and early eighties, when Bacerra's pupils—Adrian Saxe, Mineo Mizuno, Peter Shire, Elsa Rady, and Don Pilcher-would emerge as an important group of artists. These artists began to exhibit their work more extensively during the mid-1970s, particularly through the American Hand in Washington. In the 1980s the Jan Turner Gallery in Los Angeles would also begin to exhibit the work of Rady, Mizuno, and Shire. Early in the sixties, the dominant style at Chouinard was what is termed "brown bread pottery"—rustic,

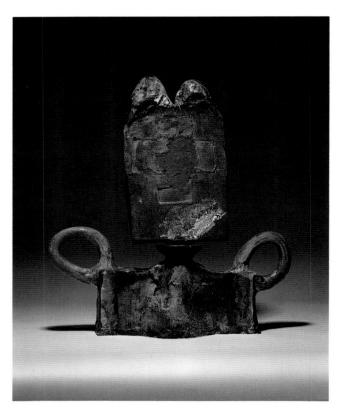

Ron Nagle Bottle with Stopper, 1960. Earthenware with glaze and china paint, height 23¹/₄". Marer Collection, Scripps College, Claremont, California.

functional wares. But by the end of the decade, all of the Chouinard "school" was beginning to experiment with color, decorative systems, and cultural contexts.

Ron Nagle, a developing artist in the Bay Area, was strongly influenced by Price and by the Los Angeles art scene in general, finding himself temperamentally removed from what he disdainfully labeled "the banana hand" school of figurative painting in the Bay Area and the "yuk-yuk" ceramics of verbal/visual gags in the Funk movement. Nagle was excited to find Price "making these little Grandma wares with bright colors on them . . . a little goofier, a little less macho—totally left field," with a different aesthetic, the whole "finish-fetish intimate-object-oriented thing." 21

Nagle's interest in china painting was influenced by his mother, who had been involved in

the technique, and by photo-decal decoration. At first, Nagle used china paints to introduce elements of bright color into his palette in such works as Bottle with Stopper (1960), one of the ceramic masterpieces of the decade. But later, when he and Melchert introduced whiteware to the ceramics department at the San Francisco Art Institute, he began to explore the possibilities of china paints in a more intense and innovative manner. He built rich, layered surfaces by firing layer after layer of china paints onto his vessels. He was inspired to some extent by the abstraction and jewel-like palette of Japanese Momoyama wares. At an early point, he adopted the cup as a vehicle for his work, following the example of Price's long fascination with this form. Nagle first exhibited his cups in 1963 in Works in Clay by Six Artists (Jim Melchert, Manuel Neri, Anne Stockton, Ricardo Gomez, and

Michael Frimkess Covered Jar, 1968. Glazed ceramic with china paint, height 23³/₄". Marer Collection, Scripps College, Claremont, California.

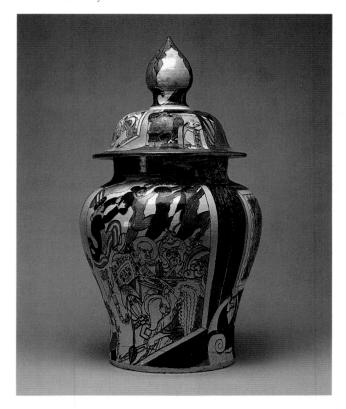

Stephen DeStaebler) at the San Francisco Art Institute.²²

This exhibition proved to be significant because it provided the first view of the mature work of Jim Melchert. In 1964 Melchert held a one-man show, *Ghostwares*, at the Hansen Fuller Gallery in San Francisco. By this date Melchert had changed from the stoneware of 1962 (such as his seminal *Legpots*) to molded, figurative, china-painted whitewares. His use of these materials became increasingly refined, culminating in his *Games* series and *a* series. Melchert provided a valuable balance in the mix of Bay Area ceramists, being one of the few who, despite the lush and rich ceramic surfaces, was primarily analytical and conceptual in his approach.

In September 1965 the exhibition *New Ceramic Forms*, which was held at the Museum of Contemporary Crafts in New York, finally acknowledged the new thrust in ceramics. All the objects on exhibition came from the whiteware, china-painted tradition.²³ At first, the polarities of the "school" were indistinct and the division of dirty and clean was less apparent. But from 1966 on, a new finesse

was established, as a group of artists began to exhibit pristine, immaculate craftmanship. An early masterwork in this genre is Richard Shaw's *Ocean Liner Sinking into a Sofa* (1966), from his *Sofa* series. This high-craft approach, belonging to the Super-Object tradition in ceramics, now began to grow rapidly, with a Surrealist base for its imagery. The Bay Area dominated for some time, but many others were also working in this style: Jack Earl in Toledo, Ohio; Victor Spinski and Ka-Kwong Hui in New York. Although Hui worked with abstract form, the accent on refinement, the touch of preciousness, and the hard-edged painting were nonetheless in harmony with the Super-Object's high-craft aesthetic.

In 1966 Hui collaborated with the Pop artist Roy Lichtenstein and assembled a body of work—piles of cups, teapots, and molded heads—that was exhibited at the Leo Castelli Gallery in New York. These works, much like the Super-Objects that were developed elsewhere, were consciously dealing with interaction between the reality of the three-dimensional form and the illusion of painting; Lichtenstein was interested "in putting two di-

mensional symbols on a three dimensional object."²⁴ More broadly, Lichtenstein's aesthetic credo is very much a summary of that of the Super-Object makers: "Lichtenstein conceals the process from an object to art . . . disguising the genuine aesthetic concern in apparent anti-sensibility and his painstaking craftmanship in the appearance of mass-production."²⁵

At the same time that Lichtenstein was showing his assembled cup sculptures and benday-dot-decorated mannequin heads, another exhibition, *The Object Transformed*, was taking place at the Museum of Modern Art, New York. The show emphasized the growing interest in the art object as an alternative to either painting or sculpture. Mildred Constantine, the exhibition's organizer, welcomed the art object as "the new still life of the twentieth century." In a review of the exhibition, Alice Adams wrote that, unlike the still lifes of Cézanne, Picasso, and Braque, where the object becomes universalized through successive analysis, the transformed object is unique and personal in concept:

Objects from the environment, things that were made for specific use, have now entered a realm of artist's media. Along with the altering of images through collage has come the actual disassemblage, shrouding, melting down or otherwise altering ordinary objects so that they resolidify into another form. Usually retaining a ghost of the original, their transformation forces a parallel change in the observer's preconceived notion of what he knows. The world of dreams and fantasies congeals before his eyes, and he must deal with it as reality.²⁶

A second school of ceramists working with these aspirations began to develop in Seattle, at the University of Washington, with leadership coming from Howard Kottler, Fred Bauer, and Patti Warashina. Kottler turned from making lumpish stoneware weed pots to making collages from store-bought decals that he fired onto commercial porcelain blanks. As the supreme irony, he would then encase his plates in luxurious, custom-made containers, lavishing more attention on the wrap-

Fred Bauer Steam Drill—Slot Pump, 1967. Painted earthenware, height 65". American Craft Museum, New York. Gift of Johnson Wax.

pings than on the "art objects" they contained. Bauer worked on the cusp of the Funk–Super-Object border. His imagery was frequently close to that of the Funk artist (cameras with penis lenses, for instance), but he defused the potential vulgarity of the concept with an elegance of craftsmanship, carefully modeling and glazing with slick, lustered surfaces. The Super-Object was beginning to come of age.

The decade ended on a high note with the exhibition *Objects: USA*, organized by Lee Nordness, of the Johnson Wax collection of contemporary crafts.²⁷ Nordness had managed to capture the mood of the decade and had acquired for the collection many works that are now among the key ceramic monuments of the decade, including Melchert's *Leg Pot # 1*, Rudy Autio's *Button Pot*, Fred Bauer's *Funk Pump*, and others. The exhibition succeeded in revealing both the innocence of the earlier part of the decade and the growing refinement and self-consciousness of the later period, which was to grow and continue into the 1970s.

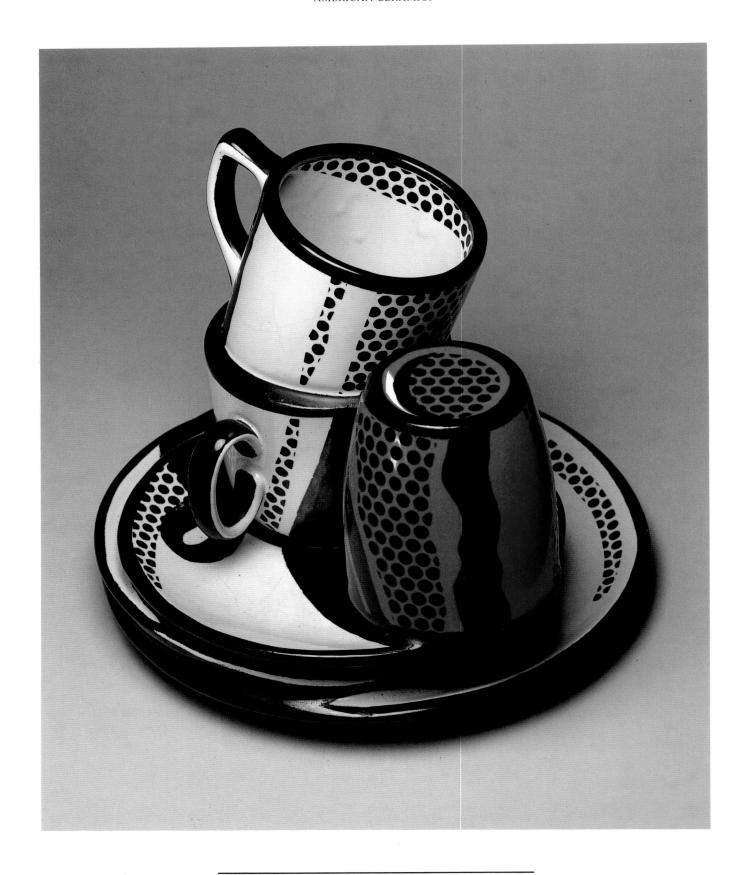

Roy Lichtenstein Ceramic Sculpture #11, 1965. Glazed earthenware with overglazes, height 7½". Collection Betty Asher.

ABOVE: Jim Melchert Plate with Muffin Tin, c. 1964. Black glazed stoneware, diameter 24". Jedermann N. A. Collection.

RIGHT: *Roy Lichtenstein* Blonde I, 1965. *Glazed earthenware with overglaze, height 15"*. *Collection Mr. and Mrs. Roger Davidson*. *Courtesy Leo Castelli Gallery, New York*.

BELOW: Ka-Kwong Hui Ceramic Form, 1967. Stoneware, thrown and assembled, glazed with on-glaze painting, height 22". Everson Museum of Art, Syracuse, New York.

BOTTOM RIGHT: Ralph Bacerra Orange Form, 1968. Earthenware vessel with orange slips and chrome overglaze, height 9". American Craft Museum, New York. Gift of Johnson Wax.

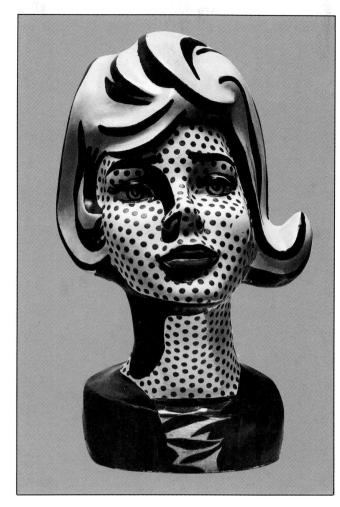

AMERICAN CERAMICS

FAR LEFT: **Manuel Neri** Loops No. 2, 1961. Glazed ceramic, height 18½". Private collection.

NEAR LEFT: **Reuben Nakian** Europa Theme, 1960. Terracotta, height 11". Hirshhorn Museum and Sculpture Garden, Smithsonian Institution, Washington, D.C.

BELOW LEFT: **Peter Voulkos** Untitled Plate, 1963. Glazed stoneware, length 19". Private collection.

RIGHT: **Daniel Rhodes** Form, c. 1962. Stoneware, height 47". Everson Museum of Art, Syracuse, New York.

BELOW RIGHT: **John Mason** Vertical Sculpture, 1962. Glazed stoneware, height 64". Jedermann N. A. Collection.

AMERICAN CERAMICS

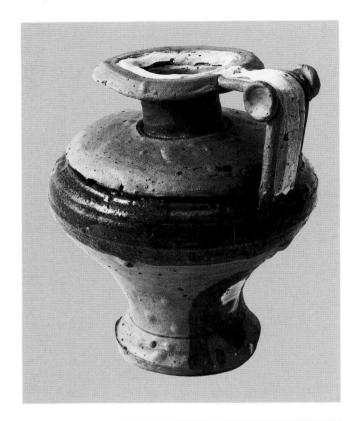

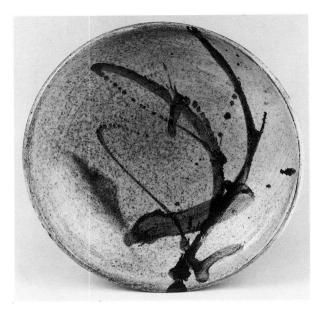

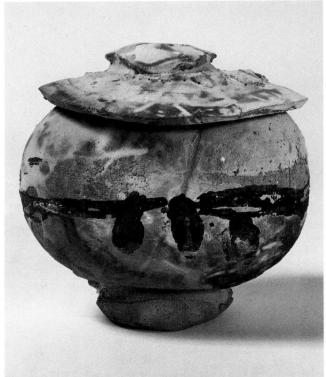

TOP LEFT: **Betty and George Woodman** Pitcher, 1966. Earthenware, raku glazed, height 14". Private collection.

BOTTOM LEFT: **Paul Soldner** Bottle, 1963. Raku-fired earthenware, height 11". Everson Museum of Art, Syracuse, New York.

Warren MacKenzie Fruit Bowl, 1965. *Glazed stoneware, diameter* 13". *University Art Museum, University of Minnesota, Minneapolis*.

RIGHT: **Peter Voulkos** Stack Pot, 1964. Stoneware, glazed, pierced, and assembled from thrown sections, height 30". The Detroit Institute of Arts, Founders Society Purchase.

Kenneth Price California Snail Cup, 1967. Glazed earthenware, height 3½". Private collection.

Robert C. Turner Storage Jar, 1965. Glazed stoneware, height 11". Everson Museum of Art, Syracuse, New York.

BOTTOM LEFT: William Wyman Terrace Bottle, 1960. Coiled and thrown, stoneware with slips, height 20". Everson Museum of Art, Syracuse, New York.

BELOW: **Beatrice Wood** Chalice, 1963. Earthenware with blue luster, height 8". Collection Daniel Jacobs.

Rudy Autio Double Lady, 1964. Stoneware with black and white slips, height 28½". Everson Museum of Art, Syracuse, New York.

Rudy Autio Kewpie Doll, 1968. Glazed stoneware with luster, height 31½". Marer Collection, Scripps College, Claremont, California.

Robert Hudson Untitled #60, 1973. Porcelain, height 9¾". Collection Daniel Jacobs.

The seventies began with an im-

CHAPTER TEN

portant event, or, to be more accurate, a nonevent: the twentyseventh Ceramic National, scheduled to take place in 1972 at the Everson Museum, Syracuse. For

in her detailed investigation into the controversial decision: "There was excitement, all right. Incomprehension. Lots of unanswered questions. Mutterings heard from amongst the clay bags. Many felt

forty years the Ceramic National provided the major platform for the ceramic artist in the United States. Over the years the Ceramic Nationals had traveled to more than fifty museums, from the Whitney Museum of American Art in New York to small-town museums in dozens of states, and had generated thousands of articles, reviews, and publicity pieces.

the jurors' action to be some sort of Olympian hoax, perpetrated by larger-than-life ceramic figures pointing a collective finger and causing a whole show to disappear. A giant power trip? A gesture of courage? Despair? Indifference? Hope?"2

By 1972 the Ceramic National had grown to unmanageable proportions—more than 4,500 slide entries were submitted for consideration. Although the standard of submissions was uneven, the upcoming National was anticipated with some optimism. James Harithas, then director of the Everson Museum, declared that the Ceramic National would now become "a basis for reevaluation of what ceramics is . . . a starting point for the presentation of a new aesthetic." But the jurors, Peter Voulkos, Robert Turner, and Jeff Schlanger, decided that the new aesthetic was not present.

In retrospect, the action seems indefensibly cavalier, as ceramics had so few supportive institutions. Selection by slides is, of course, a compromise, but one with which all juried shows have learned to live. On the other hand, it is argued that the timing of the decision was perfect, that the Ceramic Nationals would only have declined further and in so doing would have diminished the esteem of the medium. It is also possible that significant exhibitions that followed at the Everson Museum, such as Margie Hughto's New Works in Clay by Contemporary Painters and Sculptors and A Century of Ceramics in the United States 1878–1978, might not have taken place but for the courage of the jurors who canceled the National and thus left the museum open for other exhibitions.

Entrants were surprised to receive a letter stating that the Ceramic National would not take place because the jurors had found slides to be an unsuitable means of review. In place of the Ceramic National, the Everson Museum presented a mishmash, two-part invitational. The first part was an almost all-male section (except for Toshiko Takaezu) of fourteen contemporary and predictable "names." The second part was a group of old-school stalwarts selected by Anna Olmsted from previous Ceramic Nationals, combined with a slide showing of the better entries to the rejected National, and an exhibition of Robineau pots from the Everson's permanent collection. It was a compromised and inglorious end to the medium's most faithful institution, the Ceramic National.

The cancellation of the National was a particularly severe blow for younger artists, for whom it was an important springboard in gaining recognition. Another blow to the field came in 1972, with the closing of a second major juried show, the Wichita National Decorative Arts Competitive Exhibit, founded in 1946. After 1971 the Young Americans exhibitions at the Museum of Contemporary Crafts to some extent filled the void left by these cancellations. However, the Annual Ceramics Invitational at Scripps College, initiated in 1945 by William Manker, became the most important annual survey for the field and remains so today. The closure of the Ceramic National sent a very clear message out to the ceramist: a palace revolution had taken place, and a new and more radical leadership was in control. The signal was clear—

Donna Nicholas recorded the diverse reactions to the announcement of the demise of the National the 1970s were to be a decade of change.

Ceramists now no longer saw themselves as part of a polyglot community joined by the commonality of clay. The divisions between the separate disciplines of sculpture and the vessel also became clearer. In looking first at sculpture, one finds that the decade produced great diversity. Funk was no longer rampant and had splintered into a number of more personal and less aggressive styles. The Super-Object came into its own, peaking and declining within the decade.

Some ceramists rejected the notion of a permanent object altogether. They became involved in the avant-garde aspects of the sixties and the "dematerialization" of the art object through process art, installation pieces, conceptual works, and Happenings. Some ceramists dutifully attempted to do away with the kiln, and for a short time a

Jim Melchert Changes, a performance with drying slip, Amsterdam, August 22, 1972.

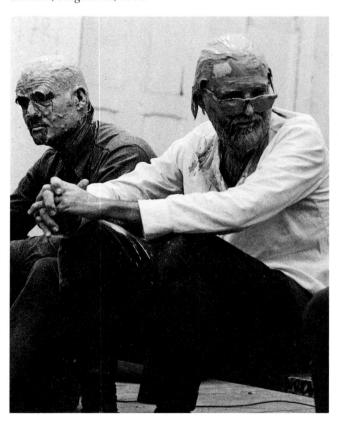

"mud 'n dust" school claimed intellectual domination of the field. In terms of creative exercises, the use of unfired clay was liberating. The first event of importance was the 1970 *Unfired Clay* exhibition at Southern Illinois University (Carbondale), which included the object makers Gilhooly, Arneson, and Victor Cikansky, as well as those more conceptually inclined, such as Jim Melchert. Commenting on the pertinence of the event, Evert Johnson suggested that the concept of making objects that were left outdoors to return to the earth had merits above the concepts of more traditional exhibitions:

There is something spiritually appropriate in the implication of the pot returning to the earth, of artists participating physically in the installation of their own exhibit, and of creative man being, for a short time at least, really at one with his work, the earth from which it was made and elements that besiege both. The whole idea was a joyful denial of the notion that art is a precious commodity. . . . It was instead a positive affirmation that the most important element in art is man.³

This notion now began to be enthusiastically explored. In 1972 Melchert produced a videotape event titled *Changes*, in which the participants dunked their heads in slip and were seated in a room that was cool at one end and hot at the other. The camera recorded the uneven return of the slip to its dry state and, at the same time and more subtly, the altering interpersonal reactions of the participants. In this way, the participants could experience the "lived surface" of a ceramic piece.

In 1973 and 1974 in Los Angeles, Sharon Hare, Doug Humble, Joe Soldate, and others formed a small avant-garde group of ceramists. Humble covered his entire home, even the car in the driveway, in slip. Hare set up installation shows in the deserts outside Los Angeles. Soldate worked with wet and dry clay in structural, installation situations. These energies came to a head in 1974 in the exhibition *Clay Images*, organized by Ed Forde and Soldate at California State University, Los Angeles.

Similar experiments with unfired clay took place elsewhere. In Colorado, Mark Boulding set up his Forest Firing. Through careful scientific analysis of the fire risk in the state forests, he selected a site that theoretically had the highest fire risk in the state. Twenty clay spheroids were placed in the area awaiting a wood firing that statistically should occur within the next two hundred years. The final event of this phase of ceramics history was Clayworks in Progress, which took place in 1975 at the Los Angeles Institute of Contemporary Art. It was described as "an exhibition of five artists whose work concerns the natural effect of time on clay; forces not at rest or in equilibrium."4 This exhibition seemed finally to exhaust the play with unfired clay. The concerns were continued to a limited extent in the clay and latex works of Bill Farrell and his students at the Art Institute of Chicago,

Roger Sweet Untitled works in progress, August 6, 1975. Clayworks in Progress, Los Angeles Institute of Contemporary Art but the issues raised by the refusal to make clay permanent through fire no longer seemed quite so relevant or important. Except as a personal learning process, one could argue that this work, with a few exceptions such as that by Melchert, was never pertinent to the art world at large, trailing after the main thrust of Conceptual sculpture. At best, the period can be seen as a time of soft-core Conceptualism, which hopefully had the effect of liberalizing the ceramist's conceptual boundaries and conservative tendencies.

In 1976 the opposite pole of thought to that of the Conceptualists was presented at the Everson Museum of Art's New Works in Clay by Contemporary Painters and Sculptors. Curated by Margie Hughto, the exhibition brought together ten mainstream artists. In collaboration with Hughto and her artist friends and students from Syracuse University, the painters and sculptors produced a body of ceramic sculptures. The project involved Billy Al Bengston, Stanley Boxer, Anthony Caro, Friedel Dzubas, Helen Frankenthaler, Michael Hall, Dorothy Hood, Jules

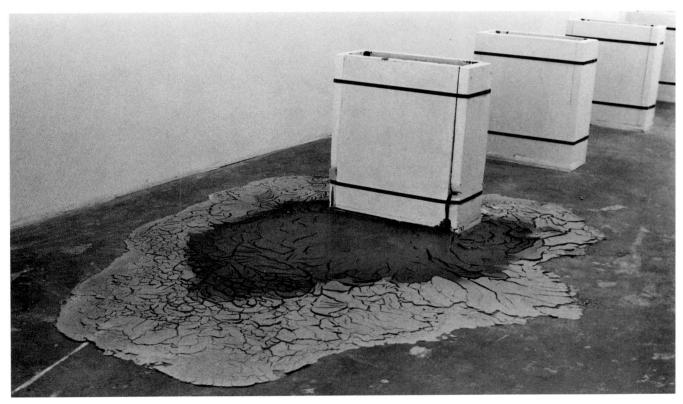

Olitski, Larry Poons, and Michael Steiner. In addition, the ceramics of David Smith were exhibited posthumously alongside these new works. The exhibition caused the ceramics establishment to seethe with controversy and discontent. They argued that there would never be an exhibition of "paintings by potters," and that this project was a waste of resources that could otherwise be applied to the specialists in the medium. But they missed the point; the purpose of the exhibition was simply to introduce a group of active, professional *artists* to a material that was not their day-to-day medium in order to bring a different perspective and, it was hoped, a fresh view to the sculptural use of clay.

In reviewing the impact of the exhibition over the distance of a decade, it has proved to be an important event for the participants, many of whom made substantial changes in their art as a result of their involvement in this project. For the ceramics world, the exhibition did not prove to be of major consequence in aesthetic terms. It did not trigger any new directions in ceramic sculpture or even in the larger world of sculpture. Viewed politically, however, *New Works* takes on significance. The controversy it generated within and without the ceramics world and the publicity it attracted played a substantial role in a growing momentum for redefining ceramic art in the United States.

Together with the Syracuse Clay Institute, a joint venture of Syracuse University and the Everson Museum of Art, Hughto went on to present two more *New Works in Clay* exhibitions. *New Works II* was shown at the Lowe Art Gallery, Syracuse University, in 1978, and *New Works III* at the Everson Museum in 1981. Excellent catalogues were pub-

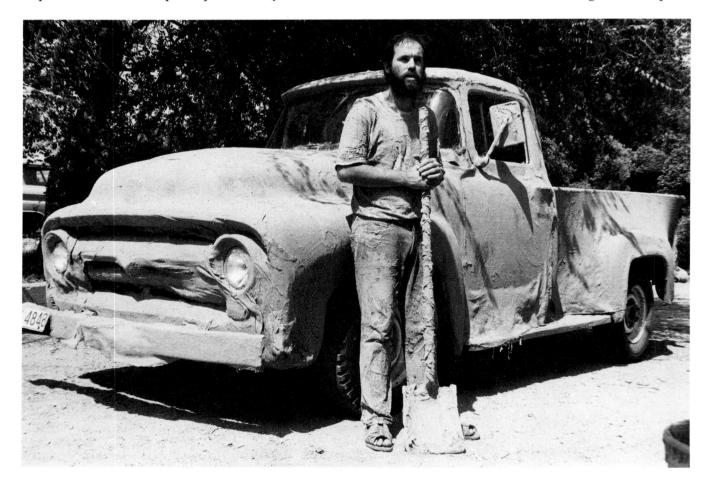

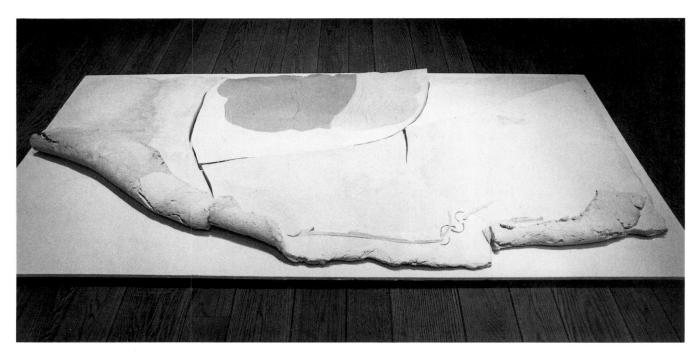

Helen Frankenthaler Mattress II, 1975. Stoneware, slips, length 75". Private collection.

LEFT: Doug Humble Slip environment, Los Angeles, 1973.

lished for each of the *New Works* exhibitions. The artists who participated in these exhibitions were now a mix of ceramists and nonceramists; the list includes Kenneth Noland, Miriam Schapiro, John Glick, Stephen DeStaebler, George Mason, Mary Frank, and others.

The Syracuse Clay Institute was housed in a huge industrial building owned by the Continental Can Company. The projects were directed toward providing the artists with assistants, resources, and equipment to create experimental works on a more ambitious scale than they could attempt in their own studios. In addition, the institute invited scholars to lecture and monitor proceedings. Students from the ceramics program at the university were invited to work with the artists as their assistants. From an educational point of view, the projects proved to be a considerable success. It was not the first of such projects to be held in the

United States; *Art in America* had initiated a similar project as early as 1964, and in 1974 Susan Peterson established an artist-in-residence program at Hunter College in New York.⁵

The New Works exhibitions had a limited impact on the ceramics community, because they dealt mainly with Abstract Expressionism at a time when the so-called new figurative movement was being welcomed in painting and sculpture. The same trend was taking place in ceramic sculpture, where figurative work was emerging as the cutting edge for the medium, providing both the freshest ideas and, at the same time, the most convincing work sculpturally. In particular, there were four artists during the seventies whose work most dramatically exhibited the renewed vigor of figurative ceramic sculpture: Mary Frank, Robert Arneson, Stephen DeStaebler, and Viola Frey. Writing of Frank in the New York Times, Hilton Kramer acknowledged that she was a magnificent anomaly among sculptors: "While so many expend their energies on making sculpture a language of cerebration, securely quarantined against direct expressions of feeling, Frank insists on making it a language of passion. The result is an oeuvre unlike any other on the

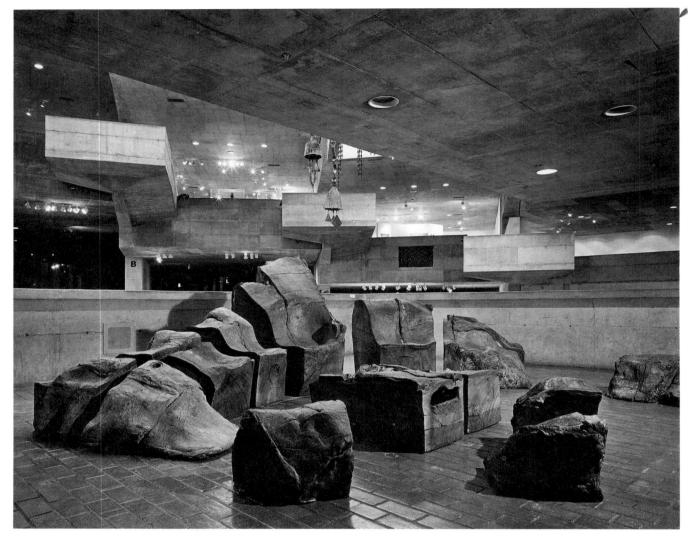

current scene—an oeuvre in which imagery of great inwardness and intimacy is combined with an earthy articulation of emotion."

Although speaking specifically of Frank, Kramer was also suggesting an aesthetic niche for clay. Emphasis on the cerebral had proved in the 1960s to be a poor bedfellow for the ceramic medium, outside the vessel tradition. Again praising the figurative mode, Kramer commented in a later review on the works of Robert Arneson that were on show at the Allan Frumkin Gallery in New York. The review was titled "Sculpture—From the Boring to the Brilliant": the boring contributed by Carl Andre, and the brilliant, a series of large-

scale portraits by Arneson. Kramer praised the "stunning mastery of characterization" in Arneson's work and welcomed the use of color in sculpture. Arneson's work, he pointed out, "reminds us that there is something of a revival of polychrome ceramic sculpture . . . in recent years that New York has never quite caught up on. Perhaps the

Stephen DeStaebler Seating Sculpture, 1970. Stoneware, height 5". University Art Museum, University of California, Berkeley.

RIGHT: *Mary Frank* Lovers, 1973–74. Earthenware, length 62". Private collection. Courtesy Zabriskie Gallery, New York.

AMERICAN CERAMICS

Clayton Bailey La Guillotine, 1973. Wood, glazed earthenware, length 20". Private collection.

BELOW: Robert Arneson George and Mona in the Baths of Coloma, 1976. Glazed earthenware, length 57". Stedelijk Museum, Amsterdam.

TOP RIGHT: Stephen DeStaebler Standing Man and Woman, 1975. Stoneware, height 96". Private collection.

BOTTOM RIGHT: *Robert Arneson* Cocks Fighting over Art, 1970. *Glaze porcelain, length 6"*. *Collection Susan and Stephen D. Paine*.

time has come for some museum to bring us up to date on this interesting and unexpected development." Arneson was now showing portraits, first of himself and later of artist friends from the Bay Area, media figures such as Elvis Presley, and iconic artists such as Duchamp, Dürer, van Gogh, and others.

The mock-heroic stance remained, but the works were now anything but one-liners; the satire had now become complex, layered, and drawn from the world of art history. A particularly important exhibition for Arneson during the seventies was entitled *Heroes and Clowns*, at the Allan Frumkin Gallery in New York. In the accompanying catalogue essay, Michael McTwigan explained one of the works, *Rrose Sélavy* (1978):

Both Robert Arneson and Marcel Duchamp have adopted poses as part of their strategy toward art. Two are shown here: Duchamp as his alter ego Rrose Sélavy and Arneson as Klown. Wearing masks, these artists can dare to do things they might not normally do and they can reveal something of themselves while claiming that it is just a game. Arneson portrays Rrose Sélavy according to two possible readings of Duchamp's pseudonym: Life is pink; eros c'est la vie. And so Duchamp is completely covered in a rose pink glaze. As for eros, the pedestal is signed 'lovingly Rrose Sélavy,'' as in the well known photograph of Duchamp dressed as Rrose, taken in 1921 by Man Ray. The fur collar surrounding Duchamp's head is heart shaped (it also resembles a huge pair of lips), a heart is pinned to his hat, and three chocolate Kisses rest on the pedestal. A fine feature of the bust is the step pattern that spirals around the pedestal—no doubt the staircase that Duchamp's Nude descends.8

McTwigan notes that Arneson has made Duchamp much more masculine in appearance than he appears in Man Ray's photograph. In doing this to Duchamp, the subtle, androgynous ambiguities of Man Ray's *Rrose* are dismissed. Instead, Duchamp is made to appear more absurd—an obvious and awkward drag queen, a figure of derision. McTwigan cites Octavio Paz, who wrote, "Like all of the very limited number of men who have dared

LEFT: **David Gilhooly** Tantric Frog Buddha, 1979. Gold-glazed earthenware, height 18". Collection Donna Schneier.

RIGHT: Richard Notkin Demons of the Intellect: Professing to Be Wise They Became Fools, 1979. Molded porcelain, height 11½". Collection Garth Clark/Mark Del Vecchio.

BELOW: *Michael Frimkess* Ecology Krater II, 1976. *Stoneware, glazed, overglaze painting, height 26"*. *Collection Daniel Jacobs*.

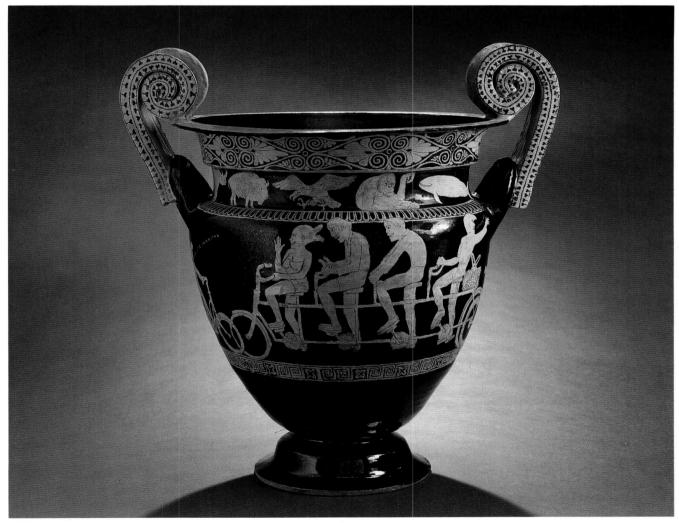

to be free, Duchamp is a clown"—a sentiment that applies as well to Arneson.

The work of Stephen DeStaebler differs totally in mood from that of Arneson. Although both sculptors developed in the Bay Area and were equally influenced by Voulkos and Company, DeStaebler's work is reverential, almost religious, in its solemn qualities, reflecting the spiritual nature of the artist and, no doubt, DeStaebler's theological studies at Princeton:

The biblical analogy of man and clay is given graphic validity in his work that is neither trite nor forced. Within the context of human participation in the universe, the reemergence of man from earth and his ultimate return to it in the symbolic cycle of life is an absorbing concept. De Staebler's figurative imagery appears to be suspended somewhere in the transformation process. The imprecise features of the faces, the amorphous bodies and the fragments of torsos and limbs seem merely transient rather than distorted or decayed.⁹

Although through the seventies and into the eighties DeStaebler increasingly concentrated on the figure, he did not work only in the figurative mode. One of his masterpieces, *Seating Sculpture* (1970), is a massive grouping of stoneware thrones and stools commissioned by the University Art Museum; University of California, Berkeley. DeStaebler also created what he termed "landscapes."

The most surprising sculptural talent of the 1970s was Viola Frey. She emerged phoenixlike in 1979 after having completely withdrawn from all public activity for over five years, a deliberate move so that she might work without any commercial or exhibiting pressures. Prior to her disappearance from the public scene, she had been developing a local reputation as an artist in California but was not known outside the state. Her first national exposure of any consequence came in 1979, at the exhibition *A Century of Ceramics in the United States*, where she attracted more attention and comment than almost any other of the 160 artists in the exhibition.

The real excitement was not about the suddenness of her appearance; it was about the provocative and original quality of her large, brightly colored figures of humans and animals, which, for all their surface appeal and apparent familiarity of subject, exude a strange undercurrent of menace and unease. Many of her works were assemblages of cast and molded objects (some coming from her massive collection of dime store figurines). Others, such as her *Desert Toys*, a series of figurines, were of her own invention—raw, brutal-looking dolls that seemed to have survived some form of fiery holocaust (or at least seem more than capable of doing so).

Robert Arneson Rrose Sélavy, 1978. Glazed ceramic, height 41". Collection the Honorable Steven D. Robinson. Courtesy Allan Frumkin Gallery, New York.

Yet, despite the dark side of her work, Frey sees her pieces as placing "an accent on the element of clay," particularly seen in her use of painting to manipulate light and shade on her sculpture—constructing and deconstructing her form. The play of images is more complex: "Clues in the sculpture will lead eventually to a variety of meanings. Hats, shoes and wheels, masks, geese, to mention a few, are all clues. They are used as contemporary symbols that are instantly recognized for what they are by their form, but may have many different meanings depending upon their inflection, size, distortion and association. My completed works are three-dimensional puzzles

Viola Frey Desert Fawn, 1973. Glazed earthenware, height 36". Private collection.

where parts fit together."10

During the seventies Frey was greatly influenced by Claude Lévi-Strauss's notion of the bricoleur, which literally means "junk man" or "handyman," although Lévi-Strauss's interpretation has stronger, shamanistic overtones. 11 The concept of the *bricoleur* is linked to mythic thought (prior science), which is in itself a form of intellectual bricolage, "building ideological castles out of the debris of what was once social discourse." Similarly, bricolage is constructed from what the French term "des bribes et des morceaux," the "debris of events." The bricoleur picks up odds and ends from his time; works with all materials at hand; is adept at performing diverse tasks and exploring diverse themes. This notion of the junk man as artist propelled Frey through the late seventies and into the eighties, when a new focus began to emerge in her work.

The most popular genre of ceramic sculpture in the 1970s was not the highly personal explorations of Frank, Arneson, DeStaebler, and Frey, but rather the seductive, glitzy world of the Super-Object, which was to dominate ceramics education and exhibitions through most of the seventies. The origins of the Super-Object are closely tied to the move from stoneware to whitewares and to the use of photographically processed decals, chinapainting, on-glaze commercial lusters, and even paint—all processes considered unacceptable within the more purist and traditional areas of the ceramics world.

Development of the Super-Object can be traced through the sixties in the work of Kottler, Melchert, Price, Nagle, and others. The Super-Object in the seventies was identified by an elaborate, almost obsessive concern with craft; the use of trompe l'oeil as the primary stylistic device, and with simplistic references to assemblage and collage and to the art object in Dada and Surrealism. Form was approached as a kind of three-dimensional illustration, mostly through found objects that had been cast in clay. Interest in the Super-Object was based on the West Coast (mainly Seattle, San Francisco, and Los Angeles) but soon spread like

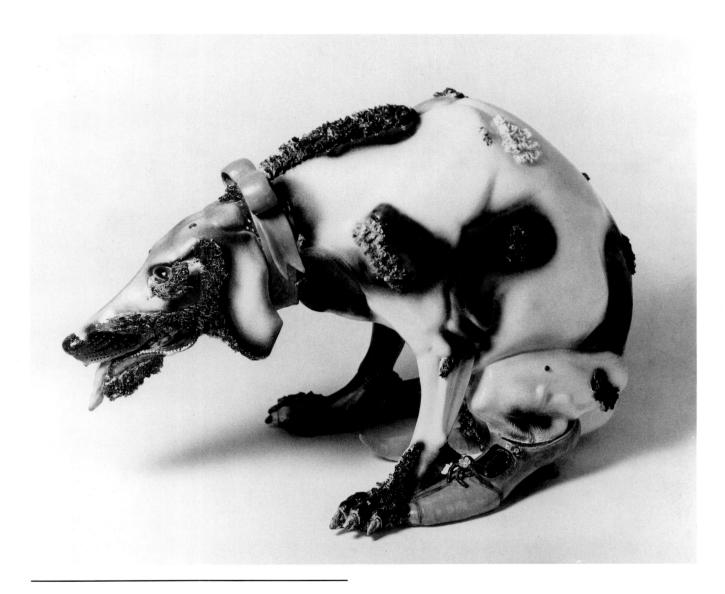

Jack Earl Dogs Are Nice, 1971. Glazed porcelain, height 17". American Craft Museum, New York. Gift of Karen Johnson Boyd.

LEFT: **Karen Breschi** The Bath, 1971–72. Clay, arcylic paint, bones, resin, and wood, length 54". Private collection. Courtesy Braunstein Gallery, San Francisco.

an epidemic of ceramic *faux* across the United States. Clay was produced in every conceivable disguise: cardboard, denim, leather, wood, metal, burlap, paper. The cast ceramic boot, faithfully glazed to look like "real" leather, became the ultimate cliché of the decade (just as the brown Japanesque stoneware bowl had been a decade before) and could be found in just about every ceramics department in the country by the mid-1970s.

The Super-Object has a long-standing, noble tradition in ceramics, reaching its apex during the eighteenth century. In France and Germany it was the vogue to create massive dinner services painted to look like wood, with the illusion of etchings and posters peeling off the surfaces. The works in this style by the Niderviller factory are partic-

Kenneth Price Untitled Two-Part Geometric, 1974. Glazed porcelain, height 5". Courtesy Willard Gallery, New York.

ularly distinguished. The development of commercial lusters in England led to the imitation of silver tea and coffee pots, what was known as "poor man's Sheffield." Josiah Wedgwood, having created a particularly rich green glaze and looking for a way to use it to its best advantage, created a series of creamware cauliflower vessels in which the green leaves were set off in perfect complement to the cream of cauliflower. In China the Yixing wares included superrealist peanuts, gnarled pieces of wood, and bamboo shoots being eaten away by worms. Later this led to the imitation of ivory, metal, and other materials in clay, under the rule of Qianlong (1736–95).

Two very fine exhibitions stimulated contemporary interest in this style. The first was *Sharp-Focus Realism*, a multimedia exhibition that took place in 1972 at the Sidney Janis Gallery in New York. The exhibition included the virtuoso work

of the ceramist Marilyn Levine, whose stoneware pieces faithfully echoed leather objects: suitcases, leather jackets, and boots. Harold Rosenberg called her works "translations of objects into a different substance without altering the appearance." Although Levine did produce objects, Rosenberg pointed out that this "was essentially a conceptual art, that brings to the eye nothing not present in nature but instructs the spectators that things may not be what they seem."13 The Super-Object provided an area where the ceramist could indulge in technical matters without the means overpowering the end. In this case the craft is the message. As the critic Kim Levin noted, "Old time illusionistic art has collided with the future becoming as literal as minimal forms . . . form has redissolved into content—Pygmalion is back in business."14

The second exhibition of importance to the development of the genre of the Super-Object was a joint show of works in porcelain by Richard Shaw and Robert Hudson in 1973 at the San Francisco Museum of Art. It was one of the most important exhibitions of the decade, with superbly conceived, genuinely poetic compositions in porcelain. The exhibition set the stage for a style of Super-Object assemblage of disparate elements that was to be widely emulated throughout the seventies. The craft was not as obsessive as the Super-Object was later to become, and the painting, although frequently suggesting another material, was still somewhat expressionistic. Hudson, a sculptor known for his polychrome metal sculpture, collaborated with Shaw. Although they made separate works, they did use common molds and techniques, and Hudson was dependent upon Shaw for technical assistance.

TOP: Howard Kottler The Old Bag Next Door Is Nuts, 1977. Earthenware, glazes, and Plexiglas, height 13". Collection Judith and Martin Schwartz.

Ron Nagle Cup, 1978. Earthenware with glaze and china paint, height 8". Private collection.

The collaboration lasted from 1972 to 1973, after which Hudson returned to metal and Shaw continued to explore trompe l'oeil surfaces, as in Cardboard Tea Set (1975), with its ceramic decals. Shaw's interest in photolithographic, four-color decals brought true trompe l'oeil illusionism into his work. This led Shaw further from the inventive, painterly incongruities of his earlier works, such as Ocean Liner Sinking into a Sofa. Shaw's work now was tied to the conceits of a superrealist tradition in ceramics. As this exploration continued through the decade, his skills increased. In the late seventies he created pieces that were almost nostalgic—assemblages of books, pipes, spent matches, and technically stunning "houses" of stacked playing cards, work that he jokingly termed "den art."

By the mid-seventies the work of Levine and Shaw was being slavishly imitated in almost every ceramics department. In a matter of a few years this style of working had become its own overpopulated genre. In 1977 the Laguna Beach Museum of Art organized the exhibition *Illusionistic Realism as Defined in Contemporary Ceramic Sculpture*, in an attempt to define this new obsession of the

ceramics world. In the catalogue essay,¹⁵ Lukman Glasgow grasped at everything from Surrealism to Gestalt in order to impose fine-arts respectability. But it was sadly apparent that most of the Super-Object makers were not dealing with the ironies of Dada or the poetry and eroticism of Surrealism. Instead, what emerged is a style that can be termed "Hollywood Magritte," a debased and decorative use of Surrealism that completely lacked the passion, the wit, and the visual literacy necessary to give the objects validity.

ABOVE: Robert Hudson Ashtray #13, 1973. Porcelain, height 11³/₄". Courtesy Fuller Goldeen Gallery, San Francisco.

LEFT: *Richard Shaw* Cardboard Tea Set, 1975. *Glazed porcelain with ceramic decals, height 7"*. *Private collection*.

RIGHT: *Mark Burns* Magician's Dinnerware, 1974–75. Earthenware and paint, height 12½". Everson Museum of Art, Syracuse, New York. Gift of Coy Ludwig.

In 1979 works of the Super-Object school dominated a similar exhibition, Northern California Clay Routes, which took place at the San Francisco Museum of Modern Art. The late Thomas Albright, astute art critic of the San Francisco Chronicle, reviewed the exhibition and noted that the dilemma facing all art in the postmodernist, pluralistic, anything-goes era was to somehow "maintain distance between the museum . . . and the overwhelming preponderance of hip, cute, clever objects that are only a step or less away from the main floor at Gump's, the Cannery or Ghirardelli Square."16 This, he noted, was a particularly delicate issue for ceramics, with its roots in the craft shop. Albright pinpointed clearly the failure of the Super-Object genre, while admitting the quality of work by a few of the artists: "The ultimate impression is of superficiality and slickness—that is, craft at its most obvious, vulgarly ostentatious level. This is largely the old ceramic Funk from a decade ago, adapted to the era of High Tech. Eccentricity is not the same as originality. It is a measure of the difference that so much eccentricity can add up to so much sameness."

On the East Coast, Rose Slivka had approached the subject of the art object, examined its context, and come up with a viewpoint that brought more dignity to the activity. In 1976, drawing on the notion of the Surrealist objects of the 1930s, Slivka coordinated *The Object as Poet* at the Renwick Gallery in Washington, D.C. The exhibition brought together the most valid of the art-object makers and suggested a union of spirit and intent that linked Levine's bags, Shaw's assemblages, Melchert's delicately lustered *Precious a* (1970), and Lucian Octavius Pompili's fragile multimedia works.

Their use of material, their selection of images, and their elegance of composition were used to create visual poetry with all the freedom and depth of personal expression that that idea implies:

The reality of the object—poem and material thing—suggests other realities. Other metaphors in the form of things and poems that interact in the old root way before specialization

divided us from ourselves and each other. The power of these objects to take us into their orbit and beget energy is endless. This is the magic. The Shamanist vision yields multiple mnemonic clues to the enigma of life through intuitive forms invented or found ready made in the touch of each individual maker.¹⁷

In essence, Slivka's comment is a plea for pure objecthood. Whether utilitarian or not, the concept of the object maker as a visual poet removes the circular debate on the boundaries of art and craft as a consideration. The viewer is thus able to confront the collage, fetish, or assemblage works that have come out of the contemporary crafts movement and deal with them beyond their more obvious virtues of craftsmanship. Slivka's view suggested a different language of appreciation, based upon a more emotional relationship and a very delicate, subtle sensibility in the use of materials, metaphors, associations, and context—a complex visual language of syntax, rhythm, and free association.

The high profile of the ceramic-sculpture movement in both the sixties and the seventies tended to obscure the fact that the vessel maker was making considerable progress, albeit in a quieter and less dramatic manner. The potter was still suffering from a condition of inferiority. Many ceramics departments did not allow students to make pots, only sculpture. Potters responded by not referring to their work as pots or pottery, developing a number of interesting and amusing euphemisms. In the seventies, however, the potters decided to reclaim an equal place for their work, alongside that of ceramic sculpture.

The first step was to return to a sense of identity and purpose. Potters such as Betty Woodman, Richard DeVore, and Bill Daley insisted that their work be described as pottery and be seen, simultaneously, as part of the millennia-old tradition of vessel making *and* as a contribution to contemporary art. Not surprisingly, many critics applauded the return to categorical clarity. The following comment by Kenneth W. Jones, in response to an exhibition of DeVore's pots at the Helen Drutt Gallery in

Marilyn Levine Two-Tone Bag, 1974. Stoneware, height 9". Los Angeles County Museum of Art. Gift of Howard and Gwen Laurie Smits.

BELOW: **Jim Melchert** Precious a, 1970. Earthenware, glaze, luster, height 6". Collection Susan and Stephen D. Paine.

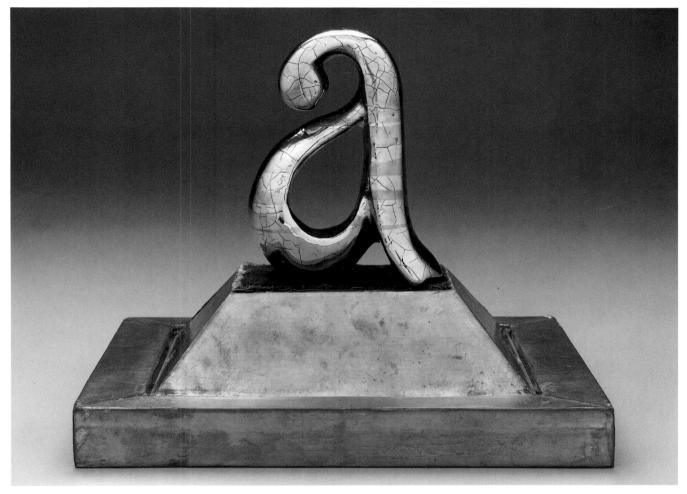

Robert Rauschenberg Tampa Piece #4, 1972. Earthenware, length 15". University of South Florida, Tampa. Courtesy Graphic Studio.

LEFT: **Thom R. Bohnert** Untitled, 1977. Ceramic and wire, height 12". Private collection.

RIGHT: **Rudolf Staffel** Untitled Vessel, 1975. Porcelain, height 7¹/₄". Collection Daniel Jacobs.

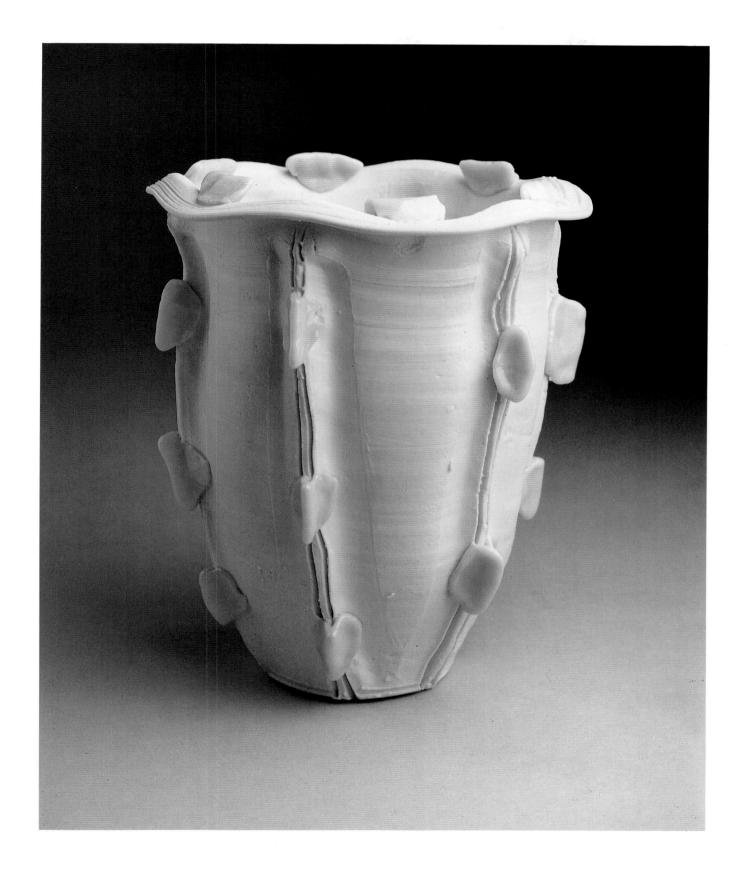

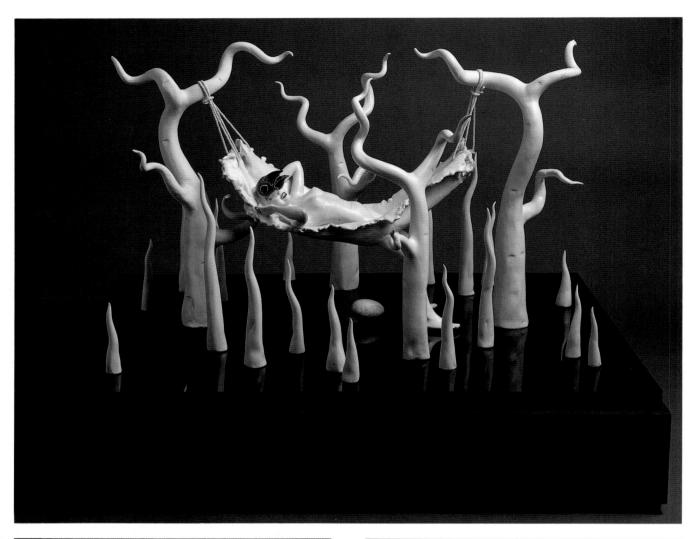

Patti Warashina Who Said I Couldn't Fly, 1979. *Porcelain, height* 21¹/₄". *Collection Daniel Jacobs*.

LEFT: Jerry Rothman Fish Tureen, 1979. Glazed stoneware, height 14". Collection Dawn Bennett and Martin Davidson.

RIGHT: Karen Karnes Untitled Vase, 1971. Salt-glazed stoneware, height 14". Collection Reed Walden.

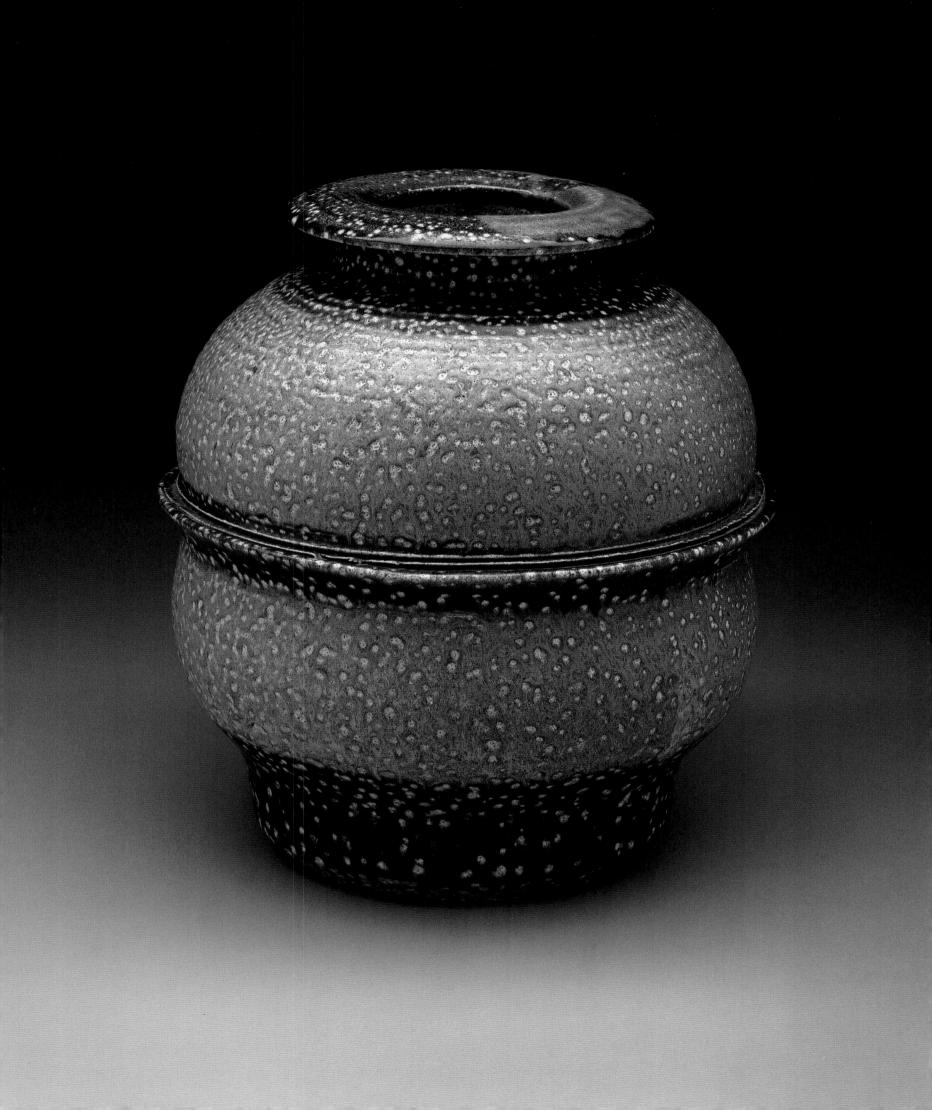

1977, is of particular interest:

Convulsing from the perplexities of his or her placement in the hierarchy of art, the ceramist has often rejected both the utilitarian aspect of pottery as well as its history as an art. Denying a chain of events can in itself be useful and even produce a new event, but too often repeated it becomes dogma based on a false or nonexistent foundation. As a solution to the problem many ceramists view their art as a sort of mini-sculpture; in consciously rejecting their own discipline, however, they have attached themselves to another. The resultant breakdown in communication creates bewilderment in the audience and frustration in the artist. 18

A year earlier Andy Nasisse wrote that it was time to acknowledge that the pot was, in a sense, its own subject matter, much as a painting was about painting: "In this extensive analysis of a pot's form one becomes aware that many of the aesthetic conclusions are unique to the idea of the vessel, and the vessel itself has the potential for becoming a major metaphor, with complex, sensuous analogies. One also becomes aware of the fallibility of a language which is intrinsically tied to logic . . . to describe these vessels' imponderable tendency to-

Rudy Autio Two Ladies: Two Dogs, 1979. *Slab-built stoneware with slips and glazes, height 25"*. *Collection Mark Del Vecchio.*

Betty Woodman Pillow Pitcher, 1978–79. Earthenware with terra-sigillata surface, height 17". Collection Daniel Jacobs.

ward the infinite. So in the final analysis, *feelings*—both emotional and tactile—become the final message.''¹⁹

But achieving this level of sensitivity toward the pot required an understanding of the potter's new sophistication that simply did not exist in the art world at that time. This was highlighted by comments made by Edy de Wilde, the past director of the Stedelijk Museum in Amsterdam. Few museum directors in Europe have had greater perceptivity about contemporary art than de Wilde, yet his remarks about Voulkos in a 1979 catalogue, West Coast Ceramics, reveal how little the fine arts understood the pottery revolution that had taken place in the United States. De Wilde warns that Voulkos's pieces "look" like pots but that we should not be deceived, "for their sole purpose appeared to be the visualization of volume and form—

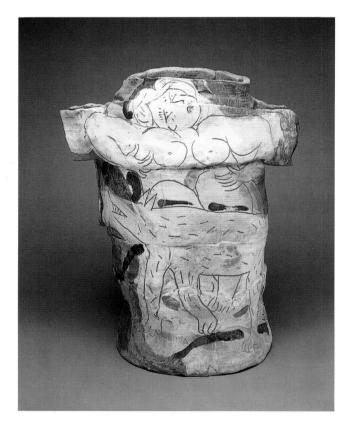

Ruth Duckworth Untitled Vessel, 1977. Stoneware, porcelain, height 61/4". Collection Daniel Jacobs.

sculpture in other words."²⁰ Volume is no longer the central issue of the sculptor, whereas it has never ceased to be the central, aesthetic dynamic of the potter. De Wilde, despite his good intentions, was suffering from a classic case of ceramic illiteracy.

The seventies produced fine work by potters, despite the problems of context and identity. New artists, such as Richard DeVore and Adrian Saxe, surfaced in the pottery mainstream, while others, who were already well established in the field, now began to produce innovative and surprising work. Among these were Betty Woodman, Robert Turner, Ken Ferguson, Ken Price, and Rudy Autio. It was a time when the potter came of age and established a new aesthetic confidence.

One of the high points of the decade was undoubtedly the Voulkos retrospective. Organized in 1978 by the Museum of Contemporary Crafts

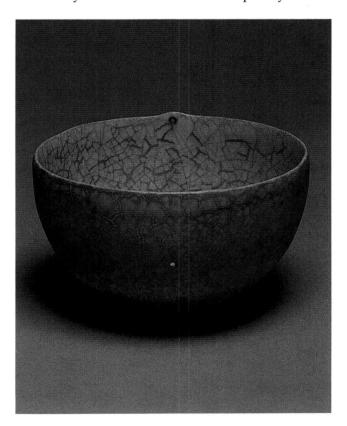

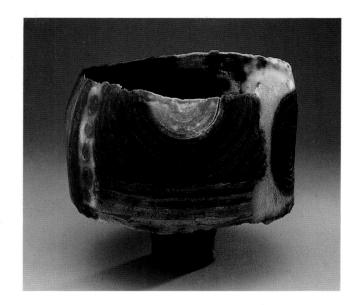

in New York, this touring exhibition opened at the San Francisco Museum of Modern Art. It both celebrated Voulkos's earlier achievement in the fifties and sixties and, in a sense, welcomed him back to ceramics as his primary medium. The problem of an overcrowded installation did little to mar the excitement of the exhibition, nor did it detract from Voulkos's extraordinary achievement in leading the liberation of the American potter from European formalism. Yet, the exhibition signaled the passing of an era. Many of the students and younger potters appreciated the exhibition but now felt distanced from the aesthetic and the ideals that the work represented. The freedoms that Voulkos and his students had striven so hard to gain were now almost taken for granted. The baton had been passed on.

Voulkos had returned to ceramics after a decade of working as a metal sculptor. He now began to concentrate on two forms: platters and massive, three-tiered "stack pots." Interestingly, these tiers, although more radical in their application, were the same divisions that had been made by the formalist Bernard Leach in most of his pots and by Korean and Chinese potters, many centuries

Richard DeVore Untitled, 1979. Stoneware, height 11". Collection Garth Clark.

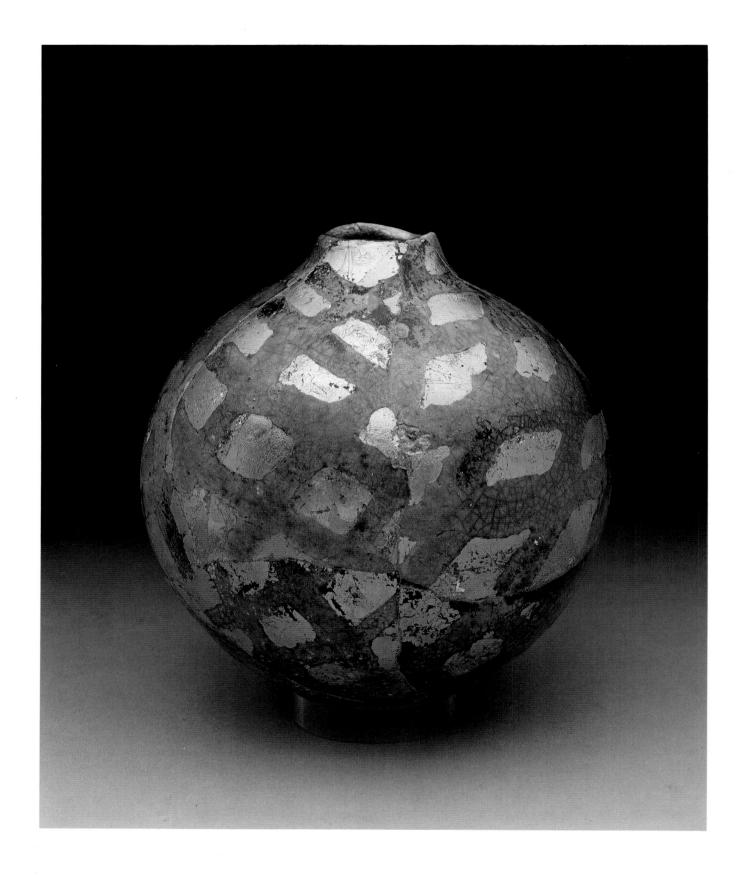

FAR LEFT: *Rick Dillingham* Globe Form #79-2, 1979. *Rakufired earthenware, glazed, height* $5\frac{1}{2}$ ". *Collection Daniel Jacobs*.

LEFT: Jane Ford Aebersold Pompey's Pillar, 1979. Stoneware with on-glaze luster, height 18". Private collection.

BOTTOM LEFT: **Val Cushing** Acorn Roll Jar, 1979–80. Thrown and glazed stoneware, height 17". Private collection.

BELOW: **Paul Soldner** VOCO, 1978. Raku, height 11". Collection Lynne Wagner.

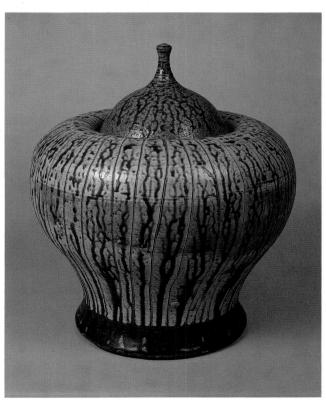

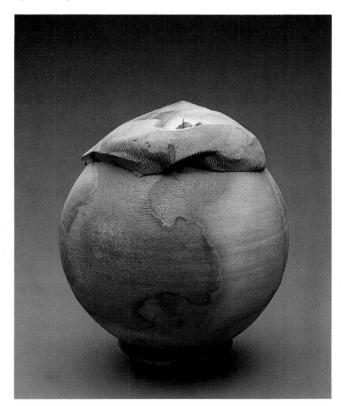

RIGHT: **Peter Voulkos** Plate, 1977. Stoneware with porcelain pellets, gas fired, diameter 23½". Victoria and Albert Museum, London. Gift of Fred and Estelle Marer.

Peter Voulkos Stack Pot, 1975–82. Stoneware, assembled from thrown elements, wood fired, height 39½". Courtesy Garth Clark.

FAR RIGHT: Robert Turner Chimney Jar, 1971. Glazed stoneware, height 14½". Collection Daniel Jacobs.

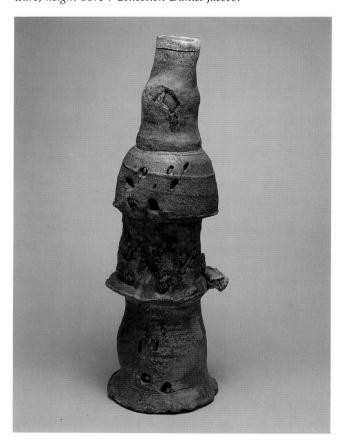

before, to emphasize the "structure" of the vessel. While these divisions were used to emphasize the "wholeness" of the traditional vessel, in Voulkos's hands the same divisions indicate the the contrary—a sense of taking apart, of deconstruction and releasing the parts from the tyranny of the whole.

The best of the platter forms were made between 1977 and 1979 and were fired in a gas kiln with a commercial glaze that produced an ersatz wood-fired look. Their liveliness derived from the energetic drawing on the surface that combined punctured surfaces, deeply incised lines, and porcelain pellets that were inserted into the surface. Reminiscent of the work of the Italian artist Lucio Fontana, they dealt with elements of space, light, and color that were at once primitive in their execution and complex in their formal content. The beginnings of this work can be traced back to a series of five black plates that Voulkos made in 1968 on one of his occasional returns to clay making. Later, in 1979, Voulkos began to fire the plates in a Japanese-style wood-fired anagama kiln and produced a few masterpieces, but these pieces were

generally retrogressive in their aesthetic, too dependent upon the generosity of the kiln and too imitative of Bizen, Seto, and other traditional Japanese kilns.

While Voulkos's influence on younger potters was beginning to diminish, he continued to have a strong influence and, in a sense, present a standard for those who had passed through the fifties and sixties with him. This was particularly evident in the work of Bob Turner, a leading functional potter of about the same age as Voulkos. The seventies saw the production of Turner's finest work to date and his emergence as a leading maker of the "art" pot. Turner had worked as a maker of utilitarian pots since the late forties, encouraged by a belief in the Arts and Crafts ideal that personalized design could be a regenerative force in society. In the 1960s he began to change from making the orthodox "Alfred vessel" to creating contemplative works, what Ed Lebow calls his "decorative" pots.²¹ The

influence from Voulkos can be plainly seen in Turner's most distinctive form, a circle cut in half and surmounted by a square tower. Voulkos developed this form in the early sixties but did not play with contradictory geometry, leaving his tower circular. Turner was inspired by Voulkos and drew his new vocabulary from Voulkos's innovations, but what he produced with this vocabulary was not imitative. As Lebow states:

Cylinders narrowed to cones or widened to hemispheres. Hemispheres opened to cubes. Domes were joined to tapering cylinders. The combination of volumes in these pots moved and shifted in fluid translation. Their geometry was simple. Form still followed function, but now the function was visual and contemplative. Turner no longer disconnected the currents of memory and spontaneity from his hands on the wheel but used them to "Alfredize" the Otis pot. The result was a kind of artistic pacifism, lyrical rather than muscular, cerebral rather than visceral.²²

The issues of organic geometry and abstraction can be viewed as the primary concern for the vessel maker in this decade. However, in contrast to the fevered physicality of the previous decades, it was now applied on a more conscious and analytical level. This can be seen in the work of Richard DeVore, Ruth Duckworth, Susanne Stephenson, Toshiko Takaezu, Bill Daley, and others. DeVore's gentle and sexually ambiguous pots seem warm and emotional but, in fact, this disguises the colder, analytical geometry that guided their creation. DeVore's pots are also a warning not to read organic work as the result of feeling rather than of intellect. Indeed, this cerebral aspect of the pot's development is so intense that it caused George Woodman to label DeVore and Daley "conceptualists of the vessel." Susanne Stephenson also employed organic abstraction in her work, taking it to a radical edge in which the twisted feet of her pots stand like gnarled wood or fragments of animal skeletons that one might find in the desert. But the interest in the organic was not to continue with the same momentum in the next

AMERICAN CERAMICS

LEFT: **David Shaner** Untitled Vessel #27, 1979–80. Stoneware, height 13". Collection Daniel Jacobs.

BOTTOM LEFT: Adrian Saxe Untitled Antelope Jar, 1979. Porcelain and stoneware, height 16". Private collection.

BELOW: **John Glick** Plate, 1979. Porcelain, slips, glaze, diameter 11". Private collection.

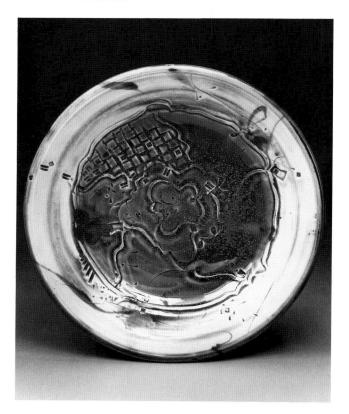

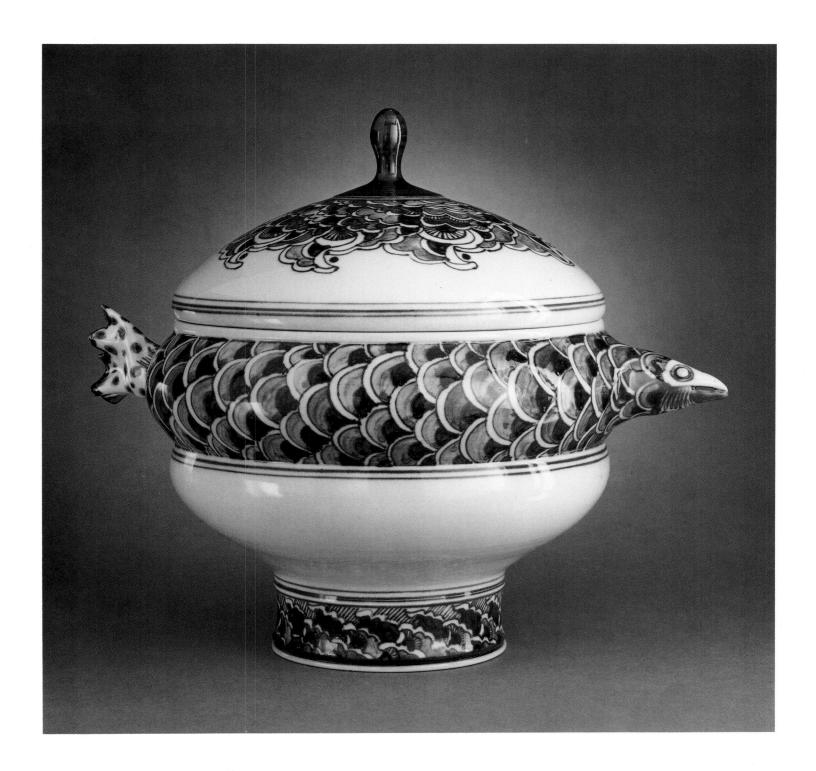

Ralph Bacerra Soup Tureen, 1978. Blue decoration on porcelain, height 15". Los Angeles County Museum of Art. Gift of Howard and Gwen Laurie Smits.

decade, when pictorial issues were to resurface strongly.

Also within the realm of the vessel are those works that were, to quote Ken Price, "not pottery so much as being *about* pottery."²⁴ The distinction may seem purely semantic but in fact it is an important one. Although one could argue that Price is more of a potter than he admits, there *are* certain bodies of work that deal with the notion of pottery as subject matter without the artist's trying to make an important pot *per se*. An example of this use of the vessel as a symbol can be found in one of the key exhibitions of the decade, Price's *Happy's Curios*, an installation at the Los Angeles County Museum of Art in 1978. In this case the impact of the installation as a whole was far greater than the quality of any of its parts.

Happy's Curios proved to be one of the most popular ceramics exhibitions of the decade, the

show being extended three times. The exhibition generated healthy, informal debate among artists, viewers, and even the Hispanic museum guards, who entered into the fray, denouncing the works (particularly those on which were painted Mexicans dozing under their sombreros) as racist. Unfortunately, the printed critiques were less lively and tended to trivialize the work as cartoons based on New Mexico folk and tourist art.²⁵ Other critics sentimentally suggested that the exhibition represented an "homage to Mexican pottery."

Price's exhibition actually had very little to say about a specific culture beyond the use of the Mexican motif. It was an homage to decorative painting, its vitality, and its pertinence today, a

Judy Chicago The Dinner Party, 1979. *Mixed media, length* 47'. *Courtesy ACA Galleries, New York.*

message made all the more effective by the use of ceramics—a decorative-arts medium. The statement was about the hierarchy in art—any art. It was a formidable treatment of the "decorative" in art the element that so disturbs the intellectual establishment. Price was taking pottery as "low art" at its most debased level—the curio shop—and painting the cliché images and forms with such skill and dash that the viewer has to respect, and so reevaluate, what he sees. Furthermore, the exhibition had to do with painting and not form. Indeed, Price did not even make many of the pots, but used painted blanks purchased from Mexican folk potters. Several of the pots that he did make were uncharacteristically flaccid and heavy. None of this mattered much in the overall context, however. As a project it proved to be so open-ended that it became physically, emotionally, and financially draining on Price. In an interview with Joan Simon, then the editor of Art in America, Price remarked, "I did what we did in Vietnam at the end—I called it a victory and got the hell out."26

Another major exhibition of this type, Judy Chicago's The Dinner Party, took place in 1979. It was a grand event—ambitious, controversial, and an important rallying point for feminist opinion. In this exhibition, as in Price's, pottery played a symbolic role. Chicago presented oversized dinner plates not simply for their aesthetic worth as individual artworks, but as key components within a massive five-year installation/collaborative art piece. The Dinner Party consisted of thirty-nine elaborate, hand-painted dinner plates placed on a large, triangular table, each with a corresponding embroidered runner. The table stood on "The Heritage Floor," which was made up of 2,300 porcelain tiles. Each dinner plate was dedicated to a "guest," a major figure (mystical or real) in the history of women. The plates were painted and modeled with symbols (centered on the form of the vagina) that were appropriate to the woman being honored. Another 999 names of "women of attainment" were inscribed on the tiles. The piece was the product of over 130 women volunteers who worked on the project. Chicago used the dinner party, an event that women plan and for which they cook but often cannot even attend, as a symbol of sexual inequality and exploitation. What Chicago was attempting to do was to create an event too large to be dismissed. "My dream is that I will make a piece so far beyond judgment that it will enter the cultural pool and never be erased from history as women's work has been erased before."²⁷

The Dinner Party opened on March 16 at the San Francisco Museum of Modern Art. The exhibition attracted large audiences but, at least from the art establishment, very poor reviews. What received particular criticism was Chicago's accompanying book/catalogue. In this she attempted a revisionist view of women's history, without any of the tools of scholarship or any attempt to back up her claims with factual data, causing one critic to write, "For God's sake Judy . . . you said you were going to write a history book, instead you wrote a bible."28 Others questioned whether Chicago hadn't herself exploited women, in creating an exhibition in which they did the work and Chicago took the glory. The ceramists were upset by the inept use of china paint and uneven ceramic techniques. Critics complained about the painting on the plates from a formalist point of view and their morbid, gynecological appearance.

Formalist criticism really had little place for *The Dinner Party*. It was not an artwork about politics. It was a political piece that *used* the vernacular of the art world and its access to large audiences. It was too didactic a work to scale the heights of aesthetic genius. With commendable candor and pragmatism, Chicago comments in her book: "No matter what people say, it is not enough to be supported by those who are powerless. It is in forcing the powerful people to accept one's ideas as significant and important that ultimately one is assured of having those ideas accepted in the world."²⁹

Laurel Reuter picked up this aspect and remarked that there is a long history of women giving dinner parties to obtain access to such influence and that this locates the focus of *The Dinner Party*—"it is about power."³⁰ As such, it only partially achieved its ends. In denying the exhibition its aesthetic endorsement, the art world has, at least for the time being, withheld the most powerful aspect of all—cultural enshrinement. Yet, it remains one of the most remarkable community events in women's art since the china-painting craze of the turn of the century.

The decade closed with a historical exhibition, A Century of Ceramics in the United States 1878-1978, curated by Margie Hughto and the author. The exhibition, which opened at the Everson Museum of Art in Syracuse on May 5, 1979, comprised 450 pieces. It was the largest exhibition of its type assembled and the first historical survey of twentieth-century American ceramics, accompanied by the first edition of this book, which functioned as its catalogue. A somewhat reduced traveling version of the show was circulated for three years through the generous support of the Philip Morris Corporation. The exhibition was shown at the Smithsonian Institution's Renwick Gallery of the National Collection of Fine Arts in Washington, D.C., and Cooper-Hewitt Museum in New York; and at other institutions. It generated reams of printed publicity as well as considerable coverage on radio and television; the Philip Morris Corporation was so taken with the exhibition that it produced a film, Earth, Fire and Water: A Century of Ceramics in the United States (narrated by Orson Welles), which was extensively shown on public television.

The time had finally arrived when contemporary ceramics had become too large and too energetic to be dismissed as commercial stuff for the craft fairs. There was a growing curiosity in the art world about ceramics and its modern history, particularly among the more adventurous collectors. Second, young ceramists had reached a point where they were curious about, and wanted to embrace, their own roots.

Suddenly critics from the fine arts were looking at ceramics in a new light, not as an orphan but as an independent discipline, coming to terms with its history. John Ashbery wrote, "The show is an important one, for it not only documents but virtually creates a continuing tradition in American ceramics over the last century, which few of us have been aware of." Many ceramists, poorly schooled in their history, enjoyed the same experience. The exhibition set off a wave of collecting (both contemporary ceramics and art pottery) that has continued unabated. The exhibition suffered from many of the flaws of a pioneering study, but in spite of these it opened a new art-historical perspective for ceramics. Writing about the exhibition in *Art in America*, Donald Kuspit commented:

It is a rare exhibition that can make us question firmly held aesthetic prejudices and help overthrow fixed, unanalyzed positions. Yet this is precisely what A Century of Ceramics in the United States 1878-1978 has accomplished. By overturning the deeply rooted negative attitude that ceramics is inherently trivial, this exhibition shatters the presumed hierarchy of the arts. . . . A democratic material in which sublime yet personal statements can be made, clay is susceptible to a variety of treatments while retaining its own Protean character. Ceramics may thus be the most truly universal art: its material is highly responsive to aspirations, while the final product is as risky and difficult to achieve as any human individuality.32

In conjunction with this exhibition, a symposium on the history and criticism of ceramics, sponsored by the Institute for Ceramic History (founded by the author), was held at the Everson Museum.³³ Its aim was to satisfy the need for a platform to discuss and encourage ceramic criticism and history. At that time the annual conferences of the National Council on Education for the Ceramic Arts (NCECA), which attracted thousands of participants, dealt mainly with technical issues, job hunting, and "hands-on" demonstrations. This annual event was socially exciting but did not address the scholarly needs of the field.³⁴ In contrast, the three-day symposium held at the Everson Museum (June 1–3), coordinated by Anne Mortimer, was strictly academic. The program attracted five hundred delegates and fifty speakers-mainly

historians, curators, and writers. This was an important moment for ceramics—it set a new tone for future conferences and provided an ongoing forum for scholarship. The keynote address was delivered by the critic Clement Greenberg, whose prioritizing of values set the tone for the conference and the decade that followed it:

Well, is ceramics getting or going to get, as photography has, the benefit of this recent leveling of status? The question requires two different answers. The one has to do with opinion, the other with actual achievement, with aesthetic results. . . . I say that the second is far the more important question, just as it's been with photography. Are ceramists to bother about being put down as potters or hailed as sculptors? Should they, and we, care about nomenclature? Opinion changes, achievement stays. Achievement also erases the difference between utilitarian [the vessels] and fine art [sculpture]. Once again, results, experienced not discussed or debated—are all that count when it comes to art as art. . . . But let the vessel maker not despair. There's nothing to say that a great pot can't match a great statue in value. Let the vessel maker show us that. There are no rules or prescriptions or laid-down-in-advance categories in art.35

Kenneth Price Town Unit, 1972–77. Wood and ceramic, height 84". Private collection. Courtesy James Corcoran Gallery, Los Angeles.

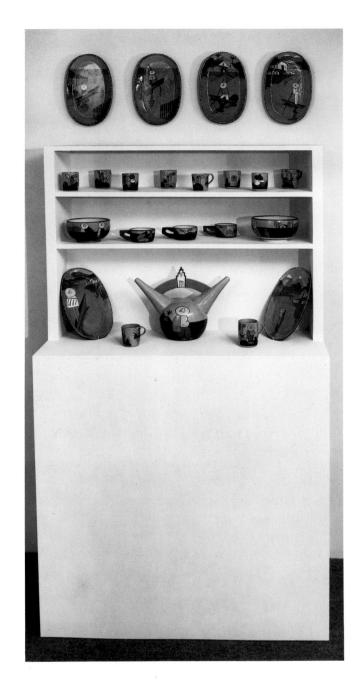

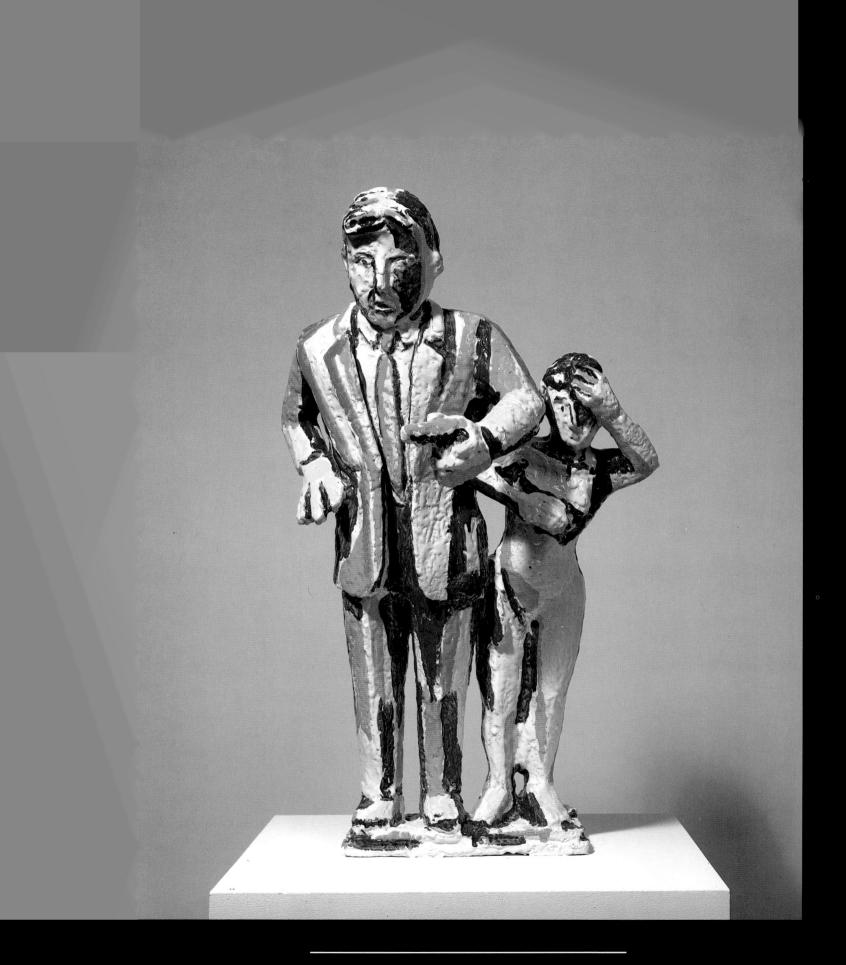

Viola Frey Man with Figurine, 1985–86. Glazed earthenware, height 35½". Collection Dr. Stanley Josephs. Courtesy Asher/Faure Gallery, Los Angeles.

historians, curators, and writers. This was an important moment for ceramics—it set a new tone for future conferences and provided an ongoing forum for scholarship. The keynote address was delivered by the critic Clement Greenberg, whose prioritizing of values set the tone for the conference and the decade that followed it:

Well, is ceramics getting or going to get, as photography has, the benefit of this recent leveling of status? The question requires two different answers. The one has to do with opinion, the other with actual achievement, with aesthetic results. . . . I say that the second is far the more important question, just as it's been with photography. Are ceramists to bother about being put down as potters or hailed as sculptors? Should they, and we, care about nomenclature? Opinion changes, achievement stays. Achievement also erases the difference between utilitarian [the vessels] and fine art [sculpture]. Once again, results, experienced not discussed or debated—are all that count when it comes to art as art. . . . But let the vessel maker not despair. There's nothing to say that a great pot can't match a great statue in value. Let the vessel maker show us that. There are no rules or prescriptions or laid-down-in-advance categories in art.35

Kenneth Price Town Unit, 1972–77. Wood and ceramic, height 84". Private collection. Courtesy James Corcoran Gallery, Los Angeles.

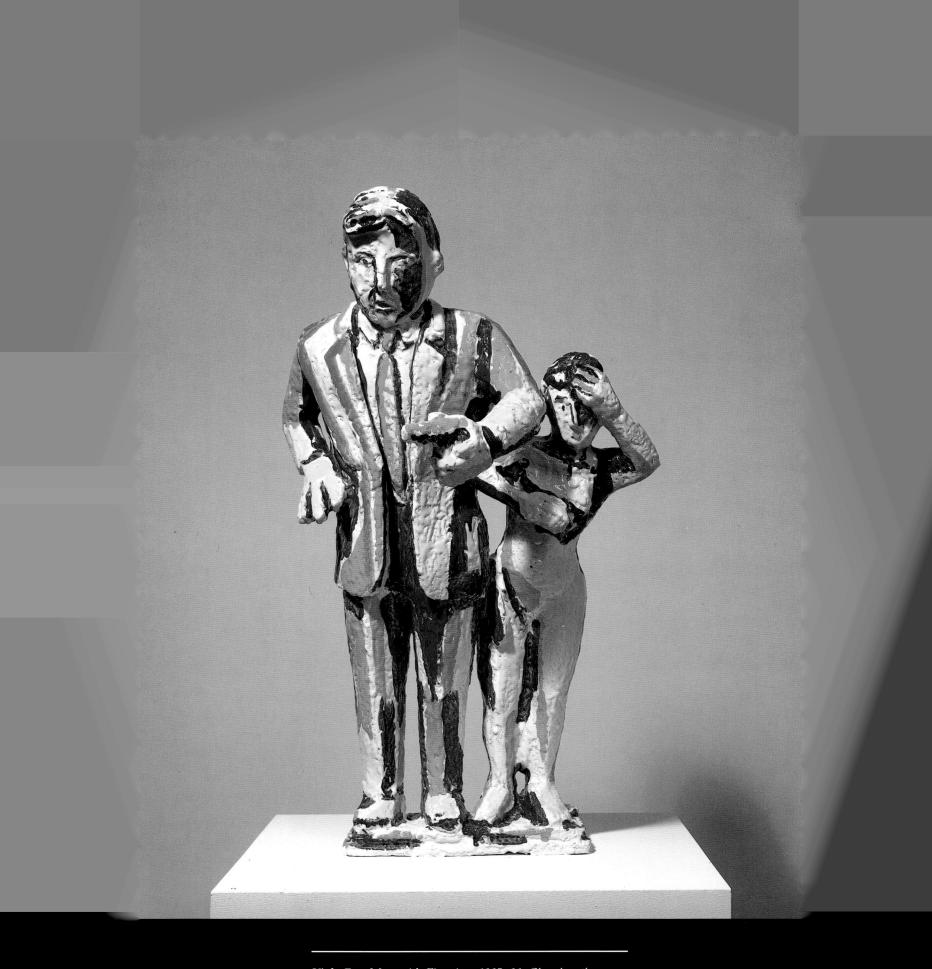

Viola Frey Man with Figurine, 1985–86. Glazed earthenware, height 35½". Collection Dr. Stanley Josephs. Courtesy Asher/Faure Gallery, Los Angeles.

surprised but excited ceramics world much of what had seemed only vaguely possible in the sev-

only vaguely possible in the seventies. The acquisition of ceramic works by museums has risen dra-

matically in this decade, as has the number of serious exhibitions. The decade has seen major retrospectives for Arneson, Autio, Frey, Wood, Turner, Andreson, Wildenhain, and others. There has also been an increase in the number of historical exhibitions, including scholarly surveys of the work of Grueby, Rookwood, Lukens, Rhead, Fulper, Ohr, Robineau, and Newcomb. The Everson Museum's exhibition Diversions of Keramos presented a detailed survey of ceramic sculpture from the thirties and forties. The overall level of scholarship (once a nonissue in the field) has surged ahead. The Institute for Ceramic History holds symposia every two years, while the annual conference of the National Council on Education for the Ceramic Arts has lessened its technical bias to include greater discussion of aesthetic, philosophical, and historical

For the first time, contemporary ceramics has begun to draw the consistent attention of art critics. There were a few critics in the past (notably John Coplans) who took an interest in ceramics, but during the eighties many of the toughest and most independent art writers, including Donald Kuspit, Jeff Perrone, John Perreault, Peter Schjeldahl, Christopher Knight, and Thomas Albright, have been attracted to the field. Other writers, such as Ed Lebow, Jeff Kelley, Michael Dunas, Sarah Bodine, Mac McCloud, though also involved in other media, have become specialists in ceramics, refining their knowledge and authority in the field. In addition, some ceramists, notably Jack Troy and Wayne Higby, have taken to the pen as well. These writers have found fine-arts and crafts journals receptive to critical appraisals of ceramic art. In addition, American Ceramics, a quarterly journal devoted solely to ceramics as an art form, was introduced in 1982.

The eighties have delivered to a CHAPTER ELEVEN

 $\overline{1980}$

During the seventies most ceramists (particularly those who made vessels) had sold through the commercial outlet of the craft shop. There were also a few pioneering specialist galleries, such as the

American Hand in Washington, D.C., Quay in San Francisco, Helen Drutt in Philadelphia, Alice Westphal's Exhibit A in Chicago, and the Hadler/ Rodriguez Gallery and Art Latitude in New York. A handful of fine-arts galleries had also shown ceramics in the seventies, notably Allan Stone and Allan Frumkin in New York. But in the eighties the interest expanded rapidly. In New York—a market once hostile to the notion of ceramic art— Stone and Frumkin were joined by some of the most respected dealers in the city: Charles Cowles, Irving Blum, Max Protetch, André Emmerich, Leo Castelli, Deborah Sharpe, Nancy Hoffman, Grace Borgenicht, Barbara Gladstone, and others. In addition, several new specialist galleries in the medium opened in New York, Chicago, San Francisco, Los Angeles, Saint Louis, and elsewhere, playing a crucial role in developing an educated group of collectors.

This growth and opportunity have not been without their cost. New tensions and pressures have emerged in the eighties, much of them stemming from a fast-changing economic structure. Until this decade the primary patron for ceramics was the university and other educational institutions that employed most of the active, exhibiting ceramic "artists." This world was expanding throughout the seventies and could be counted on to absorb most of the more talented and/or ambitious younger ceramists. During the eighties this trend has begun to reverse itself, as student enrollments decline in the studio arts. Ceramics departments have closed and faculties have shrunk. Ceramists no longer have a choice of secure teaching appointments. Furthermore, the "middle" market for functional wares has also begun to soften.

Yet, for the first time, art gallery sales are substantial enough to match and sometimes exceed

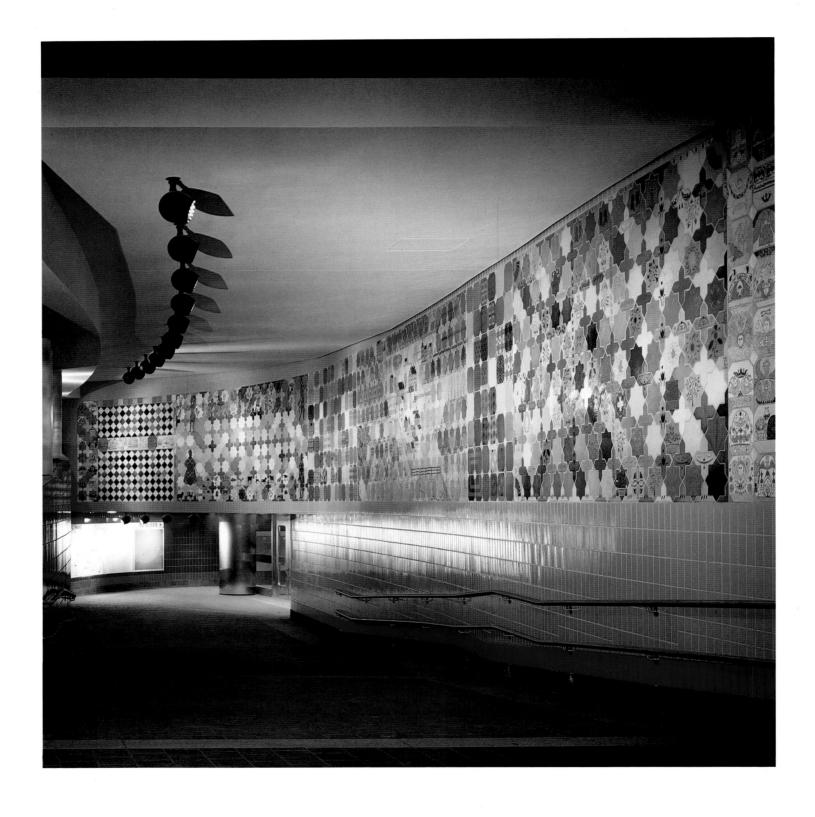

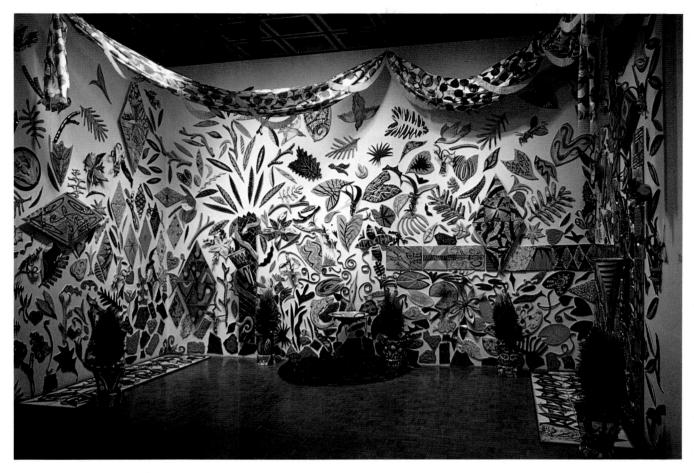

LEFT: Joyce Kozloff New England Decorative Arts, 1985–86. Tile mural for Harvard Square Subway Station, Cambridge, Massachusetts. Courtesy Barbara Gladstone Gallery, New York.

ABOVE: **Phillip Maberry** Paradise Fountain, 1983. Installation at 1983 Biennial, Whitney Museum of American Art, New York.

RIGHT: Margie Hughto Seasons, 1985. Colored stoneware clay, glaze and slips, $32' \times 28'$. Niagara Frontier Transit Authority, Utica Street Station, Buffalo, New York.

to the selection committee was perhaps foolish, given the artist's well-known taste for the seditious. However, in defense of the committee, the proposal Arneson presented seemed harmless enough and the committee had acted in good faith. It is Arneson's role that is more troublesome. Arneson professed a certain innocence throughout but could not be naive enough to believe that this piece—so explosively linked to damaged city pride, issues of sexuality, human rights, and the abuse of justice—could have been placed in public without outrage. Perhaps Arneson sought to stir the pot just a little but did not realize just how violently it would overflow. As the critic William Wilson wrote, "It's hard to see how the artist could avoid knowing he was asking for trouble with that base . . . both sides had equal opportunity to see this one coming and either work it out, or scrub the project."3

The effect of the controversy was not entirely negative. It placed Arneson in a national spotlight, increased his celebrity in the art world, and conferred the status of masterpiece on one of his more mundane works. It also caused Arneson to begin to question the direction that his sculpture had taken, an investigation that was further propelled by a withering critique by Hilton Kramer in the *New York Times*—just thirteen days after his portrait of Moscone had been rejected by San Francisco.

In 1977 Kramer had termed Arneson's work "brilliant" and "a mastery of characterization that is quite stunning." ⁴ By 1981, however, his view had changed, and, responding to the exhibition *Ceramic Sculpture: Six Artists* at the Whitney Museum, he wrote: "Mr. Arneson is obviously a star, yet his sensibility—dominated by a gruesome combination of bluster, facetiousness and exhibitionism—places a fatal limitation on what his gifts allow him to accomplish, or even to conceive. It is, I'm afraid, the sensibility of a provincial whose outlook has been decisively shaped by the art department gags of the university campus." ⁵

According to Neal Benezra, the author of Arneson's retrospective catalogue, these two rejections of his work caused Arneson to reappraise his stance and to search for a less personal, less self-indulgent focus for his art. In 1984 Allan Frumkin held an exhibition of Arneson's work. Entitled *War Heads and Others*, it was a response both to his critics and to his search for a new expression. In place of the amusing and witty figures from the legerdemain of art history was a new cast of players. They were large works—with distorted, incinerated, lesion-covered faces—

Robert Rauschenberg Pneumonia Lisa, Japanese Recreational Clayworks, 1986. Porcelain tiles with decals, height 32½. Courtesy Leo Castelli Gallery, New York.

monumental mutants from the nuclear holocaust. These heads were placed on pedestals as obscene war memorials. Those who came seeking Arneson's humor were surprised and disoriented. Yet, although there was apparently a major shift in style and content, these works were not as much of a break as they seemed; they are neatly linked to the Moscone portrait.

Until Moscone, Arneson's formula of the hero/ clown had proved to be the perfect foil for his art—using the comedy to balance the distasteful and disturbing elements in the works. But this formula could not work with Moscone. The slain mayor was neither a hero nor a clown. He was simply and tragically a victim, a condition reinforced rather than ameliorated by the sadly inappropriate smile in his portrait. War memorials are also portraits of victims. Violence exists in other works by Arneson, but it is always "self-inflicted" and made to seem foolish and nonthreatening. With Arneson's War Heads the violence was beyond the subject's control. This shift to the victim and the withdrawal of any comedic possibilities seemed to have both animated and confused Arneson. It is difficult to decide at this point whether his War Heads are an authentic expression of the artist, a sudden flush of guilt for his years of low-brow humor, or an attempt to prove the critics wrong by creating socially responsible work. Most likely they are a mixture of all three.

In an interview Arneson discussed the problems of working with humor, explaining both his nuclear work and, indirectly, the reactions to the Moscone portrait:

The nuclear issue, the implication of the holocaust, and the final solution to all mankind—that's a serious issue. I would hope that I could also have some of my natural humor get into that. . . . But humor is a problem in art. The Greeks could deal with it. The two senses of drama were humor and tragedy: The humor was real raw; the tragedy was very basic. Something has happened since the time of the Greeks; it seems like humor has become threatening or debasing. Whenever you get involved with humor people take it personally

and become offended. But you can't *not* offend anyone in dealing with tragedy. I am willing to do it, and take a lot of horseshit from the critics for doing it. Yes, it's sophomoric. But I'm sure much of our young culture [is] sophomoric. Should I be beyond that? ⁶

The only reminder of Arneson's earlier work in the Frumkin exhibition was a self-portrait, *California Artist* (1982), a self-portrait that stood in the entrance to the gallery. In this piece Arneson made fun of the East Coast critics' vision of the West Coast artist as a provincial and irresponsible figure by dressing himself in a denim jacket and placing it on a pedestal emblazoned with sensemilla leaves and other stereotypes of the sun-bleached California life-style.

Arneson shifted position again in 1986, showing the works from the latter part of that year in an exhibition at Frumkin. Some pieces, such as the "TV" portraits of Ronald Reagan, attempt to reengage the humorous, but they are neither witty enough nor black enough to be more than merely diverting. What was of greater interest in the exhibition were his "straight" portraits of Jackson Pollock. These are now moving toward heroic portraiture, with surfaces that exploit the beauty, texture, and ceramic qualities of the medium without apology or humor. One sees in these a more radical change from the *War Heads*, which, with their cartoonish images, still maintained a link to the Arneson style of caricature.

The new pieces seek to work aesthetically without the trappings of theatricality that have adorned all his previous work. Large, imposing, and brooding, they are obviously contenders as "serious" sculpture in the literal, indeed even classical, sense of the term. Arneson's iconoclasm, his perceptive intelligence and constant movement in subject, scale, content, and now, even style, have kept him in the forefront as one of the most intriguing and inventive artists in contemporary American sculpture. He also unquestionably still remains the leader in the more hermetic world of ceramic sculpture.

Robert Arneson Head-Mined, 1982–83. Glazed ceramic, height 78". Allan Frumkin Gallery, New York.

At the same time as the Moscone debate, another controversy was beginning to develop—critical response to the Whitney Museum's exhibition Ceramic Sculpture: Six Artists. The exhibition was curated by Suzanne Foley and Richard Marshall and featured the work of Arneson, Voulkos, Price, Mason, Shaw, and Gilhooly. Its opening was one of the most crowded and enthusiastic of the season. The reviews, however, did not support the opening night euphoria. Kramer denounced the exhibition as "defiant provincialism" that left him "brooding about the thinness and the spiritual impoverishment of the cultural life that has sustained this movement."7 Robert Hughes, the Time magazine critic, said that "no antidote has yet been found to the bite of the state's most annoying insect, the California cute-fly. . . . Quaintness, a whiff of sensemilla, weakness of the bone structure, a pervasive reek of the petted ego—such are the signs of the attack coupled with hermetic babblings which on that coastal paradise of the half-blown mind stand in for Imagination."8

The irony was that, although the exhibition was a failure on many levels, few of the critics were really criticizing the exhibition itself. What emerged was a bout of slightly hysterical California-bashing. The real questions that the event posed were left unanswered by all but a few. Among the writings that did address these issues were Jeff Kelley's perceptive and balanced review and John Perreault's plain-talking commentary, "Fear of Clay," in *Artforum*.9 Perreault not only explained the exhibition's considerable failings and the overall dilemma of ceramics in the art world, but he also analyzed and placed in context the hostility with which the exhibition had been greeted.

The exhibition basically lacked both a clear curatorial vision and scholarly foundations. First, the selection of artists was not particularly perceptive, and omissions, such as DeStaebler, Frimkess, and Nagle, are difficult to justify. Second, the omission of women artists (Frey and Marilyn Levine were qualified contenders) made a pointed statement about the macho bias in the early years

of the West Coast ceramics movement, but was certainly not a failing that the curators should have perpetuated. As Perreault stated, the exhibition would have been more accurately titled "Two Generations of California Male Artists working in Clay."¹⁰

Third, the exhibition was only partly about sculpture; it was also about pottery, an issue that the cautious curators decided to sidestep. This is possibly the reason they left out Voulkos's work with the plate—a central format (and the primary one for his drawing) since the 1950s. The problem was not that the curators tried to sanctify Voulkos's stack pots and Ken Price's cups as sculpture, but that they *denied* them their equal identity as pots.

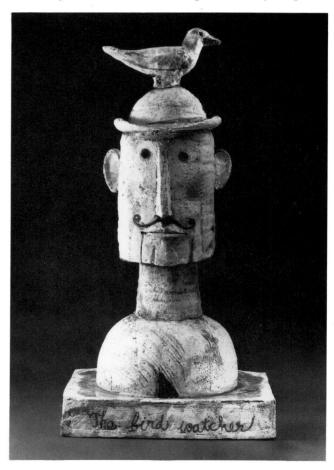

Peter Vandenberge The Bird Watcher, 1981. Stoneware, slips, height 35". Collection Daniel Jacobs.

In trying to present this medium as a newborn art form and ignoring its controversial and subversive roots in utility and craft, they missed the opportunity to make a truly radical statement.

Last, the selection and installation of work posed major problems. Each artist's work was selected according to a different set of criteria. As a result, the exhibition seemed fragmented beyond the incompatibility of aesthetics. The art ranged from Minimalism through Abstract Expressionism, Superrealism, and three-dimensional cartooning. Price's drawings and prints were shown, but the curators refused the same privilege to Arneson arguably one of the finer draftsmen of our time. The installation was a set piece in misunderstanding the objects and also in curatorial bias. Ken Price's small objects seemed to occupy a third of the space, while the monumental works of Voulkos and Mason were compressed into a small, claustrophobic area directly in front of the elevators. It was painfully apparent that the simplistic notion of "clay as art" was not enough to meld these artists into a convincing exhibition.

In the final analysis, however, *Ceramic Sculpture: Six Artists* has the distinction of being a paradox—an unsuccessful exhibition, but, by default, a most successful event. It achieved a high level of coverage from critics who, for better or worse, had not considered ceramic sculpture before, nor written about it. The exhibition also excited a period of critical evaluation in the field that went on for months, as the issues, reviews, and selections were considered. It even spawned reviews of the reviews. ¹¹ Ceramics emerged scarred but wiser, and many collectors, critics, museums, and galleries were encouraged to pick up the ceramics baton.

It is to the credit of the Whitney Museum that it did not back away totally from the field. In July 1984, at the urging of Patterson Sims, associate curator of the permanent collection, Viola Frey was given her first one-person exhibition on the East Coast. The exhibition was poorly received critically, but, as with the previous exhibition, the reviews seemed to use Frey's work as a club with

which to attack the museum on other issues.

Again installation proved to be a major hurdle. A group of ten glazed ceramic figures, ranging in height from seven to ten feet, were shown in a tight, curving arc. They stood shoulder to shoulder and were lit only from the front. As a result, they were reduced to becoming a two-dimensional wall and lost their individual character. But the carping of the critics did not slow down the growing fascination with ceramic sculpture. The Whitney acquired one of Frey's large figures as a gift to the museum. Frey was taken on by the Nancy Hoffman Gallery, and she attracted support from some of New York's more adventurous collectors. Both of the Whitney's sorties into ceramic sculpture had been, in a sense, confrontational, if for different reasons. They had awakened the art capital to the realization that ceramics was contributing to con-

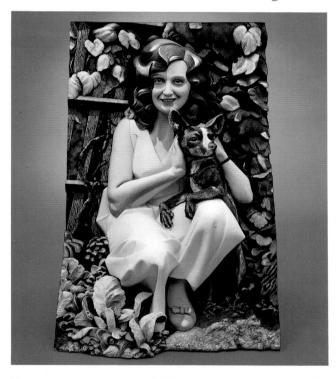

Jack Earl NOW I WILL SING TO MY WELL BELOVED A SONG OF MY BELOVED TOUCHING HIS VINEYARD. MY WELL BELOVED HATH A VINEYARD IN A VERY FRUITFUL HILL, 1985. Painted earthenware, height 33". Collection Daniel Jacobs.

temporary sculpture in a way that was fresh, original, and significant.

The exhibition that perhaps best surveyed this new energy within the sculptural movement was In the Eye of the Beholder: A Portrait of Our Time. The exhibition was curated by Michael McTwigan in 1985 at the College Art Gallery, State University of New York, College at New Paltz, New York. Unfortunately, tucked away in upstate New York, it did not attract high attendance. It was, nonetheless, an important statement. McTwigan's catalogue essay tended to give the exhibition a darkly morbid pallor: "We live in a frightening world that offers no grounds for faith, no promise for the future. . . . At the most superficial level, the tortured faces, twisted bodies, and empty lives portrayed in this seem to corroborate the verdict."12 But, in fact, there was a far lighter edge to the exhibition and an overwhelmingly more optimistic one than McTwigan acknowledged. In a similar way, McTwigan's attribution of labyrinthian psychological constructs to the works completely overwhelmed the often simple and direct visual messages that they contained.

If one puts McTwigan's essay aside, however, and examines the exhibition itself, it was a superbly perceptive assembly of work with that rare sense of symbiosis that brings survey exhibitions to life. The exhibition included eight artists: seven sculptors (Robert Arneson, Viola Frey, Arthur González, Jan Holcomb, Judy Moonelis, Patrick Siler, and Daisy Youngblood) and one potter (Akio Takamori). As always occurs in any survey, there were omissions, such as Michael Lucero and Jack Earl, but McTwigan did a good job of bringing together a mix of masters and exciting young sculptors.

The exhibition also clearly stated the two issues with which contemporary ceramic sculpture is primarily concerned—modeling and painting. Color has always been one of the attractions of ceramic sculpture. The term "painting," however, is used here quite distinctly and separately from color. In previous decades, color was used mainly in a sculptural sense. At times it became more or less

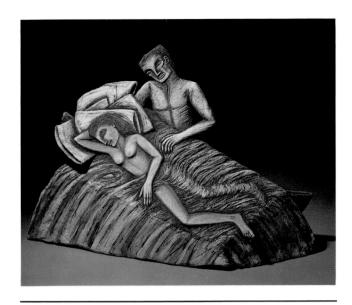

Judy Moonelis Untitled, 1986. Ceramic with painted slip, length 29". Collection Daniel Jacobs.

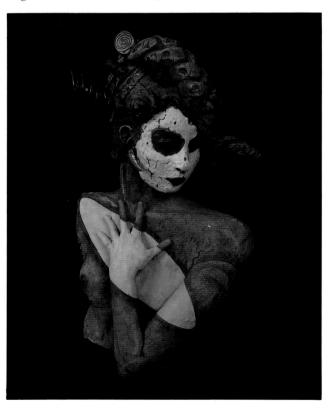

Arthur González Time Traveler, 1984. Metal, clay, slips, height 28". Collection Hope and Jay Yampol.

Jan Holcomb The Voyagers, 1984–85. Stoneware, paint, and underglaze, length 32". Collection Dawn Bennett and Martin Davidson.

Viola Frey Untitled (Man in Blue I), 1983. Glazed earthenware, height 108". Collection Betty Asher.

painterly in its application, but primarily it was used sculpturally—as a structural device to serve the form. In this exhibition only one of the artists, Youngblood, did not use painted surfaces. For the rest of the artists, however, the relative relationship of form and surface became intriguing and ambiguous. It was not apparent whether the works were paintings about sculpture or sculptures about painting. In some cases, such as that of Moonelis, the thickly encrusted slip surfaces even had the feel of heavily applied paint. Holcomb's relief sculptures were meticulously painted with acrylic, completely painting out the host material.

The exhibition dramatized the extent to which ceramics has turned its back on the modernist sculptural notion of "pure form." At one point in the recent history of ceramic sculpture, some ceramists seemed intent upon taking on the modernist sculptors. Some fine work was made, but ceramics ultimately proved to be a poor fabricating material for abstract sculpture. It was too expressionistic, resistant to large-scale use, and without the passive objectivity of metal. Today's ceramic sculptors have largely abandoned modernist sculpture and seem more intent on occupying a no-man's-land between sculpture and painting. In addition, the younger sculptors show little commitment to the moralistic nineteenth-century notion of "truth to materials," getting on with the objective business of making sculpture rather than the more romantic activity of making ceramics.

Of the artists in this exhibition it is Frey who requires further examination. Together with Arneson, she has been one of the formative influences on the direction of ceramic sculpture in the eighties. This decade has seen Frey's most dramatic and monumental work. Frey's figures have rapidly grown from modest, life-size portraits, slightly over five feet in height, to hulking figures over ten feet tall. The painting evolved from careful use of local color to the strongly abstracted use of primary

Viola Frey Untitled, 1983. *Glazed earthenware, height* 98¹/₂". *Collection Garth Clark/Mark Del Vecchio.*

color. As a body of work they are among the most remarkable clay figures ever made. In his review of her exhibition in 1986 at the Asher/Faure Gallery in Los Angeles, the *Los Angeles Times* critic William Wilson commented on the figures and their meaning:

The Bay Area sculptor has concocted an exhibition that will surely stand among the most interesting of the year. It treats the modern corporate Everyman on a par with the Pharaohs of Egypt, the heroes of the Iliad and the Shamans of the primitive tribes. This is the most openly sophisticated group of works I have seen her make. It might have been inspired by the County Museum of Art's masterful "German Expressionist Sculpture" exhibition, with a few dollops of Léger and Dubuffet thrown in for spice. But it doesn't look derivative because it isn't. Frey continues to convince us that her work is her own. She persuades us never again to snigger at the guy in the Hush Puppies taking the family to Sea World. He is Hector, she is Helen and they are the fates in adolescence.13

Frey was beginning to find that the scale of the ten-foot-high standing figures was posing a problem. The figurative gesture was losing its presence, and bulk was preying on articulation. The men in particular were becoming awkwardly humpbacked. Some figures seemed to be grappling less with notions of art than with the complexity of engineering and laws of gravity. Frey has solved this quite simply by working with reclining figures, where the sense of structure is less apparent and less physically threatening. Her figures can now continue to grow in scale. Also, the figures have now shed their floral dresses, blue suits, and red "power" ties for a comic, classical repose in the nude. Frey has also begun again to make smaller figures—about three feet in height. These objects and figures are assembled into intriguing and devious arrangements—reminiscent of her earlier china-painted tableaux of the seventies, but much

LEFT: Robert Brady Eva, 1984. Ceramic, metal, height $52\frac{1}{2}$ ". Collection Daniel Jacobs.

RIGHT: **Howard Kottler** Waiting for Master, 1986. Earthenware, simulated gold leaf and paint, height 15".

Michael Lucero Lunar Life Dreamer, 1984. Glazed ceramic, height 19". Collection Hope and Jay Yampol.

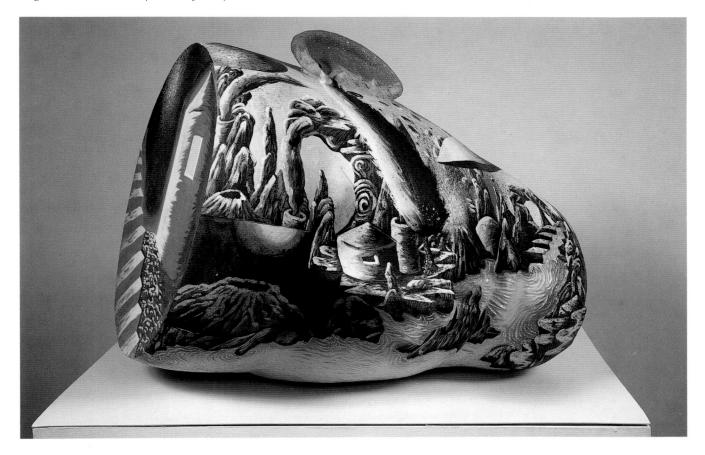

Tom Rippon An Artist and His Work, 1985. *Porcelain, height* 15". Courtesy Rena Bransten Gallery, San Francisco.

more spartan and with color employed as a structural element. The use of painting to invoke the artist's own sense of light and shade (i.e., "modeling" the surface) remains a connection between these and earlier works.

In his new work, Jack Earl uses tableaux in a completely different manner than Frey. Frey's work is about action and fragments of events, whereas Earl's work is narrative. His sculpture is supported by titles that can be ten lines or more in length and amplify the narrative, investigative quality of his work. The sculpture is presented in a "pictorial," illustrative format. The works are like a very detailed painting or illustration that has suddenly been transformed into two-and-a-half-dimensional reality. The 1980s have also seen the gradual removal of any material qualities of ceramics. In the seventies Earl used glazes and porcelain, inspired by the example of eighteenth-century figures. Now the clay is painted over with oil paint, removing from

his work any connection to ceramic tradition, a growing trend among ceramic sculptors. Earl has consistently been one of the most independent and innovative of ceramic sculptors, playing with a droll, highly personal sense of the narrative. His vision is a curious mixture of the country sage and the literate intellectual.

Michael Lucero works with the same "paint-in-the-round" approach as Earl, although his subject matter and style are unrelated to Earl's realism and folkish narrative. Lucero's interest in painting has evolved through the decade, beginning with his works from 1980—remarkable hanging figures with heads made from pots, and bodies consisting of wire and shards. With his *Dreamers* series in 1984–85, the balance of form over surface began to shift. Large heads became the canvas for the actualization of a dream landscape, where dry surfaces were mixed with liquid pools of reflecting

Richard Shaw Seated Figure with Gray Head, 1984. Porcelain, height 33". Courtesy Allan Frumkin Gallery, New York.

glaze. In these the painting began to overcome the form with noses, chins, and brows acceding to the images that covered them. As Mark Shannon comments: "Vision and flesh, eye and land, waking and dream run fluidly into one another where we wander among mountains, rippled pools, pagodas, cliffs and canyons. . . . We feel at home in their worlds; their beauty, unlike the landscape of Surrealism, is not convulsive." In the newest work the painted surface has become even more assertive, with a bright palette on large, complex insect forms.

Lucero has also begun to work concurrently in bronze, and his exhibition at the Charles Cowles Gallery in 1984 included some excellent works in this medium. Working in bronze has become something of a vogue among ceramists. Arneson, Frey, DeStaebler, and others have worked in the medium. Even potters are becoming involved, and Voulkos has recently begun to cast his pots in

Beverly Mayeri Under Scrutiny, 1984. Clay, acrylic paint, height 15". Private collection.

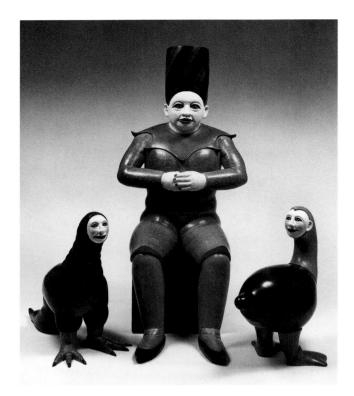

Elaine Carhartt The Wizard and Imaginary Beings, 1985. Painted ceramic, height 48" and 24". Courtesy Asher/Faure Gallery, Los Angeles.

bronze. This reflects a healthy interest for a pluralism in materials, but, given the cost of working in bronze, it also reflects a newfound confidence in the talents of these sculptors. The results of these extensions into bronze, however, have been uneven. Arneson's bronzes are flat and lifeless compared to his ceramics. Only Lucero and Frey (who paints her bronzes) have been particularly successful in using the medium with the same energy as their ceramics.

The dominant influence among the younger sculptors has been Surrealism, a romance that continues unabated since the sixties. In some cases the homage is deliberate and specific, as in Tom Rippon's reference to the proto-Surrealist paintings of Giorgio de Chirico or in Richard Shaw's porcelain figures that are assembled much in the style and mood of Miró's Surrealist assemblages from the mid-1930s. Other artists use the vocabulary of

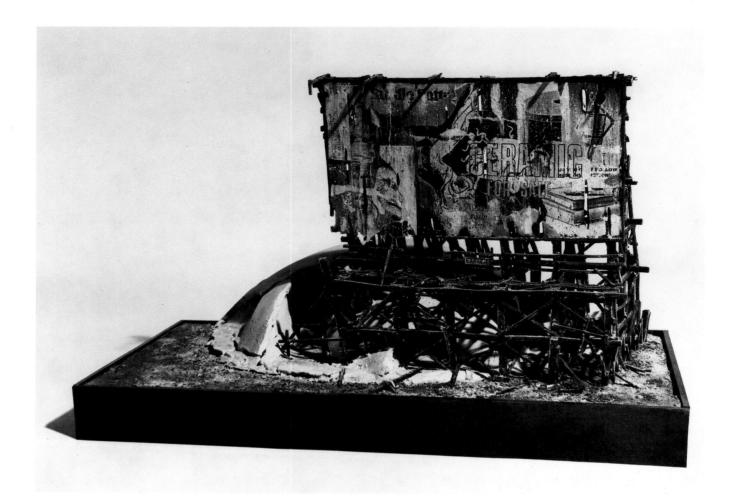

Raymon Elozua Ceramics for Sale, 1981. Ceramic, acrylic, height 15". Collection Daniel Jacobs.

Mel Rubin Phil's Diner, 1984. Earthenware, acrylic paint, length 53". Private collection. Courtesy Jan Baum Gallery, Los Angeles.

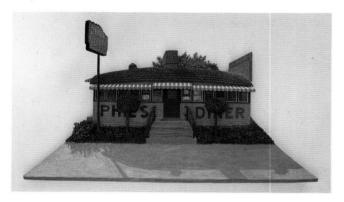

Surrealism more informally and personally. Beverly Mayeri and Elaine Carhartt both use painted surfaces on their figurative sculpture, evenly colored and without a touch of expressionism or surface emotion, creating an eerie visual silence that surrounds the work—the distinct feeling of a calm before the storm. In other sculptors' work ceramics continues to provide a vehicle for realism, as in Raymon Elozua's constructions of abandoned mines and dilapidated billboards. In Ceramics for Sale he makes a witty connection between his own medium and his interest in structure and decay. Mel Rubin, on the other hand, also uses a degree of realism, à la Hopper, to create affectionate and at times almost nostalgic evocations of architectural fragments in the urban culture.

In reviewing the interest and success achieved

by such young artists as Lucero, Moonelis, González, and others, one should bear in mind that the change in status for ceramic sculpture from a regional curiosity to a real contender in the sculpture world has been recent. Even in the late seventies ceramic sculpture was very much the in-joke, shown mainly to other ceramists in the university gallery, largely free of critical reaction, and, with a few exceptions, without serious collectors among either museums or private patrons. It was a cozy and supportive environment, very different from the tough, open market that exists today. In what remains of the decade, one will see further changes. As much as ceramic sculpture is riding a crest of interest and popularity, it is still very much a genre in flux, defining and redefining its role within the context of American sculpture.

In turning to the vessel, one finds perhaps less controversy, but certainly as much progress. Pottery has gradually acquired its independent identity as an art form. The assertion of the Seattle critic Matthew Kangas, that "most American art critics who have written about clay have never accepted the assumptions [of importance] about the vessel,"15 could hardly be more inaccurate. Indeed, the list of writers from the fine arts who have written on the autonomy of the vessel in the eighties is long and distinguished; it includes Schjeldahl, Perrone, Knight, Perreault, Gerry Nordland, and many others. This acceptance is not an attempt to place the vessel in a superior position to other works in clay, but simply to accept and explore its unique character and identity.

The concept of the pot as art has been actively argued throughout this century, but in the midseventies it began to be energetically promoted by a few writers. The potters became involved as well, and many, including Betty Woodman, Richard DeVore, Wayne Higby, and Bill Daley, discarded the notion of pottery being a subcategory of sculpture. In his 1980 review of the exhibition *A Century of Ceramics in the United States*, Perreault (then the senior art critic for the *Soho News* [New York]) made a plea for the vessel to retain its uniqueness

and warned against its total assimilation into the fine arts:

Sacrificing the tactile and kinesthetic directness of the utilitarian vessel—the pot—for sculpture may cut ceramics off from its historical, cultural, popular *and* aesthetic roots. I am all for arts/crafts interface. I am all for sculpture in clay. But a real pot, vase or plate . . . can be beautiful and even a moving thing. And pots are no more limiting as formats than those rectangular shapes the paint-on-canvas painters use. The vessel is a discipline sorely needed. 16

The impact of the British critic and historian Philip Rawson and his book *Ceramics* has been important in outlining the theory of the pottery aesthetic. Although Rawson wrote his book primarily about historical pottery, the lessons in the formal, aesthetic constituents of a vessel, in the principles of surface painting and decoration, and in the exploration of "content" through the polarities of conceit versus metaphor are as meaningful and relevant in judging contemporary pottery.

Ceramics was published in 1971 but it was not until 1980 that it was "discovered" in the United States, rapidly becoming something of a cult classic. This sudden popularity of the book prompted the University of Pennsylvania Press to republish it in 1984. Rawson's visits to the United States to deliver keynote addresses (twice for the Institute for Ceramic History symposia and once for the NCECA) have enlarged the dialogue on the aesthetic autonomy of pottery. Rawson argues that beyond a certain innocent love of the medium, there can be little growth without "ceramic literacy." Speaking at the *Echoes* conference in Kansas City, Missouri, in 1983, Rawson expanded on his literacy theme:

To people who do not possess writing, a book is a mere, mysteriously pointless object. They may have practical uses for its leaves unconnected with what is written on them; though that was not the reason for its existence. In a similar way a pot object can only be a thing, that may have its uses, to people who know how to read *its* signs and symbols. The comparison is not totally exact, I know. But I think

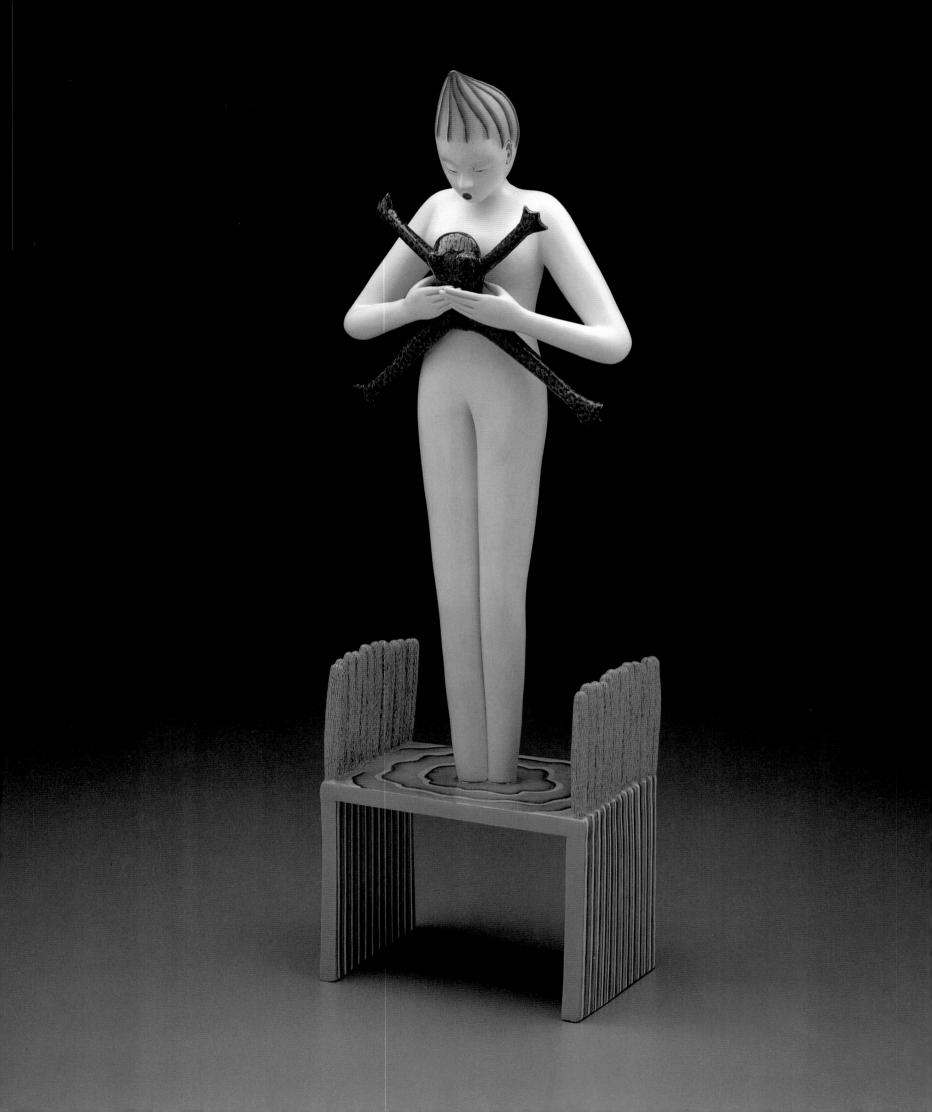

Ralph Bacerra Untitled Platter, 1986. Earthenware with underglaze, glaze and overglaze painting, diameter 23". Collection Dawn Bennett and Martin Davidson.

LEFT: Nancy Carman Desperate, 1983. Glazed porcelain, height 12". Collection Hope and Jay Yampol.

ABOVE: **Graham Marks** Stillings, 1984. Earthenware clay, coil construction with sand-blasted surface, height 31". Collection Karen Johnson Boyd.

RIGHT TOP: **Susanne G. Stephenson** Water Rock Vase, 1986. Earthenware with slips and glazes, height 17". Everson Museum of Art, Syracuse, New York.

RIGHT CENTER: William Daley To Josiah W., 1983. Unglazed stoneware, height 19". Victoria and Albert Museum, London. Gift of Mr. and Mrs. John Pickett.

RIGHT BOTTOM: **Beatrice Wood** Spiral Bottle Vase, 1984. Earthenware, luster glaze, height $16^{1}/2^{n}$. Private collection.

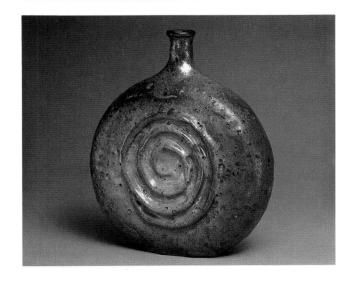

group. By then the group had lost some of its early innocence and had, to some extent, "arrived" in the art world. P&D had already developed its "stars"—Cynthia Carlson, Joyce Kozloff, Ned Smyth, Miriam Schapiro, Robert Zakanitch, Kim MacConnel, and Robert Kushner—and its influential dealers—Holly Solomon, Pam Adler, Robert Miller. But it provided little structure, fewer rules, endless possibility for experiment, and an open, nonjudgmental acceptance of materials and processes from the crafts.

In 1981 Woodman and Kozloff worked on a collaboration for the Tibor de Nagy Gallery in New York. The exhibition, consisting of pots made by Woodman and painted by Kozloff, raised eyebrows. The pots were seen as subversive "because they [were] beautiful."22 In the following year, Woodman, with Cynthia Carlson, took on a highly ambitious project entitled An Interior Exchanged at the Shirley Goodman Resource Center of the Fashion Institute of Technology in New York. Carlson made paintings of Woodman's pots. Woodman made responses in clay to Carlson's system of "relief wallpaper." Except for the paintings and the pots, which were clearly identifiable as those, respectively, of Carlson and Woodman, the issue of who did what in the decorated, L-shaped gallery was deliberately left ambiguous so that it became a true collaboration.

At this point Woodman, always a prodigious producer, began to move fast, working on room-sized installation pieces and beginning to reexamine the vernacular of the pot. In the following four years there was an extraordinary amount of activity and work. Her style is a dynamic mix of boundless energy, invention, and ambition. When the three are in harmony, they are overwhelmingly exciting. When they get out of balance, as they occasionally do, the work becomes arbitrary and empty. A case in point was Woodman's installation piece in 1985 for the exhibition *Ceramic Sculpture: Eight Concepts*, where the ambitious scale of the work completely outgrew its content.

But Woodman's ambition has also made her

one of the most experimental and innovative potters working today. Woodman has been something of a leader in expanding the potter's activity into other media, creating multimedia installations, working on fabric, presenting art events around her work, and producing handsome monoprints of vessels. In her use of the ceramic vessel she has been eclectic. She has "appropriated" (to use the patois of the postmodernists) surfaces, forms, handles, spouts, lids, silhouettes, symbols, shapes, clays, and textures from many cultures and periods—predominantly from the Chinese and the

Chris Gustin Untitled Vessel, 1984. Glazed and sand-blasted stoneware, height 30". Collection Dawn Bennett and Martin Davidson.

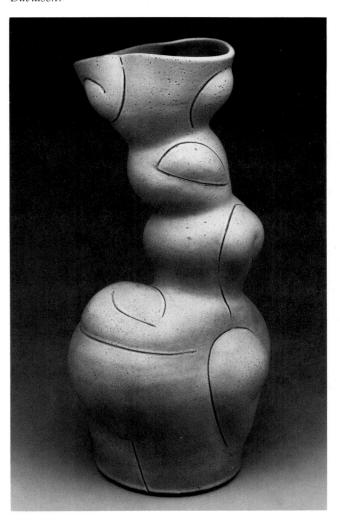

Mediterranean pottery traditions. Many of these are used with clear reference, indeed even a deeply felt homage, to their original source. But they are assembled with witty and playful incongruity—what Perrone terms "Woodman's ever changing constellation of ceramic styles";²³ for instance, a handle from a Greek krater is attached to a plump pillow pitcher drawn from Mediterranean pottery, while the surface is covered in a wash of glaze colors reminiscent of Momoyama wares.

More radically, Woodman has raised an important question in her work. What constitutes a pot? Is it a full, round, volumetric container, or can just the two-dimensional "shape" or image of the vessel suffice? Recently Woodman has been making frontal works, cutting out the silhouette of a vessel from a slab of clay and attaching it to a tall cylinder—the vase behind the vase. This cylinder can be used to hold flowers but also serves the structural role of presenting the silhouette. This is then placed on a base that either stands on a surface or is attached to the wall. This silhouette is treated just like any other pot; it can be lidded,

it is decorated, handles are added, and, if the outline happens to be a teapot, a spout is attached as well.

In addition to the pot having now been moved from a volumetric to a pictorial plane, another issue is raised. The slabs from which the outlines are cut have a spiral in light relief on the surface, the result of Woodman's technique in forming the slabs. This presents a second center for her pots. Perrone has discussed the notion of two centers in Woodman's work under the heading of "doubleness/asymmetry," but his writing deals with her full, volumetric forms. The first of the centers in her silhouette pots comes from the traditional center of the pot—that is, the vertical axis, even though this is implied rather than real. The second center is horizontal, piercing the pot from the point at which the spiral commences. Thus, two intersecting foci cross and interrelate in her work.

Woodman took this spatial play a step forward

Mark Pharis Soy Bottles, 1985. Stoneware, height 8½". Collection Dan Jacobs.

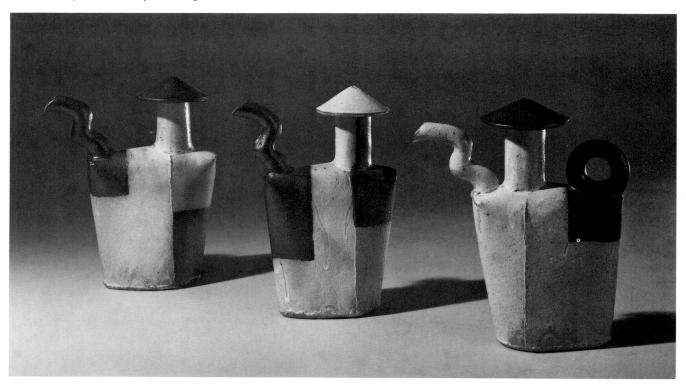

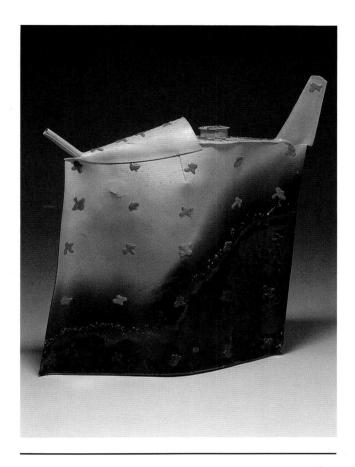

Philip Cornelius Aspen Teapot, 1983. Porcelain, slab built, height 13½". Collection Daniel Jacobs.

in her exhibition in 1986 at the Max Protetch Gallery in New York. Woodman removed the handles from her outlines and pinned them against the wall, thereby creating a third spatial element in the work. She had done this previously, with her shadow pots, but adding the shadow was a less potent gesture than physically detaching an *integral* part of the vessel.

This two-dimensional aspect of Woodman's work has been dealt with in some detail because it raises a current issue, which could be termed the "pictorialization" of the vessel. It is an important and innovative direction that is appearing in the work of many potters, and while Woodman was not its originator, she is certainly one of its most adventurous exponents. Simply, what is developing is a mixture of ideas that are pictorial visions of

the vessel (i.e., what one might do if one drew or painted a pot) and a modified, nominally threedimensional reality.

The idea has been around for centuries in one form or another, but it has not generally involved the same distortion of form that is now taking place. Its modern pioneer is the British potter Elizabeth Fritsch, who in 1971 began to make extraordinary vessels that appear from a distance to be fat, round pots. But on closer inspection, one finds, in fact, that the pots are actually flattened, oval shapes and that the foot and the rim have only been "drawn" to suggest their fullness. Fritsch influenced a number of potters who began to play with this new illusory, trompe l'oeil space.

In America this illusory volume has taken a wide variety of expression, from Harris Deller's compressed teapots to Akio Takamori's erotic envelope pots with their drawn rims of men, women, and animals. Phil Cornelius has done much the same thing with his paper-thin teapots, reducing the volume on his long, flat forms to a minimum and playing with the silhouette of the pot, which in turn takes on the shape of World War I tanks, airplanes, and battleships. Mark Pharis is the surprising entrant to this field—surprising only in that his roots are traditional, the utilitarian enclave of the Minnesota potters. In his work Pharis takes simple functional forms (mainly the teapot and the sauce bottle) and treats them as three-dimensional drawings. Some teapots are reduced to narrow, flat forms that emphasize the defining edge over volume; other pots are slightly distorted and off center, as though "drawn" from a perspective of looking down at the vessel at a sharp angle. Emerging as it does from the traditional lineage of Leach and MacKenzie, Pharis's work is optimistic and regenerative, pointing to a quiet but growing revolution among America's finest functional

The issue of the pot as a drawing takes on a different significance in the work of Andrew Lord, a British potter who has recently moved to the United States via Amsterdam. Lord's arrival has

Judith Salomon Slab Vase, 1984. *Glazed earthenware, height* 16". Private collection.

BELOW: Andrea Gill Teapot and Cup, 1984–85. Tin-glazed earthenware, height 27". Collection Betty Asher.

BELOW RIGHT: **Roseline Delisle** Série Pneumatique 10, 1986. Porcelain, height 11". Collection Laddie J. Dill.

FAR RIGHT: Jerry Rothman Ritual Tureen, 1982. Glazed stoneware, thrown and hand-built elements, height 22". Private collection

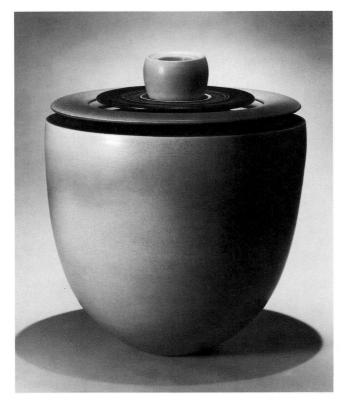

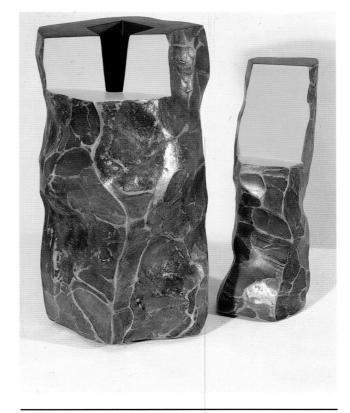

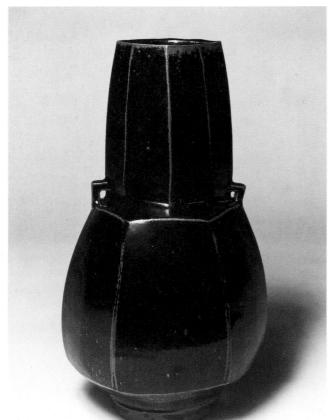

TOP LEFT: Art Nelson Meta Vessel, 1984. Glazed earthenware, height 17". Collection Hope and Jay Yampol.

LEFT: **Jeff Oestreich** Vase, 1986. Glazed stoneware, height 14". Private collection.

ABOVE: **Kenneth Price** Gomo, 1985. Acrylic and metallic paint on earthenware, height $10^{1/2}$ ". Courtesy Willard Gallery, New York.

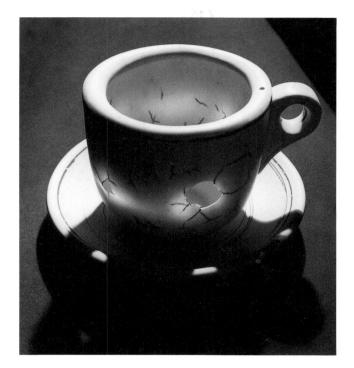

RIGHT: *Irvin Tepper* Daniel's Cup, 1982. *Porcelain; cup, height* $5^{1}/_{2}^{n}$; saucer, diameter 8^{n} . Collection Dan Jacobs.

BELOW: **James D. Makins** Cup/Saucer, 1983. Black porcelain, height 7". Courtesy the artist.

Andrew Lord Coffee Service, 1985. Painted stoneware, height 3⁷/₈"-7⁵/₈". Courtesy BlumHelman, New York.

ruffled the feathers of the hermetic ceramics world. This was the result of several factors—a touch of xenophobia, a degree of envy and distrust surrounding Lord's instant celebrity in the United States, and a healthy dose of irritation from the art press's uninformed claims of historical innovation in Lord's work. Although Lord had been exhibiting actively in England and Europe since the early seventies, his first exhibition in the United States took place in 1981, at the BlumHelman gallery. The *New York Times* critic John Russell called it "the most original show of the month," while

Roberta Smith wrote in the *Village Voice* of the lack of alignment of form and surface as "unusual for ceramics and [something that] makes the work seem poised, ready for action."²⁵ The claims about the unique use of the vessel and the "break" with ceramic tradition in Lord's work were certainly spurious. Lord's visual vocabulary was at least twenty-five years old by American standards and a good deal older if one takes into account the work of the Italian Futurist "Aeroceramisti" from the twenties. Whereas the Futurists had produced forms similar to Lord's, the Otis group had advanced the idea of breaking up surface and form into a more dynamic relationship. It was probably with this in mind that Michael McTwigan de-

nounced Lord's work as "some kind of disfigured ceramic," noting that "the brilliance of the gallery spotlights certainly aided Lord. . . . I would suspect these [pots] would look rather dull in the light of day. They certainly would in the light of a little history."²⁶

But, although Lord's work was not unique in terms of content, it was fresh and innovative in style. As with the work of Pharis, Lord's pots were also drawings—monochrome extractions of pots from the still lifes of Cubist painting. Because they drew from the two-dimensional realm, Lord's pots did not have to "behave" like conventional pots. They were disfigured because they were being constructed with the freedom of a modernist draftsman more than the modern potter. In evaluating Lord's place in the eighties, it is important to distance oneself from the distorting adulation that has been heaped on his work and to examine the real contribution, which is, nonetheless, substantial and impressive.

Examined individually the pots are mute and strangely uninteresting. But to analyze them in this traditional context is incorrect. Lord's pots function only within the idea of a still life, working in groupings of anything from three to fifty-five pieces. Christopher Knight calls these "pictures that have been pushed, pulled, coaxed and cajoled into volumetric space." Some works, where the vessel is flattened, are certainly less volumetric than others, but even in these the tease between two-dimensional origins and three-dimensional realities remained.

What is exciting in Lord's work is that it has consistently grown and expanded. The vocabulary remains limited to a few forms, some of which Lord has been using since his student years, but the level of articulation of his ideas constantly increases, as does his shrewd play with the modern still life. This was particularly apparent in his 1986 exhibition at the Margo Leavin Gallery in Los Angeles, which arguably included his finest work to date. The works show many cracks and fissures to indicate an indifference to the formal concerns

of craft. Some are left exposed. Other cracks are "healed" with a gold resin. In early pieces this use of gold was subtle, filling a crack or two as a highlight. But in this exhibition it was expanded into an impressive, painterly statement. In his newer work Lord dapples the entire surfaces of his bigger still-life groupings with gold "flashes," playing brilliant light against flat, receding darkness. In his geometric still lifes one sees considerable progress as well. The play of line between the two or three vessels making up the group has become more sophisticated and kinetic, resulting in complex relationships of real and implied space.

Whether the work belongs properly to the realm of the vessel or to that of sculpture is possibly more a question of marketing than of the work's true location in art. It could be argued that Lord belongs to both. And yet, Knight is incorrect in stating that Lord's pots have "little if anything to do with the traditions of pottery and crafts." Certainly the making of a traditional pot is not the raison d'être for his work, but Lord is no more

Andrew Lord Jug, Vase, and Dish, Geometry, 1986. Stoneware painted with oxide, height 4"-10". Courtesy Margo Leavin Gallery, Los Angeles.

free from connections to the tradition of pottery than a painter can ever be free of the traditions of painting. It is not his *freedom* from this tradition that matters, but his *relationship* to the tradition.

Lord's work is filled with references to pottery. The use of pitcher forms, bowls, and lidded jars is specific, and, as a result, the association with utility lies just under the surface. It is subconsciously and unavoidably part of the content of the work, even though it is patently not the intent. Lord's forms reveal quite specific and identifiable connections to the history of pottery, particularly to the coarse, satisfying shapes of English medieval wares and to the lidded "ginger jars" of Delft. The cracks and fissures that "would lead any selfrespecting potter to consign the [pot] to the scrapheap"29 in fact have a distinguished precedent from the sixteenth century to the present in Japanese Bizen ware and its aesthetic of the perfect imperfection. In addition, the mending of the cracks in Lord's pots with gold-while functioning superbly for him on an aesthetic level—also has its precedent in ceramic tradition.

In Japan the collector has for centuries had the more valuable pots obviously restored with gold lacquer. This is a symbolic act, placing the aesthetic value of the vessel above that of precious metal. These connections to the potter's tradition are not drawn in order to reduce Lord's work to the level of a craft object but simply to place the claims of innovation in perspective and to illustrate the complexity of his relationship to the sustaining tradition of pottery.

The pictorialization of the vessel extends beyond the abstraction of Woodman, Pharis, and Lord. It is also concerned with more traditional applications of the pictorial—that is, drawing *on* the pot rather than making the pot itself the subject of a drawing. It is only within the last ten years that placing images on vessels has again become fully respectable. In the sixties and for a good part of the seventies the use of pictorial elements on a pot was considered decoration and, by definition, trivial. This was the result of the general dominance

of post-1950s American art by the Abstract Expressionist/Minimalist aesthetics. During this time most ceramists considered even the finest painted maiolica and Greek vases irredeemably decadent. Potters were either exploring the more rugged "truth-to-materials" aesthetic of Japanese pottery or the purity of organic abstraction. Consequently, an undecorated pot was held to be a more pure and serious object.

The current master of this genre of the painted pot is unquestionably Rudy Autio. His appearance in this text has been delayed until the eighties because, much as with Woodman, it is only after thirty years of work that contemporary taste and Autio's art have connected. In addition, the eighties have been Autio's most prolific and accomplished

Rudy Autio Sacrifice of Iphigenia on Her Wedding Day, 1983. Porcelain, glazed, slab built, height 40". Museum of Art, Carnegie Institute, Pittsburgh, Pennsylvania. Decorative Arts Purchase Fund.

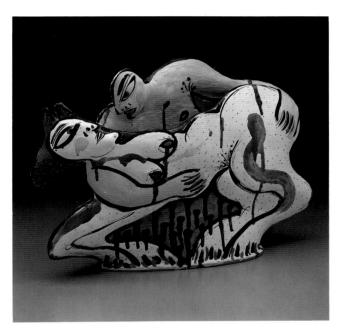

Akio Takamori Man with Dog/Woman, 1983. Stoneware with glaze and slips, height 17". Collection Hope and Jay Yampol.

period of work. Autio works on large, vaguely anthropomorphic vessel forms, on which he paints a floating and complex landscape of figures with a style drawn loosely from Matisse, Chagall, and others. Although the appearance of the work is unquestionably contemporary, the concept of the work is centuries old and connects Autio with the tradition of the figural painted vessel. Writing of this continuity, Autio has commented that his situation was not unique:

Images can lose a sense of proportion even though they may seem graphically correct if viewed from any given face of the vessel. I can imagine an early Greek master in sixth century B.C. working on his pots in the agora, turning the amphora around and around, wondering as he painted how the space would work on the other side. "How will I complete the image? What should I put on the other side to make it work? I have to keep the spirit and the design the same, or nearly like the one on this side and yet it has to be different." A Zuñi potter setting down the geometric patterns of his tradition has the same thoughts. . . . An age-old problem for the potter.³⁰

This age-old problem is nonetheless constantly a fresh challenge. Certainly Autio has given the idea new life and a warm, fecund sexuality. There are differences between Autio's use of the pot's pictorial space, or what Rawson prefers to call "potter's" space, and that of the potters of ancient Greece. The Greek pot painter worked within the specific "frame" of the pot and did not involve himself that deeply with the form. The relationship of image to form was complementary but passive. In Autio's work the surface/form relationship becomes active and dynamic. Writing about this relationship, Edward Lebow notes that in Autio's early figurative works the forms were explicitly

Akio Takamori Self-Portrait, 1985. Salt-glazed stoneware, height 28". Collection Richard Schroeder.

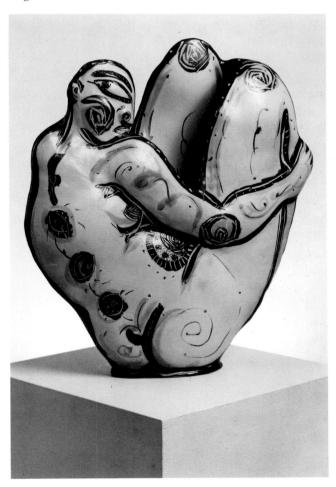

AMERICAN CERAMICS

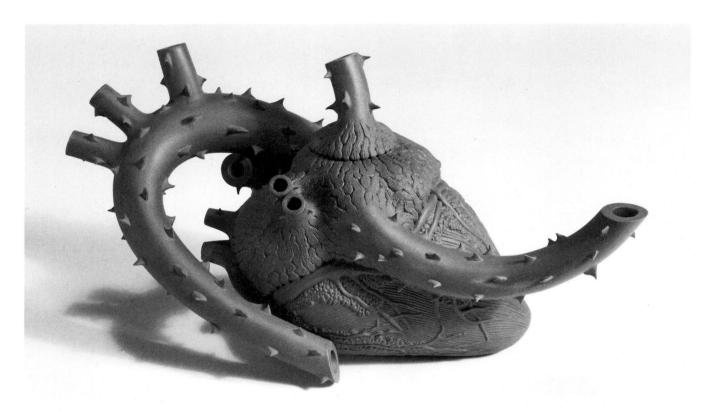

Richard Notkin Heart Teapot: Sharpesville, 1986. Unglazed stoneware, height 6". Collection Dawn Bennett and Martin Davidson.

RIGHT: *Richard Notkin* Cooling Towers Teapot #3B, 1983. *Stoneware, height 6". Collection Daniel Jacobs.*

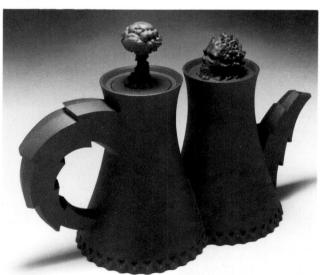

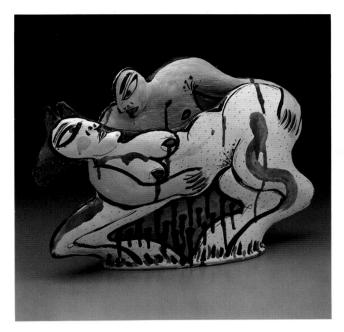

Akio Takamori Man with Dog/Woman, 1983. Stoneware with glaze and slips, height 17". Collection Hope and Jay Yampol.

period of work. Autio works on large, vaguely anthropomorphic vessel forms, on which he paints a floating and complex landscape of figures with a style drawn loosely from Matisse, Chagall, and others. Although the appearance of the work is unquestionably contemporary, the concept of the work is centuries old and connects Autio with the tradition of the figural painted vessel. Writing of this continuity, Autio has commented that his situation was not unique:

Images can lose a sense of proportion even though they may seem graphically correct if viewed from any given face of the vessel. I can imagine an early Greek master in sixth century B.C. working on his pots in the agora, turning the amphora around and around, wondering as he painted how the space would work on the other side. "How will I complete the image? What should I put on the other side to make it work? I have to keep the spirit and the design the same, or nearly like the one on this side and yet it has to be different." A Zuñi potter setting down the geometric patterns of his tradition has the same thoughts. . . . An age-old problem for the potter.³⁰

This age-old problem is nonetheless constantly a fresh challenge. Certainly Autio has given the idea new life and a warm, fecund sexuality. There are differences between Autio's use of the pot's pictorial space, or what Rawson prefers to call "potter's" space, and that of the potters of ancient Greece. The Greek pot painter worked within the specific "frame" of the pot and did not involve himself that deeply with the form. The relationship of image to form was complementary but passive. In Autio's work the surface/form relationship becomes active and dynamic. Writing about this relationship, Edward Lebow notes that in Autio's early figurative works the forms were explicitly

Akio Takamori Self-Portrait, 1985. Salt-glazed stoneware, height 28". Collection Richard Schroeder.

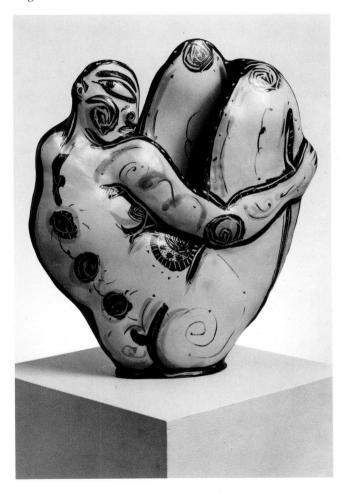

AMERICAN CERAMICS

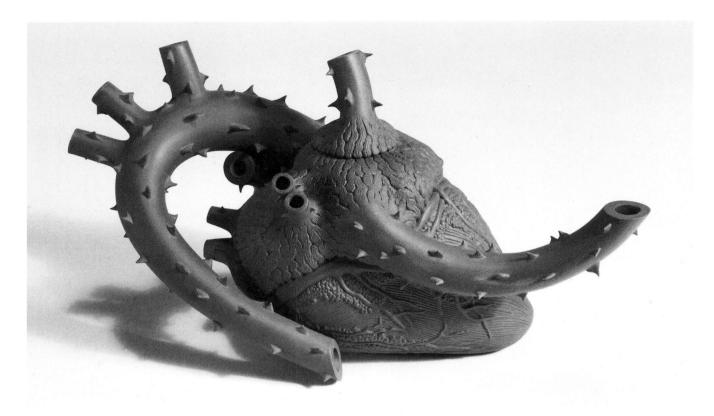

Richard Notkin Heart Teapot: Sharpesville, 1986. Unglazed stoneware, height 6". Collection Dawn Bennett and Martin Davidson.

RIGHT: *Richard Notkin* Cooling Towers Teapot #3B, 1983. *Stoneware, height 6". Collection Daniel Jacobs.*

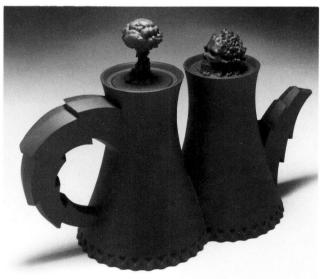

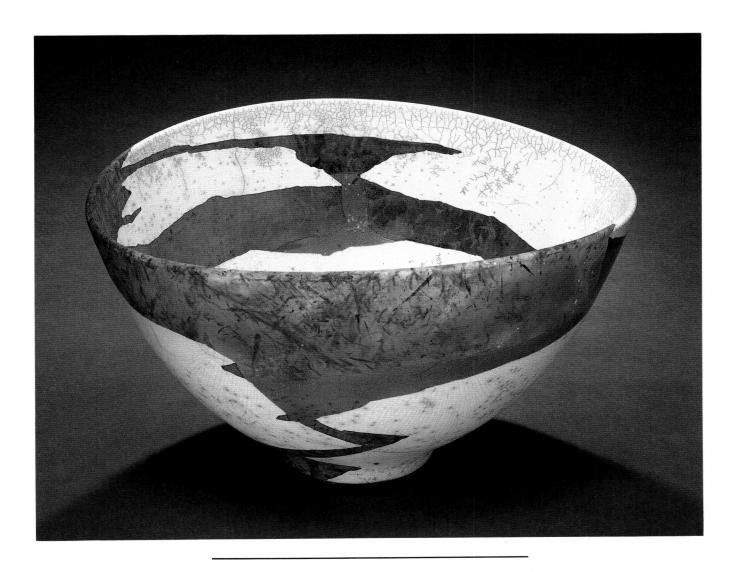

Wayne Higby Sun Rim Canyon, 1984. Glazed earthenware, raku fired, height 10½". Collection Daniel Jacobs.

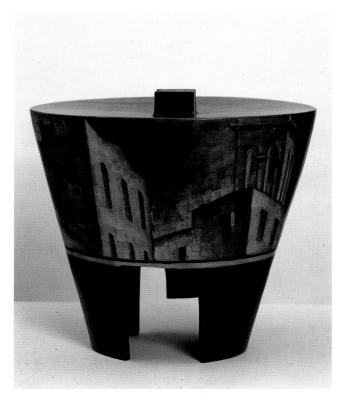

torsos, but that this anthropomorphism has now become abstracted and liberated, and that his pots are now slab-built into irregular cruciform shapes:

Not a precise and well formed cross, but crooked, asymmetric, schematic—apparent only after some consideration. By drawing the eye to its irregular but simple volumetric profile it establishes the terms of our experience of the pot. Certainly, Autio must have realized this, for he appears to have begun using these volumetric outlines to waken rather than merely to accommodate the linear power and sensuosity of the surface drawings. He began to draw the hollow shapes more completely. . . . Like the animals that primeval man incised and painted on the outcropping walls of caves, Autio's drawings appeared to bring out the innate forms of the underlying clay. This wasn't simply a matter of the surfaces illustrating what their forms already conveyed—though in weaker works this does occur—but one of empathy between their effects.31

Younger potters have entered the field of figural vessels and have produced some new "perspec-

Lidya Buzio Roofscape Vessel, 1986. Earthenware, slab built and burnished and painted with underglazes, height 16". Collection Betty Asher.

tives"—in both the figurative and literal sense of the word. Akio Takamori combines drawing on his pots and the notion of the pot as a drawing. He has released the rim of the pot to become a free form, a fluid line with which he can draw the outlines of animals, figures, or heads. The image on the vessel and the shape of the pot merge to become one. In addition, the tight, compressed, envelope-shaped forms create the ideal visual tension for Takamori's erotic exploration of sexual ambiguity. In the work of Anne Kraus we find a set of informally molded vases, cups, saucers, teapots, and compotes that draw from familiar shapes in eighteenth-century Meissen and Sèvres pottery as well as from the more vulgar excesses of the nineteenth century. At first the pots seem disarmingly decorative, but closer inspection of the drawings and legends in the reserved panels reveals the subject matter is both contemporary and disturbingly personal—dealing with doubt, alienation, despair, and a collection of moments of disappointment and self-doubt.

As the illustrations to this chapter attest, there are many more artists working on this aspect of the decorative vessel. Among the works by these artists are Wayne Higby's bowls, with their elusive play with perspective and the marrying of inside and outside. Using the dry, transparent manner of fresco, Lidya Buzio paints the sensual, burnished surfaces of her tensely curving pots with a beehive of "inner" architectural volumes. Her literal subject matter is the SoHo roofscape, but her real interest is in creating the effect of plunging deep into the pictorial interior of the vessel by painting architectural perspectives on curved surfaces. Christina Bertoni's constellation bowls appear like latter-day Mimbres pots in their dramatic use of positive and negative. They seem to serve a similar symbolic function in trying to locate man between the tangible and the universal. Richard Notkin's teapots

use another aspect of pictorialism. The teapots become representational images of other things. Drawing from the tradition of late–Ming Yixing teapots, he has created a series of provocative works that deal with political issues. The *Cooling Towers Teapot* functions with symbolic clarity. The thought of steaming tea pouring from this object is an image of immediate potency.

The pottery of Adrian Saxe does not fall into the category of either the "new decorative vessel" or the pictorialization of the vessel. Even though the pots are highly decorative and employ pictorial elements, Saxe's work is about something else altogether—a kind of supermannerist collaging of style, cultural appropriation, and witty irony. With Saxe this becomes a confusing combination in which, within a single piece, one decorative device appears simply for its aesthetic appeal (i.e., its beauty), while other elements are suffused with symbolism, literal meanings, and sharp satire. Peter Schjeldahl sees this mixture of beauty and content as making Saxe's pots "glamorous and untrustworthy, like a pedigreed dog that has been known to bite."32

A case in point is the *Untitled Jar* (1985) that was exhibited in Los Angeles. In the review of the exhibition in the *Los Angeles Herald Examiner*, Knight remarked on the symbolism in the work and how Saxe was able to incorporate a sybaritic enjoyment of Sèvres pottery into a social and political matrix: "One of the finest pieces is a luxurious royal blue vessel decorated with a golden fleur-de-lis and crowned by a spherical bomb with a gaily upturned fuse. The crazed lust for Sèvres porcelain by the French monarchy—and the subsequent economic chaos brought on by overindulgence of monumental

TOP RIGHT: Anne Kraus I'm Always Here Teapot, 1986. Glazed earthenware, height 10". Collection Hope and Jay Yampol.

BOTTOM RIGHT: *Anne Kraus* Patience/Ambition Vase, 1986. *Glazed earthenware, height 9". Private collection.*

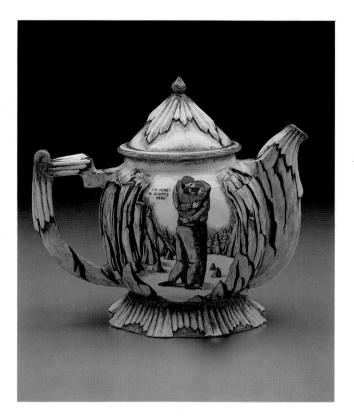

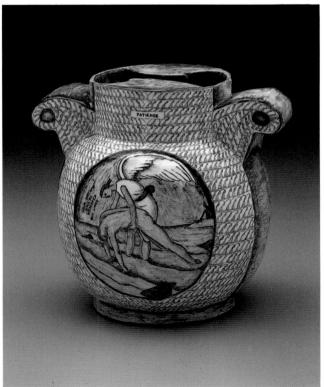

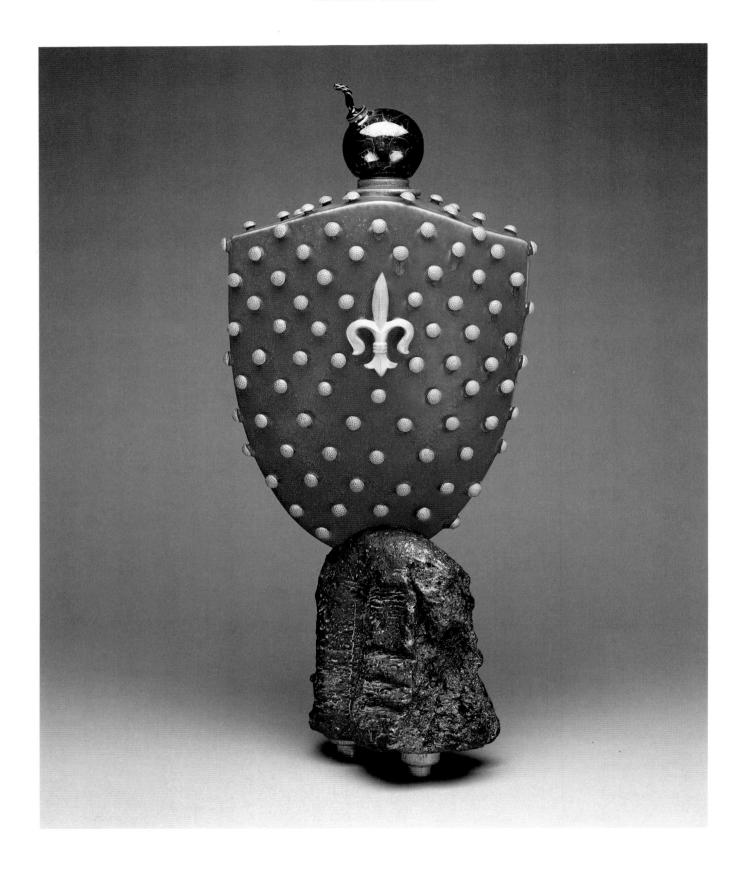

Adrian Saxe Untitled Jar, 1985. Porcelain and stoneware with glazes and overglaze, height 22". Collection Gary McCloy.

proportions—has long been recognized as one of the primary matches that lit the fuse of the French Revolution."³³

Certainly the identification of Sèvres porcelain as one of the more *visible* aspects of France's social irresponsibility does give a subtle political edge and unease to Saxe's use of Sèvres—and other court porcelains—as one of his primary motifs. The use of gold luster, remarkably beautiful silver and platinum tracings, and jewel-like glazes is deliberately subversive. Saxe enjoys these surfaces for their decadence while at the same time is happy with the fact that their opulence will set many teeth on edge and raise social issues. This is part of their inherent tension.

In examining Saxe's work Schjeldahl came up with the term "the smart pot." His comments are primarily directed toward the work of Saxe but they are broadly instructive and point the direction in which the vessels of the eighties are already beginning to move:

The smart pot is an academic object positing an imaginary academy, the brains of an allembracing civilization. The smart pot is so removed from innocence, so thoroughly implicated in every received notion of nature and culture, so promiscuous in its means and open in its ends, that it's almost innocent all over again like Magellan leaving by the front door and circumnavigating the globe to come in the back. The smart pot is tantalizing rather than pleasing. It hangs fire. It is not "art." The smart pot Xrays the hoary art/craft distinction to reveal its confusion of values: values of prestige fouling up values of use. . . . The smart pot accepts the semiotic fate of everything made by human beings, the present wisdom that every such thing is consciously or unconsciously a sign. Given the choice, the smart pot opts to be conscious. It represses no meaning, however disturbing.34

TOP RIGHT: Adrian Saxe Untitled Bowl, 1983. Porcelain and raku, height 18". Collection Al and Mary Shands.

BOTTOM RIGHT: Adrian Saxe Teapot, 1983. Porcelain, glaze, overglaze, height 10". Collection George and Dorothy Saxe.

With the increasing sense of the vessel as a separate and distinct art format has come the idea that the ideal home for the potter in the eighties is *not* the fine arts but the decorative arts. To some potters, after years of trying to win over the fine arts (and having achieved a little success), this seems to be a form of heresy—a retrogressive view. But, in fact, it has many benefits. As both Perreault and Schjeldahl have noted, the excitement of the pot is its very "outsider" quality, that it presents ideas, values, and issues that cannot be dealt with in the fine-arts establishment. Full membership in the fine arts would require the potter to give up many of the qualities that form the most intriguing aspect of the ceramics tradition. With a few exceptions, most potters work out of the decorative arts as their base and primary source of inspiration. As always, there are exceptions, and some nominal vessels, notably those of Arnold Zimmerman, have little to say about pottery and, given their scale (up to eight feet in height), reflect the artist's use of the vessel as an image for sculpture.

There is a growing trend toward examining the fine and decorative arts as equal but separate elements. The Museum of Modern Art's 1986 exhibition Vienna 1900 is an excellent case in point, showing the period as a cultural entity that encompassed painting, sculpture, decorative arts, and architecture. Another example is the Art Museum of the Carnegie Institute, which now installs contemporary decorative arts and painting in the same halls. These developments, which are being emulated by other institutions, mean that the potter, while retaining his or her separateness, can look forward in the future to being integrated into major exhibitions and museums without having to kowtow to fine-arts formalism.³⁵ This ability to occupy the cusp between the fine and decorative arts will ultimately give the potter the greatest creative freedom and expressive potential.

In looking back over the past decade at the extraordinary progress of American ceramics, one cannot but wonder about the future of the medium.

The collector Fred Marer once referred to the activity of the historian as "predicting the past," which, even with all the facts at hand, is a perilous undertaking. Predicting the future is even more foolhardy. Yet it is always intriguing to peer over the wall of time and imagine what lies ahead. First, one perceives that the process of selection through the marketplace will continue and may become even more exclusive and restricted than it is today. As the collectors become more literate, they grow more sophisticated and demanding in their tastes. At the same time, rewards will increase for those whose level of achievement keeps them in the active arena

For the ceramic sculptor the best scenario for the future might well be the dissolution of the "ceramic sculpture" movement and the integration of its best artists into the fine-arts mainstream. For the potter, a degree of aloofness and distance from the fine-arts embrace seems appropriate. This should not be seen as a gesture of dismissal, envy, or fear, but rather as one of independence and caution. If the trend of declining studio programs in the universities continues, the numbers in the ceramics movement (already radically lower than in the late seventies) will continue to diminish. This will cause new economic problems and solve some of the current ones. With fewer potters in the market, those who produce superior functional wares will be able to restore a once lucrative marketplace.

The major problem in this projection for American ceramics will be the young ceramist. Most of those who are today producing their mature work were supported during their formative periods by the educational institutions. Others survived by making objects for the more commercial "middle" market for crafts. Neither option is as open today, and thus the ceramist coming out of the art departments faces a tougher situation. He or she is usually too underdeveloped for the art market and has little chance of a teaching post. To some extent, attrition is healthy. American ceramics at the beginning of this decade had become bloated,

with talentless ceramists being churned out year after year by over 450 graduate and postgraduate ceramics programs. So, after a period of oversupply, the current slimming program is healthy, but only to a point. The current generations that are surveyed in this book will carry ceramics into the twentyfirst century with energy and literacy. Thirty years from now, however, the field may find itself losing continuity unless means can be found to bridge the present and the future for the young ceramist. Maintaining levels of achievement in American ceramics will always be the first priority of the goals for tomorrow, but this must now share its place on the agenda with a pedagogic imperative making sure that there will be a new generation to whom the ceramic baton can be passed.

Arnold Zimmerman Five Ceramic Vessels, 1982. Stoneware, stains, height 72". Everson Museum of Art, Syracuse, New York. Gift of Lucia Beadel, Edward Beadel, Jr., and Lucia Wisenand in memory of Edward F. Beadel.

CHAPTER TEN 1970-79

- 1 Donna Nicholas, "The Ceramic Nationals at Syracuse," *Craft Horizons*, December 1972, 33.
- 2 Ibid., 31.
- 3 Evert Johnson, "Two Happenings at Southern Illinois University: 1) Clay Unfired," *Craft Horizons*, October 1970, 39.
- 4 Tobi Smith, "Clayworks in Progress," Los Angeles Institute of Contemporary Art *Journal*, November/December 1975, 38–47. The event, which was curated by Tobi Smith, included the work of George Geyer, Tom McMillan, Larry Shep, Roger Sweet, and Tom Colgrove.
- See Everson Museum of Art, New Works in Clay by Contemporary Painters and Sculptors (Syracuse, N.Y.: Everson Museum of Art, 1976). The museum had originally intended to curate an exhibition of ceramic works by Picasso, Gauguin, Miró, and others, but found the exhibition too expensive. The "New Works" project replaced this original idea. This event was the second one of its kind in America. The first, which was initiated by Art in America, took place in 1963. Twelve artists, directed by the painter Cleve Gray and with the technical assistance of David Gil of Bennington Potters, Vermont, had produced a body of limited-edition ceramics. Those involved in the project were Louise Nevelson, Cleve Gray, Alexander Liberman, Milton Avery, Helen Frankenthaler, David Smith, James Metcalf, Ben Shahn, Jack Youngerman, Leonard Baskin, Seymour Lipton, and Richard Anuszkiewicz. See "Ceramics by Twelve Artists," Art in America 52 (December 1964), 27-41, and Richard Lafean, "Ceramics by Twelve Artists," Craft Horizons 25 (January 1965), 30-33, 48-49. In addition, the Clay Works Studio Workshop in New York, established by Susan Peterson for nonclay artists to explore clay with ceramists during threeweek work sessions, was established as a pilot project in 1973. It was inspired by the collaborative format of June Wayne and the Tamarind Lithography Workshop; the original inspiration came from Rose Slivka, the editor of Craft Horizons, who took the concept of a collaborative workshop in clay to the National Endowment for the Arts in 1971 and helped guide its inception. Later a permanent and independent home for the Clay Studio was established in downtown New York, with a capable young "veteran" of the New Works project, James Walsh, as its director. Andrea DiNoto and Léopold

- Foulem are currently writing a complete study of the role of "visiting" painters and sculptors during this century that will be published in 1989 by Abbeville Press, New York.
- 6 Hilton Kramer, "Art: Sensual, Serene Sculpture," *The New York Times*, January 25, 1975.
- 7 Hilton Kramer, "Sculpture—From the Boring to the Brilliant," *The New York Times*, May 15, 1977.
- 8 Michael McTwigan, *Heroes and Clowns* (New York: Allan Frumkin Gallery, 1979), 11–13.
- 9 See Harvey L. Jones, *Stephen DeStaebler: Sculpture* (Oakland, Calif.: Oakland Museum, 1974), unpaginated catalogue.
- 10 Viola Frey, "Artist's Statement," in *Viewpoints: Ceramics 1977* (El Cajón, Calif.: Grossmont College Art Gallery, 1977).
- 11 For a more detailed examination of the link between Lévi-Strauss's notion of the *bricoleur* and the exploration of this theme in Frey's work, see Garth Clark, "Cracks in the Sidewalk: A Chronological Study of the Art and World of Viola Frey." in *Viola Frey: Retrospective* (Sacramento, Calif.: Crocker Museum, 1981).
- 12 Claude Lévi-Strauss, *The Savage Mind* (Chicago: The University of Chicago Press, 1962), 22.
- 13 Harold Rosenberg, "Reality Again," in *Super Realism: A Critical Anthology*, ed. Gregory Battcock (New York: E. P. Dutton, 1975), 139–40. The essay was first published in the *New Yorker* (February 5, 1972).
- 14 Kim Levin, "The Ersatz Object," *Arts Magazine*, February 1974.
- 15 See Lukman Glasgow, *Illusionistic Realism as Defined in Contemporary Ceramic Sculpture* (Laguna Beach, Calif.: Laguna Beach Museum of Art, 1977).
- 16 Thomas Albright, "The Dividing Line between Ceramics and Schlock," San Francisco Chronicle, August 21, 1979, 41.
- 17 Rose Slivka, *The Object as Poet* (Washington, D.C.: Renwick Gallery, National Collection of Fine Arts, Smithsonian Institution, 1977), 12.
- 18 Kenneth W. Jones, "Richard E. De-Vore," *Philadelphia Arts Exchange* 1 (March/April 1977), 7.
- 19 Andy Nasisse, "The Ceramic Vessel as Metaphor," New Art Examiner, January

- 1976. The title was later taken for an exhibition at the Evanston [Illinois] Art Center in 1977.
- 20 See Edy de Wilde, "Preface," in West Coast Ceramics (Amsterdam: Stedelijk Museum, 1979), 1. Credit must be given to de Wilde's prescience if not to his scholarship. While American museums were ignoring the achievement of the West Coast potters, de Wilde was assembling a collection of masterpieces by Arneson, Voulkos, Notkin, Price, Nagle, Gilhooly, Shaw, and Brady that, for its period, has yet to be matched by any American institution.
- 21 See Ed Lebow, "Turner," *American Craft* 46 (June/July 1986), 67. The article is an excellent analysis of Turner's development.
- 22 Ibid.
- 23 George Woodman, "Ceramics Decoration and the Concept of Ceramics as a Decorative Art," in *Transactions of the Ceramics Symposium 1979*, ed. Garth Clark, (Los Angeles: Institute for Ceramic History, 1980), 107.
- 24 Discussion between the author and Price, November 21, 1979; the discussion revolved around Price's inclusion in the author's book *American Potters*.
- 25 See Suzanne Muchnic, "Curios from the Home Folk," Los Angeles Times, April 16, 1978, 96.
- 26 Joan Simon, "An Interview with Kenneth Price," *Art in America* 68 (January 1980), 32.
- 27 Judy Chicago, *The Dinner Party: A Symbol of Our Heritage* (New York: Doubleday, Anchor Books, 1979), 29.
- 28 Laurel Reuter, "The Dinner Party: A Personal Response," *The Shards Newsletter* 1, no. 2 (Winter 1980–81), 3.
- 29 Chicago (1979), 32.
- 30 Reuter (1980–81).
- 31 John Ashbery, "Feelin' Grueby," *The New York Times*, March 17, 1980, 56.
- 32 Donald B. Kuspit, "Elemental Realities," *Art in America*, January 1981, 79, 87.
- 33 The ICH briefly published the *Shards Newsletter* but functions primarily as a catalyst for the running of the International Ceramics Symposium, which was held at Syracuse University in 1979; at the Waldorf-Astoria, New York, in 1981; in Kansas City in 1983; in Toronto in 1985; and at the Victoria and Albert Museum, London, in 1986. The

- symposium now has a permanent home at the Everson Museum of Art, where the event will be presented every three years.
- 34 The NCECA changed the focus of its conferences after its 1981 conference at San Jose examined the West Coast contribution to ceramics. Although technical panels and papers are still a major interest, the NCECA conferences have increasingly brought in serious scholars, commissioned presentations on history, published transactions of the conferences, and established a journal. The 1985 conference dealt with architectural ceramics; the 1987 conference, at the Everson Museum of Art, discussed the theme "Ceramics and the Art World," reflecting the new priorities.
- 35 See Clement Greenberg, "The Status of Clay," *The Shards Newsletter* 1, no. 2 (Winter 1980–81). Also published in *Transactions of the Ceramics Symposium* 1979, ed. Garth Clark (Los Angeles: Institute for Ceramic History, 1980).

CHAPTER ELEVEN 1980-the Present

- 1 The figurative style thrived on the West Coast largely because of Bay Area painters. During the fifties and sixties, the painters David Park, Richard Diebenkorn, Elmer Bischoff, and James Weeks dynamically combined the notion of abstraction and figuration, keeping the tradition of the figure vital long after it had been pronounced dead on the East Coast.
- 2 Letter from Dianne Feinstein to San Francisco Art Commission, December 4, 1981.
- 3 William Wilson, "S. F. Exhibit: Clay... And Now Moscone," Los Angeles Times, April 25, 1986, 86.
- 4 Hilton Kramer, "Sculpture—From Boring to Brilliant," *The New York Times*, May 15, 1977, D27.
- 5 Hilton Kramer, "Ceramic Sculpture and the Taste of California," *The New York Times*, December 20, 1981, 31.
- 6 Arneson, quoted in Susan Wechsler's "Views on the Figure," *American Ceramics* 3, no. 1 (1984): 23.
- 7 Kramer (1981).
- 8 Robert Hughes, "Molding the Human Clay," *Time*, January 18, 1982, 66.
- 9 See Jeff Kelley, "Re Clay," Arts Magazine, 56 (March 1982), 77–79; and John Perreault, "Fear of Clay," Artforum 21 (April 1982),

70-71.

- 10 Perreault (1982), 71.
- See Beth Cofflet, "East Is East and West Is West: The Great Divide," San Francisco Sunday Examiner and Chronicle, April 4, 1982, 24-30. Cofflet's article is an indictment of East Coast snobbism. After reviewing the comments of Hilton Kramer, Robert Hughes, and Peter Schjeldhal, she criticizes their writings as a classic case of the territorial imperative, comparing them to the ring-tailed lemur, who, "when threatened by newcomers to his arena, does a handstand, raises his tail and squeezes a perineal gland located near its rear end to mark off its territory and warn off interlopers" (p. 25). She also quotes Kay Larson (art critic for New York magazine), who wrote that "California can claim half a dozen art ideas that are wholly its own but getting the East Coast to acknowledge them can be harder than originating them." See Kay Larson, "California Clay Rush," New York, January 11, 1982, 41.
- 12 Michael McTwigan, "A Portrait of Our Time," in *In the Eye of the Beholder: A Portrait of Our Time* (New Paltz, N.Y.: College Art Gallery, State University of New York, College at New Paltz, 1985), 17.
- 13 William Wilson, "The Art Galleries: Viola Frey," Los Angeles Times, March 28, 1986, 10.
- 14 Mark Shannon, "Michael Lucero: The Unnatural Science of Dreams," *American Ceramics* 5, no. 2 (1986), 33.
- 15 Matthew Kangas, "Rudy Autio," American Ceramics 3, no. 4 (1985), 65. In part, Kangas's attitude has to do with the fact that he is a highly partisan writer, promoting the cause of Seattle ceramic sculpture. Seattle has not produced any vessel makers of national consequence and this, no doubt, contributes to Kangas's unease with the notion of the pot as art.
- 16 John Perreault, "Feats of Clay," Soho News, March 5, 1980, 47.
- 17 Philip Rawson, "Keynote Address: Echoes Symposium," unpublished paper, 1983, 3.
- 18 Perreault (1982), 71.
- 19 Jeff Perrone, "Some Sherds on Pottery," in *Surface/Function/Shape: Selections from the Earl Millard Collection* (Edwardsville, Ill.: Southern Illinois University, 1985).
- 20 Ibid.

- 21 George Woodman, "Ceramic Decoration and the Concept of Ceramics as a Decorative Art," in *Transactions of the Ceramics Symposium 1979*, ed. Garth Clark, (Los Angeles: Institute for Ceramic History, 1980), 109.
- 22 For a description of the installation, see John Perreault, "A Pattern of Exchange," *Soho News*, March 9, 1982, 52.
- 23 Jeff Perrone, "Betty Woodman: A Working Analysis," in *The Ceramics of Betty Woodman* (Reading, Pa.: Freedman Gallery, 1986), 6.
- 24 John Russell, "Art: Household Objects Don Mysterious Guises," *The New York Times*, December 18, 1981, 23.
- 25 Roberta Smith, "Simple Pleasures," *The Village Voice*, December 16, 1981, 17.
- 26 Michael McTwigan, "Andrew Lord," American Ceramics 1, no. 2 (Spring 1982), 58.
- 27 Christopher Knight, "Lord of the Latter Day Impressionists," Los Angeles Herald Examiner, June 5, 1985, E5.
- 28 Ibid.
- 29 Ibid.
- 30 Rudy Autio, "About Drawing," *Studio Potter* 14, no. 1 (December 1985), 49.
- 31 Edward Lebow, "The Flesh Pots of Rudy Autio," *American Ceramics* 4, no. 1 (1985), 34.
- 32 Peter Schjeldahl, "The Smart Pot: Adrian Saxe and Post-Everything Ceramics," in *Adrian Saxe* (Kansas City, Mo.: University of Missouri Art Gallery, 1987).
- 33 Christopher Knight, "Artists' Vessels Sail on a Revolutionary Sea," *Los Angeles Herald Examiner*, November 10, 1985, E5.
- 34 Schjeldahl (1987).
- 35 For further discussion of this matter, see Garth Clark, "Comment," *American Craft* 46 (December 1985); and Lorne Falk, "Will Ceramics Secede from the Art World?" *New Art Examiner* 13 (May 1986).

CHRONOLOGY

Only major exhibitions have been included in this chronology. For a more definitive listing of ceramics exhibitions and a complete roster of the Ceramic Nationals, please see the appendix "Selected Exhibitions."

1876

Centennial Exposition, Philadelphia. The exhibition of Japanese pottery and French *barbotine* wares has a strong influence on the nascent ceramic-arts movement in America.

Pennsylvania Museum (renamed Philadelphia Museum of Art in 1938) is founded. Under the guidance of the ceramics historian and curator Edwin Atlee Barber, the museum is one of the first to develop a major collection of art pottery. A large part of the collection would later be deaccessioned.

1878

Mary Louise McLaughlin produces the first successful underglaze slip-painted ware.

1879

Formation of the Cincinnati [Ohio] Pottery Club.

McLaughlin receives an honorable mention for her wares at the Exposition Universelle, Paris.

1880

Maria Longworth Nichols (later Mrs. Bellamy Storer) founds the Rookwood Pottery in Cincinnati.

McLaughlin publishes her Cincinnati Limoges technique in the handbook *Pottery Decoration under the Glaze*.

1881

Rookwood School for Pottery Decoration opens in Cincinnati; closes in 1884.

1882

Oscar Wilde visits the Rookwood Pottery.

1883

Laura Anne Fry adapts the atomizer to apply colored slips to greenware.

1884

The Rookwood Pottery discovers the tiger'seye glaze.

1887

Pennsylvania Museum and School of Industrial Art sponsors the *Pottery and Porcelain Exhibition*, Philadelphia. Rookwood wins two first prizes.

Kataro Shirayamadani joins the Rookwood Pottery.

Rookwood wins special mention at the twelfth Annual Exhibition of Painting on China, London.

1889

The Rookwood Pottery wins a gold medal at the Exposition Universelle, Paris. Mc-Laughlin receives a silver medal for china painting.

1890

Organization of the Keramic Club of San Francisco.

1892

Susan Frackelton forms the National League of Mineral Painters.

Formation of the Chicago Ceramic Association.

Organization of the New York Society of Ceramic Arts.

1893

World's Columbian Exposition, Chicago. Rookwood receives the highest award in ceramics.

Publication of Edwin Atlee Barber's Pottery and Porcelain of the United States.

Ceramic Congress held in Chicago.

1894

Ohio State University, Columbus, opens the first school of ceramics in the United States; directed by Edward Orton, Jr.

1895

Establishment of the Newcomb Pottery in New Orleans.

First issue of *Ceramic Monthly*; last issue in 1900.

1897

William Grueby produces his first mat glazes. (Mat glazes had previously been produced on an experimental basis by the Chelsea Keramik Art Works.) First Exhibition of Arts and Crafts in Boston sets off a popular interest in the Arts and Crafts Movement. Other exhibiting societies form throughout the United States.

1899

American Ceramic Society founded.

Publication of *Keramik Studio*, with Adelaide Alsop Robineau as the editor. It was renamed *Design–Keramik Studio* in 1924, and *Design* in 1930.

1900

Exposition Universelle, Paris; Rookwood, Newcomb, Dedham, and Grueby win honors.

New York School of Clayworking and Ceramics, Alfred University, Alfred, New York, founded, under the direction of Charles Fergus Binns.

1901

Pan-American Exposition, Buffalo, New York

Artus Van Briggle commences commercial production in Colorado Springs, Colorado.

Publication of the first issue of the *Craftsman* by founder/editor Gustav Stickley.

1902

New Jersey School of Clayworking and Ceramics opens at Rutgers University, New Brunswick, New Jersey, under the direction of C. W. Parmelee.

1903

The Pewabic Pottery founded in Detroit.

1904

Louisiana Purchase International Exposition, Saint Louis, Missouri.

1906

Formation of the Detroit Society of Arts and Crafts.

Organization of the National Society of Craftsmen in New York; it is later merged with the New York Society of Ceramic Arts, by which name it becomes known.

1910

Formation of the School of Ceramic Art at the People's University in University City (a suburb of Saint Louis), Missouri; Taxile Doat is the first director. The Newark Museum, Newark, New Jersey, under the direction of John Cotton Dana, holds its first exhibition of contemporary art pottery, *Modern American Pottery*. Newark's progressive approach to industrial design and decorative art strongly influences other institutions.

1911

Turin Exposition, Turin, Italy. The American Women's League wins the grand prize for fifty-five porcelains by Adelaide Alsop Robineau. The artist herself receives the Diploma della Benemerenza.

The Newark Museum begins its collection of contemporary ceramics.

1915

Panama-Pacific International Exposition, San Francisco.

1916

Frederick Rhead publishes the first issue of the *Potter*.

1917

Syracuse [New York] University confers the degree of doctor of ceramic sciences on Adelaide Alsop Robineau.

1918

First issue of American Ceramic Society Journal.

1922

First issue of the *Bulletin of the American Ceramic Society*, Columbus, Ohio.

First issue of Ceramic Age.

Henry Varnum Poor holds his first exhibition of ceramics at Montross Gallery, New York.

1924

Keramik Studio becomes Design-Keramik Studio.

1925

Exposition Internationale des Arts Décoratifs et Industriels Modernes, Paris.

1926

American Ceramic Society awards the first Charles Fergus Binns Award for "notable contribution to the advancement of ceramic art" to Marion L. Fosdick, a professor of ceramics at Alfred University.

1927

Annual Exhibition of Work by Cleveland Artists and Craftsmen (the "May Show") creates a new category, Ceramic Sculpture, and awards the first prize to Alexander Blazys.

1928

American Federation of the Arts holds the *International Exhibition of Ceramic Art* at the Metropolitan Museum of Art, New York.

1929

Adelaide Alsop Robineau dies; the Metropolitan Museum of Art, New York, holds a memorial exhibition of her work.

1932

First Robineau Memorial Ceramic Exhibition, at the Syracuse Museum of Fine Arts. In 1932 the entrants are limited to artists from New York State. In 1936 it is renamed the National Ceramic Exhibition and by 1947 is known as the Ceramic National. Held annually from 1932 to 1952, and biennially from 1952 to 1970, the National (the twenty-seventh) was cancelled in 1972. It was revived in 1987.

New York School of Clayworking and Ceramics is renamed New York State College of Ceramics.

The University of Southern California, Los Angeles, offers its first ceramics courses under Glen Lukens.

Waylande Gregory initiates a ceramics course at the Cranbrook Academy of Art, Bloomfield Hills, Michigan. Maija Grotell is appointed head of ceramics in 1938.

1933

Establishment of the federal Welfare Art Program of the Works Progress Administration. In 1935 Edris Eckhardt becomes director of the WAP's Ceramic Sculpture Division.

Scripps College, Claremont, California, offers its first ceramics course, under William Manker.

1934

Charles Fergus Binns dies.

1935

The Metropolitan Museum of Art, New York, holds a memorial exhibition of Binns's work.

California Pacific International Exposition, San Diego.

1936

Laura Andreson revives ceramics education at the University of California, Los Angeles. Pottery had been first offered as a course in 1920, under Olive Newcomb, and later discontinued.

1937

Contemporary American Ceramics exhibition tours Helsinki; Göteborg, Sweden; Copenhagen; and Stoke-on-Trent, England, and is then shown at the Whitney Museum of American Art, New York.

1938

Waylande Gregory creates *The Fountain of Atoms* for the New York World's Fair. The fountain consists of twelve figures, each weighing over a ton. He also creates *American Imports and Exports* for the General Motors Corporation.

First California Ceramics Exhibition, organized by William Manker, Glen Lukens, and Reginald Poland. Repeated in 1939.

1939

World's Fair, New York.

Golden Gate International Exposition, San Francisco.

Aileen Osborne Webb organizes the Handcraft League of Craftsmen, which merges with another organization to become the Handcraft Cooperative League of America. Renamed on several occasions, the latter is finally named the American Craft Council in 1979. The ACC would become the primary institution for the craft media, with a membership of over forty thousand craftspersons.

1941

First issue of *Craft Horizons* published by the Handcraft Cooperative League of America. The publication is renamed *American Craft* in 1979.

1945

William Manker establishes the Scripps College Annual Ceramic Exhibition. Continued to the present, by Rick Petterson and Paul Soldner, the exhibition is the longest continual ceramics annual in the United States.

F. Carlton Ball organizes the Association of San Francisco Potters.

1946

Wichita National Decorative Arts Competitive Exhibit is founded; closes in 1972 and is reinstituted in 1985.

1949

Robert Turner organizes a ceramics course at Black Mountain College, Asheville, North Carolina. The course closes in 1956.

1950

Bernard Leach tours the United States for four months and receives the Binns Medal from the American Ceramic Society.

First *Young Americans* exhibition at America House, New York, showing work by craftspersons under thirty years of age. From 1971 on it is held at the Museum of Contemporary Crafts, New York.

1951

Archie Bray Foundation, Helena, Montana, is founded, with Rudy Autio as the resident sculptor and Peter Voulkos as potter. Later directed by Ken Ferguson and David Shaner; the current director is Kurt Weiser. In 1984 the foundation expands and acquires the adjacent brickworks.

1952

Bernard Leach tours the United States with Shoji Hamada and Soetsu Yanagi. The tour is organized by Alix MacKenzie.

1953

International Ceramics Symposium, Black Mountain College, Asheville, North Carolina, with Bernard Leach, Shoji Hamada, Soetsu Yanagi, and Marguerite Wildenhain.

First issue of Ceramics Monthly.

1954

Peter Voulkos joins the Los Angeles County Art Institute (later known as the Otis Art Institute).

Rosanjin tours the United States; donates a collection of his work to the Museum of Modern Art, New York; and has an exhibition at the Grace Borgenicht Gallery, New York.

1955

International Ceramics Exposition, Cannes,

France; the gold medal is awarded to Peter Voulkos.

1956

American Craftsmen's Council (formerly the Handcraft Cooperative League of America and now the American Craft Council) establishes the Museum of Contemporary Crafts in New York. It is renamed the American Craft Museum in 1979.

1957

The Clay Art Center is founded in Port Chester, New York.

First National Craftsman's Conference, at Asilomar, California.

1958

World's Fair, Brussels.

1959

International Ceramics Exhibition, Ostend, Belgium; the United States wins the Grand Prix des Nations.

1961

Establishment of the Design Division of the Educational Council of the American Ceramic Society.

1962

Adventures in Art, Fine Arts Pavilion, Century 21 Exposition, Seattle.

1963

Works in Clay by Six Artists, San Francisco Art Institute.

Clay Today, University of Iowa, Iowa City.

1965

Art in America initiates the exhibition Ceramics by Twelve Artists, which is presented by the American Federation of Arts, New York.

1966

John Coplans organizes the exhibition *Abstract Expressionist Ceramics* at the University of California, Irvine.

National Council on Education for the Ceramic Arts (NCECA) is founded out of the Design Division of the American Ceramic Society.

1967

Peter Selz organizes the exhibition Funk at

the University of California, Berkeley.

First Annual Conference of the National Council on Education for the Ceramic Arts (NCECA), Michigan State University, East Lansing.

John Michael Kohler Arts Center, Sheboygan, Wisconsin, founds its arts and industry program, providing ceramists with fourweek residencies at the Kohler ceramic works.

1968

Dada, Surrealism and Their Heritage, the Museum of Modern Art, New York; includes the work of Robert Arneson.

SuperMud, annual ceramics symposium, organized at Pennsylvania State University, University Park; last one held in 1978.

Syracuse Museum of Fine Arts, Syracuse, New York, is renamed Everson Museum of Art.

1969

Objects: USA, exhibition of the Johnson Wax collection; organized by Lee Nordness. Opens at the National Collection of Fine Arts, Smithsonian Institution, Washington, D.C.

1970

Ceramics 70 Plus Woven Forms is held in place of the traditional Ceramic National Exhibition, though later it is apparently interpreted as a Ceramic National.

1972

What is then viewed at the twenty-seventh Ceramic National Exhibition does not take place as a Ceramic National. When jurors Jeff Schlanger, Robert Turner, and Peter Voulkos reject 4,500 entries for this exhibition at the Everson Museum of Art, Syracuse, New York, a compromise exhibition—part invitational, part an assembly of past Ceramic National prize winners—is held. There is no catalogue. The National is revived in 1987.

Sharp-Focus Realism, Sidney Janis Gallery, New York; includes work of Marilyn Levine.

1973

Ceramics International '73, Alberta College of Art, Calgary, Alberta, Canada.

The Carborundum Company establishes the Ceramics Museum, Niagara Falls, New York. It is renamed the Crafts Museum in 1975 and closes in 1976.

Edith Wyle founds the Craft and Folk Art Museum in Los Angeles.

The National Endowment for the Arts establishes a Crafts Program within the Visual Arts Division and awards its first fellowships.

1974

Robert Arneson—Retrospective, Museum of Contemporary Art, Chicago, and San Francisco Museum of Art.

Hunter College, City University of New York, organizes Clayworks Studio Workshops as an artist-in-residence program.

1976

New Works in Clay by Contemporary Painters and Sculptors, Everson Museum of Arts, Syracuse, New York; exhibition and collaboration by Margie Hughto.

1977

First course in modern ceramic art history, Bennington College, Bennington, Vermont.

1978

Peter Voulkos: Retrospective opens at the San Francisco Museum of Modern Art and makes a short national tour that includes its organizer, the Museum of Contemporary Crafts, New York.

1979

Founding of the Institute for Ceramic History (ICH) by Garth Clark. The ICH holds the First International Ceramics Symposium at Syracuse University, New York; organized by Anne Mortimer.

A Century of Ceramics in the United States 1878–1978, Everson Museum of Art, Syracuse, New York. The exhibition travels for three years to, among other locations, the Smithsonian Institution's Renwick Gallery, National Collection of Fine Arts, Washington D.C., and Cooper-Hewitt Museum, New York

American Crafts Council is renamed American Craft Council; its Museum of Contemporary Crafts becomes the American Craft Museum, and its publication *Craft Horizons* is retitled *American Craft*.

1980

First issue of *Craft International*; founding editor, Rose Slivka.

The National Council on Education for the Ceramic Arts publishes the first issue of the *NCECA Journal*.

1981

Symposium on Scholarship and Language in Craft Criticism, cosponsored by the National Endowment for the Arts and the National Endowment for the Humanities, Washington, D.C.

Second International Ceramics Symposium of the Institute for Ceramic History, the Waldorf-Astoria, New York. The theme of the symposium, organized by Mark Del Vecchio, is "Ceramics and Modernism: The Response of the Artist, Craftsman, Designer and Architect."

Ceramic Sculpture: Six Artists, Whitney Museum of American Art, New York, and San Francisco Museum of Modern Art, attracts hostile reviews from New York critics and provokes national dialogue.

Viola Frey: A Restrospective opens at the Crocker Art Museum, Sacramento, California; an abridged version travels to seven institutions through 1983.

1982

First issue of *American Ceramics*; Michael McTwigan is the founding editor.

A ceramic portrait of slain Mayor George Moscone, commissioned from Robert Arneson, is rejected by the City of San Francisco and causes a national furor.

NCECA: San Jose [California] '82 conference examines the role of the West Coast in American ceramics.

1983

Ceramic Echoes: Historical References in Contemporary Ceramic Art, the Nelson-Atkins Museum of Art, Kansas City, Missouri; presented by the Contemporary Art Society as part of the celebration of the museum's fiftieth anniversary.

The Contemporary Art Society, Kansas City, Missouri, organizes the Third International Ceramics Symposium of the Institute for Ceramic History; coordinated by Lennie Berkowitz.

West Coast Ceramics, at the Anderson Ranch, Aspen, Colorado, a historic week-long conference that brings together Peter Voulkos, Robert Arneson, Ron Nagle, Jerry Rothman, Richard Shaw, Marilyn Levine, Philip Cornelius, Michael and Magdalena Frimkess, Viola Frey. Garth Clark and Patterson Sims serve as cochairs.

Rudy Autio Retrospective opens in Helena, Montana, prior to a national tour that ends at the American Craft Museum, New York.

1984

Ceramics and Architecture, NCECA Conference, Saint Louis.

1985

Fourth International Ceramics Symposium of the Institute for Ceramic History in Toronto, accompanied by fifty-five exhibits of ceramics, is organized by Anne Mortimer and Margaret Melchiori-Malouf.

American Potters Today, Victoria and Albert Museum, London. The Fifth International Ceramics Symposium of the ICH, organized by Garth Clark and John Huntingford, takes place at the Victoria and Albert Museum in connection with the exhibition. The symposium moves to the Everson Museum of Art, Syracuse, New York, as its permanent home.

Art/Culture/Future, ninth national conference of the American Craft Council, Oakland, California.

Robert Arneson: Retrospective, Des Moines Art Center, Des Moines, Iowa. The exhibition travels nationally to, among other places, the Hirshhorn Museum and Sculpture Garden, Smithsonian Institution, Washington, D.C.; and the Oakland Museum, Oakland, California.

American Craft Museum, New York, reopens in a new building, with the inaugural exhibition *Craft Today: Poetry of the Physical*.

The Everson Museum of Art, Syracuse, New York, opens the Syracuse China Center for the Study of American Ceramics.

New Art Forms Exposition, Navy Pier, Chicago.

1987

Art of Collecting Ceramics, symposium sponsored by American Ceramics at Equitable Center, New York.

Ceramics and the Art World, NCECA conference at the Everson Museum of Art, Syracuse, New York.

New Art Forms Exposition: 20th Century Decorative and Applied Arts, Navy Pier, Chicago.

SELECTED EXHIBITIONS

Several thousand exhibitions of American ceramics have taken place in public and private spaces within the last decade alone. This listing of exhibitions is by necessity, therefore, not exhaustive. Exhibitions have been listed if they generated significant publications and/or reviews, if they introduced aesthetic innovation, or if they were otherwise historically significant. International exhibitions have been included when American ceramics played an important role either through a large number of participating American artists or an American artist taking one of the major prizes. Multimedia exhibitions that meet the aforementioned criteria have also been included. Titles and dates of the Ceramic Nationals are given as they appear on the title pages of the exhibition's catalogues. When the titles on the covers of the catalogues do not correspond exactly to the wording on their title pages, both titles are indicated.

1876

Centennial Exposition, Philadelphia.

1879

Exposition Universelle, Paris.

1880

First Annual Reception and Exhibition of the Cincinnati Pottery Club, Frederick Dallas Pottery, Cincinnati.

1887

Pottery and Porcelain Exhibition, Pennsylvania Museum and School of Art, Philadelphia.

1889

Exposition Universelle, Paris.

1890

Tenth (and last) Annual Reception and Exhibition of the Cincinnati Pottery Club, Cincinnati.

1893

World's Columbian Exposition, Chicago.

1897

First Exhibition of Arts and Crafts, Representing the Application of Art to Industry . . . , Copley and Allston Halls, Boston.

1899

First Annual Exhibition of the Society of

Arts and Crafts, Copley and Allston Halls, Boston.

1900

Exposition Universelle, Paris.

190

Pan-American Exposition, Buffalo, New York.

Exposition Internationale de Céramique et Verrière, Saint Petersburg, Russia.

French Ceramic Art, Tiffany's, New York.

1903

Arts and Crafts Exhibitions, Syracuse Museum of Fine Arts (later known as the Everson Museum of Art), Syracuse, New York.

1904

Louisiana Purchase International Exposition, Saint Louis, Missouri.

1910

Modern American Pottery, The Newark Museum, Newark, New Jersey.

1911

Turin Exposition of Decorative Art, Turin, Italy.

1915

Clay Products of New Jersey at the Present Time, The Newark Museum, Newark, New Jersey.

Panama-Pacific International Exposition, Golden Gate Park, San Francisco.

1922

Exhibition of Decorated Pottery, Paintings and Drawings by H. Varnum Poor, Montross Gallery, New York.

1928

American Designers' Gallery Exposition, New York

International Exhibition of Ceramic Art, The Metropolitan Museum of Art, New York.

1929

Adelaide Alsop Robineau Memorial Exhibition, The Metropolitan Museum of Art, New York.

1931

Exhibition of Contemporary American Ceramics, W. & J. Sloane and Company, New York.

1932

Murals by American Painters and Photographers, The Museum of Modern Art, New York.

Robineau Memorial Ceramic Exhibition, Syracuse Museum of Fine Arts, Syracuse, New York.

1933

Second Annual Robineau Memorial Ceramic Exhibition (National), Syracuse Museum of Fine Arts, Syracuse, New York.

1934

Third Annual Robineau Memorial Ceramic Exhibition (National), Syracuse Museum of Fine Arts, Syracuse, New York.

1935

California Pacific International Exposition, San Diego.

Charles Fergus Binns: Memorial Exhibition, The Metropolitan Museum of Art, New York

Fourth Annual Robineau Memorial Ceramic National Exhibition (National), Syracuse Museum of Fine Arts, Syracuse, New York.

1936

Contemporary American Ceramics, Syracuse Museum of Fine Arts, Syracuse, New York, traveled to Scandinavia; England; and Whitney Museum of American Art, New York, in 1937.

The Fifth National Ceramic Exhibition (The Robineau Memorial), Syracuse Museum of Fine Arts, Syracuse, New York.

1937

The Sixth National Ceramic Exhibition (The Robineau Memorial), Syracuse Museum of Fine Arts, Syracuse, New York.

1938

First California Ceramics Exhibition, Los Angeles County Museum of Art.

The Seventh National Ceramic Exhibition, Syracuse Museum of Fine Arts, Syracuse, New York.

1939

Decorative Arts, Denver Art Museum.
Golden Gate International Exposition

Golden Gate International Exposition, San Francisco.

New York World's Fair.

Second California Ceramics Exhibition, Los Angeles County Museum of Art.

The Eighth Annual National Ceramic Exhibition, Syracuse Museum of Fine Arts, Syracuse, New York.

1940

Contemporary European and American Decorative Arts, The Toledo Museum of Art, Toledo, Ohio.

The Ninth Annual National Ceramic Exhibition, Syracuse Museum of Fine Arts, Syracuse, New York.

1941

Contemporary Ceramics of the Western Hemisphere: In Celebration of the Tenth Anniversary of the National Ceramic Exhibition, Syracuse Museum of Fine Arts, Syracuse, New York.

1943

America House Gallery—Inaugural Exhibition, America House, New York.

1944

Contemporary American Craft, The Baltimore Museum of Art.

First Scripps College Annual Ceramic Exhibition, Scripps College, Claremont, California.

1946

Maija Grotell/Natzler, The Art Institute of Chicago.

Eleventh National Ceramic Exhibition, Syracuse Museum of Fine Arts, Syracuse, New York. Wildenhain/Longenecker/Natzler, University of Oregon Museum of Art, Eugene.

1947

Twelfth National Ceramic/Ceramic National Exhibition, Syracuse Museum of Fine Arts, Syracuse, New York.

1948

Modern Design and Craft, Los Angeles County Museum of Art.

Sam Haile Memorial Exhibition, Institute for Contemporary Art, Washington, D.C.

Thirteenth National Ceramic/Ceramic National Exhibition, Syracuse Museum of Fine Arts, Syracuse, New York.

1949

Fourteenth National Ceramic/Ceramic National Exhibition, Syracuse Museum of Fine Arts, Syracuse, New York.

1950

Bernard Leach, Institute for Contemporary Art, Washington, D.C.

First International Exhibition of Ceramic Art, National Collection of Fine Arts, Washington, D.C.

Fifteenth National Ceramic/Ceramic National Exhibition, Syracuse Museum of Fine Arts, Syracuse, New York.

Small Sculptures by Elie Nadelman, Edwin Hewitt Gallery, New York.

Young Americans, America House, New York.

1951

16th Ceramic National, Syracuse Museum of Fine Arts, Syracuse, New York.

Industrie und Handwerk USA, Stuttgart, Germany.

1952

Design for Use, USA, XXI Salon des Arts Ménagers, Grand Palais, Paris.

5000 Years of Art in Clay, Fine Arts Building, Los Angeles County Fair, Pomona, Calfornia.

17th Ceramic National, Syracuse Museum of Fine Arts, Syracuse, New York.

1953

Isamu Noguchi—*Ceramics*, Bijutsu Shuppan-Sha, Tokyo.

1954

18th Ceramic National, Syracuse Museum of Fine Arts, Syracuse, New York.

1955

California Design, Pasadena Art Museum, Pasadena, California.

International Ceramics Exposition, Cannes, France.

1956

19th Ceramic National, Syracuse Museum of Fine Arts, Syracuse, New York.

Peter Voulkos: Ceramics, Felix Landau Gallery, Los Angeles.

1957

Peter Voulkos, Museum of Contemporary Crafts, New York.

1958

XX Ceramic International, Syracuse Museum of Fine Arts, Syracuse, New York.

Figures and Figurines by Elie Nadelman, Edwin Hewitt Gallery, New York.

World's Fair, Brussels, Belgium.

1959

Amerikanische Keramik, Stuttgart, Germany. First Paris Biennial, Musée National d'Art Moderne, Paris.

International Ceramics Exhibition, Ostend, Belgium.

Man and Clay, Wight Art Gallery, University of California, Los Angeles.

Peter Voulkos: Bronzes and Ceramics, Stuart-Primus Gallery, Los Angeles.

Peter Voulkos: Ceramic Sculpture and Paintings, Pasadena Art Museum, Pasadena, California.

1960

California.

American Keramik, Antwerp, Belgium. Ceramics and Sculpture by Robert Arneson, The Oakland Museum, Oakland,

Moderne Amerikansk Keramik, Copenhagen, Denmark.

Peter Voulkos: Ceramic Sculpture and Painting, The Museum of Modern Art, New York. XXI Ceramic National, Syracuse Museum of Fine Arts, Syracuse, New York.

1961

Craft Forms from the Earth: 1000 Years of Pottery in America, Museum of Contemporary Crafts, New York.

1962

Amerikanische Keramik 1960/1962, Prague, Czechoslovakia.

Ceramics 1962, Paul Sargent Gallery, University of Illinois, Chicago.

Contemporary Craftsmen of the Far West, Museum of Contemporary Crafts, New York. Robert Arneson: Ceramics, Drawings, and Collages, M. H. de Young Memorial Museum, San Francisco.

22nd Ceramic National Exhibition, Syracuse Museum of Fine Arts, Syracuse, New York. Works in Clay by Six Artists, San Francisco Art Institute Galleries.

1963

Clay Today, University of Iowa, Iowa City.

1964

California Sculpture Today, Kaiser Center, Oakland, California.

Critters/Clayton Bailey, Museum of Contemporary Crafts, New York.

International Exhibition of Contemporary Ceramic Art, National Museum, Tokyo.

23rd Ceramic National Exhibition, Syracuse Museum of Fine Arts, Syracuse, New York.

1965

Ceramics by Twelve Artists, American Federation of Arts, New York.

New Ceramic Forms, Museum of Contemporary Crafts, New York.

Peter Voulkos: Sculpture, Los Angeles County Museum of Art.

1966

Abstract Expressionist Ceramics, Art Gallery, University of California, Irvine.

Ceramic Arts USA 1966, International Minerals and Chemical Corporation, Skokie, Illinois.

Ceramics from Davis, Museum West, American Craftsmen's Council, San Francisco

Ceramic Work of Gertrud and Otto Natzler, Los Angeles County Museum of Art.

John Mason—Ceramic Sculpture, Los Angeles County Museum of Art.

Roy Lichtenstein: Ceramics, Leo Castelli Gallery, New York.

Twenty American Studio Potters, Victoria and Albert Museum, London.

24th Ceramic National Exhibition, Syracuse Museum of Fine Arts, Syracuse, New York.

1967

Alexander Archipenko: A Memorial Exhibition, Wight Art Gallery, University of California, Los Angeles.

Ceramics USA, Art Academy, Spoleto, Italy. Funk Art, University Art Museum, Berkeley, California.

Maija Grotell, Cranbrook Academy of Art Museum, Bloomfield Hills, Michigan.

Surrealist Paintings and Drawings of Sam Haile, City Art Gallery, Manchester, England.

1968

Dada, Surrealism and Their Heritage, The Museum of Modern Art, New York.

Dedham Pottery and the Earlier Robertson's Chelsea Potteries, Dedham Historical Society, Dedham, Massachusetts.

Gertrud and Otto Natzler Ceramics: Collection of Mrs. Leonard M. Sperry, Los Angeles County Museum of Art.

25th Ceramic National Exhibition, Everson Museum of Art, Syracuse, New York.

1969

Objects: USA, National Collection of Fine Arts, Washington, D.C.

25 Years of American Art in Clay, Art Gallery, Scripps College, Claremont, California.

1970

Ceramics 70 Plus Woven Forms (later appears to have been interpreted as twenty-sixth Ceramic National) Everson Museum of Art, Syracuse, New York.

Laura Andreson: A Retrospective, University of California, Los Angeles.

Unfired Clay, University Museum, Southern Illinois University, Carbondale.

1971

Ceramic Work of Gertrud and Otto Natzler: Retrospective 1940–1971, M. H. de Young Memorial Museum, San Francisco.

Clayworks: 20 *Americans*, Museum of Contemporary Crafts, New York.

Contemporary Ceramic Art: Canada, U.S.A., Mexico, Japan, National Museum of Modern Art, Tokyo.

Nut Pot or Art without Tears? The Art Center of the World, Davis, California.

Porcelains by Jack Earl, Museum of Contemporary Crafts, New York.

1972

Arts and Crafts Movement in America 1876–1916, The Art Museum, Princeton University, Princeton, New Jersey.

Ceramic invitational (replaces twenty-seventh Ceramic National), Everson Museum of Art, Syracuse, New York.

Decade of Ceramic Art: 1962–1972, San Francisco Museum of Art.

George E. Ohr and His Biloxi Pottery, J. W. Carpenter, Port Jervis, New York.

International Ceramics 72, Victoria and Albert Museum, London.

Nut Art, University Art Gallery, California State University, Hayward.

1973

Beatrice Wood: A Retrospective, Phoenix Art Museum, Phoenix, Arizona.

Form and Fire: Natzler Ceramics 1939–1972, Renwick Gallery, National Collection of Fine Arts, Smithsonian Institution, Washington, D.C. Ceramics International '73, Alberta College of Art, Alberta, Canada.

Richard Shaw/Robert Hudson: Works in Porcelain, San Francisco Museum of Art.

Thinking, Touching, Drinking Cup: International Exhibition, Nagoya, Japan.

1974

Baroque '74, Museum of Contemporary Crafts, New York.

California Ceramics and Glass 1974, The Oakland Museum, Oakland, California.

California Design, 1910, Pasadena Center, Pasadena, California.

Clay, Whitney Museum of American Art, Downtown Branch, New York.

Clay Images, California State University, Los Angeles.

Frans Wildenhain Retrospective, University Art Gallery, State University of New York, Binghamton.

Fred and Mary Marer Collection, Scripps College, Claremont, California.

In Praise of Hands, World Crafts Council, Ontario Science Center, Toronto.

John Mason: Ceramic Sculpture, Pasadena Museum of Art, Pasadena, California.

Robert Arneson—Retrospective, Museum of Contemporary Art, Chicago.

Stephen DeStaebler: Sculpture, The Oakland Museum, Oakland, California.

1975

Catalogue of Kaolithic Curiosities and Scientific Wonders, Wonders of the World Museum, Porta Costa, California.

Clayworks in Progress, Los Angeles Institute of Contemporary Art.

Craft Multiples, Renwick Gallery, National Collection of Fine Arts, Smithsonian Institution, Washington, D.C.

Exhibition of Master Potters, Fairtree Gallery, New York.

Frans Wildenhain, Rochester Institute of Technology, Rochester, New York.

Homage to the Bag, Museum of Contemporary Crafts, New York.

Jim Melchert, San Francisco Museum of Art.

1976

American Crafts 76: An Aesthetic View, Museum of Contemporary Art, Chicago.

Art Deco Environment, Everson Museum of Art, Syracuse, New York.

(1976), for example, two of the most famous faces—Mona Lisa and George Washington (the latter dressed in his finest banknote green)—share the waters. Through this piece Arneson expressed his cynicism about the art world—art, money, and fame—and his own ambivalent ambition to be a member of the club.

His exhibition Heroes and Clowns, held at the Alan Frumkin Gallery, New York, in 1979, brought a new sophistication to his work, with portraits of Elvis Presley, Rrose Sélavy (Duchamp's female alter ego), Vincent van Gogh, and Arneson's close friend, the painter William T. Wiley. The heroic aspect of Arneson's work began to appear in the larger-than-life scale of his works of the seventies and in his use of the traditional bust format—a format historically associated with nobility and the military. In part, the title of the exhibition was also autobiographical, for Arneson's image in the art world at large and within the narrower boundaries of the ceramics community was part hero, part clown. The heroism came from his courage in challenging the traditional notions of ceramics as a sculptural medium. On the other hand, the content of his work was frequently dismissed as childish clowning—the dilemma of the artist who uses humor as his primary vehicle and then asks the world to take him

The early 1980s saw a change in Arneson's work. His portraits of artists-particularly major works such as Pablo Ruiz with Itch and A Likeness of Francis B. (1981) became more complex, more deeply rooted in the literature of art history, and, in a sense, more academic—further from the visceral Arneson of the sixties. Much like Duchamp, whose shadowy presence seldom seems far from Arneson's oeuvre, the artist had become an art critic, or at least a debunker of the heroic notion of the artist. Also at about this time Arneson's drawings began to come into their own. Always an inspired draftsman, Arneson now began to create magnificent drawings that in the past six years have come close to overtaking his achievement in ceramics.

In 1981 Arneson became embroiled in a public debate over his portrait of the slain mayor of San Francisco, George Moscone. This event, explained in detail in chapter 11, had a surprisingly profound impact on Arneson and was one of the reasons for a radical change in his subject matter. Arneson began to deal with nuclear weapons, an issue that concerned many artists at that time. After 1982 he began to explore this theme in works which lacked his usual hu-

mor. They are painful portraits of victims, mutants that were delivered by a nuclear age. While the artist denies that the move from comic-heroism to death has anything to do with his own personal battle with cancer, this must play a role in the new sense of mortality and vulnerability that has entered his work. The critic Donald Kuspit, however, argues that death, in a quieter, less dramatic form, has always been a part of Arneson's work:

No Deposit, No Return presents a discarded bottle—a negated form, fit only for art. And Funk John and John with Art (1964) are really about excrement, which is a form of death. Arneson's effort to sexualize objects, as in Call Girl and Typewriter, both 1966, creates life in dead objects. And the hand reaching out of Toaster, 1965, is like the hand of Lazarus as it reaches out of the tomb. Smorgi-Bob, the Cook, 1971, is a memorial to the abundance of life that is possible in the dead space of Art-about the contradiction in terms, the living death (death of living, living of death) which art is. With Fragments of Western Civilization and Assassination of a Famous Nut Artist, death became an explicit theme in Arneson's art—both the world's death and self's death. He was now openly on the way to the great tragic artist he has become. (Kuspit, 1986)

Autio, Rudy (1926-). Born in Butte, Montana, Autio was educated at the Aviation Machinist's Mate School, United States Navy (1943-44); and at Montana State University, Bozeman, where he studied ceramics with Frances Senska and graduated with a B.S. in 1950. In 1952 he received the M.F.A. from Washington State University, Pullman, after which Autio, together with Peter Voulkos, was resident artist at the Archie Bray Foundation (Helena, Montana) until 1956. During that period, he completed a number of architectural commissions, including a ten-foot-by-thirty-foot ceramic wall relief, The Sermon on the Mount, for the First Methodist Church in Great Falls, Montana. In 1957 Autio became assistant curator of the Montana Museum (Missoula), transferring shortly thereafter to the University of Montana, Missoula, where he was professor of ceramics and sculpture until his retirement.

Autio had originally been hired as a sculptor (Voulkos as the potter) by Archie Bray, but found himself attracted to the vessel form. In the 1960s Autio began to produce pots that were inspired by what was happening at Otis as well as by his own interest in Abstract Expressionism:

"The forms were concoctions of thrown and shaped cylinders and slabs. Pinched, folded, scored and creased, their clamorous surfaces showed that Autio's emotions were in his fingers. They worked feverishly to convey what he knew in his eyes. The volumes themselves seemed to squirm, anxious to find room and comfort for the awkward bulges in their developing anatomy" (Lebow, 1985).

The scarcely suppressed anthropomorphism gradually gave way to the fully figurative work on which Autio's reputation as an artist is now based. A landmark in this development is Flesh Pot (1963), which presides "over his relatively modest previous works like one of those gargantuan water tanks that inevitably command hilltops at the outskirts of small towns" (Lebow, 1985). But in this pot the form had not yet found its signature. The work is monumental but conventional. It was in his black-and-white Double Lady Vessel, exhibited at the Ceramic National in 1964, that the full expression of Autio's style emerged—the abstracted, vigorous drawing, and the sensual, somewhat fragmented structure of the forms. Another masterwork of this time is *Kewpie* Doll (1968), a large, hedonistic vessel, with its decadent surface of overglaze luster.

Autio's ceramics attracted little attention at the time outside the ceramics world. He turned to other sculptural materials—working in concrete and metal—and made relatively little clay during the 1970s. Ex-

Rudy Autio

hibitions such as *A Century of Ceramics in the United States 1878–1978* in 1979 and *The Contemporary American Potter* in 1980, helped to reintroduce the artist to collectors at a point in time when the art world had taken up the pluralist banner and was again interested in the figurative vessel. Autio's interest in ceramics was revived by the increased attention, and in 1980 he produced a significant body of work for an exhibition at Greenwich House in New York. This was followed by highly acclaimed, one-person exhibitions at Exhibit A in Chicago and in 1981 at Okun/Thomas in Saint Louis.

In 1981 Autio visited the Arabia factory in Helsinki, Finland, and stayed on as artist in residence. At Arabia he worked in porcelain, a simple undertaking within the support structure of a large factory. In 1982 he returned to the United States with a brighter palette and continued to work in porcelain. However, he found porcelain to be too temperamental a material for the large scale that he was developing in his work. Before returning to stoneware clays, however, he created some major porcelain pieces, notably his Sacrifice of Iphigenia on Her Wedding Day (1983), a large, complex lidded vessel in which the drawing takes on a three-dimensionality as horses' heads erupt from the surface of the pot, adding a sense of drama to the painted imagery.

The new pots have changed from their predecessors in the 1960s; the forms no longer encompass one figure but are now landscapes inhabited by legends, floating women, and animals. Instead of creating the form around the figure, Autio now fashions a ceramic "canvas" without a preconceived notion of what will be painted on the surface. Once the form is complete, he begins his "search for the figures," and the drawings begin to occupy "a dream space in which the most irrational urges of the psyche appear, transformed, in linear equivalents. Figures of people and animals romp and float in a directionless but enveloping atmosphere. Not up, not down, but around and around, their eroticism borne by the rich suggestiveness of a hollow clay device with a hole in the top" (Lebow,

In 1983 the University of Montana organized a retrospective of his work, which traveled to the American Craft Museum in New York. The retrospective provided an enticing glimpse of Autio's genius but was disappointing in terms of its installation, uneven selection of works, and poor catalogue. The true retrospective and evaluation of Autio's work have yet to arrive.

Bacerra, Ralph (1938-). Born in Orange County, California, Bacerra studied under Vivika Heino at the Chouinard Art Institute, Los Angeles, where he received his B.F.A. After teaching briefly at Chouinard, Bacerra left in 1961 for two years of military service. Heino also left Chouinard in the same year, for the Rhode Island School of Design, so when Bacerra returned to Los Angeles, in 1963, he became chairman of the Chouinard ceramics department. He proved to be an effective and passionate teacher, who had a strong influence on his students. Heino had taught a kind of technical fundamentalism at Chouinard and to some extent Bacerra continued this, insisting on regular and formal critique sessions with the students. At these sessions the students developed an appreciation for technique as an "edge," which if pushed far enough can provide tension, character, and content in the work. In many other schools at the time it was the vogue to approach the science of ceramics on a very informal level, but Bacerra also insisted on classes in glaze formulation.

The importance of Bacerra's teaching was not immediately apparent. The students at Chouinard were late bloomers. But by the late 1970s his students—Elsa Rady, Adrian Saxe, Mineo Mizuno, Peter Shire, and Don Pilcher—had risen to prominence. Most were linked by a distinctive finesse and richness in their handling of materials that became known colloquially as the "Chouinard school," even though in terms of content and vision, their work had little else in common.

In 1972 the ceramics department closed and Chouinard, renamed the California Institute of the Arts, moved to Valencia, on the outskirts of Los Angeles. Bacerra now divided his time between developing his own work and creating innovative technology for industry, in particular, creating special tiles with the thermal shock qualities necessary for induction heating in ceramic stove tops. By 1968 his work had begun to drift away from the functional, traditional look that the Chouinard students had inherited from Heino—creating organic forms with dry, brightly colored glazes and slick, gold-lustered mouths.

In 1975 Bacerra made an extraordinary series of "horses," inspired by a Tang horse and camel he had bought in the Far East. Bacerra eventually returned to the vessel format, but his horses signaled a new complexity in his surfaces and forms. The direction came from two primary sources: nature (he maintains a large hothouse of

orchids and other rare plants) and the decorated ceramics of Japan. He was particularly fascinated by Imari wares, as well as by Kutani pottery, Chinese polychromes, and Persian miniatures. Bacerra developed a complex surface system of repeating images, interlocking, overlapping, and combining them to create larger versions of the same image. He developed this partly from the example of W. C. Escher, the Dutch graphic artist, but also from similar traditions in Japanese decorative art, in particular in fabric design from 1650 to 1900. In turn, these fabric designs were the basis for the interlocking patterns in Imari and Kutani wares, as well as in Nabeshima wares (which Bacerra finds too cold and perfect).

In 1983 Bacerra temporarily set aside the vessel again to make a series of large wall pieces constructed out of interlocking tiles and using a bird motif. Sarah Bodine wrote about these works, which were exhibited at the Theo Portnoy Gallery in New York: "Bacerra has pulled his delicate porcelain casserole lids flat and made their decoration jump into three dimensions like a kind of child's pop-up toy. The rhythmic bird-form motifs are now enlarged into a pillowlike, sensuous, tangible relief. An aesthetic comparison with [Escher] is inevitable, although Bacerra's shapes and progressive relationships of form are less mechanical, less calculated, less resolved...like Cubist painting, this work contorts perceptual expectations' (Bodine, 1983).

Bacerra subsequently turned to a major series of works on the platter form and to the creation of elaborately painted boxes. The play with flat pattern has for the present been interrupted. Bacerra's plates now are host to an equally complex, illusory painting of floating boxes, cylinders, and triangles—moving from the surface into the conceptual volumes of "potter's space." Bacerra's contribution to American ceramics has yet to be fully explored or appreciated. This is due in part to the artist's intermittent production, but it is also due to his placement in a decorative-arts category with which the art world is only now coming to terms.

Baggs, Arthur Eugene (1886–1947). Baggs was living in Alfred, New York, in 1900 when New York State established the School of Ceramics at Alfred. He entered the school to study drawing and design, without any thought of becoming a potter, but "in the general course of things I made a few pots and got the bug which has been spreading its infection through my system ever since" (Baggs, 1929). Professor Charles Fergus

Binns sent Baggs to Marblehead, Massachusetts, for a summer job at the end of his sophomore year. In Marblehead Baggs assisted Dr. Herbert J. Hall in setting up a pottery department for occupational therapy at his sanitarium. By 1908 the Marblehead Pottery had developed into an independent, commercial venture with a weekly output of two hundred pieces, most designed by Baggs, with subtle, conventionalized decoration and mat glazes. For six years, Baggs taught elementary pottery and provided technical assistance for the Ethical Culture School of New York City, while studying at the Art Students League. In 1915 he purchased the Marblehead Pottery from Dr. Hall and continued to work there during the summers until the closing of the pottery in 1936. During the academic years from 1925 to 1928, Baggs worked as a glaze chemist for the Cowan Art Pottery Studio and taught at the Cleveland School of Art. In 1928 Baggs became professor of ceramic arts at Ohio State University, Columbus.

Baggs's work shows an obsession with glaze chemistry, ranging from his superbly bland, mat glazes for Marblehead to the Egyptian blue and Persian green glazes for

Arthur Baggs

Cowan. In the 1930s Baggs became interested in reviving the salt-glaze process, which, apart from isolated work such as that of Susan Frackelton in the 1890s, had been neglected as a decorative medium.

Baggs won many awards during his career, including the Ogden Armour Prize at the Exhibition of Applied Art in Chicago (1915); the medal of the Boston Society of Arts and Crafts (1925); the Charles F. Binns Medal at the American Ceramic Society (1928); and first prize for pottery at the May Show, Cleveland (1928). He was an active exhibitor at the Ceramic Nationals, winning first prize in 1933 and 1938 and a second prize in 1935. His Cookie Jar, which won the first prize at the Ceramic National in 1938, is considered his masterwork and one of the major pieces of the decade.

Bailey, Clayton (1939—). Born in Antigo, Wisconsin, Bailey received his M.A. from the University of Wisconsin in 1962, having studied under Harvey Littleton, Clyde Bert, and Toshiko Takaezu. After graduation, Bailey taught at various midwestern universities and became instructor of ceramics at the University of Wisconsin, Whitewater. After two semesters as a guest artist at the University of California in Davis, working alongside the painters Roy De Forest and Wayne Thiebaud and ceramist Robert Arneson, Bailey settled permanently in California, teaching at California State College, Hayward.

By the time of his move to California, Bailey had already established a reputation as an unconventional artist, exhibiting fourfoot-long inflatable rubber grubs and "nosepots" that were covered in tacky layers of latex "glaze." He had also had major oneman shows, including one in 1964 at the Museum of Contemporary Crafts, New York, and one at the Milwaukee Art Center in 1967. In the 1970s Bailey dealt with a series of themes in his work, ranging from pornography, the medical establishment, and primitive man of the "kaolithian" period, explored through his now-famous workshops and staged events. The latter masterfully exploited the ceramic-arts tendency toward a craft hypochondria—a neurotic search for new glazes and craft skills to cure imagined creative ills.

Bailey's work is the most truly Funk of the Bay Area artists and he is one of the few whose work still patently belongs to this genre. In 1976 he installed his works in a "penny arcade" installation in Porta Costa, California. Viewers paid a nominal entrance fee to see the Wonders of the World Museum, where Bailey maintained that his public could enjoy his works without the alienation of a museum or art gallery environment. The museum has now been transferred to his home. In the past few years Bailey's ceramic output has slowed, replaced with an interest in metal and a fascination with robots.

Ball. F. Carlton (1911-). Born in Sutter Creek, California, Ball studied painting at the University of Southern California, Los Angeles, from 1931 to 1936. While a student at USC, Ball became interested in pottery through the classes offered by Glen Lukens. In 1936 Ball had the opportunity to teach pottery at the California College of Arts and Crafts (Oakland) and arrived with some hastily assembled glaze recipes from Lukens. Ceramics was an empiric craft on the West Coast and Ball admits that he had never "stacked a kiln or lit one, or mixed a glaze" until he taught his first pottery classes (Bray, 1980). Ball taught at Mills College (Oakland, California) from 1939 to 1950, also teaching craft skills through the war years in the United States Army Occupational Therapy Emergency Program. By the time he left Mills College, in 1950, its ceramics department had been transformed into one of the most active on the West Coast. In addition, the Mills Ceramic Guild had been formed to promote workshops and exhibitions. Ball later taught at the University of Wisconsin (1950-51); Southern Illinois University (1951–56); and the University of Puget Sound, Washington, from 1968 until his retirement, in 1977

Concerned about the lack of educational material in the field, Ball has published numerous technical articles for *Ceramics Monthly* and other publications. He was one of the pioneers on the West Coast in the use of the wheel and directed much of his energy toward achieving proficiency in this area. He was particularly interested in the skills necessary to throw and assemble the very large vessel forms that are the most distinctive works in his oeuvre.

Bauer, Fred (1937—). Born in Memphis, Tennessee, Bauer studied at the Memphis Academy of Art, taking his B.F.A. in 1962, and in 1964 receiving his M.F.A. from the University of Washington. He worked at the Archie Bray Foundation in Helena, Montana, in 1964, and taught at the University of Wisconsin, Madison (1964–65); the Aztec Mountain School of Craft, Liberty, Maine (1967); the University of Michigan, Ann Arbor (1965–68); and the University of Washington, Seattle, until 1971. In 1966 he was the recipient of a Louis Comfort Tiffany Foundation Grant.

Fred Bauer

The mercurial Bauer achieved early notoriety as a ceramic artist in the Funk/Super-Object vein. Bauer's style, irreverence, and evident talent made him a romantic hero for the young ceramic artists of his day. He presented numerous workshops and gave elaborate slide presentations. Eventually the pressures of being artist-performer-guru were destructive, and Bauer abruptly left ceramics in 1972, seeking seclusion as a farmer in northern California. Despite the short period of his involvement, Bauer was a prolific producer, developing from a skilled, functional potter to an imaginative sculptor. His oeuvre from the latter part of the 1960s is the most interesting, with its phallic cameras, plates with pyramids of lustered peas, and six-foot-high Funk pumps.

Bengston, Billy Al (1934—). Born in Dodge City, Kansas, Bengston moved at an early age to California, where he attended the Manual Arts High School in Los Angeles. It was there that he first became involved in ceramics. After leaving high school, Bengston studied at Los Angeles City College from 1953 to 1956 and the Otis Art Institute in Los Angeles in 1956–57. He was part of the group of experimental artists around Peter Voulkos, working as a technical assistant at Otis and signing his works

"Moonstone." After leaving Otis, Bengston turned from pottery to painting. The rich, spontaneous surfaces of two genres of Japanese ceramics—raku and Oribe—strongly influenced his painting. He returned to ceramics in June 1975, when he was invited to participate in the New Works in Clay by Contemporary Painters and Sculptors exhibition at the Everson Museum of Art. His works were produced with the assistance of the Syracuse China Corporation from designs (wax models and drawings) that he submitted for execution. These required several modifications before the final plaster molds were prepared by Don Foley for production in flintware. In this body of work, Bengston employed the iris motif by spraying glazes over a template. The iris, what he terms "dracula," is a favorite motif in Bengston's ceramic work and also appears in many of his paintings.

Bertoni, Christina (1945—). Born in Ann Arbor, Michigan, Bertoni studied at the University of Michigan, Ann Arbor, where she received her B.F.A. in 1967. She received her M.F.A. in 1976 from the Cranbrook Academy of Art, Bloomfield Hills, Michigan. She currently works in Pascoag, Rhode Island.

Bertoni's primary format is the vessel. During the eighties she has at times departed from this discipline to make relief wall sculpture. Her early works dealt with astrological themes. They also strongly emphasized the inside and outside of the vessel, which Bertoni manipulated with strong contrasts of black interiors and white exteriors. In her more recent work, Bertoni has approached the vessel with a more conceptual edge, writing legends on her works and creating simple yet evocative marks and signs on the surfaces of shallow shapes that evoke the sense of small moon craters rather than vessels in the cultural and functional sense. Bertoni describes her work as "a process of exploring a body of ideas and attempting to articulate them visually.... Bowls are vehicles for my speculations on the nature of such things as existence/nonexistence, order/chaos, microcosm/macrocosm, space/matter" (Clark and Watson, 1986).

Binns, Charles Fergus (1857–1934). Born in Worcester, England, Charles Fergus Binns was the son of Richard William Binns, director of the Royal Worcester Porcelain Works. As a child the younger Binns attended the Cathedral King School, and at the age of fourteen he was apprenticed to his father at the porcelain works. Charles

Fergus Binns studied chemistry in Birmingham, England, after which he established a ceramics laboratory at the plant, which sought to bring the production at the factory under more scientific control. In 1897 Binns came to the United States to become principal of the Technical School of Sciences and Art in Trenton, New Jersey, and in 1900 he became the first director of the New York School of Clayworking and Ceramics (renamed the New York State College of Ceramics in 1932) at Alfred University. A year after joining Alfred, the university gave him the honorary degree of master of science in recognition of his work; and in 1925 it presented him with the degree of doctor of science.

Binns was one of the charter members of the American Ceramic Society, which was founded in 1899. He was elected trustee at the first meeting; the following year he was made vice-president and in 1901 president of the society. When Professor Edward Orton resigned as secretary in 1918, Binns accepted that office and acted as secretary of the society for four years. He was also a member of the English Ceramics Society and various art organizations, as well as a fellow of the Boston Society of Arts and Crafts. He was the author of numerous essays and technical papers that were published in the Craftsman, Keramik Studio, Transactions, and Journal of the American Ceramic Society, as well as other publications.

Charles Fergus Binns

He also wrote three books: *The Story of the Potter, The Potter's Craft,* and *Ceramic Technology.*

Binn's greatest contribution came in the field of ceramic education. Under his guidance, a generation of significant ceramics teachers emerged, including Arthur Baggs, Harold Nash, Myrtle French, Paul Cox, R. Guy Cowan, Ruth Canfield, and Charles Harder. Binns was a man of strong convictions—evident both in the standards he set for his work as an artist and in his dedication to the church. In 1923 Binns was ordained as a priest in the Protestant Episcopal Church. After his death a memorial exhibition of the superbly glazed stonewares for which he was famous was held in New York at the Metropolitan Museum of Art in 1935. A full account of Binns's contribution to education in American ceramics can be found in Melvin Bernstein's fascinating study Art and Design at Alfred.

Bogatav, Paul (1905-1972). Born in Ada, Ohio, Bogatay studied at the Cleveland School of Art under R. Guy Cowan and briefly under Arthur Baggs. Bogatay was later a graduate student under Baggs at Ohio State University (Columbus), where he himself became a ceramics instructor in the early 1930s, remaining there until 1971. Bogatay received two first prizes for his sculptural works at the Ceramic Nationals, and a \$100 purchase prize in 1946. He was the recipient of a Tiffany Fellowship, and for three years he was a fellow of the Rockefeller Foundation. Apart from his interest in clay as a sculptural material, Bogatay was also strongly involved in industrial concerns and was an active member and officer of the American Ceramic Society.

Bohnert, Thom R. (1948–). Bohnert studied at Southern Illinois University, Edwardsville, from 1965 to 1969, when he received his B.A. He earned his M.F.A. in 1971 at the Cranbrook Academy of Art, Bloomfield Hills, Michigan, where he majored in ceramics and minored in printmaking and metalsmithing. Bohnert has exhibited extensively since 1966 and has received numerous scholarships and awards, including the National Endowment for the Arts' Craftsman Fellowship in 1978.

Bohnert has evolved a unique method of dealing with both volume and space. He creates polychrome assemblage vessels with wire and ceramics so that the "pot" becomes a series of lines and fragments suspended in space. In essence, Bohnert's work is an

act of drawing in which the vessel becomes the subject. Writing on "linear order" (Studio Potter, 1985) Bohnert describes his involvement with drawing and how he attempts to translate the two-dimensional dynamic into form: "The 3-D form strives to obtain drawing elements: contours that define multiple interplay with volume and shape, a sensation of depth also communicated by the color of each line and fragmented plane."

Brady, Robert David (1946—). Born in Reno, Nevada, Brady studied with Viola Frey and Vernon Coykendall at the California College of Arts and Crafts in Oakland, receiving his B.F.A. in 1968; he received his M.F.A. in 1975 from the University of California at Davis. Brady taught for six months at the Appalachian Center for the Crafts in Smithville, Tennessee, and currently maintains a studio in Sacramento, where he teaches with Peter Vandenberge at California State University.

Brady's early exhibitions were distinguished by a random eclecticism; indeed, his 1978 exhibition of ceramics and paintings was so diverse and scattered that at least one critic described the event as a group exhibition. There was a particularly obvious debt in these works to both Viola Frey and to the Jasper Johns retrospective at the San Francisco Museum of Modern Art, which preceded Brady's one-person show.

The eighties have seen an impressive growth and sense of individuality and maturity in Brady's figurative sculpture. Today Brady ranks among the most original and provocative of the ceramic sculptors. He has moved back to the vessel forms that he first showed in 1975 and again in 1983 at the Braunstein Gallery, San Francisco. These large, hand-built vessels have gradually become less and less specific in their sense of being pots and are now simply hollow mounds with a strange biomorphic presence. But it is his figures and masks that dominate his ouevre. In 1982 he produced an inspired group of masks whose forms refer to African primitive art. The surfaces, however, are covered with an elegant series of black circles on white. Several of these masks were included in the exhibition Modern Masks at the Whitney Museum of American Art in 1984. Brady's figures have distinctive sticklike arms and legs, shriveled genitalia, and a somewhat tortured surface that speak of an inner pain and disquiet. Brady's contribution to American ceramic sculpture has yet to receive its full due and is at an ideal point for a mid-career survey.

Breschi, Karen (1941—). Born in Oakland, California, Breschi studied at the California College of Arts and Crafts, Oakland, where she received her B.F.A. in 1963. She continued her studies at San Francisco State College through 1965, and from 1968 to 1971 she studied at the San Francisco Art Institute, where she taught after graduating. Breschi had her first one-person show, *Dreams and Visions*, in 1972, at the University Art Gallery, Berkeley. Subsequently she has shown at the Braunstein Gallery, San Francisco.

Breschi creates fired-clay figurative sculptures, which she later paints and occasionally embellishes with other materials and found objects. These works involve macabre dream imagery in which animals dressed in clothes act out human dramas dealing with highly personal issues and an underlying feminist agenda. Her later work has involved a series of self-portraits and figures, such as *False Fronted Man* (1973). These have extended Breschi's investigation of the mask, a theme that she has explored extensively in her work. Over the past decade her output (and involvement with ceramics) has been sporadic.

Burns, Mark A. (1950—). Born in Springfield, Ohio, Burns received his B.F.A. in 1972 from the College of the Dayton Art Institute, Dayton, Ohio, with a major in ceramics. He took his M.F.A. in 1974 at the University of Washington, Seattle, under Howard Kottler and Patti Warashina. He has taught at the College of the Dayton Art Institute; the University of Washington; the Factory of Visual Arts, Seattle; the State University of New York, Oswego; the Philadelphia College of Art; and California State University, Chico.

Labeling Burns's work "Punk Art" is to oversimplify what are in fact intensely personal statements of the artist's search for identity. Burns employs bizarre, exotic, and sadomasochistic imagery in his immaculately crafted works. In 1977 he held a oneman exhibition of his works at the Drutt Gallery, Philadelphia, which incorporated a total painted environment. In 1984 he was commissioned by the Pennsylvania Academy of the Fine Arts to create an installation as an homage to the architect Frank Furness. The Society for Art in Craft, Verona, Pennsylvania, organized a midcareer survey of his work in 1986 entitled Mark Burns—Decade in Philadelphia.

Buzio, Lidya (1948—). Born in Montevideo, Uruguay, Buzio studied drawing and painting with Horacio Torres, J. Montes, and G. Fernandez (1964–66), and ceramics with José Collel in 1967. In 1972 she moved to the United States and set up a studio in New York City.

Buzio's art reflects many influences, but the formative one was undoubtedly that of Joaquin Torres-Garcia (1874–1949), the Uruguayan modernist painter. Although Torres-Garcia died a year after Buzio was born, her sister married his son Horacio. Lidya Buzio grew up surrounded by Torres-Garcia's art, and that of his sons and his followers. Her work is not, however, imitative of Torres-Garcia's. Indeed, Buzio's style is very personal and distinct. But what she has taken from the Uruguayan master is a particular sense of structure and geometry, which, since he was a Constructivist, was the central factor in his work.

Lidya Buzio

There is also a parallel in their response to New York City. When Torres-Garcia visited in 1920, he filled his sketchbook with cityscapes. Buzio, trained in the figurative traditions of Horacio Torres and José Collel, also found herself drifting toward the cityscape after her move to New York. In her case the fascination was with the roofs of SoHo and their strange Italianate quality. She began to transfer these to slab-built pots, burnishing the images onto the surface of the unfired vessel. Inspired by Renaissance frescos, she created a dry, slightly transparent surface with a delicate play of tonal values. Painted onto the tense, curving surfaces of her work, the space she creates is strangely illusory.

Ed Lebow wrote of the spatial issues in her work, commenting: "Buzio splices illusory space with real. She has a keen eye for the fundamental difference between working on flat and on three-dimensional ground. Unlike a flat surface, a volumetric one is not static. It moves through space, lending the image it carries the full effects of the hollows and swells. Since there are no true straight or flat lines Buzio cheats the eye by gently tilting the edges of buildings to give them a plumb appearance, or by toying with angles and curves to accentuate the volumes that the walls and lines seem to hold and describe" (Lebow, 1983).

The result of this surface distortion is a kind of visual "breathing" in which the eye moves from the real surface of the pot into the imaginary space it suggests in line and perspective, only to be drawn back by the slightest distraction to the burnished surface. Philip Rawson, the distinguished writer on aesthetic theory in ceramics, sees this as the consequence of a masterful use of what he terms "potter's space." In an unpublished address to the Kansas City Third International Ceramics Symposium in 1983, he spoke of potter's space as comprising not only one volume (the vessel) but a number of component volumes: "One of the most splendid uses of potter's space seems to me to be in Lidya Buzio's pots. The tension between the curved surfaces which subtend that independent potter's volume and the superficially banal perspectives of the cityscapes that she paints onto them seems to be what generates their extraordinary enigmatic atmosphere.... One volume-content flows into another to make a beautifully modulated content of space: something carvers or makers can never achieve, only potters.'

Carhartt, Elaine (1951-). Born in 1951 in Grand Junction, Colorado, Carhartt studied at Colorado State University, Fort Collins, receiving her B.F.A. in 1975. The following year she moved to Pasadena, California, where she established a studio, and in 1980 received the prestigious New Talent Award of the Los Angeles County Museum of Art. Her work is figurative; it involves curious and disquieting figures that are at once saccharine in their charm and curiously untrustworthy, even threatening. The sweetness and charm of the work suggest something subterranean and uneasy. As the Los Angeles Times art critic Suzanne Muchnic comments, "Carhartt's work always had more going for it than charm.... New pieces seem to have acquired an increasingly unsettling twist... What are we to make of a pig, a penguin and yes, a worm that stares up at us through human eyes?... their faces are masks as inscrutable as a sphinx" (Muchnic, 1985).

Carman, Nancy (1950—). Born in Tucson, Arizona, Carman studied at the University of California, Davis, receiving her B.A. in 1972, and at the University of Washington, Seattle, from which she graduated with a M.F.A. in 1976. In 1980 she received a Visual Artists Fellowship from the National Endowment for the Arts. Carman makes small figurative sculptures that are a blend of "poetic narratives and psychological drama that is very much autobiographical" (Bell, 1985).

Chicago, Judy (1939–). Born Judith Cohen in Chicago, she changed her name in 1970 to Judy Chicago to "divest myself of all names imposed upon me through male social dominance." Chicago received her B.A. from the Art Institute of Chicago in 1962 and her M.F.A. from the University of California in Los Angeles in 1964. She became a central figure in the feminist movement, founding (with Miriam Schapiro) the first feminist art program at Fresno State University and playing an important role in establishing the Woman's Building in Los Angeles. In 1975 Chicago published her autobiography Through the Flower: My Struggle as a Woman Artist.

Chicago's interest in ceramics began to develop on a trip along the Northwest Coast in 1972, when she stopped at an antiques shop and saw a porcelain plate that was china painted with "the most delectable roses." Chicago felt that the china painting medium had a great deal of expressive potential and began to study china painting in the hobbyist circuit. Soon Chicago realized that china painting was very much a woman's art form in the twentieth century and that in addition to the painterly quality of the technique, it had close historic and symbolic ties to the women's movement.

In 1975 she established and obtained funding for a major project, *The Dinner Party*, which involved four hundred women volunteers in the painting of the thirty-nine large dinner plates and tiles and in the embroidering of the fabric runners that were the focus of the piece. *The Dinner Party* was first shown at the San Francisco Museum of Modern Art, and then traveled throughout the United States and Europe. The exhibition attracted widely differing reviews. It was hailed by feminist critics such as Lucy Lippard, but damned by others, par-

ticularly and predictably by male critics. The exhibition did have its flaws, in particular the accompanying book/catalogue, The Dinner Party: A Symbol of Our Heritage, by Judy Chicago. John Richardson's article in the New York Review of Books in 1980 is a particularly interesting examination of the Dinner Party saga. As Richardson states, the event came into its own less as an art piece than as a political event: "The Dinner Party deserves to be taken seriously as agitprop of remarkable potential.... It has served as a sorely needed rallying point in women's ongoing war of independence....And, not least, it has given the women who worked on [the project] a gratifying sense of communal fulfillment that has been an inspiration to women's groups all over the country" (Richardson, 1980).

Cornelius, Philip (1934—). Born in San Bernardino, California, Cornelius discovered art in the Army Services Library. After his return from army duty he studied at San Jose State University, where he received his B.A. in 1960, and at the Claremont Graduate School, receiving his M.F.A. in 1965. He is a professor at Pasadena City College and maintains a studio in Pasadena, California. Cornelius received two major Visual Artists Fellowships from the National Endowment for the Arts, in 1981 and 1984.

While in San Jose Cornelius studied with Herbert Sanders, from whom he learned about glaze chemistry. At the Claremont Graduate School, where he studied with Paul Soldner, he began to explore the aesthetic energy of ceramics. His early work consisted of large stoneware vessels, often lidded, with hard-edged, architectonic shapes decorated with various patterns and the recurring motif of the salamander.

In 1970 Cornelius accidentally stumbled onto a technique that was to introduce a totally original field of exploration and to become his central focus for the next seventeen years:

While Cornelius was making some large platters, a thin slab of residue stoneware came loose from the platter bat. This intriguing sheet of clay demanded investigation, so he cut open his paper coffee cup and, using it as a template, constructed an identical cup from the paper thin stoneware. To prove to himself that nothing so fragile could survive a firing, he included it in the next kiln load. Amazingly it held together and the first "thinware" was completed. Over the years Cornelius developed these pieces into more complex forms, finally

settling on the teapot—the most complex of utilitarian ceramic forms. (Burstein, 1982)

This breakthrough in Cornelius's work highlights the way in which many ceramists innovate—through the complex technology of the medium. Except for a few ceramists who use the most rudimentary of processes, technique remains a central and often a creative core. Parallel to his interest in thinware, Cornelius was exploring charcoal firing, attempting to achieve the same expressionistic effects in a modern gas kiln as the Japanese potters were achieving with traditional village kilns. He visited Japan in 1977. At first the charcoal effects were explored on heavy stoneware pieces, but then Cornelius decided to combine this effect with his thinware (which he was now making in porcelain). Surprisingly, even though the mortality rate was high, a large number of the thinwares survived the charcoal firing, and the results on the surface were stunningly dramatic and powerful. In these teapots—with their slab structures derived loosely from World War I tanks and later from aircraft—Cornelius has made a unique and rich contribution to American ceramics, extending the traditions with which he has been nourished.

Cowan, R. Guy (1884–1957). Born in East Liverpool, Ohio, to a family that had been in the pottery industry for generations, Cowan was one of the first graduates of the New York School of Clayworking and Ceramics, where he studied under Charles Fergus Binns. In 1913 he opened his own pottery in Cleveland, scoring his first public success in 1917, when he was awarded the first prize for pottery at the Art Institute of Chicago.

After World War I Cowan moved his pottery to Rocky River, a suburb of Cleveland, and changed the company name from Cleveland Tile and Pottery Company to Cowan Pottery Studio. There he concentrated on molded, limited-edition ceramics, winning many awards, including the Logan Medal for Beauty in Design (Chicago, 1924). He also worked with a white porcelain clay, designing most of the figurative and vessel pieces himself until 1927, when Paul Manship, Waylande Gregory, A. Drexler Jacobsen, and Thelma Frazier began to design limited-edition works for the pottery. With the addition of Arthur Eugene Baggs to the staff between 1925 and 1928, Cowan's glazes also improved in variety and quality. Cowan's ceramics, particularly the figurines,

R. Guy Cowan

were popular, and the company was reincorporated with \$100,000 capital. Still, the studio was unable to survive the Depression and in 1931 went into receivership.

Cowan moved to Syracuse, New York, and became the art director for the Onondaga Pottery Company, producers of Syracuse china. In Syracuse he became one of the guiding figures in the Ceramic Nationals. A fitting memorial to his achievement now exists in the Cowan Pottery Museum at the Rocky River Public Library, which has a collection of over eight hundred works and comprehensive archives of catalogues and correspondence. The collection is based mainly on the John Brodbeck collection, which the library purchased in December 1976.

Currier, Anne C. (1950—). Born in Louisville, Kentucky, Currier studied at the Art Institute of Chicago, where she received her B.F.A. in 1972, and at the University of Washington, Seattle, where she received her M.F.A. in 1974. She has received several awards, including a Visual Artists Fellowship from the National Endowment for the Arts in 1986. Currier currently teaches at the New York State College of Ceramics at Alfred University, Alfred, New York.

Currier is one of the few artists to graduate from the University of Washington's ceramics program who has not followed a figurative style. Instead, her interests have focused on minimal, hard-edged forms, at first black-and-white vessels that echoed the stylization of Art Deco. However, she soon moved away from the vessel and has concentrated on sculptural forms, influenced by such sculptors as Sol LeWitt. Her latest works are a rhythmic exploration of volumetric elements in a tightly linear format.

Cushing, Val Murat (1931-). Born in Rochester, New York, Cushing received his education at the New York College of Ceramics at Alfred University, Alfred, New York, taking his B.F.A. in 1952 and his M.F.A. in 1956. He later taught at the University of Illinois, Champaign-Urbana, and was the director of the Alfred University summer school course in pottery from 1957 to 1965. He is now a professor of pottery at Alfred University and is an active participant in the ceramic arts. Cushing was chairman of the Standards Committee of the New York State Craftsmen and from 1962 to 1966 chairman of the Technical Committee of the National Council for Education in the Ceramic Arts. His work has been extensively exhibited in major group and one-man shows, and he was recently awarded the Binns Medal of the American Ceramic Society. In recent years Cushing's work has revolved around the exploration of a "roll-top," lidded jar, with the formal climax of the vessel arriving through the tall, spirelike handles of his lids.

Daley, William (1925—). Born in Hastingson-Hudson, New York, Bill Daley studied at the Massachusetts College of Art in Boston and at Columbia University Teachers College, New York, receiving his M.Ed. in 1951. He has taught in Iowa, New York, New Mexico, and since 1966 at the Philadelphia College of Art, where he heads the ceramics department. Daley has developed a distinctive architectonic form, creating large, press-molded, stoneware vessels. In addition, he has considerable experience in architectural ceramics. He has created murals, both in bronze and ceramic, for the Atlantic Richfield Corporation, the South African Airlines office in New York, and a work entitled Symbolic Screen for the IBM Pavilion at the Seattle Century 21 Exposition in 1962.

His early vessels grew out of an interest in Shang bells, with their ellipsoidal cross sections and scooped rims. Gradually other influences altered his vessels. The forms evolved slowly, always retaining the common theme of a play between inner and outer

William Daley

space. An important turning point for his work came in 1972, when as a guest lecturer in New Mexico, Daley was introduced to Anasazi cliff dwellings and to collections of early Pueblo pottery. The black-and-white painted Mimbres pots particularly fascinated Daley, because they spoke to his own obsession with negative and positive space. When he returned to the East he attempted to translate the abstract designs from Pueblo pottery into three-dimensional forms: "the steps and zigzags were marvelous building structures when three-dimensional, recapitulating earlier play with modules, bumps and patterns-from pummelled clay surfaces to Iowa tractor treads and worm gears" (McTwigan, 1983).

In order to increase the exploration of the inner/outer space, Daley began to work on multiple "exits" and "entrances" that lead the eye in and out of the vessel: "attempting to use the edge to control the sense of open and closed, sometimes outside segments had larger negative sections to suggest they might be inside a greater space" (Clark, American Potters, 1981). In the catalogue Who's Afraid of American Pottery? (Clark et al., 1983), Michael McTwigan likened the complexity of geometry in Daley's pots to Islamic ornament (a subject that fascinates Daley). McTwigan quotes Henri Focillon's explanation of the tesselation systems in Islamic ornament: "'a sort of fever seems to goad on and to multiply the shapes; some mysterious genius of complication interlocks, enfolds, disorganizes and reorganizes the entire labyrinth...whether they be read as voids or solids, as vertical aexesor diagonals, each one or both withholds the secret and exposes the reality of an immense number of possibilities.' "

Daly, Matthew A. (1860–1937). Born in Cincinnati, Daly counted among his boyhood companions Artus Van Briggle and Ernst Blumenshein, the magazine illustrator. Daly was one of the first decorators to join the Rookwood Pottery, where he remained for twenty years. He left Rookwood to become the art director of the United States Playing Card Company, a post he held for thirty years. Daly was a charter member and president of the Cincinnati Art Club, as well as a member of the American Artists' Professional League.

Delisle, Roseline (1952-). Born in Quebec, Canada, Delisle studied at the Collège du Vieux Montreal in 1975. Coming to the United States in 1978, she established a studio in Venice, California, and soon attracted attention for her small porcelain vessels with their precise black-and-white decoration. Some of her vessels are lidded, with complex, turned finials. In 1985 Delisle received a commission from the J. Paul Getty Center for the History of Art and the Humanities in Santa Monica, California, to make vases for the entrance area. This pushed her into increasing the scale of her work considerably. Her works, still with their mat black decoration on a white porcelain body, have taken on a new monumentality.

DeStaebler, Stephen (1933-). Born in Saint Louis, Missouri, DeStaebler studied with Ben Shahn and Robert Motherwell at Black Mountain College in 1951. He subsequently traveled to Europe, where he concentrated on making stained-glass windows. In 1954 he received his B.A. degree, with high honors, in religion from Princeton University. He served in Germany with the United States Army from 1954 to 1955. In 1957 he worked at the Union Settlement House, East Harlem, New York, and studied ceramics with Ka-Kwong Hui at the Brooklyn Museum School. He later moved to southern California, where he taught history and art at the Chadwick School in Rolling Hills. In 1958 he studied ceramics with Peter Voulkos and took his M.A. in art history at the University of California, Berkeley. Since 1967 he has been associate professor of sculpture at San Francisco State . University. DeStaebler is an active sculptor,

Stephen DeStaebler

exhibiting in major group shows since 1962 and carrying out commissions for the Newman Center Chapel, the University Art Museum, Berkeley, and the Bay Area Rapid Transit Station at Concord, as well as for private residences. In 1974 he had a major one-man show at the Oakland Museum.

DeStaebler works on a large scale (his freestanding sculptures are eight to nine feet in height) and draws his inspiration from the terrain and landscapes, particularly of the West. Insofar as there is direct symbolism in his work, he draws strongly from the gestation of earth and rock. Nature, not cultural references, is the major source in his works. Writing about DeStaebler in the 1974 catalogue of his one-man exhibition at the Oakland Museum, Harvey L. Jones remarked that the power and appeal of DeStaebler's sculpture derives in a large part from his attitude toward the clay:

He has learned by long experience to recognize the intrinsic character and beauty of the medium and, more important, to respect its natural limitations. DeStaebler responds to the peculiar qualities which clay possesses: its plasticity when wet, its fragility when dry, its tendency to warp, crack, and slump during the drying and firing processes. He equates the obvious but frequently overlooked fact that clay is earth. He has developed a vocabulary of earth forces: gravity and pressure, eruption and erosion, shearing and breaking. By yielding to clay and discovering what it wants to do, he has evolved a unique art form. Since 1982 DeStaebler has been working

in bronze as well as clay. The bronzes are constructed from the shards of previous clay pieces that were technically unsuccessful. This has enabled DeStaebler to extend the figure in directions that were "antithetical to clay's structural properties." Writing of his work in *American Ceramics* (1984), Joanne Burstein comments, "Above all, the tactile surfaces of his work strike an emotional chord, not an analytic one, as we see the whole destroyed and reassembled with honor.... These are the dichotomies of reverence in an age without religion."

DeVore, Richard E. (1933—). Born in Toledo, Ohio, DeVore was educated at the University of Toledo, where he received his B.Ed. in 1955; and at the Cranbrook Academy of Art, Bloomfield Hills, Michigan, where he studied under Maija Grotell and received an M.F.A. in 1957. In 1966 Grotell chose DeVore as her successor to head the ceramics department, a position he held until 1978, when he joined the faculty of the University of Colorado at Fort Collins.

During the 1960s DeVore's work explored a range of interests, from brightly colored vessels to lustered male torsos preciously contained in framed glass boxes. Since 1970 this eclecticism has been replaced with an intense, sharply focused investigation of the vessel format. His works reveal a virtuoso handling of the dynamics of the potter's aesthetic, presenting a refined and tensely controlled treatment of line, volume, entrapped and displaced space, tactilism, and color. This process of distillation to achieve the essence of these qualities is understandably a highly conscious and intellectual pursuit. While the cerebral quality of DeVore's work is certainly evident—and potent in its power and attraction—the vessels never lapse into an academic format.

One of the dominant features of DeVore's vessels is the lip or rim area, which, as the final act of making, establishes and orders the compositional priorities in the eye of the viewer. Although the forms seem a mixture of the biomorphic and the anthropomorphic, the rims, frequently offset by points or protuberances, allude to a geometric logic that is the foundation of DeVore's compositional style. His aesthetic Achilles' heel is the foot of the vessel. In common with his teacher Grotell, he often seems to render the foot awkwardly and without convincingly integrating it with the rest of the form. This is most noticeable in DeVore's "torso" forms. But on his bowls (particularly what Gerald Nordland terms his "deep"

bowls), works that are arguably his toughest and finest work, the foot disappears under the vessel and the bowls simply float in space. These bowls, with their small interior cavities, create some of the most complex geometries of his works and the most lavered sense of metaphor: "A bowl may begin one way and then as the artist changes the cross section of the cylinder, the piece takes on a new posture.... With an undulating of the outer wall DeVore can gain a new impression suggesting a slumping motive, as if a pressure were operating negatively beyond the centrifugal and gravitational forces required for its forming" (Nordland, 1983)

In dealing with the sensual anthropomorphism of the work, Andy Nasisse refers to DeVore's pots as androgynous, combining the male, or dark principle, with a contrasting, light-giving female principle:

The open bowl form is receptive, which embodies the female principle. The various heights allow a versatility of presentation, some related more to the male principle.... The female quality of light as opposed to male darkness is inherent in DeVore's use of color. Often the interior surface has a mottled use of color which appears to give off its own light. The surface is always mat but never flat. Even in pieces seemingly all black there is a subtle combination of deep hued color which appears gradually. DeVore's particular genius and paradox is his ability to create an object of almost seductive beauty and serenity, which at the same time is invested with an extremely turbulent level of spatial reality. (Nasisse,

Diederich, Hunt (1884-1953). Born in Hungary, Diederich studied in Paris, in Rome, and at the Pennsylvania Academy of the Fine Arts in Philadelphia. Diederich worked primarily in bronze, specializing in animals and figures for monuments and fountains and winning several awards, including the gold medal from the Architectural League. He produced his ceramics in the mid-1920s, painting individual pieces as well as designing for mass production. His works were included in the International *Exhibition of Ceramic Art* at the Metropolitan Museum of Art in 1928. Diederich's ceramics, although produced for a limited period, exhibit both superb draftsmanship and an ability to employ the translucency of his glazes to achieve a sense of depth.

Dillingham, James Richard (1952–). Born in Lake Forest, Illinois, Rick Dillingham studied at the California College of Arts

and Crafts, Oakland, and at the University of New Mexico, Albuquerque, where he received his B.F.A. in 1974. In 1979 he received his M.F.A. from the Claremont Graduate School, Claremont, California. Dillingham received Visual Artists Fellowships from the National Endowment for the Arts in 1977 and 1982. He maintains a studio in Santa Fe, New Mexico. Apart from his work as an artist, Dillingham has interested himself in a broad range of activities. He is a dealer in historic American Indian pottery and Navajo textiles. He has also written on American Indian pottery and curated a number of exhibitions—the most recent being The Red and the Black, a 1983 retrospective of the Santa Clara potter Margaret Tafoya at the Wheelwright Museum in Santa

Dillingham's pottery reflects his knowledge of and interest in American prehistoric Indian pottery. The pots are not imitative in any sense, although they draw from forms that are generic to most so-called primitive pottery. Dillingham became intrigued by the notion of the vessel as an assembly of shards when he was restoring pots at the Museum of New Mexico, Laboratory of Anthropology, in Santa Fe. Dillingham's pots are not simply broken and reassembled. The breaks are carefully controlled and "drawn" into the pot before firing. Apart from setting up a different context and mood for his work, the act of reassembling the pot from a number of pieces allows Dillingham a variety of discrete elements on which to paint. Each shard is treated separately and painted with line and pattern out of a palette that is a mixture of bright, primary colors and earthy hues. Some shards are painted with a flat color or covered in gold and silver leaf. When they are reassembled, there is a compositional unity and complexity that places Dillingham's surface painting among the most complex and sophisticated work of this type in contemporary ceramics.

Doat, Taxile (1851–1938). Born in Albi, France, Doat was a student at the Ecole des Arts Décoratifs, Limoges, France, and the Ecole des Beaux-Arts, Paris, and also studied with the sculptor Augustin Dumont. In 1879 Doat joined the Sèvres Manufactory as a sculptor, modeler, and decorator. He became a specialist in *pâte-sur-pâte*, a technique of painting porcelain slips in light relief against contrasting ground, using the translucency to give qualities of light and shade. Doat became one of the leading ceramists in France, winning gold medals for

his porcelains at Antwerp in 1885, Barcelona in 1888, and at the Exposition Universelle in Paris in 1889. In 1898 he established his own studio in Sèvres at 47, rue Brancas. Doat was in contact with the American publisher of *Keramik Studio*, Samuel Robineau, and with Robineau's wife, Adelaide, by 1903. The Robineaus first published a series of Doat's articles on high-fire ceramics in *Keramik Studio* and in 1905 published them together as a book, *Grand Feu Ceramics*. It was the first handbook of its kind to be published in English and had a strong impact on the ceramics community in the United States.

Doat came to the United States in 1909 at the invitation of Edward G. Lewis, founder of the American Women's League, and the People's University in University City near Saint Louis, Missouri. The purpose of the trip was to have a "conference with the League's architects in order that the erection of one of the most perfectly designed and equipped art potteries in the world might be immediately begun." Doat was appointed director of the University City Pottery, where he assembled a distinguished faculty, including Adelaide Robineau, Frederick Rhead, Katherine E. Cherry (a local china painter), and two of his European associates—Eugène Labarrière, foreman of a pottery in the suburbs of Paris, and Emile Diffloth, former art director of the Boch Frères Pottery, La Louvière, Belgium. The first firing of the kiln took place in April 1910, and although the American Women's League foundered in 1911, Doat reorganized the pottery and continued it

Taxile Doat

until early 1915, when he returned permanently to France.

While in the United States, Doat sold his collection of almost two hundred pieces to the league for \$7,000. Herbert Rhead described the group as "without exception...one of the finest groups of the work of one potter in existence" (Weiss, 1981). It was a meticulous selection of his works, showing each and every change in his style and technique. The collection was later housed in the Saint Louis Art Museum. In 1945 the collection was deaccessioned by the museum and only eighteen pieces were retained.

Duckworth, Ruth (1919-). Born in Hamburg, Germany, Duckworth moved to England in 1936. While in Germany, she, as a Jew, was not allowed to enter any art school. Not long after World War II, she filed a "loss of education" claim against the German government and bought her first kiln with the money she received. In England she studied at the Liverpool School of Art from 1936 to 1940. Duckworth worked as a sculptor, learning to carve stone and even earning a living for a while carving tombstones. She began to see and admire pots; she remembers attending a Red Rose Guild exhibition in London, where she saw a very large pot: "I don't know who made it...I know I wanted to put my arms around it and hug it" (Duckworth and Westphal,

Around 1955 she began to do some simple clay sculpture, and at the suggestion of the potter Lucie Rie she returned to school to learn about glazing. After a short period at the Hammersmith School of Art, which she found too doctrinaire, requiring that "a pot must have a foot, a middle, a lip," she moved to the Central School of Arts and Crafts in London (1956-58). It was there that her work began to develop, and by 1960 she was teaching at the Central School. In 1964 she moved to Chicago to assume a teaching position at the University of Chicago, accepting the offer because she was "curious to see the United States and Mexico and to find out why people made those ugly pots I saw so often in Craft Horizons" (Duckworth, 1977). She is now a resident of Chicago, where she has her studio.

Duckworth's involvement with ceramics covers a wide spectrum. Her early work ranged from small, delicate, highly secretive porcelain forms of an organic nature to large, roughly textured weed pots in stoneware. She later created massive stoneware murals, freestanding sculptural forms,

vessels, and delicate porcelain forms reminiscent of her earlier work. Recently she has returned to small-scale porcelain vessels, an area where her sensibility is most powerfully expressed, and, paradoxically, where she seems to provide most effortlessly an illusion of monumentality. The pots are created in groups of three to four, with delicate, flat "keys" inserted into the form.

Duckworth has been one of the strongest influences on the liberalization of ceramics in the United Kingdom and has been a successful teacher and artist in the United States. She has participated in several onewoman and many group exhibitions, and has produced several architectural commissions, including Earth, Water and Sky (1968) at the Laboratory for Geophysical Sciences, the University of Chicago; Clouds over Lake Michigan (1976), a 240-square-foot mural for the Dresner Bank in the Chicago Board of Trade building; The Creation (1983) for Congregation Beth Israel, Hammond, Indiana; and a mural in 1984 for the State of Illinois Building in Chicago.

Earl, Jack (1934—). Born in Unipolis, Ohio, Earl took his B.A. at Bluffton College, Ohio, in 1956, returning to school in 1964 to take an M.A. at Ohio State University in Columbus. From 1963 to 1972 he taught at the Toledo [Ohio] Museum of Art, where the magnificent collection of ceramics—early Meissen figures, Kandler dinner services, faience sculptures of the Della Robbia family, and other works—had a strong impact on his work and his perfectionist craftsmanship.

Initially there was little evidence of aesthetic vision in Earl's work; he first made a populist style of pottery that was distinctly commercial, then turned to Japanese pottery for inspiration. But by the time of his oneman show at the Museum of Contemporary Crafts in New York in 1971, a unique style had emerged. One of the centerpieces of the exhibition was a dog in slippers that was a disarmingly realistic portrait of an actual animal, including the trickle of ooze from the dog's eyes. Although inspired by the eighteenth-century porcelains of Europe, the style was anything but imitative of this tradition. Also, for this work a distinctive, long title had emerged, giving the work a strange shamanistic/folk context:

Dogs are nice and make wonderful companions I've been told, and most people get dogs when they are young and cute and so much

fun to play with, not thinking about how long a dog can live. You got to train them when they are young too, of course a kid can't train a dog right. I wouldn't take a grown dog who had a previous owner, cause you can never tell what you are getting, even though some of them look real good and lay still for you. You can't change a used dog's bad habits either and they stink, dogs all smell the same. The best dog has a greedy streak and will howl and drool and paw until they get what they want and I like old dogs best because they just lay around and don't bother you so much any more.

Increasingly this mood of narrative has defined Earl's works, recently resulting in complex, delicately painted landscapes and portraits that appear to have magically become three-dimensional. With the move from porcelain to painted earthenware, the sense of figurative ceramic traditions has been severed. But the personal chord remains the same; "Turning a penetrating eye outward at people and places and events around him, Jack Earl succeeds in making viewers look inward and reconsider their relationship with reality" (R. H. Cohen, 1985). In 1985 Earl's biography, Jack Earl: The Genesis and Triumphant Survival of an Underground Ohio Artist, written by Lee Nordness, was published.

Eckhardt, Edris (1907–). Born in Cleveland, Eckhardt studied at the Cleveland School of Art, where she was awarded a scholarship and remained for five years, graduating in 1932. In her last year at the

Edris Eckhardt

school, she participated in a collaborative ceramics program created by three institutions: the Cleveland School of Art, the Cleveland Museum of Art, and the Cowan Pottery. After leaving the school, she set up her own studio and became involved with glaze chemistry.

In 1933–34 Eckhardt participated in a pilot program of the Public Works of Art Project (PWAP), which operated for five months and provided a number of specific assignments for individual artists. Through this program she conceived the idea of producing small-scale sculptures for use in children's library programs. These were based on *Alice in Wonderland*, the Mother Goose stories, and W. H. Hudson's *Green Mansions*, then popular with adolescent readers. Her *Alice in Wonderland* series was particularly successful; a piece from this series was acquired by Queen Elizabeth II for her private collection.

In 1935, when the WPA-FAP began local operation, Eckhardt was made director of the Cleveland department of ceramic sculpture. She held this position until the program, which later passed into state control, was finally discontinued, in 1941. Eckhardt continued to work in the ceramic medium, producing one of her major pieces, *Painted Mask*, which she exhibited in Cleveland at the May Show in 1947.

In 1953 Eckhardt began to work in glass and rediscovered the technique of fusing gold leaf between sheets of glass—producing the first-known examples of gold glass in almost two thousand years. The original technique had been perfected by the Egyptians, who used it in glass vessels and jewelry. Eckhardt has since developed her technique into multiple laminations of sheet glass, using layers of enamels, foils, and other materials to add depth to the surfaces.

Eckhardt has been the recipient of several awards for her research and was a Guggenheim Fellow in 1956 and again in 1959. She has also received a Louis Comfort Tiffany Fellowship for her work in stained glass. Eckhardt is an active exhibitor throughout the country in both one-woman and group shows and is recognized as one of the pioneering glass artists.

Elozua, Raymon (1947–). Born in Germany, Elozua came to the United States in 1951. He studied at the University of Chicago, originally intending to be a lawyer. But in his third year as a political-science

major, Elozua was attracted to the work of Ruth Duckworth, who was a member of the university's art faculty. Elozua was so drawn both to Duckworth as a teacher and to clay as a material that he dropped out of all his classes and spent six months in the clay studios. He recalls: "Ruth Duckworth had a special attitude and sensibility that was really refreshing. She taught you how to think about what you were doing" (Wechsler, 1982).

In 1969 Elozua moved to New York and worked on set construction at Juilliard but found the theater world too precarious financially. In 1974 he bought a kiln and five hundred pounds of clay, and by 1975 he had been accepted for the Rhinebeck Craft Fair, where he exhibited small bowls and porcelain sculptures. In the eighties his sculptural instincts led him to produce complex, moody miniature "landscapes" of abandoned mining buildings, decaying amusement parks, and decrepit sawmills and billboards. This work was rendered in a detailed, realist style. In a sense it was a continuation of his work at Juilliard, where he always made small models of the stage sets. Elozua says, "What I have really done is remove the proscenium. I look at the work as maybe shadow boxes without the box" (Wechsler, 1982).

Around 1983 Elozua began to explore a new content in his work. Derived from his earlier series of billboards, these works have a sharpened political edge. In fact, it is so sharp that Ivan Karp, after first approving the work for an exhibition at the O.K. Harris Gallery, abruptly changed his mind and at the last minute refused to exhibit the works. Writing about the shift in emphasis, Akiko Busch commented: "If Elozua first considered the machinery of the American Dream, he now considers its operators. His new work looks at the blue-collar workers who fought World War II and returned to make good in the post-war manufacturing boom; at the millworkers and steelworkers whose labors have been rewarded by the erosion of American industry, who bought the American Dream, and watched it fall flat" (Akiko Busch, 1987). The portraits are somber, built up of small shardlike pieces of clay assembled on large panels. The shards make up images of eagles, helmeted G.I.s, fighter pilots, and the Statue of Liberty, mixing symbols of patriotism with an overall mood of decay and disillusionment. Still working with the shard, Elozua has also begun to explore the still life, dealing with the notion of fragmentation and reassembly.

Kenneth Ferguson

Ferguson, Kenneth (1938-). Born in Elwood, Indiana, Ken Ferguson studied at the American Academy of Art (summer school), Chicago; at the Carnegie Institute of Technology, Pittsburgh, where he received his B.F.A., in 1952; and at Alfred University, Alfred, New York, where he was awarded an M.F.A. in 1954. He has taught at various institutions, including the Carnegie Institute; Alfred University; and the Archie Bray Foundation, Helena, Montana. From the early 1960s through the present, he has headed the ceramics department of the Kansas City [Missouri] Art Institute. Under Ferguson's guidance KCAI has become one of the most important undergraduate ceramics schools in the country. His students from the 1970s now dominate the leading edge in American ceramics—John and Andrea Gill, Richard Notkin, Chris Gustin, Irv Tepper, Akio Takamori, Arnie Zimmerman, Chris Staley, Kurt Weiser, and others.

Ferguson has been a strong influence as a functional potter; his work is distinguished by a sensuality of form and surface. In summing up his personal view of his art, Ferguson comments: "I enjoy the versatility. For this reason I work with functional and nonfunctional forms—stoneware, salt firing, raku, porcelain and low temperature, thrown forms and handbuilding, and castware. I reflect the fine arts traditional craft and the need to make things. I try to be honest with myself and honest with clay" (Nordness, 1970).

In the 1980s his work has taken a strong step forward, to become more sculptural and more personally subjective than his earlier work, which was more involved with utility. In a review in the *Los Angeles Times* of a 1986 exhibition of Ferguson's pots, the critic Colin Gardner wrote:

There is an urgent Dionysiac vitality about Kenneth Ferguson's pots and platters that injects his basically utilitarian works with a strangely animalistic eroticism. The veteran ceramist mines the muscular fluid decoration of Japanese oribe pottery as well as the 17th-century tradition of Staffordshire "Adam and Eve" iconography to create an idiosyncratic hybrid that is at once graceful, voluptuous and slightly clumsy, much like the contours of a Rubens nude. Ferguson's favourite form is a lidded jar, in this case a small smoke-stack-like piece, whose gun-metal metallic glazes, protuberant lines and patinaed surface suggest aging industrial architecture rather than a decorous household object. The platters and baskets are slightly more genteel, particularly those in white clay with ethereal blue glazes. Yet their deeply etched motifs (mermaids, Adam and Eve, bounding rabbits) express a barely restrained bawdiness, as if the malleable clay were metamorphosing into human flesh, ripe for kneading and probing. (Gardner, 1986)

Frackelton, Susan Stuart Goodrich (1848-1932). The daughter of a brickmaker, Frackelton established the Frackelton China and Decorating Works in Milwaukee in 1883. She employed decorators, and within a short time the factory's weekly production of objects ranged from 1,500 to 2,000 pieces. In 1885 she published Trial by Fire, which rapidly became the bible of the china painters. In addition, in 1892 she organized the National League of Mineral Painters, whose membership included Adelaide Robineau and Mary Chase Perry, and in 1894 she patented "Frackelton's Dry Colors." Frackelton exhibited salt-glazed wares at the World's Columbian Exposition in Chicago in 1893. She later moved on to what were termed delftwares—blue, underglaze-decorated wares—which she exhibited at the 1900 Exposition Universelle in Paris. Frackelton ceased potting at the beginning of the twentieth century and moved to Chicago, where she was an active lecturer until her death in 1932.

Edwin Atlee Barber paid \$500 for her famed *Olive Jar* (1893), which he purchased for the collection of the Pennsylvania Museum. The major collection of her work is

Susan Frackelton

in the State Historical Society, Madison, Wisconsin; most of this collection was donated by her daughter, Susan Frackelton.

Frank, Mary (1933—). Born in London, England, Frank was the only child of Eleanore Lockspeiser, a painter, and Edward Lockspeiser, a musicologist and critic. She immigrated to the United States in 1940, and at the age of seventeen worked for a short period in the studio of the sculptor Alfred van Loen and studied modern dance with Martha Graham. Following her marriage to the Swiss photographer Robert Frank, she studied drawing with Max Beckmann at the American Art School in Holland, and after 1951 studied drawing with Hans Hofmann at his Eighth Street School in New York.

Although she never formally studied sculpture, Frank was attracted to this medium. Her early works were small, wooden figures influenced by Giacometti, Egyptian art, and the work of Henry Moore. Inspired by Reuben Nakian's ceramic wall plaques and Margaret Israel's ceramic sculpture, Frank began to work in wet clay; since 1969 most of her works have been produced in stoneware. The first major exhibition of these works took place at the Zabriskie Gallery, New York, receiving an enthusiastic notice from Hilton Kramer, who called her works "marvels of poetic invention...the very process of the ceramic medium seems to have released the requisite spontaneity" (Kramer, 1970). Three years later, Frank produced her first larger-than-life figures, demonstrating maturity in the handling of her material and great originality, showing only a slight debt to the strong, early inspiration of Nakian.

Since the early seventies, Frank's work has grown rapidly in stature, has been charged with erotic energy, and has consistently explored myth and metamorphosis. Hayden Herrera, the guest curator of Frank's one-woman exhibition in 1978 at the Neuberger Museum, State University of New York, Purchase, wrote evocatively of the artist's having "created a strange, Arcadian world populated by nudes, earth goddesses, forest spirits, Nereids and winged nymphs in flowing gowns. In this world the human figure is at home in nature. There is no hint of the romantic artist's insatiable yearning to connect with nature; figures are nature, embodying all time. All this without a glimmer of romantic nostalgia; although her sculpture is full of poetic whimsy, it is too urgent and earthy ever to be sentimental or sweet" (Herrera, 1978).

Frankenthaler, Helen (1928–). Born in New York City, Frankenthaler received her art education at Bennington College, Vermont. Her work has been widely exhibited, including a one-woman retrospective at the Whitney Museum of American Art in 1969. Her paintings are clear, simple forms with irregular boundaries that avoid the familiar and the geometric. She is particularly known for her technique of stain painting, in which she washes colors onto unprimed canvas.

In 1964-65 Frankenthaler participated in the Art in America project Ceramics by Twelve Artists, producing a limited number of plates that echoed the transparency of color on her canvases. Ten years later, in November 1975, she worked at the Clay Institute in Syracuse on the Everson Museum of Art's project New Works in Clay by Contemporary Painters and Sculptors. Frankenthaler approached the project with caution and afterward wrote: "The idea of working in clay has never really appealed to me; in all ways it is too fragile and my fantasyscale of what I wanted to do sculpturally seemed to go way beyond the possibilities of wet earth. But the project called memuch in the same way I had made metal sculpture, a ceramic tile wall and a series of 71 ceramic tiles" (Hughto, 1976). In working on her pieces, Frankenthaler was not interested in using drawings or models or running tests, but wished to stress the immediacy of her contact with the medium: "From the beginning I wanted nothing to

resemble arts-and-crafts, ashtrays, abstract lamp bases, etc. The point was sculpture out of clay in my terms" (Hughto, 1976).

Frazier, Bernard ("Poco") (1906–1976). Born on a cattle ranch near Athol, Kansas, Frazier received his first artistic training at Kansas Wesleyan University in Salinas in 1924. He then enrolled in the newly created school of design at the University of Kansas, Lawrence. Upon graduation in 1929, he traveled to Chicago to work as an apprentice to the sculptors Lorado Taft and Fred Torrey, studying there intermittently at the National Academy of Art, the Chicago School of Sculpture, and the Art Institute of Chicago, as well as briefly at Moholy-Nagy's New School, an offshoot of the Bauhaus. Returning to Kansas in the mid-1930s, he was awarded a grant in 1938 by the Andrew Carnegie Foundation to serve as sculptor in residence at the University of Kansas, remaining there to establish the first regular department of sculpture. During the next three decades, his local reputation grew and he was continually involved in the fulfillment of important commissions. Two of his major ceramic works—Untamed (1948) and Prairie Combat (1940)—are in the permanent collection of the Everson Museum of Art, Syracuse, New York.

Frey, Viola (1933-). Born in Lodi, California, Frey studied at the California College of Arts and Crafts, Oakland, receiving her B.F.A. in 1956. While a student she studied painting under Richard Diebenkorn and took an elective course in ceramics under Vernon Coykendall and Charles Fiske. She received her M.F.A. in 1958 from Tulane University in New Orleans, where she studied under Katherine Choy. After graduating, she joined Choy's newly founded cooperative, the Clay Art Center, in Port Chester, New York, and took a bookkeeping job at the Museum of Modern Art in New York. In 1960 she returned to the Bay Area, where she began to exhibit actively. In 1965 Frey joined the California College of Arts and Crafts (CCAC) faculty in a part-time capacity while maintaining a full-time job at Macy's, Oakland. In 1970 she turned to full-time teaching, working in the ceramics department, as well as teaching a course on color in the CCAC painting department. Frey still teaches at the CCAC in the ceramics department.

Frey's early work was involved with the Bay Area's fashionable interest in Japanese and Chinese ceramics during the 1950s. For a time she made only pots, but gradually she returned to her figurative concerns. In the 1960s her work became more iconographic. Influenced by Robert Arneson's toilets and trophies, she turned to everyday objects for her subjects. On weekends she haunted the giant flea market at Alameda and developed a large collection of dimestore figurines and other industrially made decorative ceramics, which the artist felt had "a frozen presence far beyond their value. They become images from childhood, memories enlarged and scary. Amongst these artifacts are little animals—dogs, cats, roosters, birds—and their attendant human. I decided to make them big-take them out of the crib and off the coffee tables, make them myths of childhood. I altered their poster colors using overglazes to give them alertness and vividness, and to unfreeze them" (Chicago et al., 1977).

Frey's interest in overglaze painting grew out of her color-light studies at the CCAC. She sees this involvement in two phases: the first, trying to match effects achieved in painting—spray effects for clouds and the modulation of colors to add activity and depth to the surface of the object. In the second phase she used china painting to manipulate the surface of forms. By painting light and shadow, she was able to establish auxiliary forms upon the base structure.

By 1970 her work had grown in complexity, scale, and volume. She was now beginning to develop a name as a ceramist, and her exhibitions sold very well. Frey was at a crucial point in her personal development, and it distressed her to see pieces leave the studio so rapidly, before she could live with and learn from them. As a result, in the mid-seventies she withdrew from all public exhibiting and began to work at a furious pace, filling her fivestoried home from ground floor to attic with her works. Several series of works emerged between then and 1981: detailed, china-painted tableaux with the look of incomplete "paint by numbers" projects that explored the chiaroscuro of light and shade in its most subtle modulations; the Desert Toys—ominous, brutal-looking pieces with raw surfaces and a sense of menace; large assemblages of cast ceramic bric-a-brac that Frey called her "bricolages" after Claude Lévi-Strauss's notion of the junkman, or bricoleur, as an artist; paintings and lifesize ceramic figures that began to develop in scale and abstraction.

In 1979 she returned briefly to the public arena in the exhibition *A Century of Ceramics*

in the United States, her first major national exhibition platform. But she kept out of the commercial circuit until after her acclaimed retrospective in 1981, which opened at the Crocker Art Museum in Sacramento and then traveled to seven other institutions. Since then Frey has had an active exhibit record, including a one-person exhibition at the Whitney Museum of American Art in 1984.

Her oeuvre of the early eighties has been dominated by an interest in the figure; the life-size portraits of family and self from the late seventies have now become massive figures that stand up to eleven feet in height. Yet, despite their scale, they remain tied to the notion of the figurine. In a brochure for Frey's exhibition at the Whitney, the curator, Patterson Sims, described the figures as "immobile sentinels...they engage the viewer in an unequal dialogue. Intimidatingly aggressive they glower at their human counterparts, turning the viewer into the figurine. Grown-up and fantastic versions of Frey's beloved bric-a-brac, they amplify her dictum that 'figurines function in order to make acceptable those things our culture finds unacceptable.' Frey's huge figures ...reveal the average, kitsch, and the stereotype as mirrors of American cultural values" (Clark and Sims, 1984).

About late 1985–86 Frey's tall, clothed figures began to take on an awkward quality, straining to cope more with their complex concerns of engineering and gravity than with content. But the earlier inventiveness returned through a generation of smaller figures, which has returned the tableaux to Frey's work and the sense of what Lévi-Strauss termed "deviousness." The larger figures have now shed their clothes and become recumbent, strangely fascinating vulgarizations of the classical nude.

The strongest link of her present work to the Frey of the seventies can be seen in her platters. Plates bring Frey back to the uncomplicated play with ideas and forms; "they are created in a limited time. It can take several weeks to create a figure but I can do several plates in an afternoon. They explore whatever the time allows" (Clark and Sims, 1984). In these pieces the *bricoleur* still reigns supreme, encrusting the surfaces with a relief of cast objects, glazed with the lavalike lines of Egyptian paste and viscous, bright glaze. They are the sculpture of a major American sculptor entering her creative prime.

Frimkess, Michael (1937-), and Magdalena Suarez Frimkess (1929-). Born in Los Angeles, Michael Frimkess entered the Otis Art Institute at the age of fifteen to study sculpture. He was one of Otis's youngest students and one of the last to join the ceramics course under Peter Voulkos, a decision he made after a peyote trip, during which he had the vision of throwing a pot. At nineteen Frimkess moved to Italy, where he worked in a ceramics factory in the south. He returned to Los Angeles in 1958 and spent some time at the Berkeley "pot shop" at the University of California. In 1963 he moved to New York, where some of his work was shown at the Allan Stone Gallery. When he delivered his work, Frimkess found the gallery crammed with the china-painted works of Robert Arneson: "I was shocked.... They took my breath away, it was like seeing one aspect of myself. I could have done that if I had the opportunity. But I had been wax finishing Malvina Hoffman's bronzes at the Italian Bronze Foundry in Queens" (Clark and Frimkess,

Michael Frimkess

Frimkess later worked at a commercial pottery in Pennsylvania, where he replaced an Italian potter who had been using a technique of throwing hard clay without water. Frimkess learned this technique and began studying the ancient Greek ceramics in the Metropolitan Museum of Art, deciding that they had probably been thrown by this method. He returned to Venice, California, where he established a studio.

Since the late sixties the central focus on Frimkess's work has become the throwing of hard clay without water. His forms have distinct cultural references, such as the Greek amphora and the Chinese ginger jar. These he decorates with bright, overglaze patterns. Some consist of purely decorative motifs, and others employ complex, comicbook illustrations that deal with his experiences of being a member of "the last Jewish family left in Boyle Heights," where he grew up with Japanese, Chicano, and black children. The objects he has created have symbolically become ethnic melting pots, wherein all racial differences and discrimination can be dissolved.

From 1966 to the early seventies there was an extraordinary outpouring of vessels from Frimkess's studio. Jazz musicians played riffs on Kang Xi vases, and cyclists pedaled across volute kraters (*Ecology Krater II*, 1976). Labels for the fictional firm Gilbey's and Benson appeared on panathenaic amphorae, and in *Covered Jar* (1968) Uncle Sam, with rape on his mind, pursues third-world maidens across ginger jars, while various godheads and superheroes look on.

These works represent a major departure in style from his earlier pieces, which dealt with iconographic assemblages in mixed media and with bronze television-set sculptures, such as Hooker (1962). The vessel remains the main Frimkess format: "Today's pottery continues as ever, an art form. Wheel throwers remain philosophers, humanitarians, and men of conscience, aware of their time's mission, ever on a par with the greatest sculptors, perfectionist painters, writers and musicians. Due to throwing's freedom-giving limitations, it is still one of the finest roads towards self improvement' (Frimkess, 1966). During the past two decades illness has greatly reduced Frimkess's output and particularly limited his drawing.

In addition to the independent works of Michael Frimkess are the many important pieces on which he and his wife, Magdalena Suarez, have collaborated. She had studied painting at the Escuela Artis Plastica in Caracas, Venezuela, showing a great facility for draftsmanship. She interrupted her studies in 1947, when she was married, and did not return to them until 1954, when she took classes at the Catholic University of Chile in Santiago. Magdalena came to the United States on a scholarship to study at the Clay Art Center in Port Chester, New York. There she met Michael Frimkess. Several years later they married and began to collaborate in their work. In some ways her work is similar to Michael's in that she uses a mixture of national styles, her most distinctive being a blending of Mayan and Hispano-Moresque. Unlike her husband, however, she makes no attempt at philosophical statements in her work. She achieves these mixes intuitively: "I only care what my work looks like, whether it works compositionally, whether the color is right...I am indifferent to what it means" (Clark and Frimkess, 1982).

Fry, Laura Anne (1857–1943). Born in Indiana, Fry was the daughter of a noted wood-carver, William Henry Fry. She studied wood carving, china painting, sculpture, and drawing at the Cincinnati School of Design from 1872 to 1876. She continued her studies in Trenton, New Jersey (the American equivalent of Stoke-on-Trent, Britain's industrial center for ceramics), and then in France and England. In 1881 she joined the decorating team at the Rookwood Pottery, where she worked in the style of Hanna Barlow (an artist from Doulton's Lambeth Art Studio), incising decoration and rubbing in cobalt oxide.

In July 1883 Fry introduced the technique of applying slips to greenware with an atomizer—the first use of the "spray gun" in American ceramics. She was granted a patent for the technique in 1889. Fry became professor of industrial art at Purdue University, Lafayette, Indiana, in 1891, but a year later she returned to Ohio, joining the Lonhuda Pottery in Steubenville. There she attempted to restrain Rookwood from using her atomizer technique, but the courts ruled against her in a judgment delivered by Judge William Howard Taft in 1898.

Fry returned to her teaching post at Purdue after finding the public interest in the women's decorative-art movement to be sharply on the wane. She remained at Purdue until 1922. Fry was one of the leading figures in the Cincinnati women's art movement; her innovation in pottery decoration was directly responsible for the "Standard Rookwood" style. Upset by the failure of her patent claim, however, Fry refused to give any of her works to the Cincinnati Art Museum and instead donated a substantial collection of her wares to the Saint Louis Art Museum in 1911.

Fulper, William H. (1872–1928). Born in New Jersey, Fulper came from a family that had operated a pottery since 1805. The importance of the pottery in the production of art ware was slight until late in 1909,

when the Fulper Pottery Company first introduced the Vasekraft line at their plant in Flemington, New Jersey. The body used in these wares was made from a natural New Jersey clay and was fired at a high temperature alongside the pottery's commercial ware. The superb range of luster crystalline, mat, and high-gloss glazes attracted considerable attention—but the most prestigious glaze was the so-called famille rose developed by William Fulper. Fulper effectively capitalized upon the interest in Chinese pottery in his Ashes of Rose glaze, selling individual works for as much as \$125. The Fulper was one of the few "regenerative" art potteries of post-1910, selling well at a time when most other art potteries were in decline. Fulper Vasekraft won the gold medal of honor at the Panama-Pacific International Exposition in 1915. Fulper shared a stand with Gustav Stickley, and the vases were shown on Stickley's furniture.

One year after Fulper's death in 1928, the Flemington plant was destroyed by fire and with it all the pottery's records. Production was transferred to the new plant in Trenton, New Jersey. In 1930 the pottery was acquired by J. Martin Stangl, formerly the superintendent of the pottery's technical division. Despite their frequent and often heated differences of opinion, Stangl had risen to become Fulper's right-hand man in the pottery. In 1955 the corporate title was formally changed to the Stangl Pottery Company.

A collection of major works of Fulper art ware was given to the Philadelphia Museum of Art in 1911. Other important collections are at the Newark Museum and New Jersey State Museum, Trenton. In 1979 an exhibition organized by Robert Blasberg for the Jordan-Volpe Gallery in New York brought a new wave of interest in collecting Fulper wares and, for a while, some overoptimistic speculation as to the financial value of the wares.

Gilhooly, David (1943—). Born in Auburn, California, Gilhooly received his B.A. from the University of California, Davis, in 1965 and his M.A. in 1967. He has taught at San Jose State University, California; Canada's University of Saskatchewan, Regina, and York University, Toronto; and the University of California, Davis (1975—76).

Gilhooly's early work was based on a satirical play on animal motifs, such as his *Elephant Ottoman* (1966). Between 1968 and 1984, he worked prolifically on a body of work that is almost without parallel in the ceramic arts. Each year has seen the pro-

Higby's inventive use of raku and landscape imagery was a welcome and necessary break from the aesthetic of the "Alfred vessel," which had been constantly reinforced by the tradition of employing Alfred graduates. Higby uses his vessels as a threedimensional canvas on which valleys, lakes, and canyons appear. In some works the image is used in an illusionary manner that blends the vessel's interior and exterior. Higby defines his works (and indeed all vessels made with artistic intent) as objects "that present the formal essence of a pot exaggerated to reveal a personal artistic vision uninhibited by pragmatic issues of function" (Higby, 1986).

Higby uses only two forms—a high, oval bowl and a nest of lidded vessels. The forms are emphatically pots but deliberately without direct cultural or historic reference. Higby sees his work as dealing with the symbolic nature of the vessel. Speaking of his work in a recent article, Higby commented on both its visual schema and its aesthetic content:

I like to think that there's an equal tension of balance between the three-dimensional form and the drawn illusion of projecting and receding space. It's a balancing [act]. I think of [my] pot as a figure. People ask why there aren't any people in my landscapes, but the pot itself is a figure, a personification of a kind of human condition, a series of polarities: the pot is me. As the bowl radiates outward, it becomes a metaphor for human consciousness and our strange existence in space. The bowl form has that potential resonance; it can deal with finite space and infinite, illusory space-things that also exist in our psyches." (Klemperer, "Higby," 1985)

Over the past fifteen years Higby has refined his forms and surface imagery within a narrow palette and range of forms. The growth has been directed horizontally, with subtle nuances and shifts, rather than with any vertical movement. In the 1980s his energies have increasingly been directed toward the ceramics field at large. He has become an active writer on ceramics and has served on the boards and committees of many organizations, including the Haystack Mountain School of Crafts, the Gallery Association of New York State, the National Endowment for the Arts, and the New York State Council on the Arts. Higby's works have been widely exhibited, and in 1973 he was given a one-man show at the Museum of Contemporary Crafts in New York.

Holcomb, Jan (1945-). Born in Washington, D.C., Holcomb attended the University of Michigan, Ann Arbor, where he received a B.A. in history in 1968 and a B.F.A. in painting and ceramics in 1975. In 1977 he received his M.A. in ceramics from California State University, Sacramento. He has taught ceramics at the Rhode Island School of Design since 1978 and maintains a studio in Pascoag, Rhode Island. Holcomb's sculpture deals with the landscape in the Surrealist sense as a metaphor for the subconscious. Alienation and loneliness are recurring themes but are presented with objective distance. There is no self-pity or even latent anger in the work—just a perceptive and gentle observation of the human condition.

The influences active on Holcomb's art are diverse, ranging from Disney cartoons and political caricaturists to Max Ernst and Funk artists Robert Arneson and Jim Nutt. Holcomb places the greatest emphasis in his work on the face, giving it a stylized quality with a touch of the grotesque. He says that his work "always starts with the face, because that is really the focus of the psychological and emotional energy and information. The figure is like an appendage of the face" (Wechsler, 1984). Holcomb's landscapes were originally produced as tableaux but now they are mainly wall sculptures, modeled in relief with very carefully detailed painting on the surface. "My work is very controlled," says Holcomb; "The handling of the imagery is neatly done. I really enjoy taking all the care to clean them up and make them nice.... [But] the figures are really not nice, and there's the contrast between their attractiveness and the emotional states that is not attractive. Some of the figures are darker than others, some characters have to do with darker issues, like mortality. Some are defensive characters, with emotions of fear or trying to fend people off. Sometimes it's exterior forces that are creating anxiety. Whether overt or subtle, it's sort of an existential plight" (Wechsler, 1984).

Hudson, Robert (1938–). Born in Salt Lake City, Hudson studied at the San Francisco Art Institute, where he received his B.F.A. in 1962 and an M.F.A. in 1963. Hudson is known for his exploratory use of color in his distinctive polychrome metal sculpture and for his fastidious craftsmanship. In 1972–73 he produced a body of ceramic works in conjunction with Richard Shaw. Although they shared molds and

techniques, they worked individually, sharing inspiration and knowledge. Writing of these works, Peter Schjeldahl commented:

Even in California's twenty-year history of avant-garde clayworks I wonder how many pieces, judged by the standard of Hudson and Shaw, seem primarily or even necessarily to be ceramic objects rather than extensions into the medium of generalized art intentions. The achievement of Hudson and Shaw was to perceive the limitation of the ceramic object as a thing of, if not domestic function, domestic scale and feeling and to realize within that limitation a maximum creative freedom. There is a kind of dreamlike abstract logic to these works, a blend of nonchalance and inevitability that can be best understood, I believe, in terms of a radical coming to grips with the medium. (Robert Hudson, 1977)

Hughto, Margie (1944—). Born in Endicott, New York, Hughto studied at the State University of New York at Buffalo, where she received her B.S. in art education, with minors in ceramics and painting, in 1966. She later studied at the Cranbrook Academy of Art in Bloomfield Hills, Michigan, and received an M.F.A. in ceramics in 1971. Both before and after graduating from Cranbrook, Hughto taught at public high schools in Michigan and New York State. In 1971 she joined the faculty of Syracuse University, Syracuse, New York, where she has been a full-time ceramics instructor since 1974.

In 1975 Hughto became project director and curator for the exhibition New Works in Clay by Contemporary Painters and Sculptors, producing a ninety-six-page catalogue that documented the project and the exhibition. The project brought together ten major figures in the fine arts to work during a concentrated period on the production of a body of ceramic sculpture. The project was a considerable success. With funds from the Ford Foundation, Syracuse University established its Clay Institute, which occupies the full top floor of the old Consolidated Can Company building. Since 1976 several of the artists who participated in the original project, including Anthony Caro and Friedel Dzubas, have returned to work with Hughto. There have also been new artists: Kenneth Noland, Mary Frank, Stephen DeStaebler, and others. Hughto was responsible for initiating and co-curating the exhibition A Century of Ceramics in the United States 1878-1978, which was accompanied by the first edition of this book.

Hughto has continued an important tradition at Syracuse University of dedicated women artists who support the ceramics field at large. Much like the editor-artist Adelaide Alsop Robineau and the authorsculptor Ruth Randall, both of whom are from Syracuse, Hughto has developed her own work into one of the more original statements in contemporary ceramics today. She has also contributed richly toward the broad needs of the art through her directing of the Clay Institute and, until 1981, as adjunct curator of ceramics at the Everson Museum of Art, Syracuse. Hughto curated Nine West Coast Clay Sculptors: 1978, the first major exhibition on the East Coast to look specifically at the importance of the West Coast in the post-World War II development of ceramic art. She organized an exhibition, New Works II, in 1979 and then in 1980, New Works III, the last of the New Works series.

In the eighties Hughto has concentrated mainly on large-scale ceramic commissions for IBM, the Buffalo Mass Transit System, and other corporations and institutions. She has organized a model studio in Syracuse for these labor-intensive projects, while continuing to hold one-person exhibitions, including her 1980 exhibition at the André Emmerich Gallery in New York. Her interest in paper, which began through her collaboration with Kenneth Noland, has continued through the years and is as important as her work in clay. In her clay work the abstracted image of the fan has been replaced with a series that deals with floral subject matter, but again abstractly rendered in roughly textured, high-relief wall pieces.

Hui, Ka-Kwong (1922-). Born in Hong Kong, Hui attended Kong Jung Art School in Canton, China, and the Shanghai School of Fine Arts in Shanghai. Before coming to the United States in 1948, he was apprenticed to Cheng Ho, a sculptor. He worked with the Wildenhains at Pond Farm in California and then went to Alfred University, where he received both his B.F.A. and M.F.A. from the New York State College of Ceramics. After obtaining his degrees, Hui taught at the Brooklyn Museum Art School and at Douglass College, Rutgers University, New Brunswick, New Jersey. In 1964-65 Roy Lichtenstein invited Hui to be his technical collaborator in a series of cup sculptures and ceramic mannequin heads that were later exhibited at the Leo Castelli Gallery in New York. Although Hui was not working in the Pop idiom as such, there was a strong affinity between his workthe flat, bright color of his forms—and Lichtenstein's. Hui continues to work in the style of his early works.

Irvine, Sadie (1887-1970). A graduate of the Sophie Newcomb Memorial College for Women, New Orleans, Irvine was one of the best-known decorators of the Newcomb Pottery's mat-glazed pottery after the arrival of Paul Cox in 1910. Little firm biographical information is available on Irvine. In her correspondence with Robert Blasberg (Blasberg, 1971), she was vague about dates, giving the year that she joined the pottery as "between 1910 and 1912." She was the originator of one of the pottery's most popular designs, the live oak, an honor that she later claimed to regret. The beautiful moss-draped oak trees appealed to the buying public, "but nothing is less suited to the tall graceful vases—no way to convey the true character of the tree—and oh how boring it was to use the same motif over and over again." She presented one of these vases to Sarah Bernhardt "on one of her many farewell tours" (Blasberg, 1971). Irvine remained at Newcomb and taught there until 1952. In later years her creative activities were directed toward watercolors and block

Karnes, Karen (1920–). Born in New York City, Karnes studied at Brooklyn College, New York, in 1946 and at the New York State College for Ceramics at Alfred University, Alfred, New York, from 1951 to 1952. In 1952 Karnes and her husband David Weinrib became potters in residence at Black Mountain College in Asheville, North Carolina. Karnes and Weinrib set up their own pottery at Stony Point, New York, in 1954. Karnes was later divorced but remained at Stony Point and established herself as one of the leading functional potters in the United States. Her works are distinctive for their sturdy, powerful forms and their superbly textured salt-glazing. Karnes has received many awards and honors, including the Tiffany Fellowship in 1958; awards from the Everson Museum's Ceramic Nationals in 1950 and 1958; a silver medal at the thirteenth Triennale de Milano, Italy. In 1976 she was made a member of the Academy of Fellows of the American Craft Council and received a fellowship from the National Endowment for the Arts. In 1980 she was made a fellow of the National Council on Education in the Ceramic Arts.

In the late seventies her work began to take on a dual identity. She continued to make inexpensive utilitarian pottery, but also made one-of-a-kind pots. An important exhibition in this development took place at the Hadler/Rodriquez Gallery in New York in 1977. Writing of the work in the exhibition catalogue, Judith Schwartz com-

Karen Karnes